故宫博物院藏品大系

故宫博物院藏品大系

绘画编

4

宋辽金

故宫博物院 编

故宫出版社

图书在版编目（CIP）数据

故宫博物院藏品大系．绘画编．4，宋辽金：汉英对照／故
宫博物院编．—北京：故宫出版社，2008.3（2012.2.重印）
ISBN 978-7-80047-720-1

Ⅰ．故… Ⅱ．故… Ⅲ．①历史文物—中国—图录②中国
画—作品集—中国—宋代 Ⅳ．K870.2 J222.44

中国版本图书馆 CIP 数据核字（2008）第 019456 号

故宫博物院藏品大系

绘画编 4 宋辽金

主　　编：袁　杰

编　　委：傅东光　赵炳文　陶　静

摄影统筹：胡　锤

摄　　影：胡　锤　刘志岗　冯　辉　赵　山

　　　　　周耀卿　孙志远　司　冰

翻　　译：李绍毅

编辑统筹：陈丽华　王亚民　赵国英

责任编辑：徐小燕

装帧设计：李　猛

出版发行：故宫出版社

　　　　　地址：北京市东城区景山前街 4 号　邮编：100009
　　　　　电话：010-85007800　010-85007816　传真：010-65129479
　　　　　网址：www.culturefc.cn　邮箱：ggcb@culturefc.cn

印　　刷：北京雅昌彩色印刷有限公司

开　　本：787×1092 毫米　1/8

印　　张：40

字　　数：10 千字

图　　版：238 幅

版　　次：2008 年 3 月第 1 版
　　　　　2012 年 2 月第 1 版第 2 次印刷

印　　数：2,001~3,000 册

书　　号：ISBN 978-7-80047-720-1

定　　价：480.00 元

总目

图版目录

图版

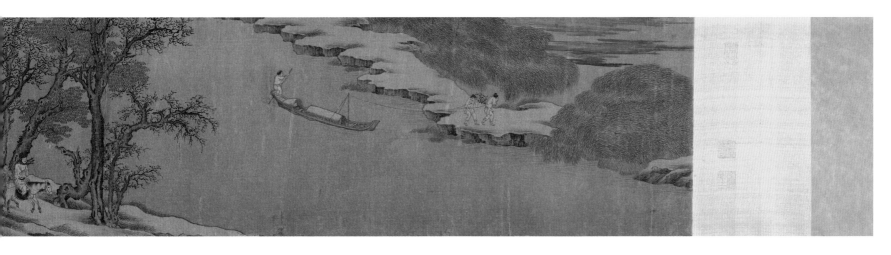

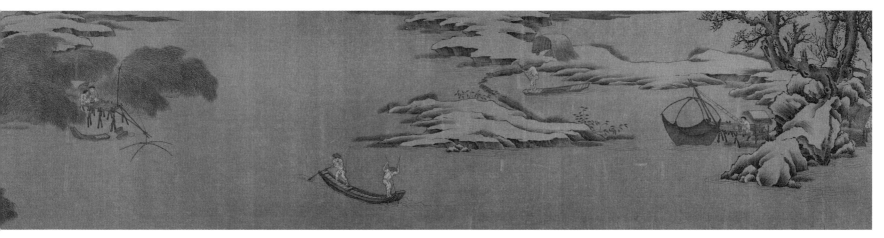

新147494

宋 佚名
雪渔图卷

I | 绢本　纵25.3厘米　横332.6厘米

Xin147494

Anonymous, Song dynasty
Fishing in Snow

Handscroll, silk
25.3 × 332.6 cm

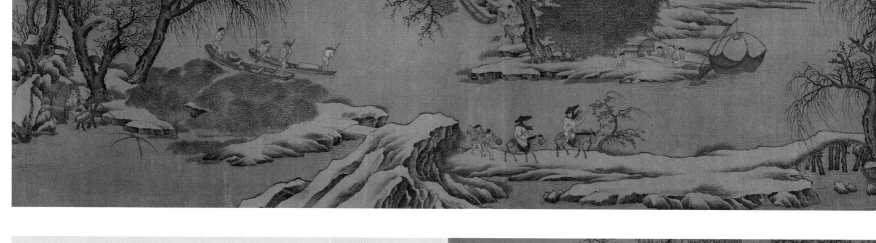

此卷屌生以為雪溪圖天命
三合攘似吳弟樹石非枣
大年本色常毫高克明
葉萬与趙之穰参僑松
著而像雪生偽羊宗时

趙大年雪溪高英品格正在子里之上
金是黄岭坡之京家之浚見此卷大年
宗王和朱葉不聯出油五百云公枝為寄
千速雪景光綠之嘉家牀傲千羊光社
社傲令镶从心不不而肉肉也珠堂
陳穈

雪漁圖不始於宋人畫友戴王維
捕魚圖水波渺瀰洲渚隱見其
晴岸木葳葵御独黄羊蔓銭
眠黄天惨雪而风人物承唐
寒意蓋畫江南和雪時也此叩
雪漁所戴昭合西葦麦与右
廛史千雪齋寺圖相似其方宋
人規摹唐人之此等疑舊為吾
勝王氏沙藏今歸
申甫若大兄可謂月所撮至京
師出以相示真平生那福也
咸豊己未玉前一日題於諸名軒
鴨旅匡源

生平所見宋人墨跡不下五七本就中
惟盡之襄江山雪霽卷為最江天寥
瀾矢齡如帘寒夓敝障荒蘆無
際葦墨越速自非庚午西及此卷
明淨營深自非宋人不能
申甫仁兄九乃此桂膠西壁誠劍亞
雪漁乃載名譏逼合衣非偶然

大年八筆上林得郡无千藏蒠愿政尔師
承罡許近不妨鍟別董陳珠
鬼湖所藏趙大年奉羊法勤古傳世所者絠哥
沈曽植題於戊世柳堂

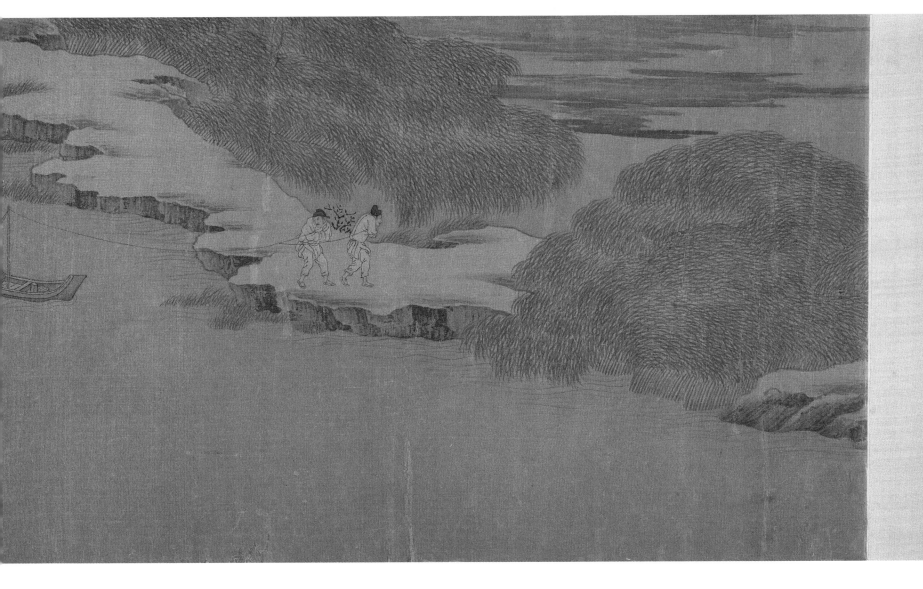

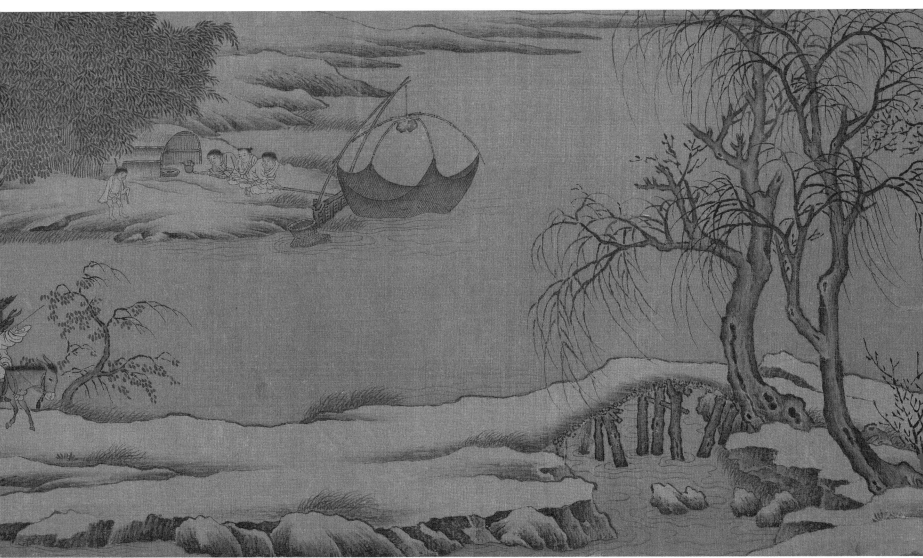

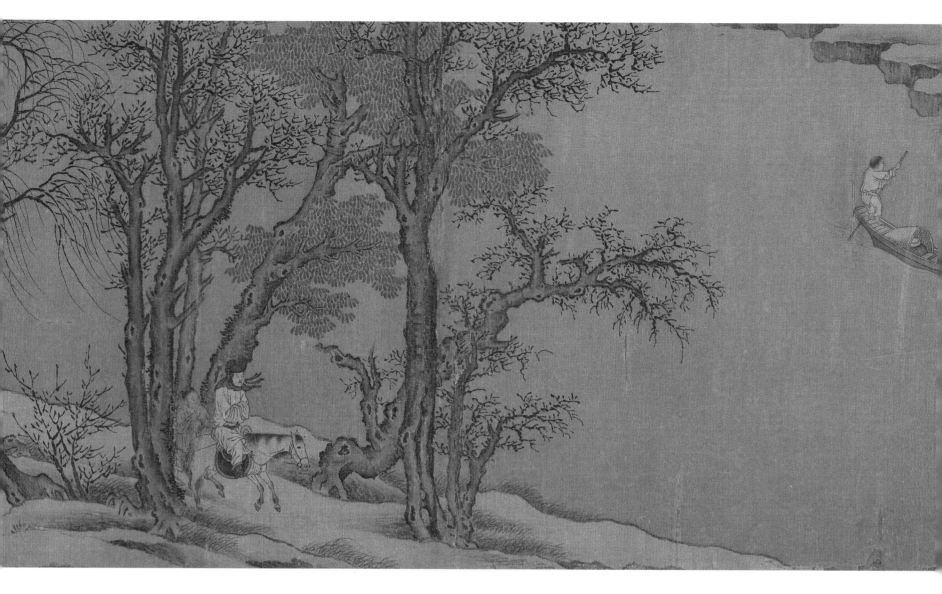

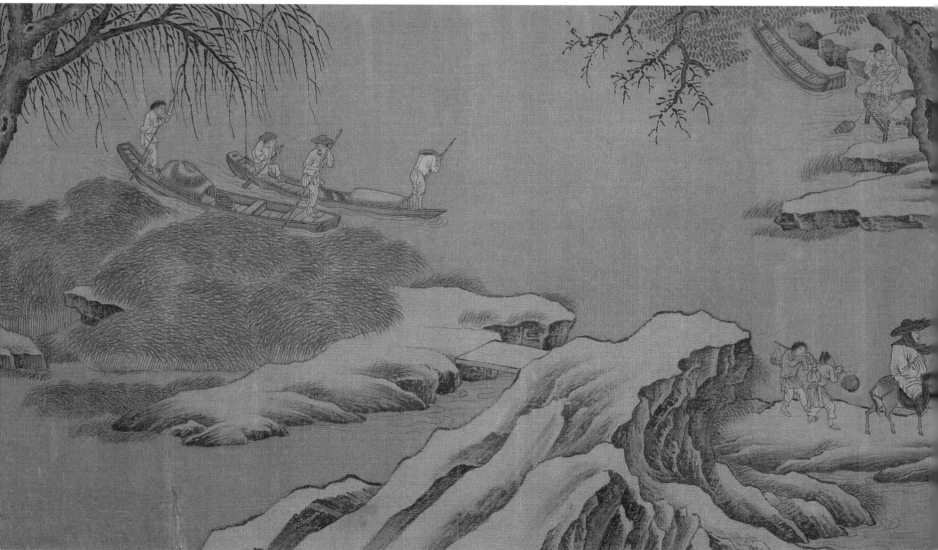

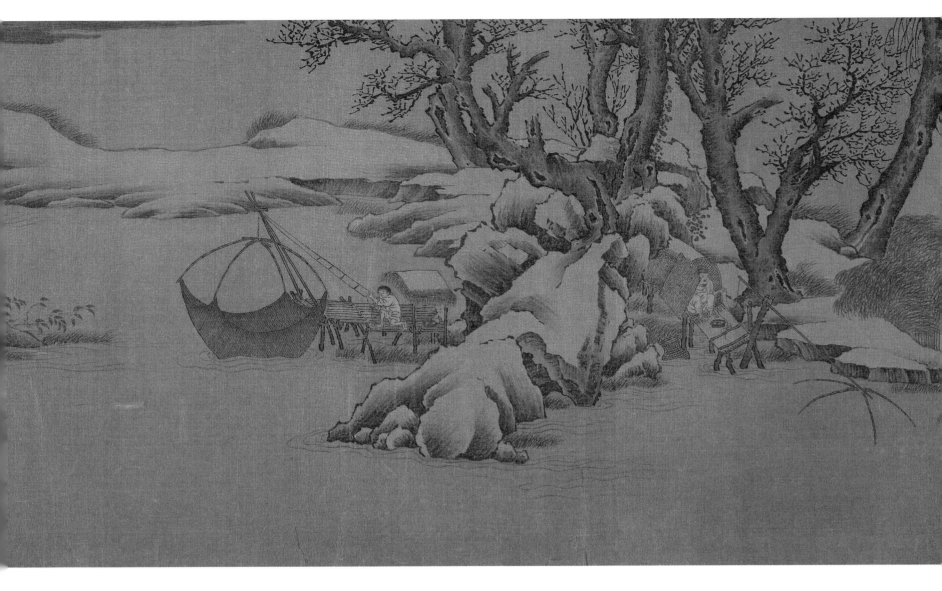

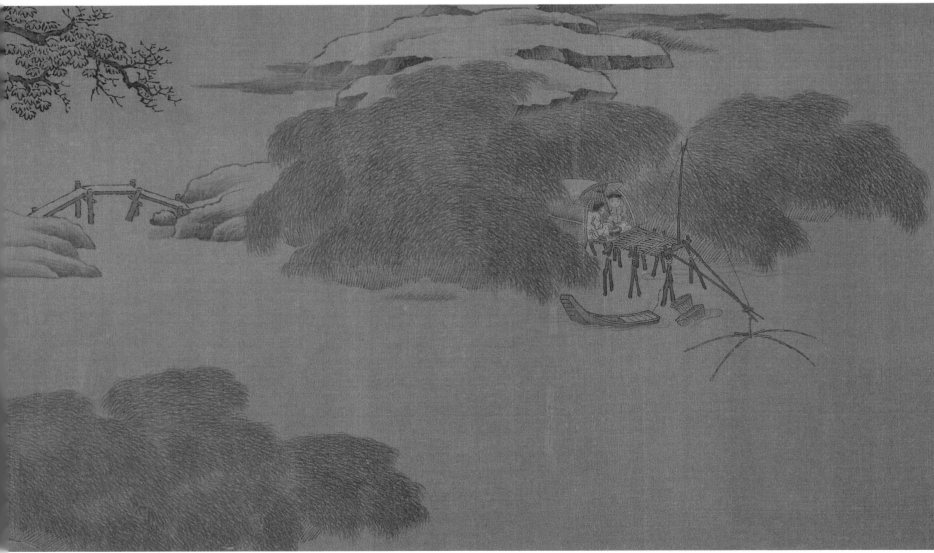

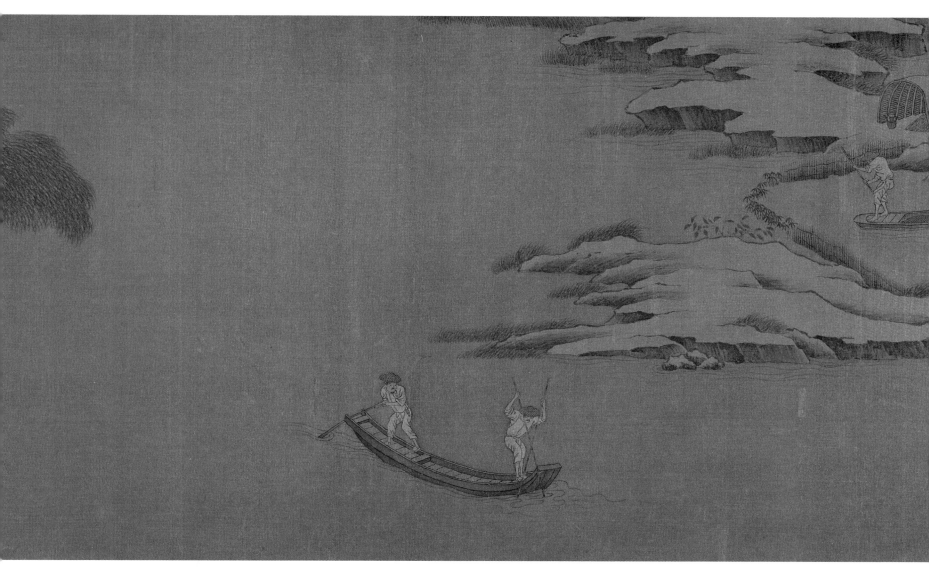

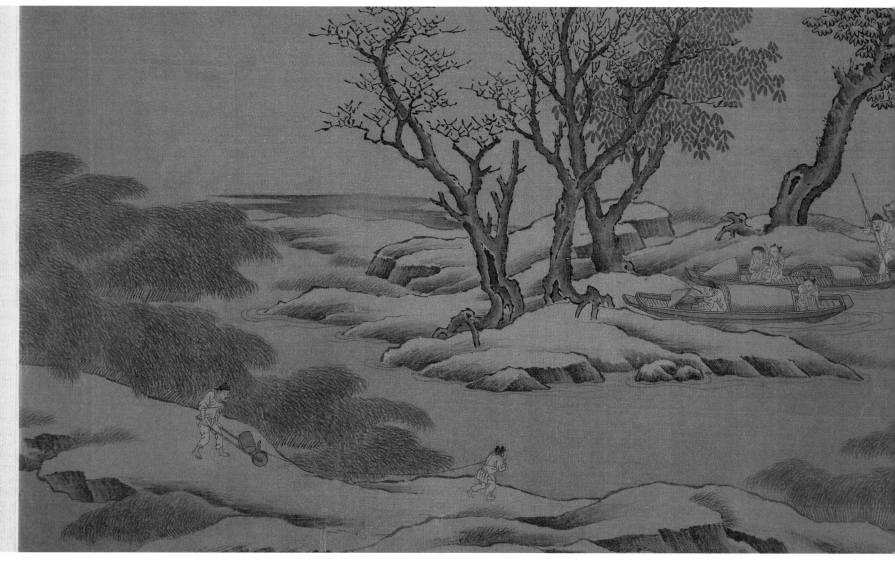

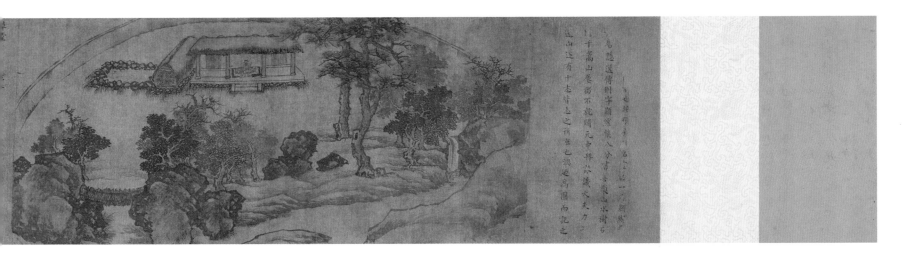

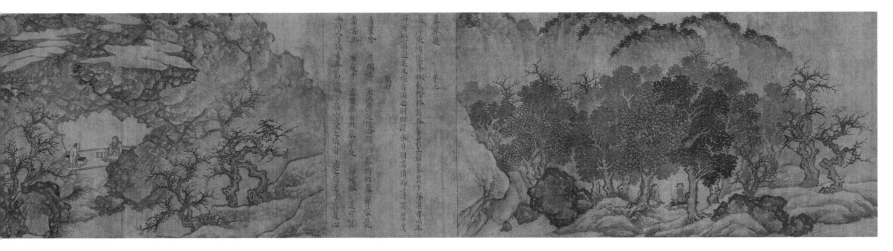

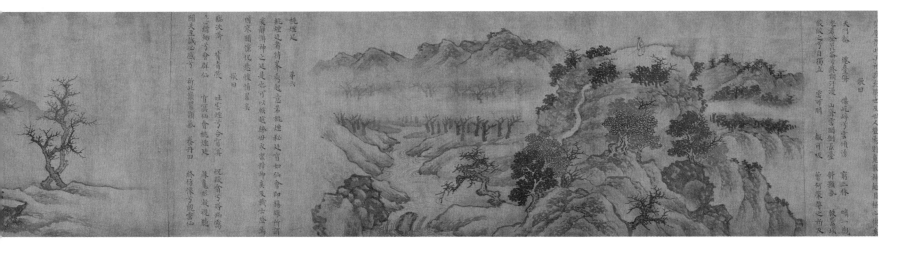

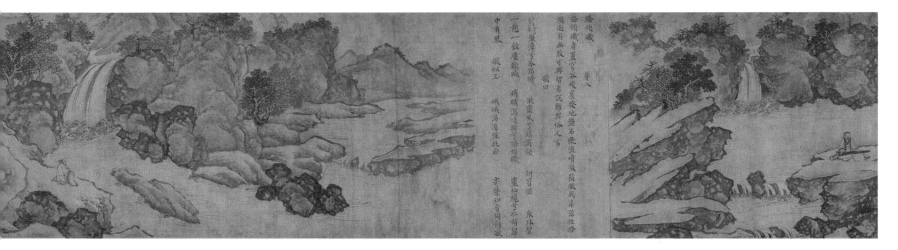

新147497

宋 佚名
卢鸿草堂十志图卷

2 | 绢本　纵25.6厘米　横711.6厘米

Xin147497

Anonymous, Song dynasty
Illustration of Ten Views from a Thatched Hut of Lu Hong
Handscroll, silk
25.6 × 711.6 cm

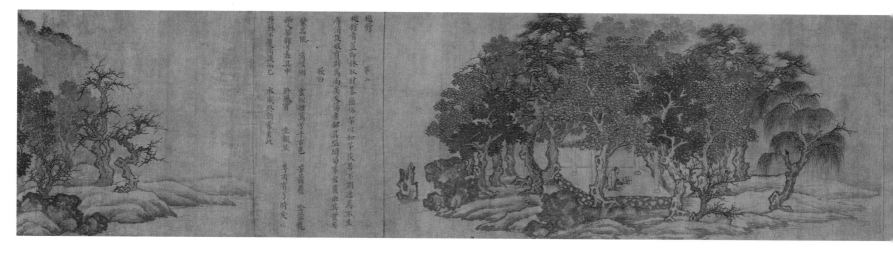

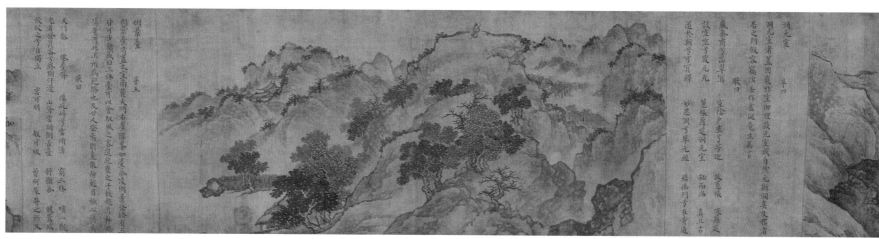

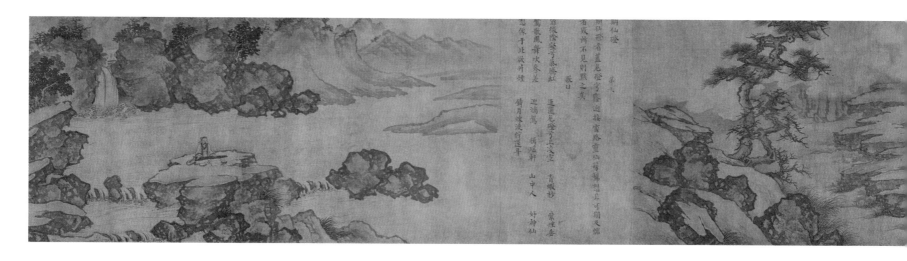

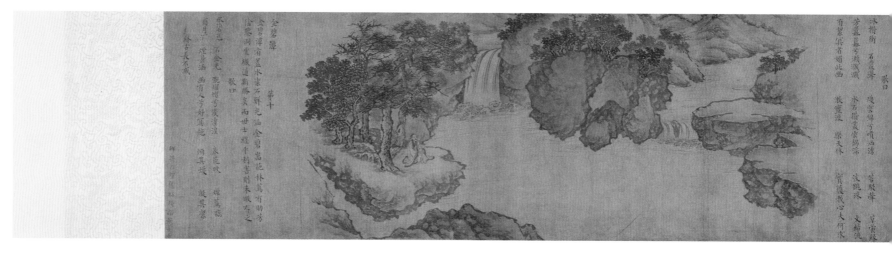

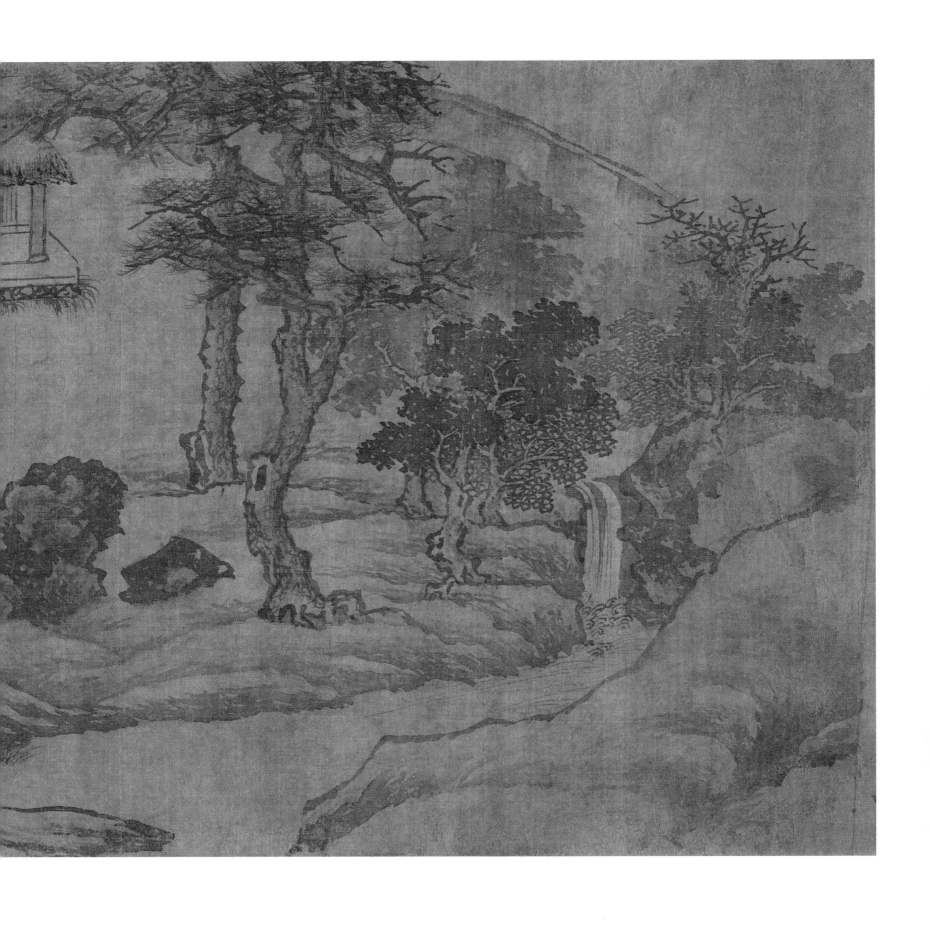

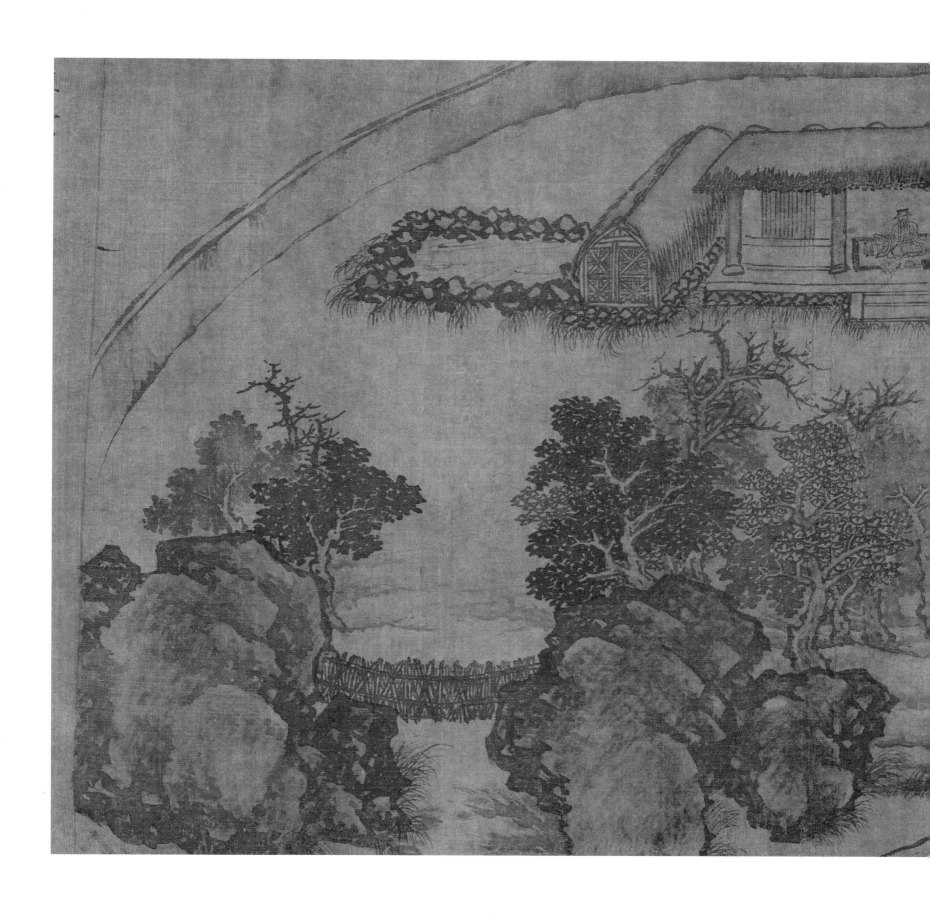

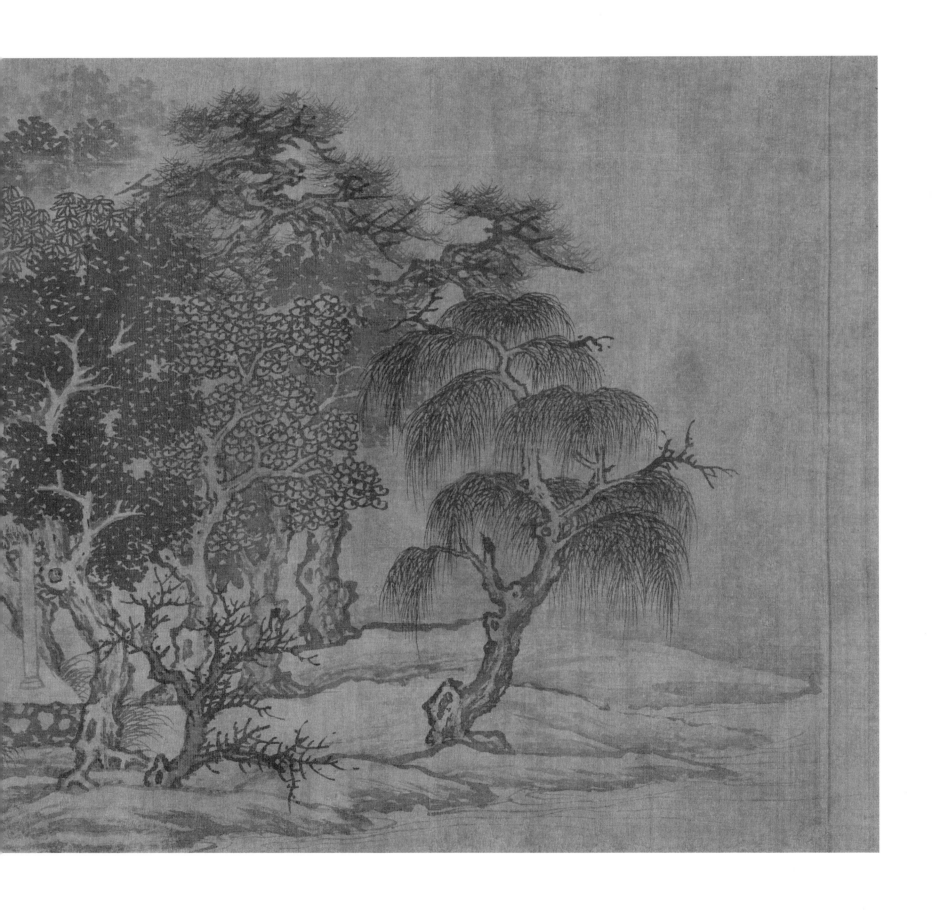

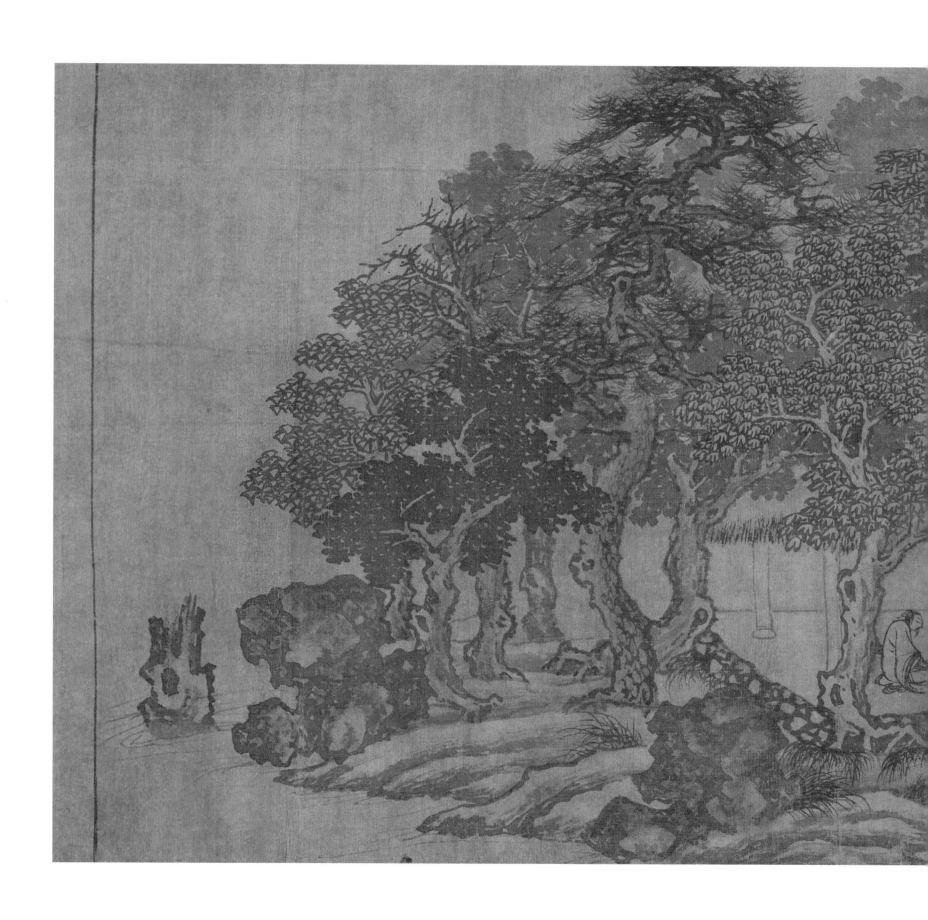

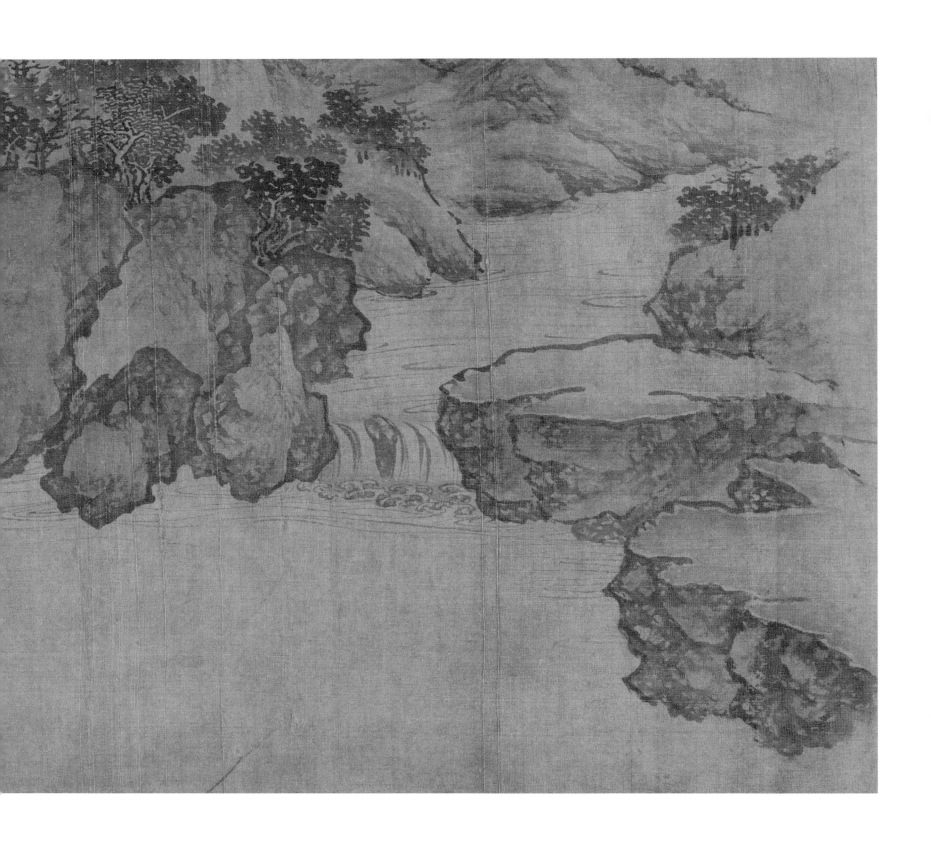

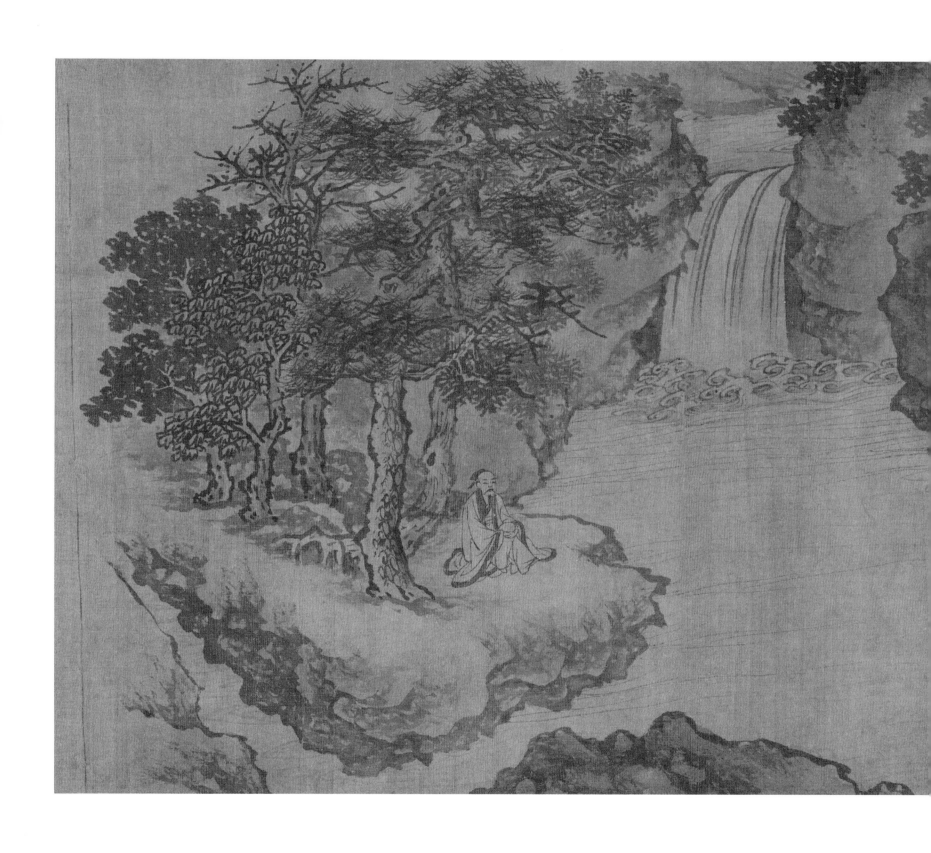

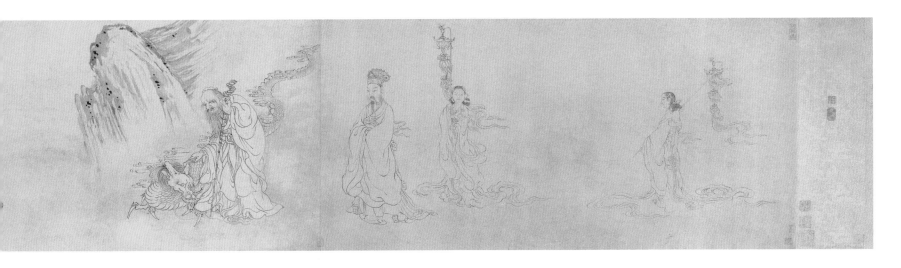

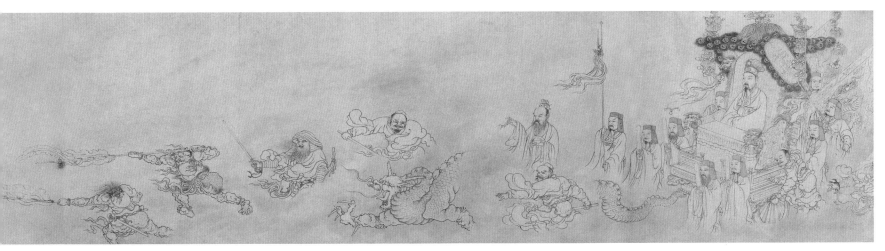

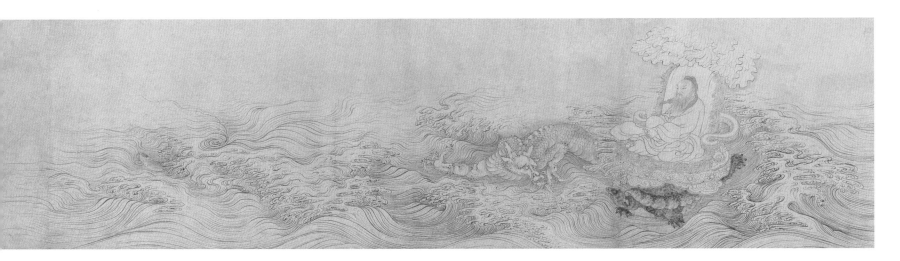

新121183

宋 佚名
九歌图卷

3 纸本　纵40厘米　横885厘米

Xin121183
Anonymous, Song dynasty
Nine Songs
Handscroll, paper
40 × 885 cm

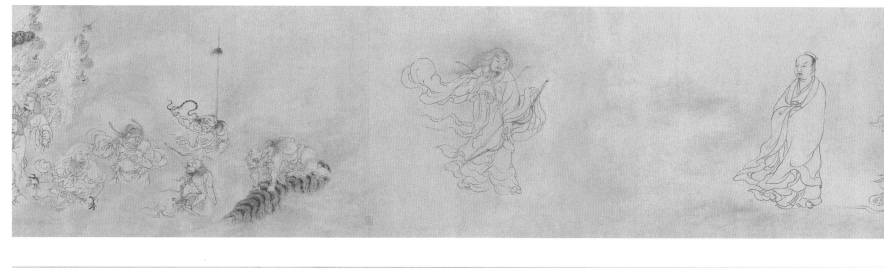

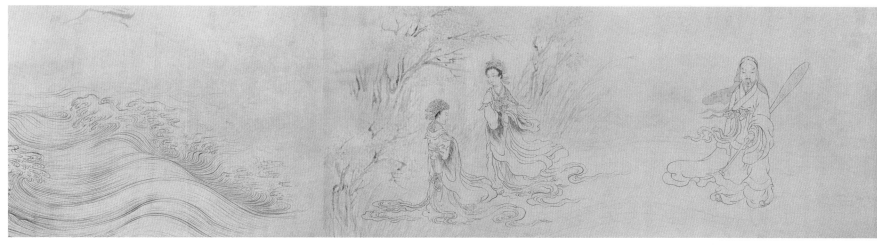

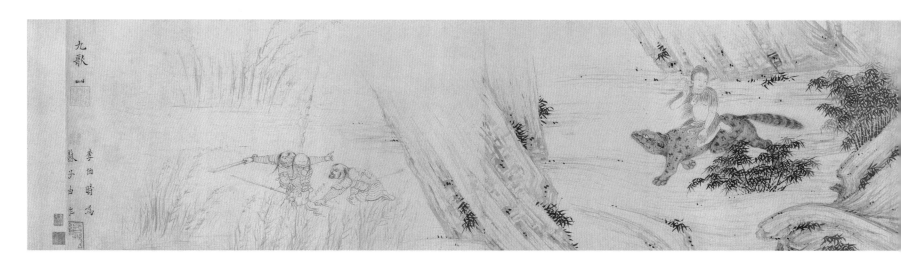

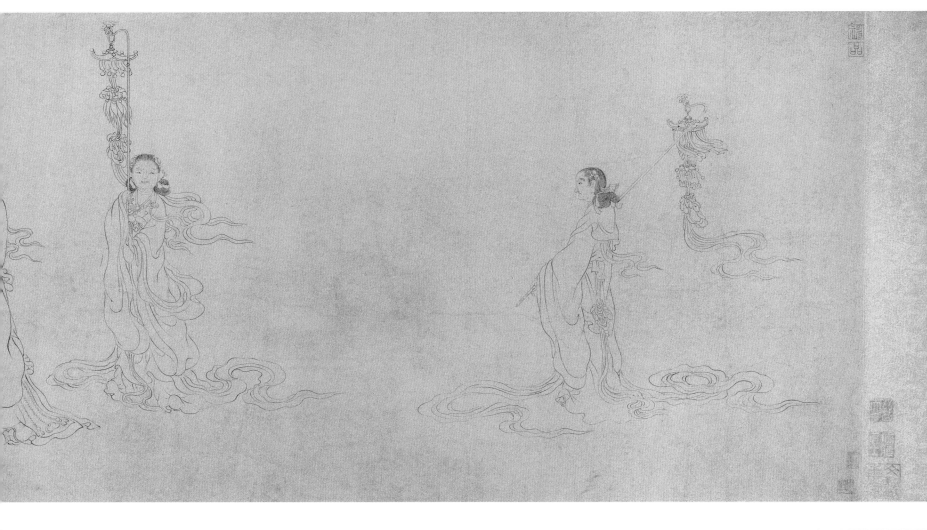

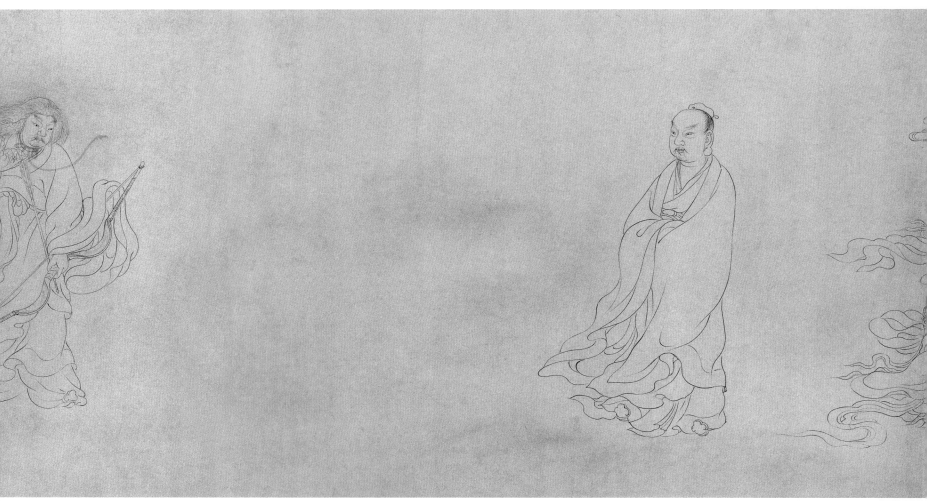

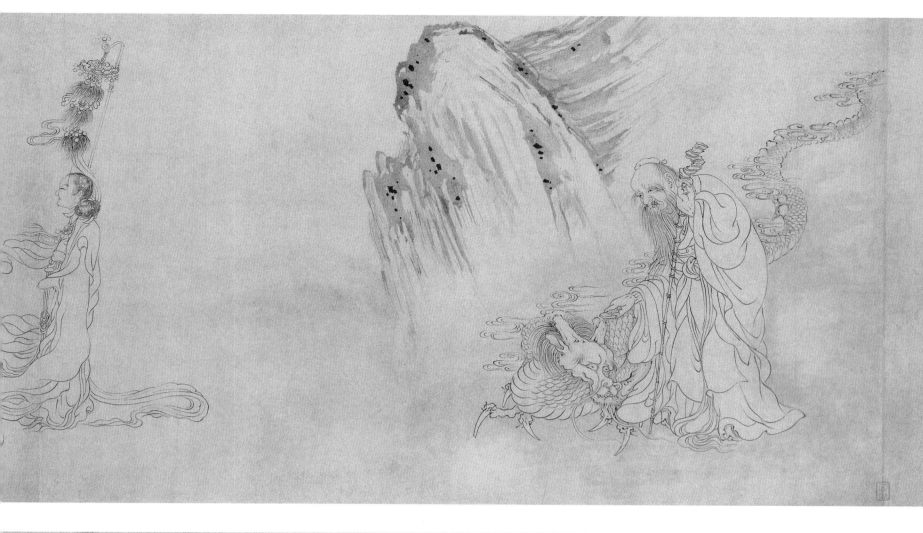

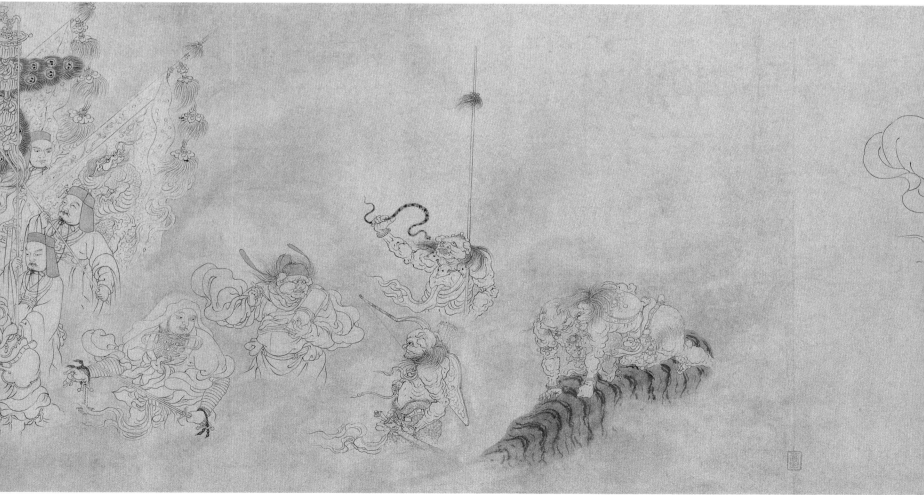

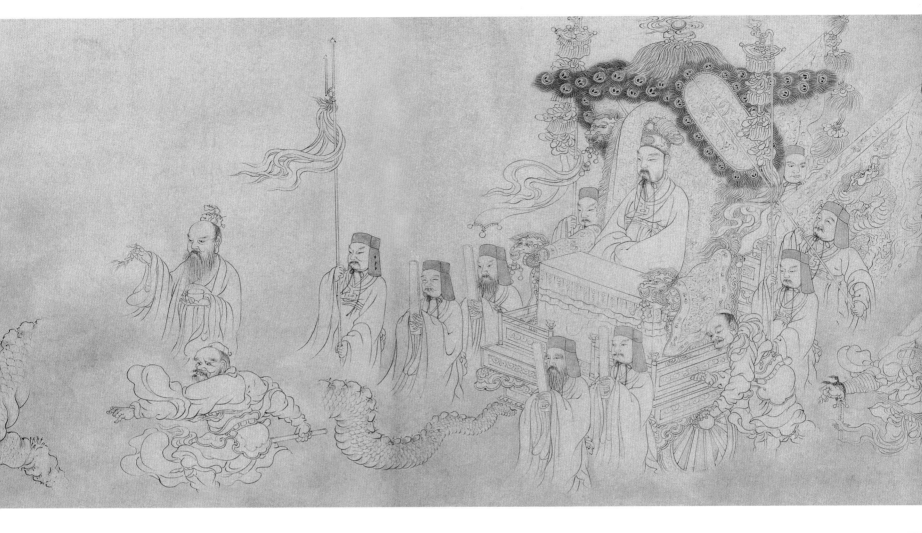

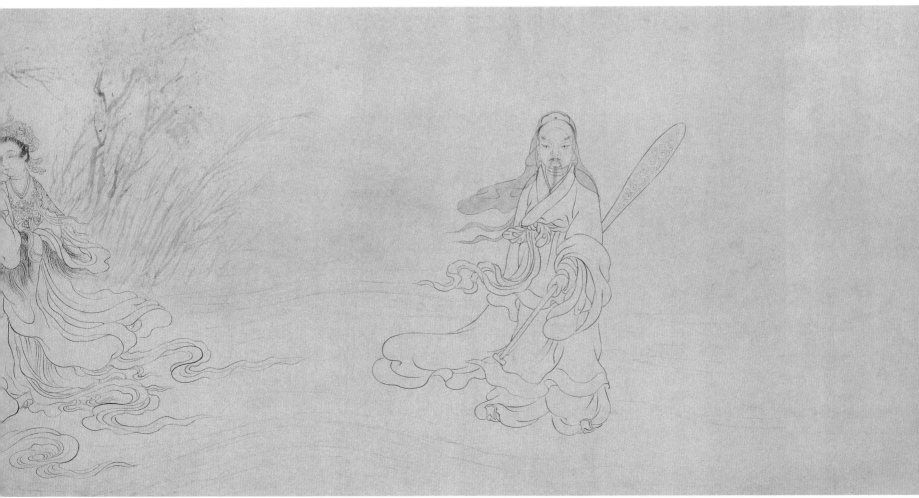

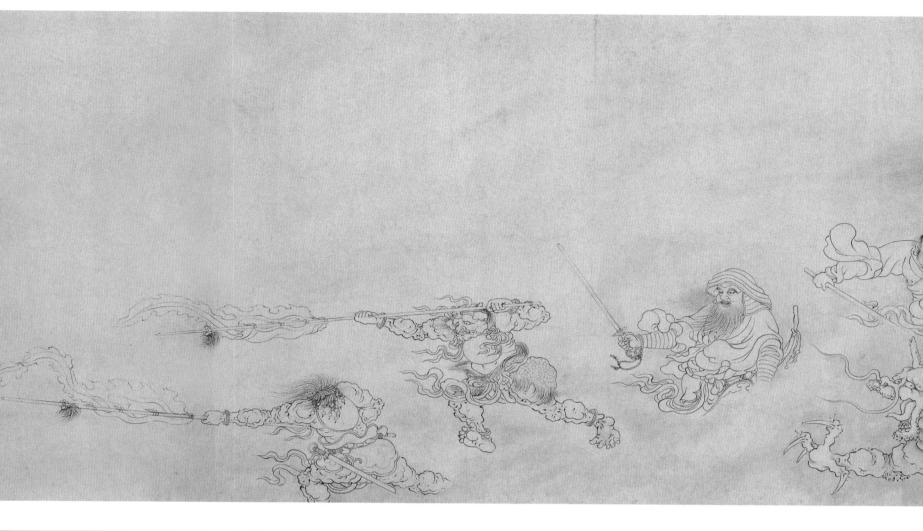

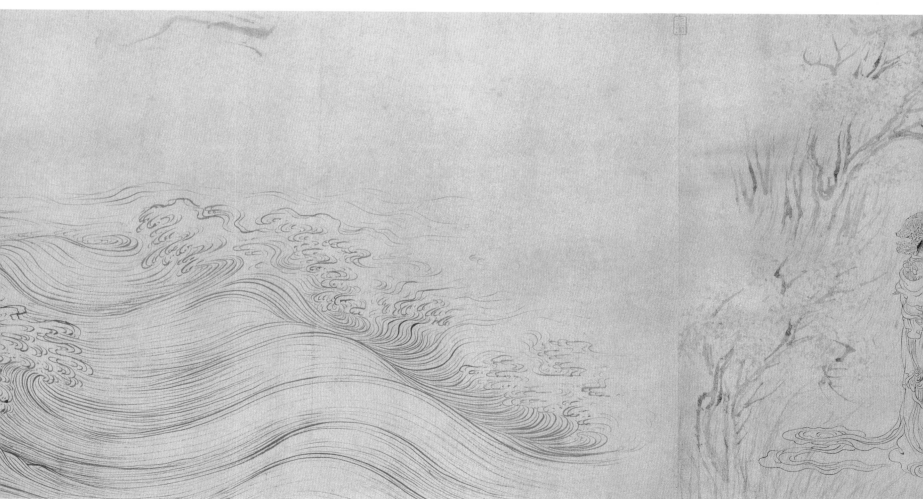

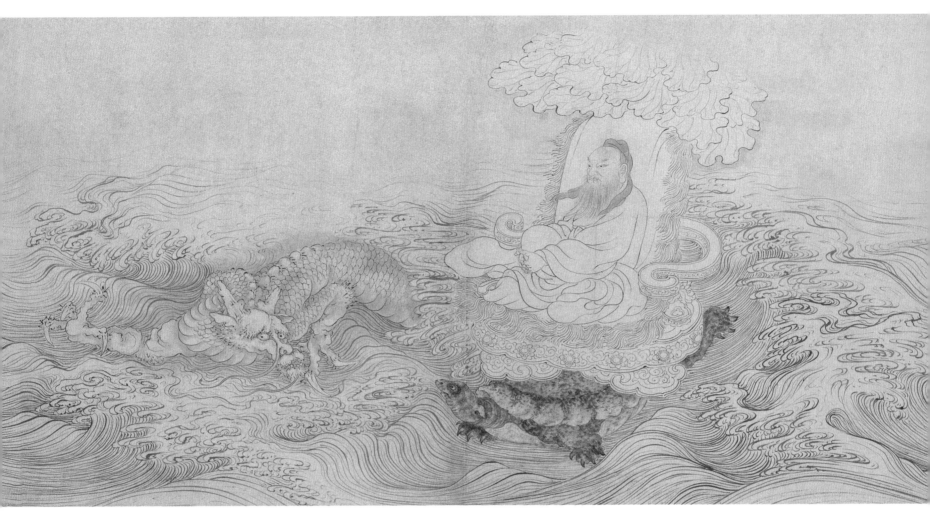

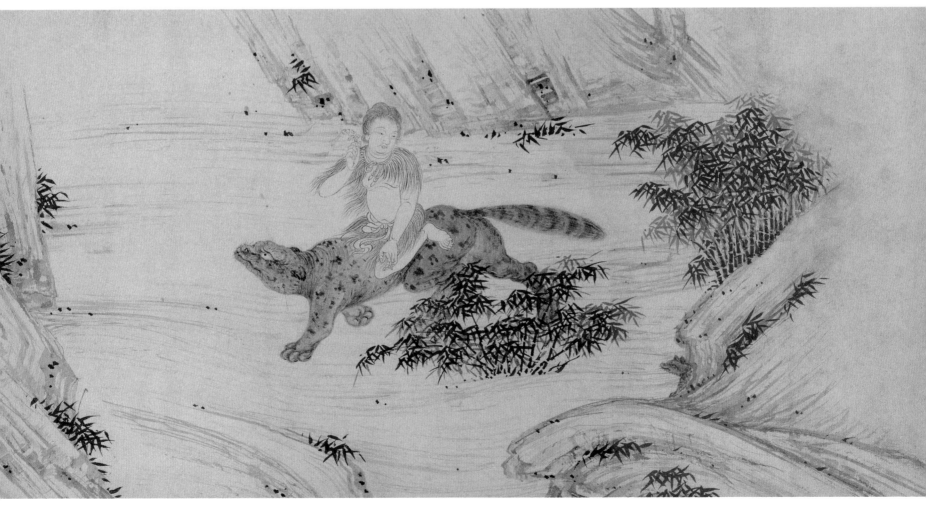

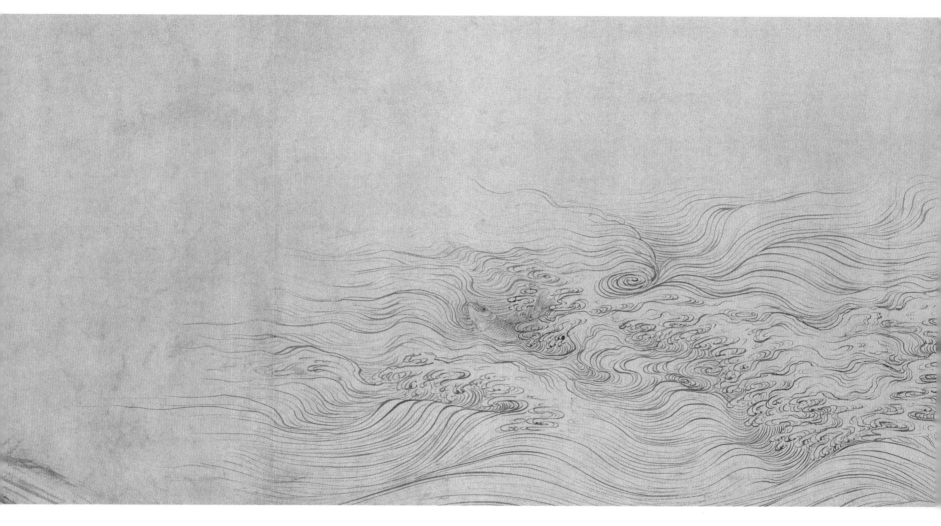

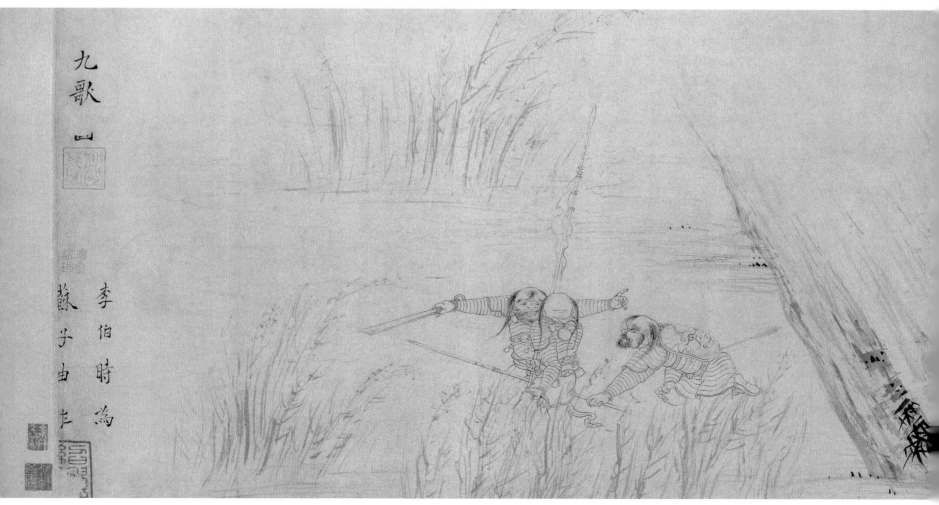

九歌

李伯時為

蘇子由作

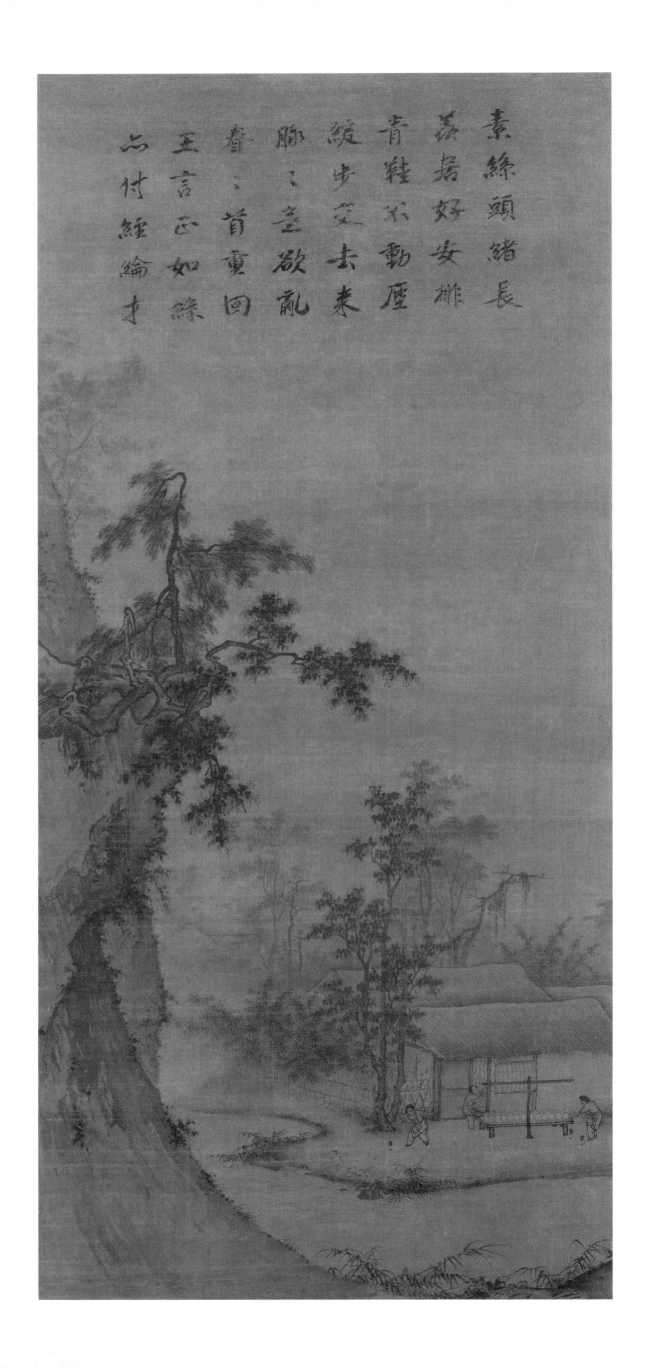

素絲頭緒長
蒸揉好安排
青鞋不動塵
縱步空去來
腳不意欹亂
春首重回
玉言正如絲
以付經綸才

新147482
宋 佚名
丝纶图轴
绢本　纵83.2厘米　横37.6厘米
Xin147482
Anonymous, Song dynasty
Spinning
Hanging scroll, silk
83.2 × 37.6 cm

4

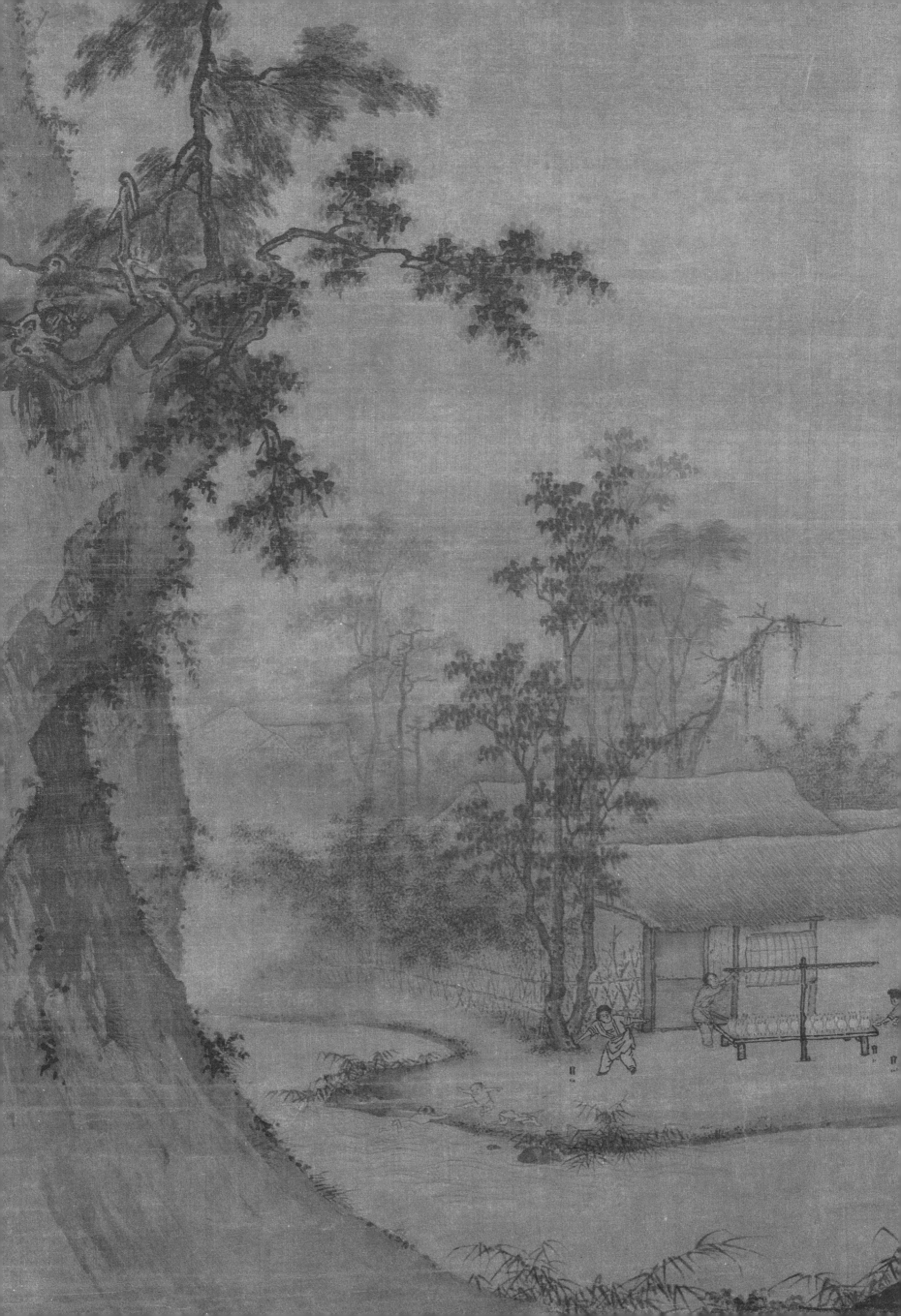

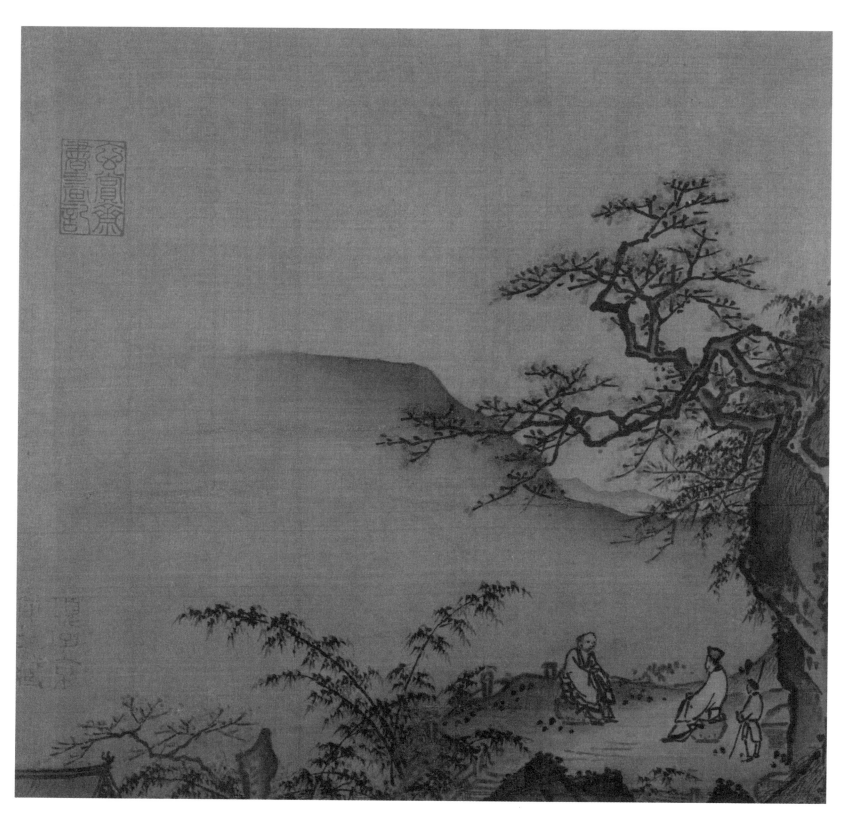

新147423 3/12

宋 佚名
山坡论道图页

5 绢本　纵25.4厘米　横25厘米

Xin147423 3/12

Anonymous, Song dynasty
Discussing Doctrine on a Hill Side
Album leaf, silk
25.4 × 25 cm

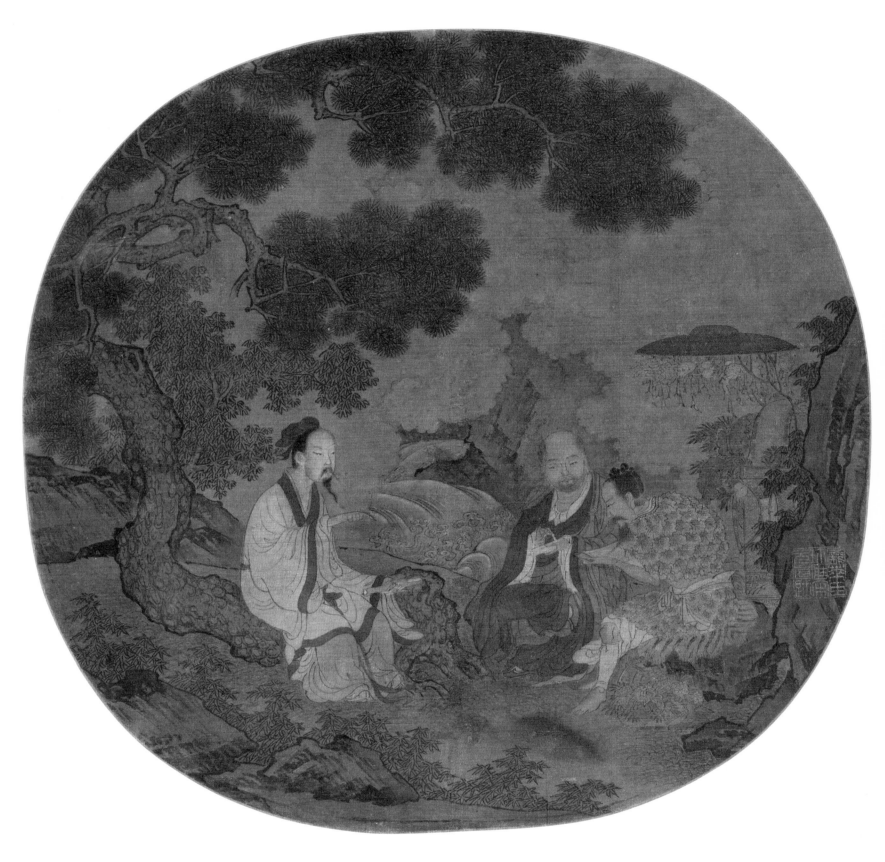

新147427 3/10

宋 佚名
松荫谈道图页

6 | 绢本　纵25.3厘米　横25.6厘米

Xin147427 3/10

Anonymous, Song dynasty
Talking about Doctrine in the Shade of a Pine

Album leaf, silk
25.3 × 25.6 cm

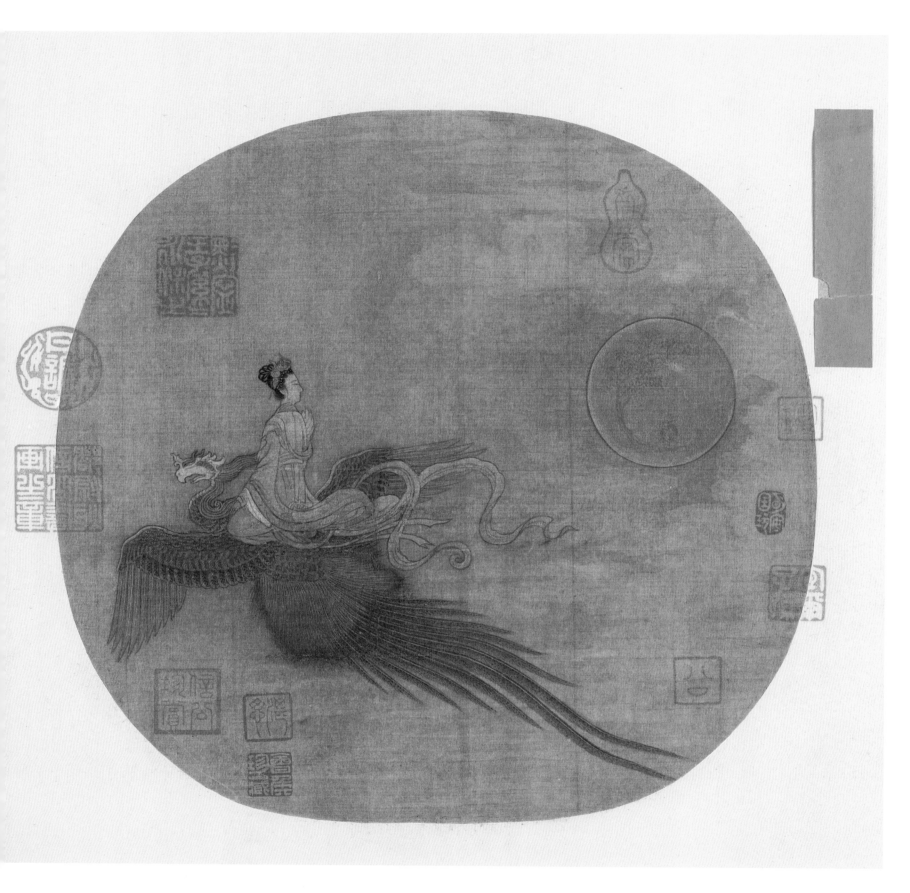

新147426 1/14

宋 佚名
仙女乘鸾图页

绢本　纵26.2厘米　横25.3厘米

7

Xin147426 1/14

Anonymous, Song dynasty
Fairy Riding on a Phoenix
Album leaf, silk
26.2 × 25.3 cm

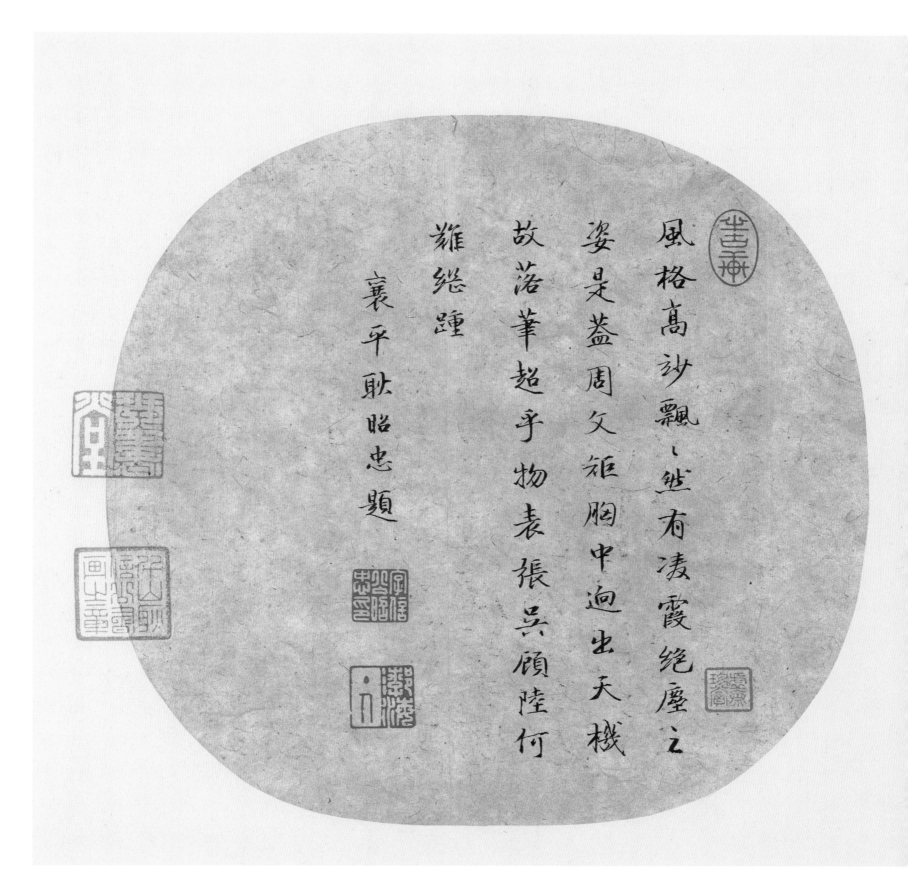

風格高妙飄ㄥ然有凌霞絶塵之
姿是益周父矩胸中迥出天機
故落筆超乎物表張吳顧陸何
難継踵
　襄平耿昭忠題

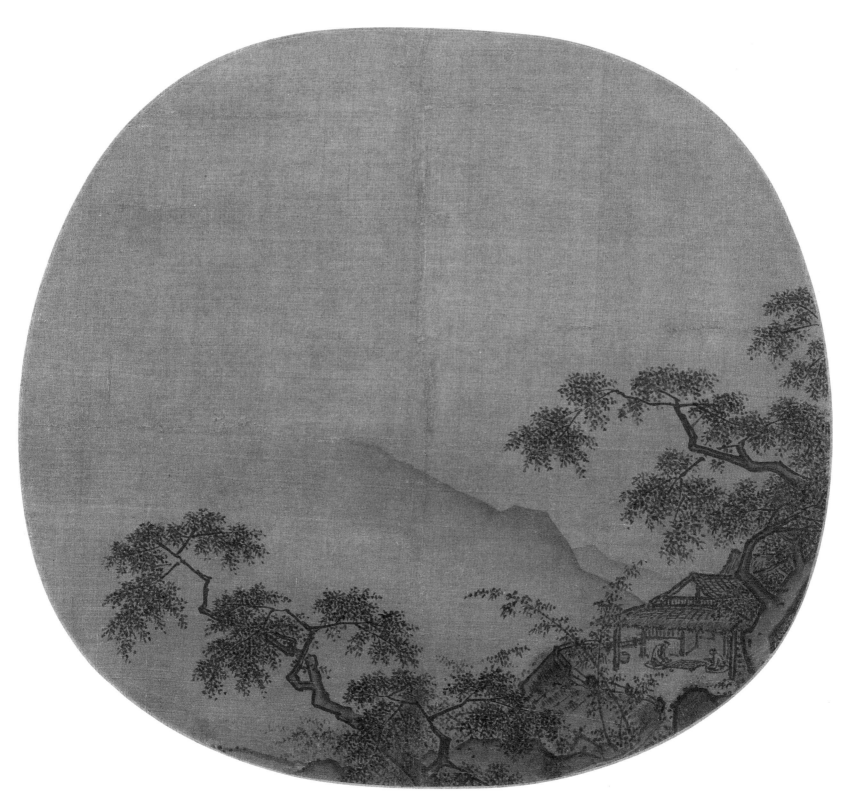

新147423 11/12

宋 佚名
山居对弈图页

8 绢本　纵24.8厘米　横24厘米

Xin147423 11/12
Anonymous,
Song dynasty
Playing Chess in the Mountains
Album leaf, silk
24.8 × 24 cm

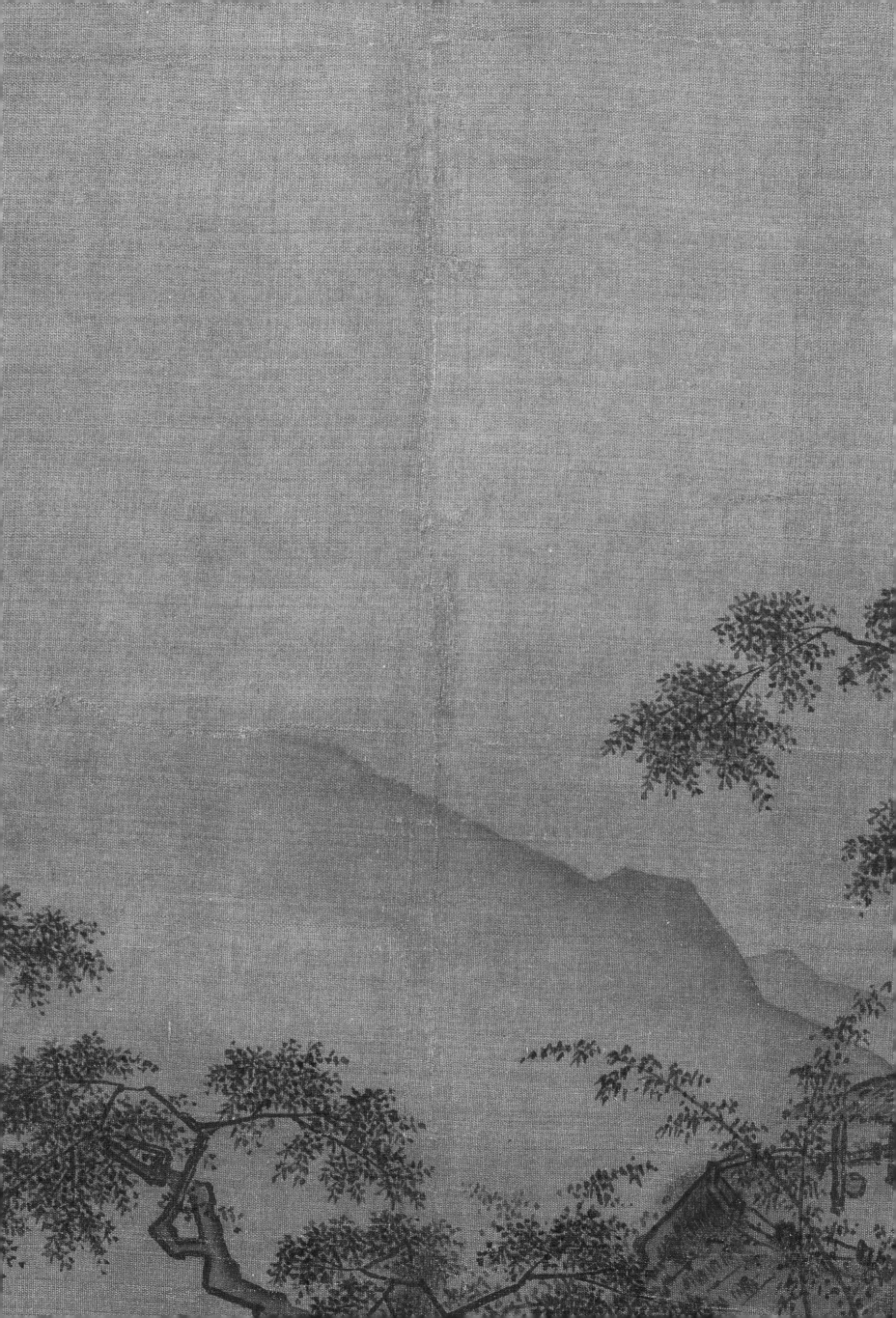

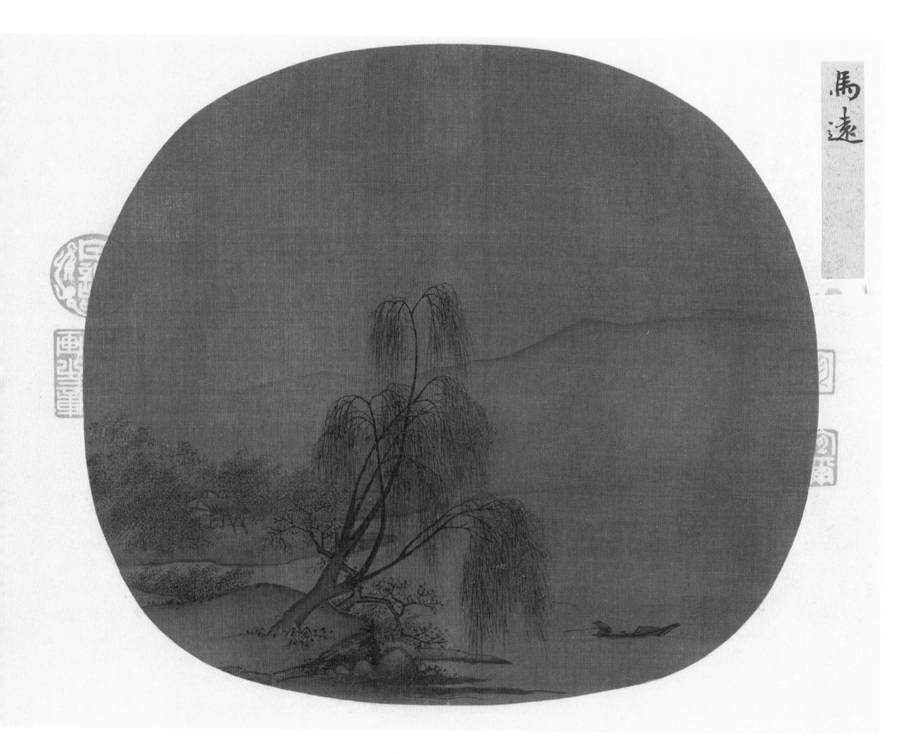

新147426 13/14

宋 佚名
柳溪钓艇图页

9 | 绢本　纵24.5厘米　横23厘米

Xin147426 13/14

Anonymous, Song dynasty
Fishing on a Willow Stream

Album leaf, silk
24.5 × 23 cm

馬遠此圖用筆流逸景物竦
奕幾脫畫院習氣矣

信公

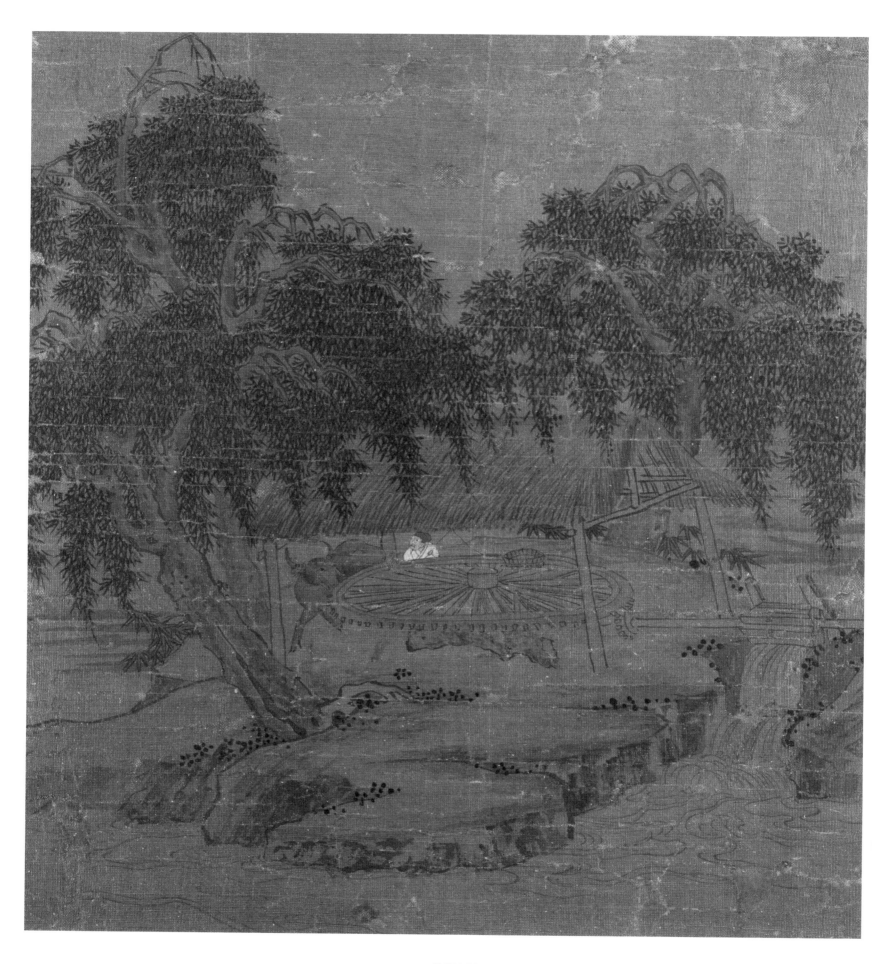

故6152 5/10

宋 佚名
柳荫云碓图页

绢本　纵23厘米　横20.6厘米

Gu6152 5/10
Anonymous, Song dynasty
Hulling Rice in Willow Shade
Album leaf, silk
23 × 20.6 cm

IO

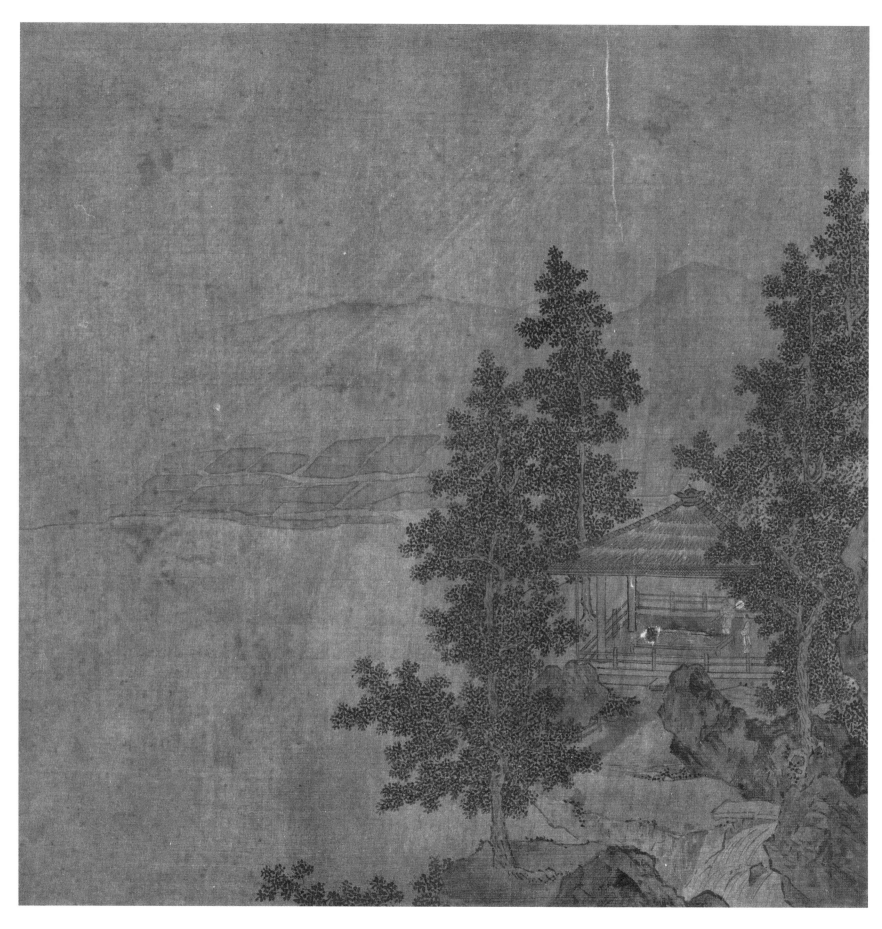

新13844 6/14

宋 佚名
水阁风凉图页

II 绢本　纵22.7厘米　横21.3厘米

Xin13844 6/14

Anonymous, Song dynasty
Cool Breeze at a Waterside Pavilion
Album leaf, silk
22.7 × 21.3 cm

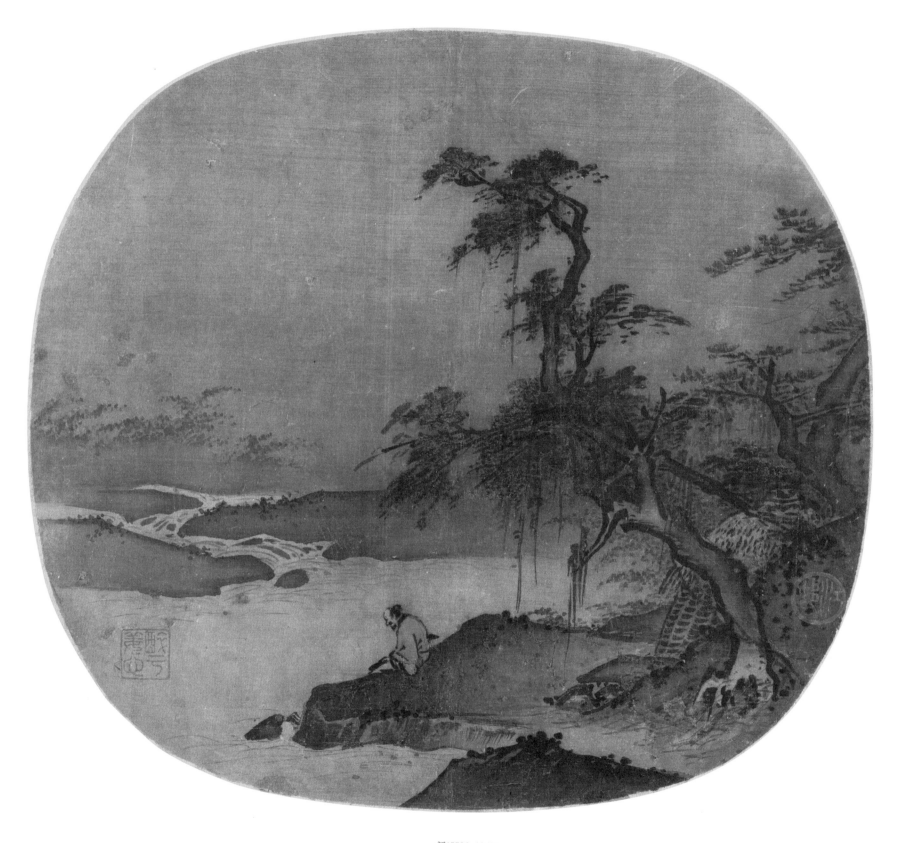

宋 佚名
临流抚琴图页

12 绢本　纵25.5厘米　横26.5厘米

Anonymous, Song dynasty
Playing a Zither by a Stream

Album leaf, silk
25.5 × 26.5 cm

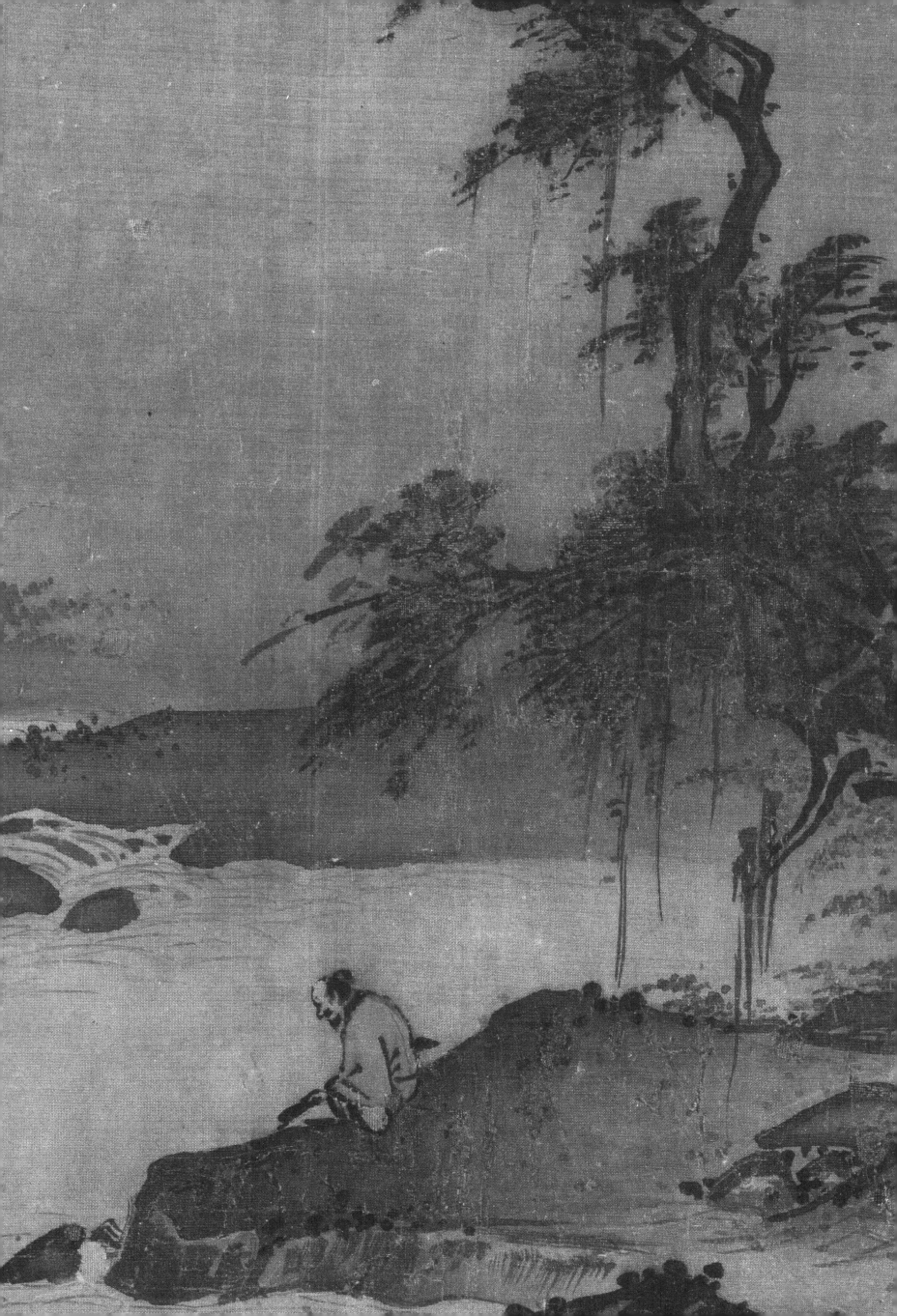

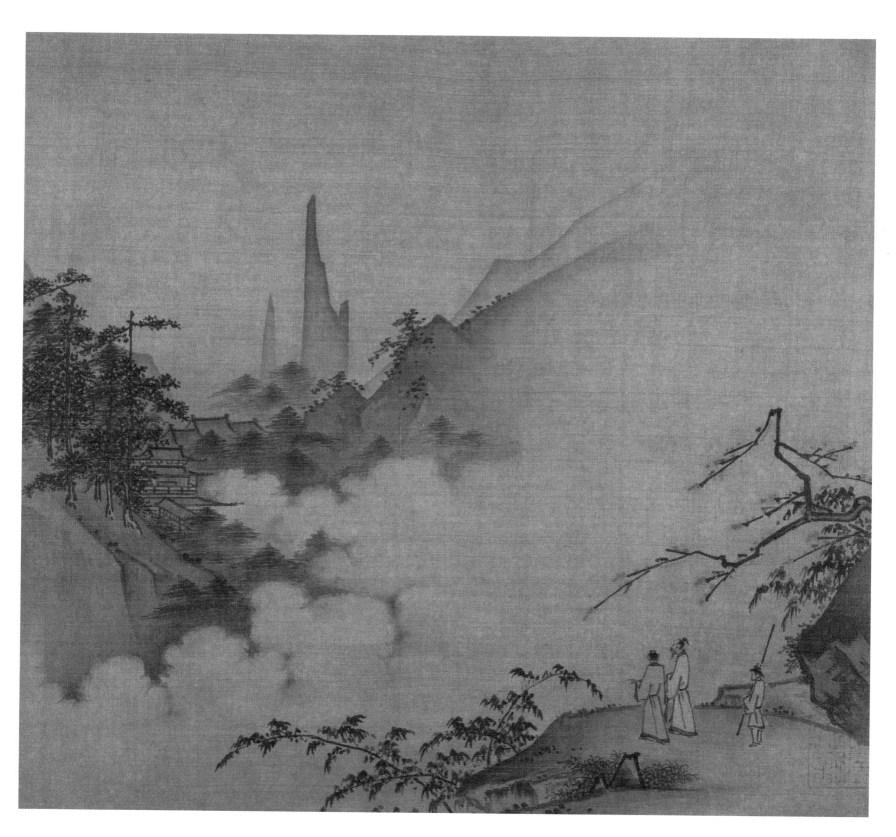

新147505

宋 佚名
云峰远眺图页

13 | 绢本　纵24.8厘米　横26.4厘米

Xin147505
Anonymous, Song dynasty
Distant View of Peaks and Clouds
Album leaf, silk
24.8 × 26.4 cm

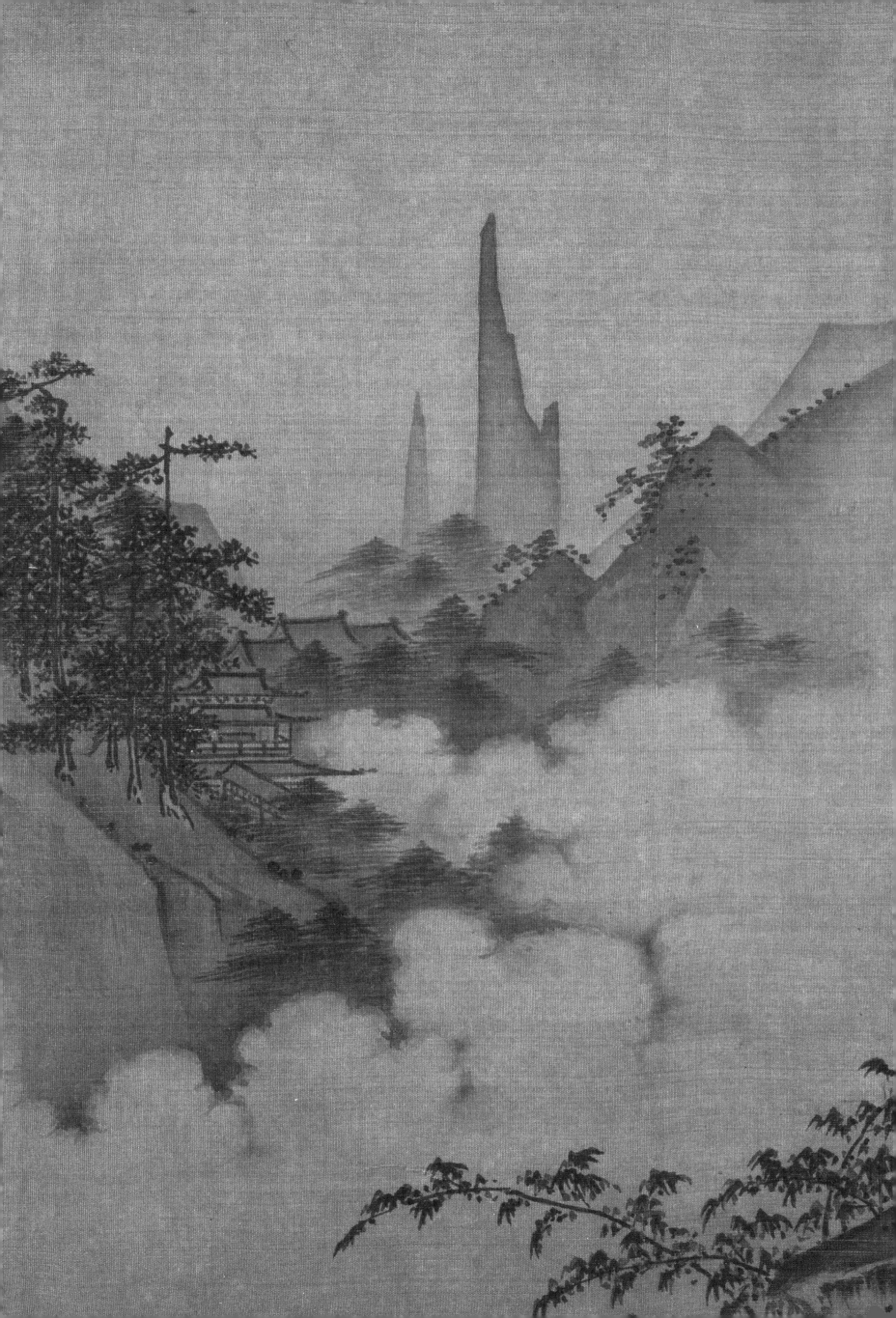

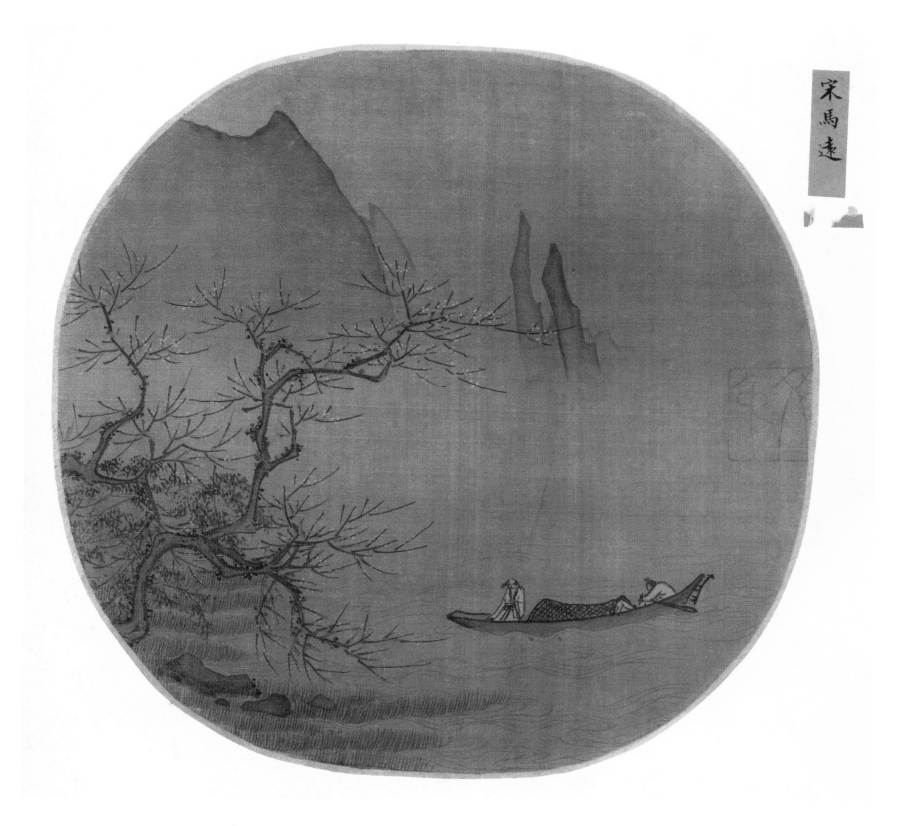

新14729 4/12

宋 佚名

梅溪放艇图页

14 | 绢本 纵24.4厘米 横24.8厘米

Xin14729 4/12

Anonymous, Song dynasty
Boating on Stream with Plum Trees on the Bank
Album leaf, silk
24.4 × 24.8 cm

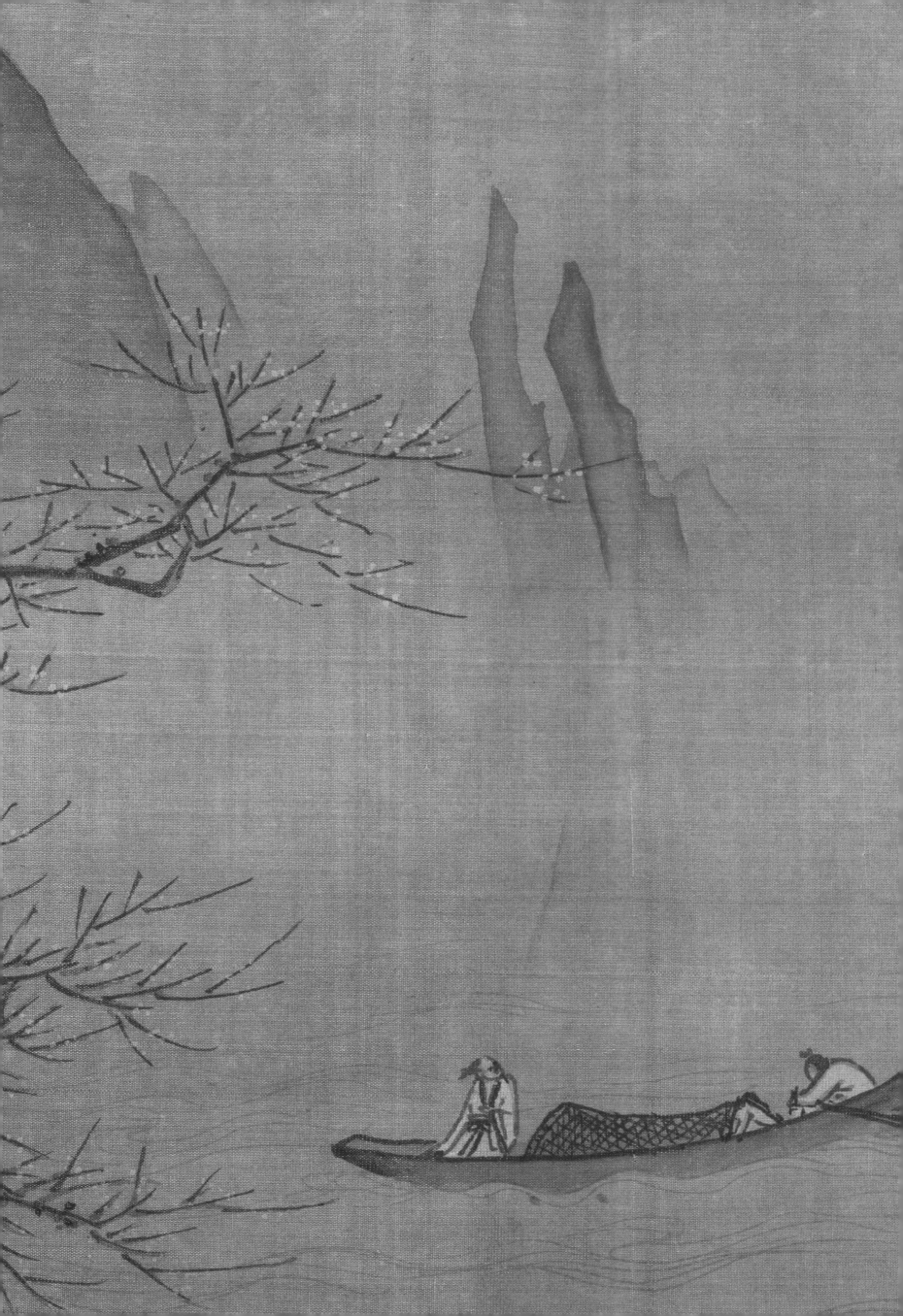

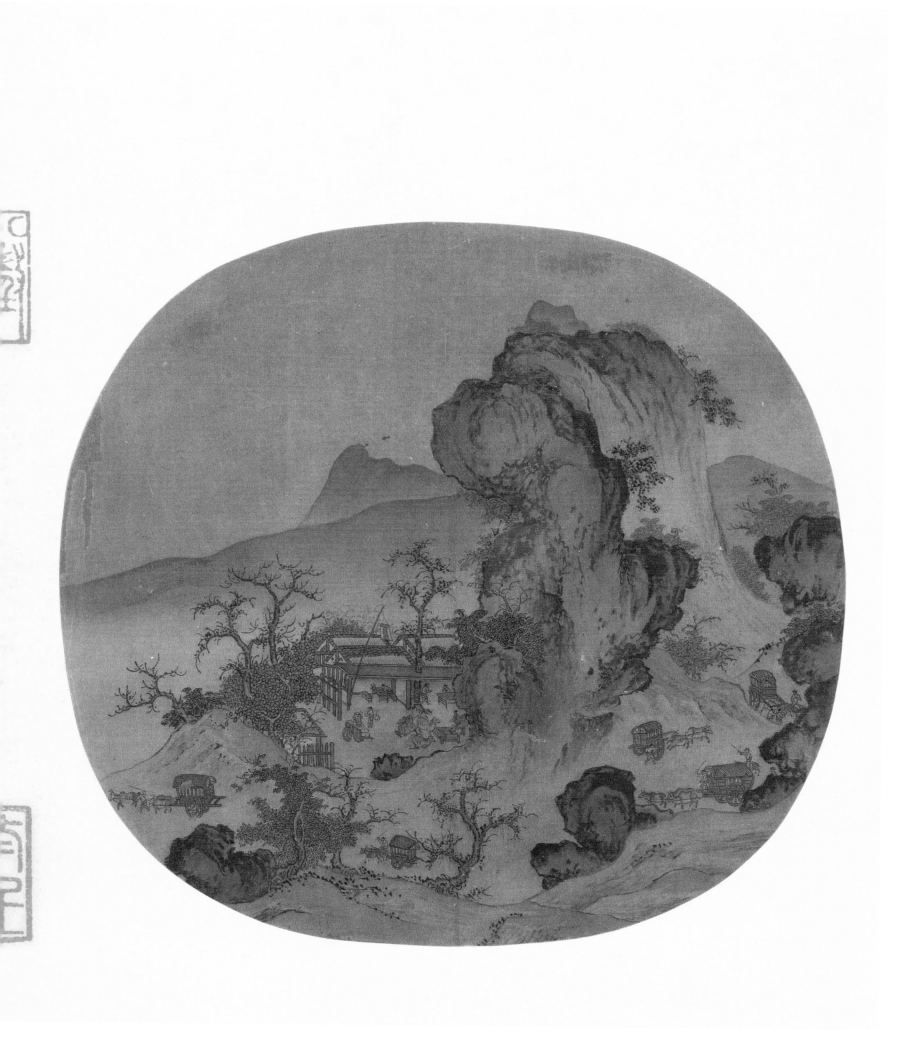

新6150 4/10

宋 佚名
山店风帘图页

绝本　纵24厘米　横25.3厘米

15

Xin6150 4/10
Anonymous, Song dynasty
An Inn in the Mountains
Album leaf, silk
24 × 25.3 cm

石渠多所弄真贗或真亦之小幅看山店閒情在酒撫漢唐不拘法天地可為師後以循名較陳狂恐毋宜

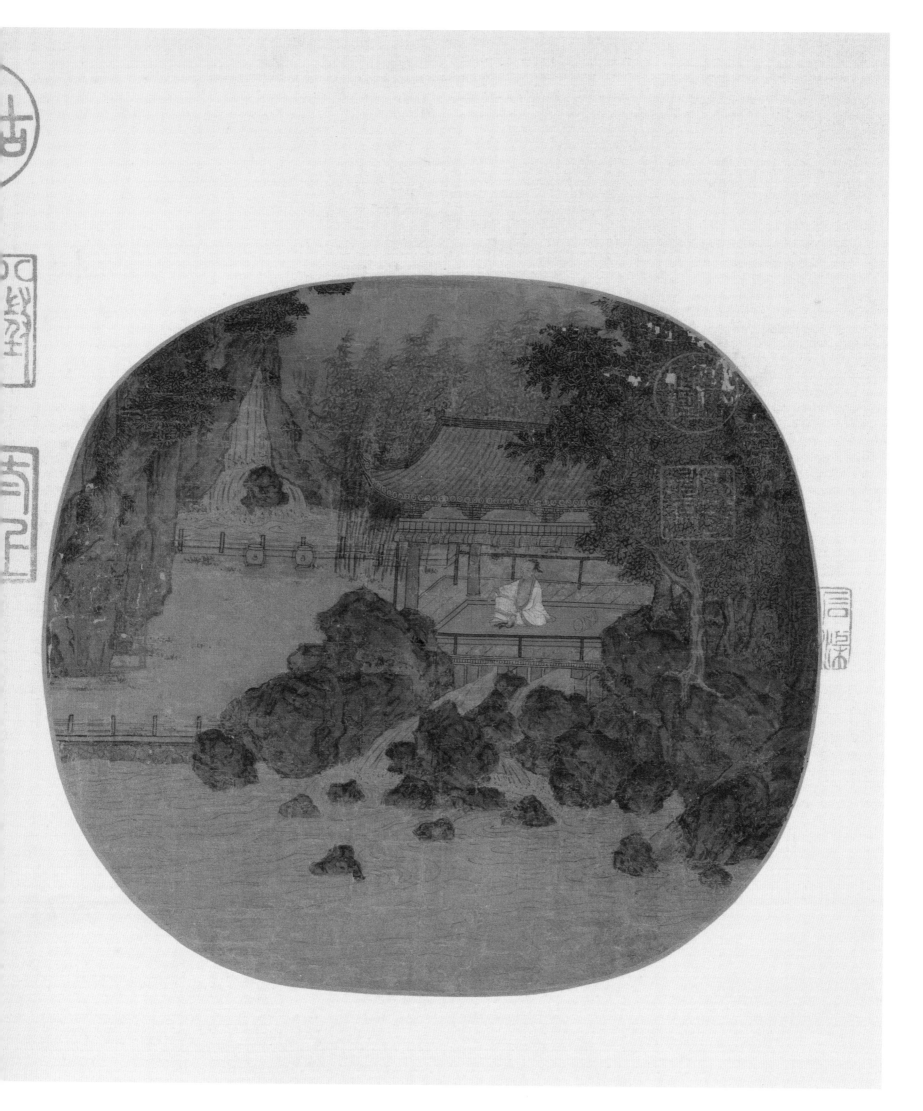

新147428 1/12

宋 佚名
纳凉观瀑图页

16 绢本　纵24.7厘米　横24.8厘米
Xin147428 1/12
Anonymous, Song dynasty
Viewing Waterfall and Enjoying Coolness
Album leaf, silk
24.7 × 24.8 cm

畫法開宗北宋
初風觀猶識李唐
餘精工權異七夕巧
慘淡真看一幢櫳杜
氏納涼斯有謂張家
觀瀑雅相�如名流集
藻彙十二舍是誰
當冠冕諸

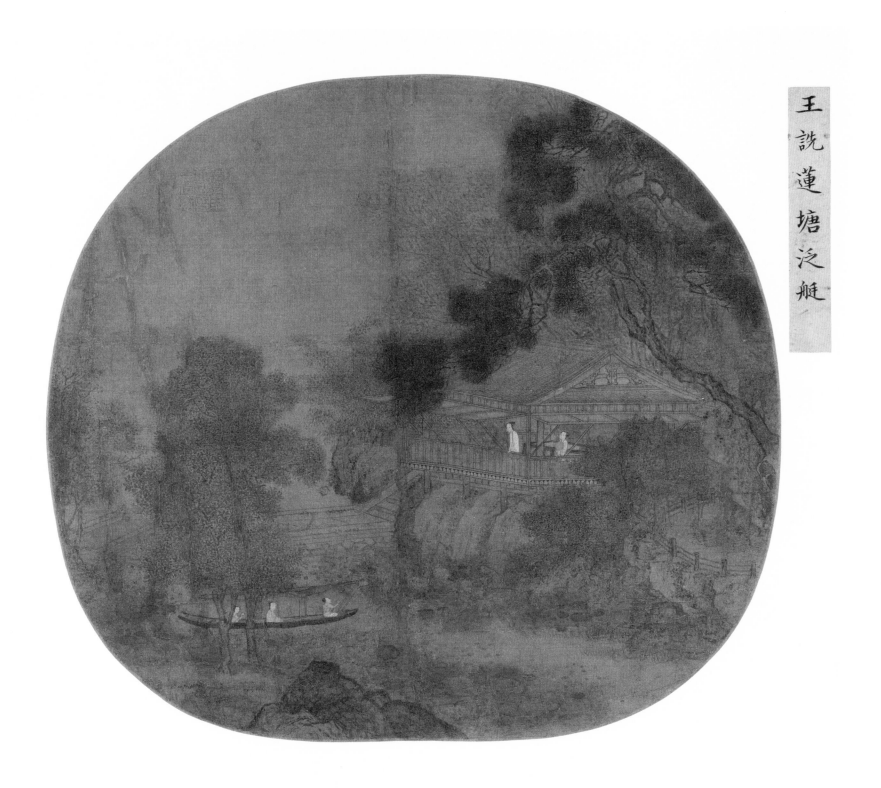

王詵蓮塘泛艇

新147427 6/12

宋 佚名
蓮塘泛艇圖頁

17 絹本　縱24.3厘米　橫25.8厘米

Xin147427 6/12

Anonymous, Song dynasty
Boating on a Lotus Pond

Album leaf, silk
24.3 × 25.8 cm

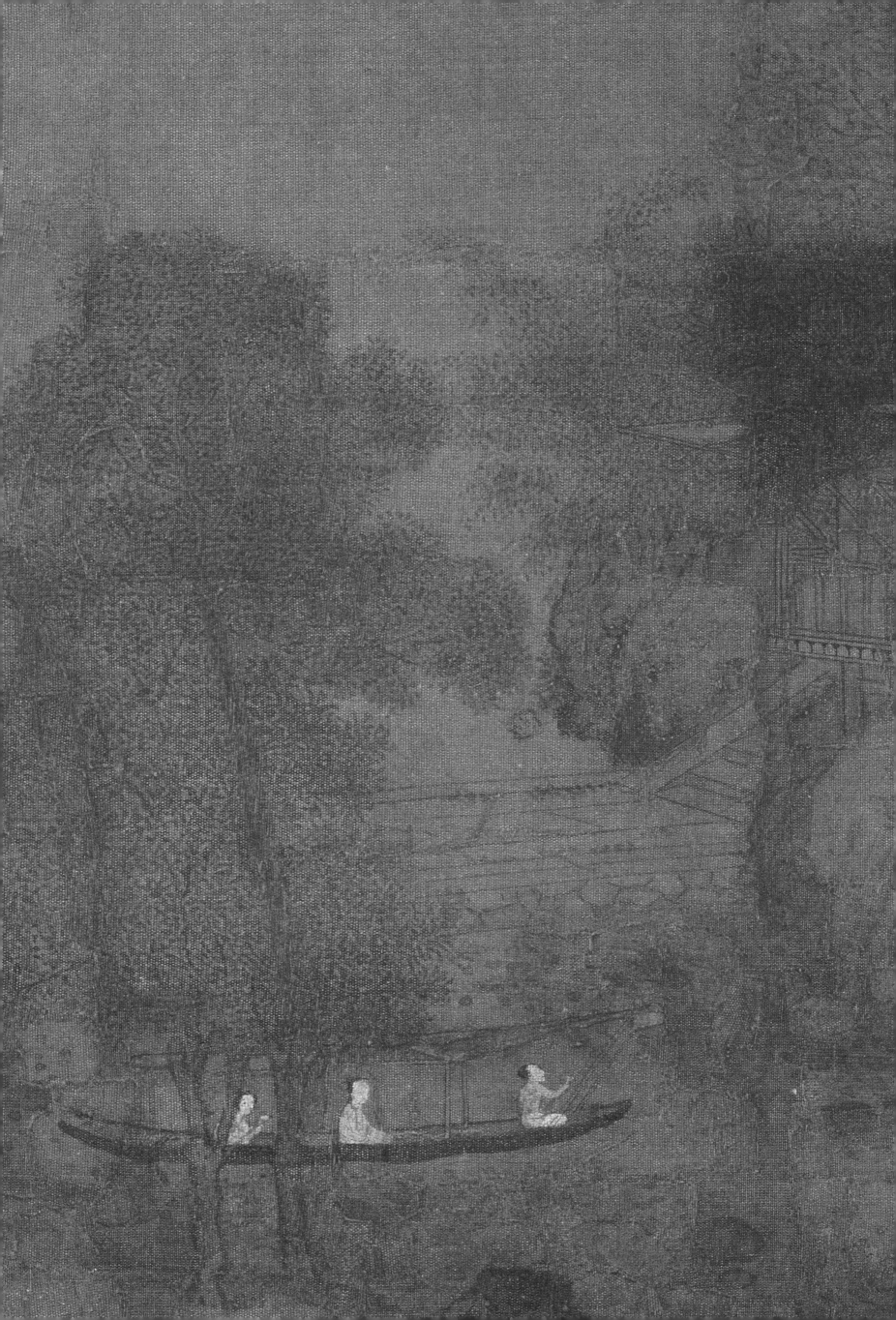

新147427 7/10

宋 佚名
桐荫玩月图页
绢本　纵24厘米　横17.5厘米

18

Xin147427 7/10
Anonymous, Song dynasty
Enjoying the Moon in the Shade of Pawlonia Trees
Album leaf, silk
24 × 17.5 cm

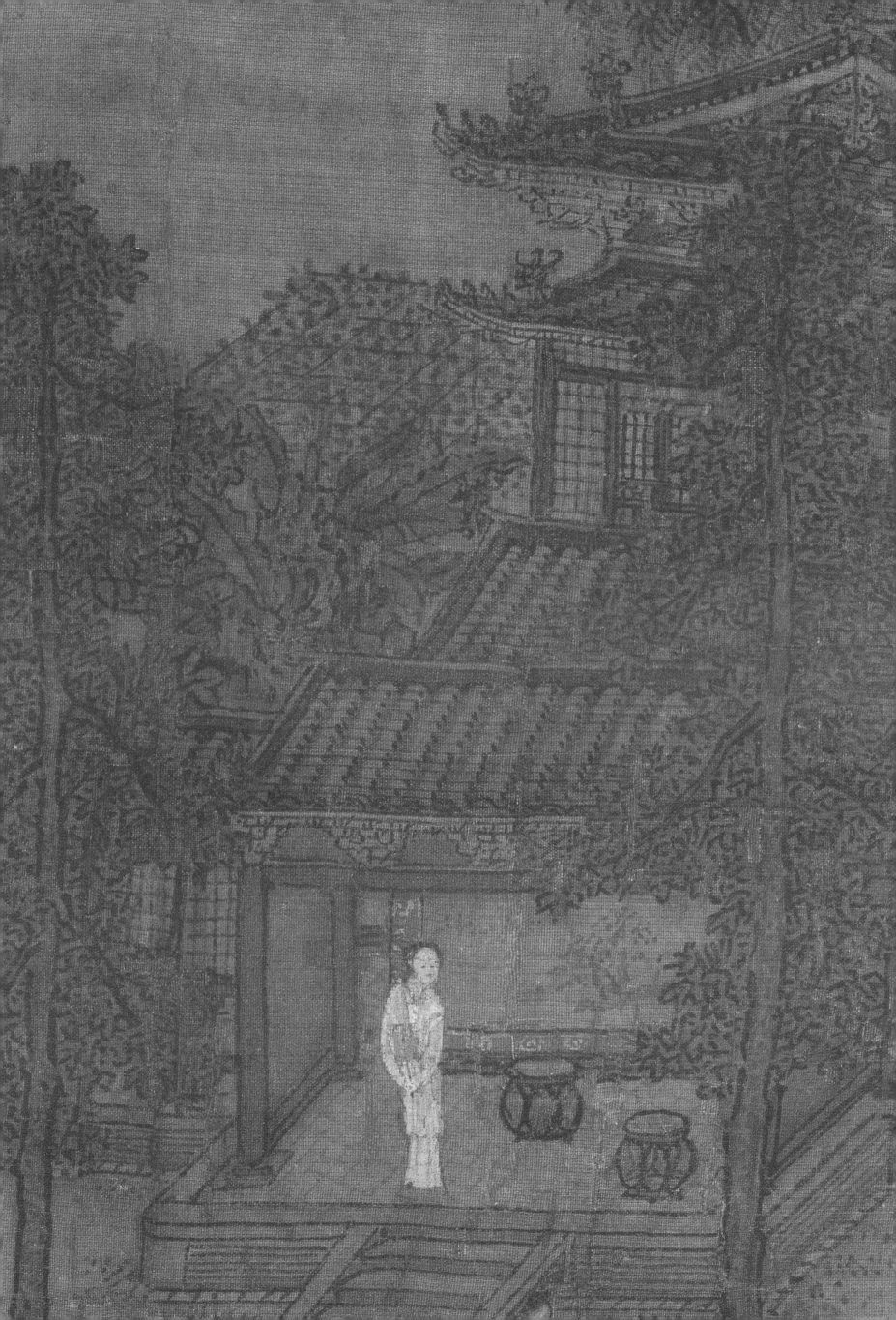

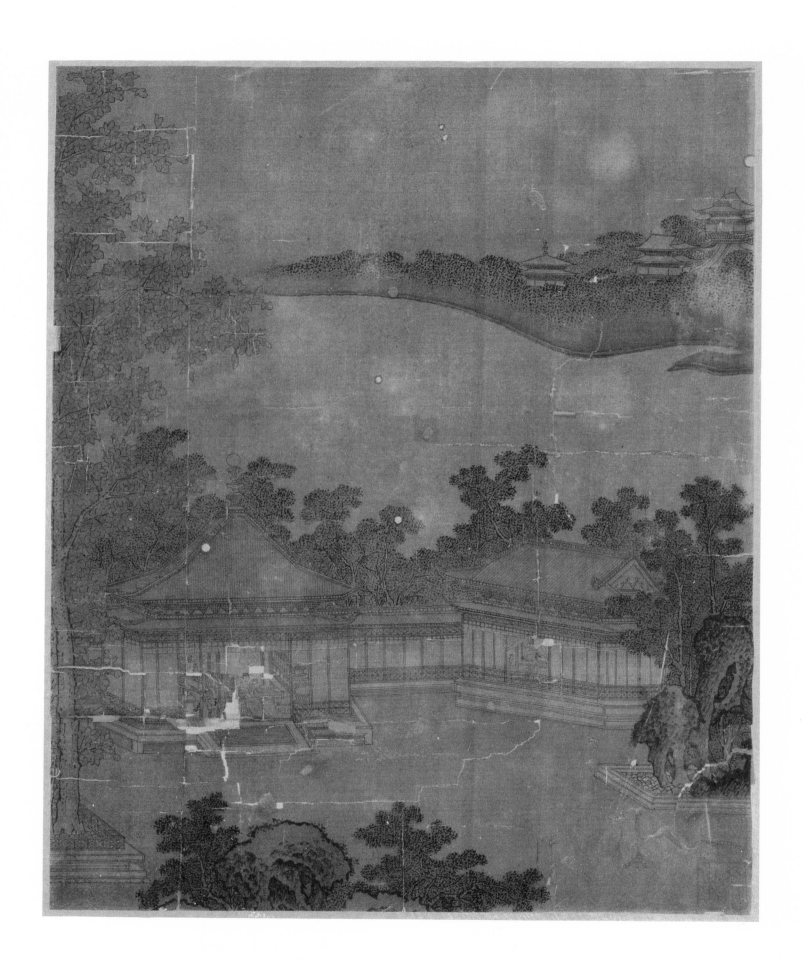

新13844 10/14

宋 佚名
梧桐庭院图页

19 绢本　纵24厘米　横19.3厘米

Xin13844 10/14
Anonymous, Song dynasty
Courtyard under Paulownia Trees
Album leaf, silk
24 × 19.3 cm

此幅無欵舊籤題郭忠恕桐陰宮
殿乃歙鮑固某所藏按忠恕字恕先
宋史本傳云兩圖屋壁重複之狀頗
極精妙游王侯公卿家乘興即畫苟
意不欲固請必然得者以為寶觀此
宮殿林木丌精精妙墨色絹質亦確
係數百年前之物斷為忠老筆當不
霞也　　李佐賢題

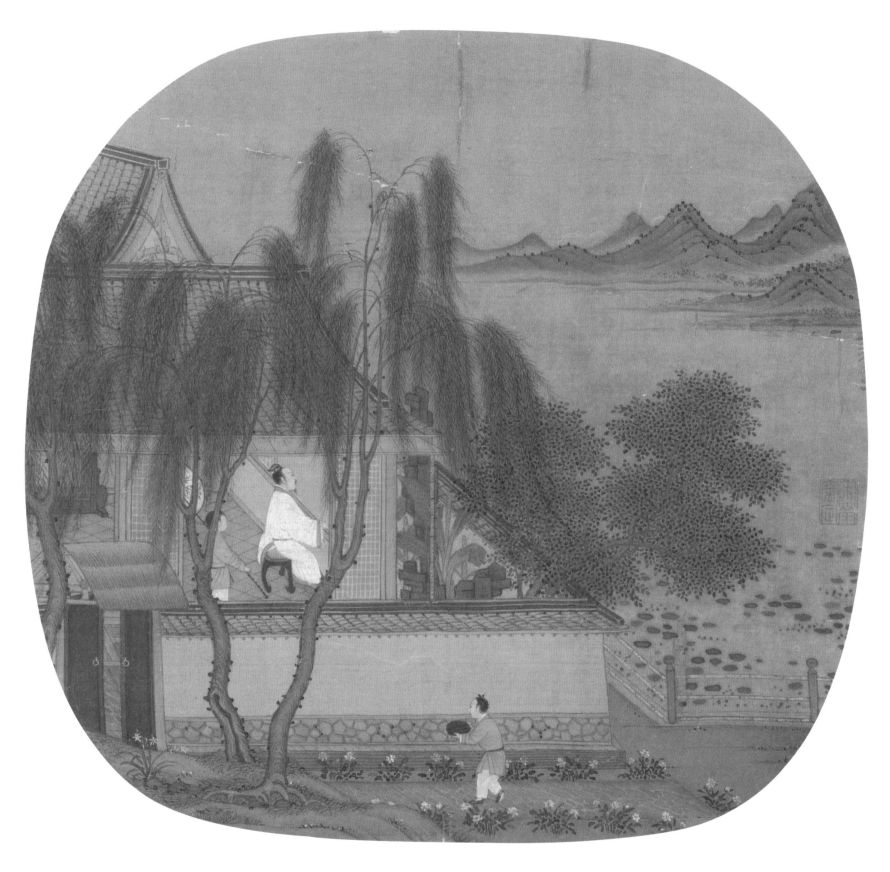

故6158 3/16

宋 佚名
柳院消暑图页

20 绢本 纵29厘米 横29.2厘米

Gu6158 3/16

Anonymous, Song dynasty
Enjoying the Breeze in Willow Courtyard
Album leaf, silk
29 × 29.2 cm

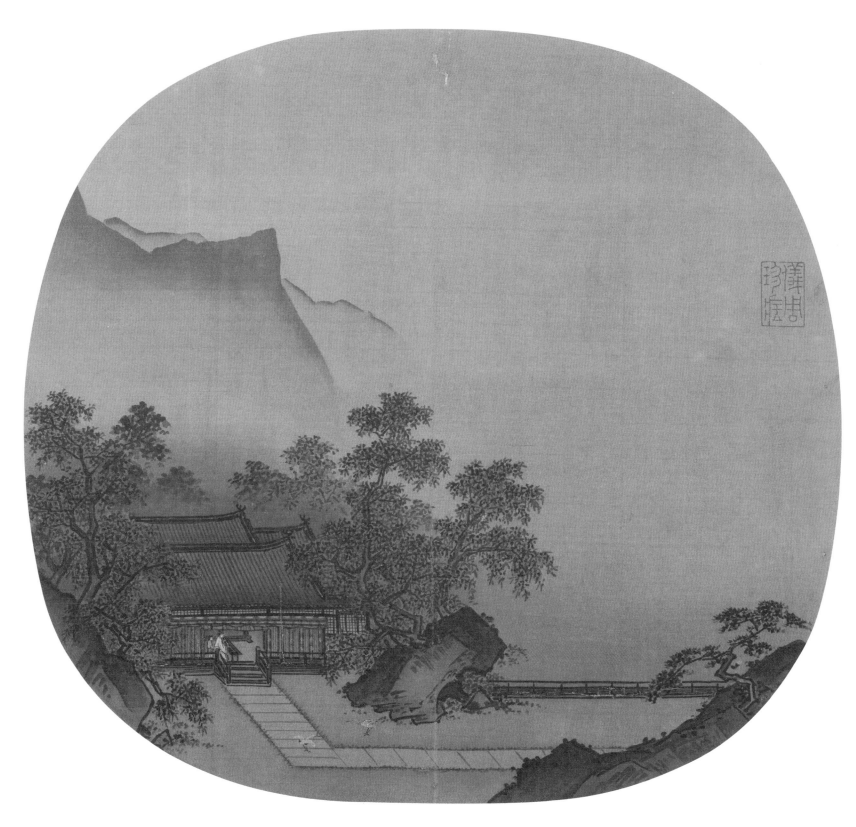

故6158 14/16

宋 佚名
深堂琴趣图页

21 绢本　纵24.2厘米　横24.9厘米

Gu6158 14/16

Anonymous, Song dynasty
Playing a Zither in a Quite Hall
Album leaf, silk
24.2 × 24.9 cm

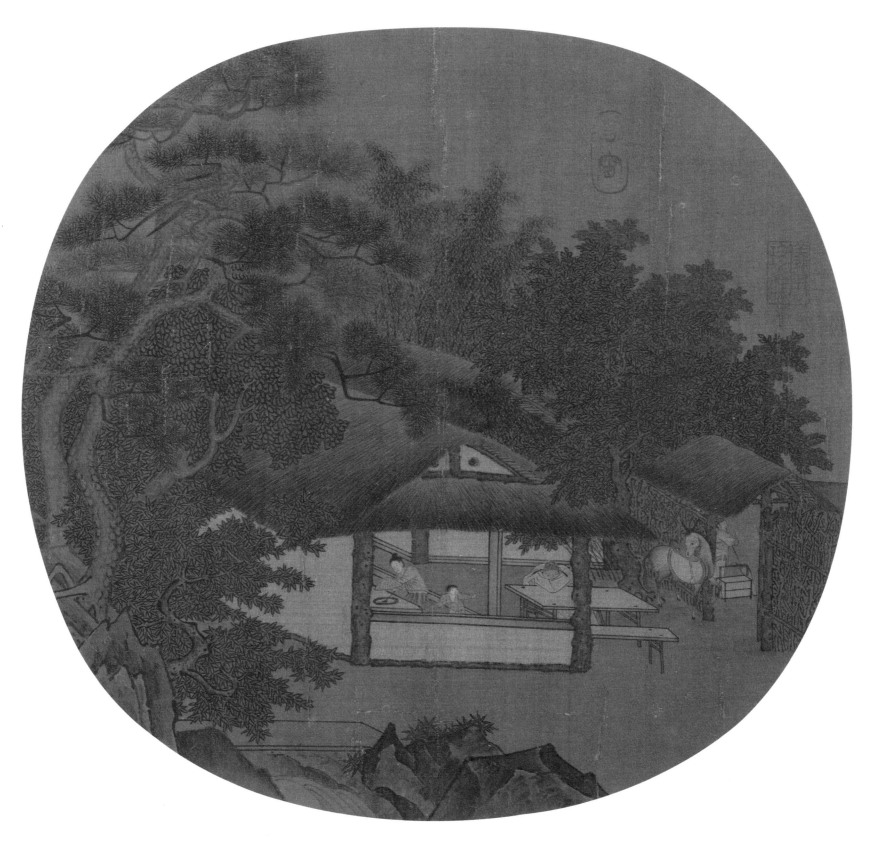

故6158 13/16

宋 佚名
征人晓发图页

22 | 绢本　纵25.2厘米　横25.2厘米

Gu6158 13/16

Anonymous, Song dynasty
Thatched Inn

Album leaf, silk
25.2 × 25.2 cm

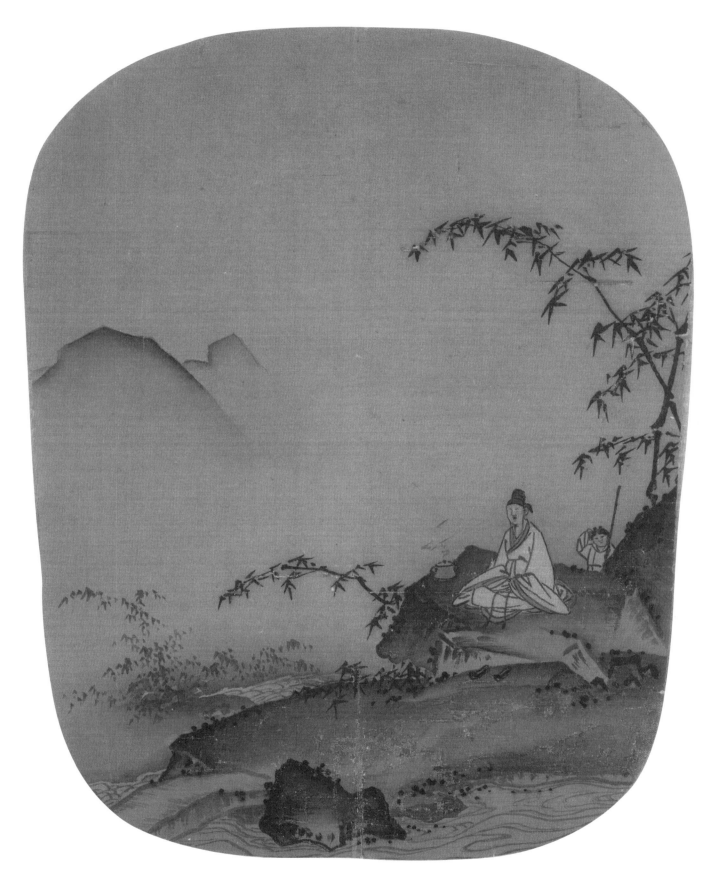

故6152 3/10

宋 佚名
竹涧焚香图页

23 | 绢本　纵26厘米　横20米

Gu6152 3/10

Anonymous, Song dynasty
Burning Incense at Bamboo Ravine
Album leaf, silk
26 × 20 cm

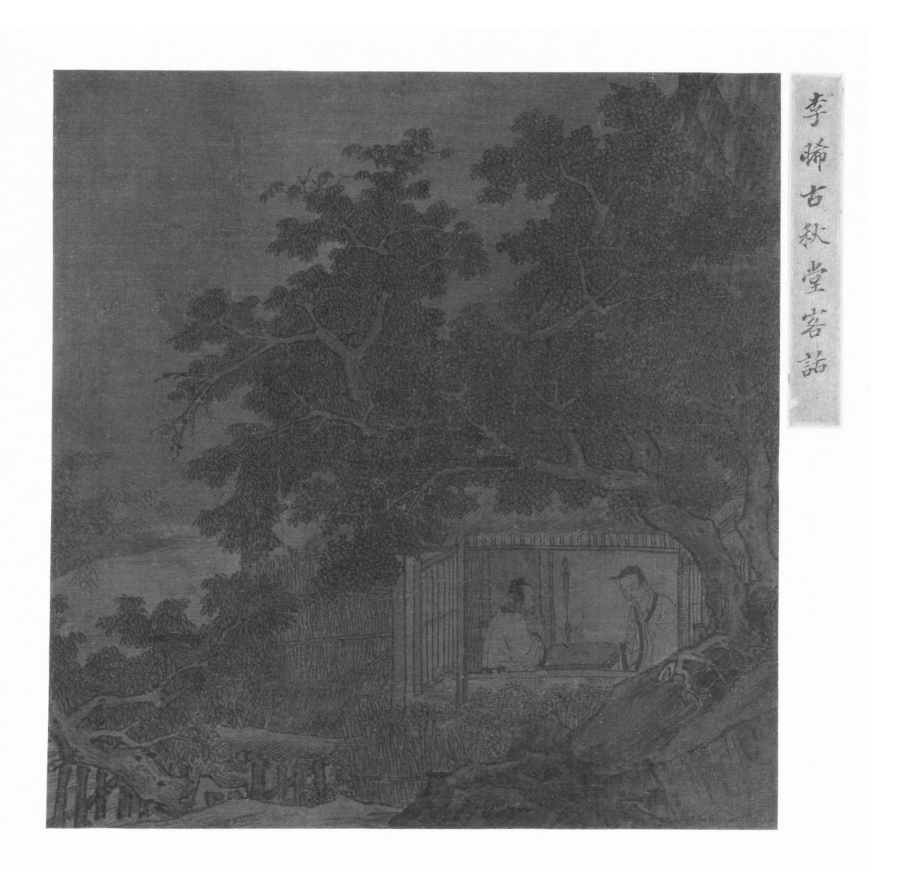

李瑞古秋堂客話

新147425 1/12
宋 佚名
秋堂客话图页
绢本 纵24.3厘米 横22.6厘米
24 Xin147425 1/12
Anonymous, Song dynasty
Chatting in Autumn Pavilion
Album leaf, silk
24.3 × 22.6 cm

晞古抄繪較馬夏更勝一籌昭唐
六如得之隽永失其厚實
李晞古於徽宗朝入畫院建炎間為
待詔賜金帶年近八十此帖沈著痛快
而自饒秀色經崔林相國鑒題羅六
湖度稱其較勝馬夏洵不誣也
同治丁卯冬日李佐賢題

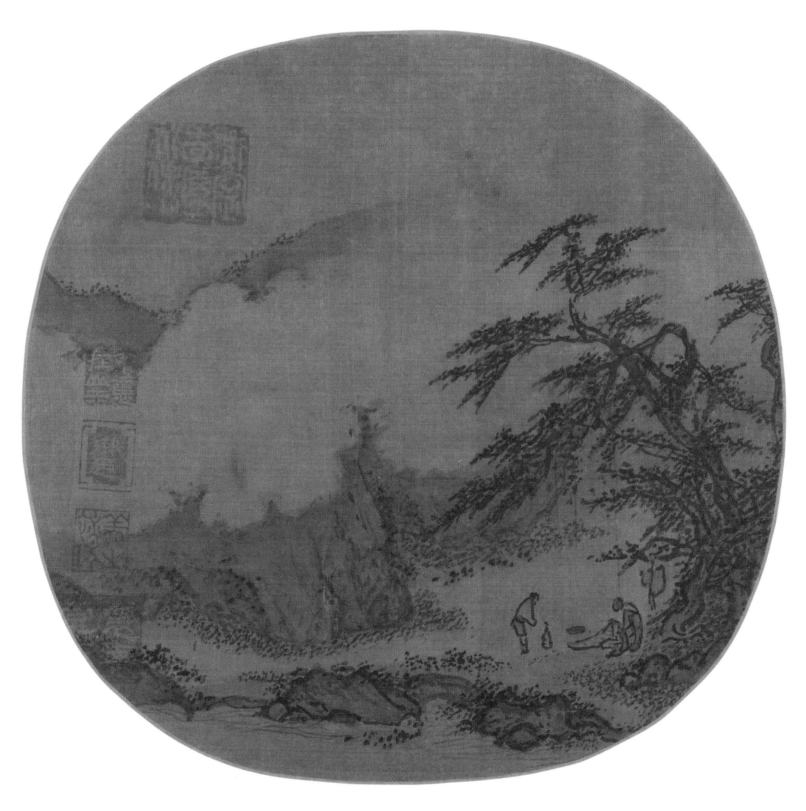

新156354

宋 佚名
松谷问道图页

25 | 绢本 纵21.8厘米 横21.2厘米

Xin156354
Anonymous, Song dynasty
Asking the Doctrine in Pine Ravine
Album leaf, silk
21.8 × 21.2 cm

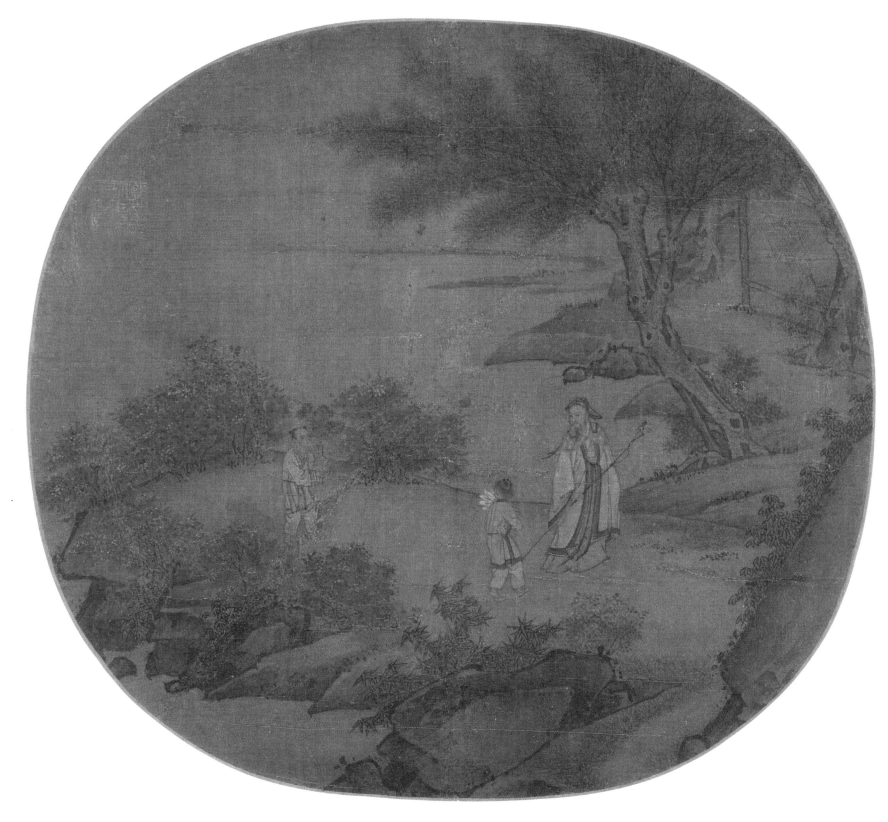

新147424 12/12

宋 佚名
采花图页

26 | 绢本　纵24.1厘米　横25.2厘米

Xin147424 12/12
Anonymous, Song dynasty
Picking Flowers
Album leaf, silk
24.1 × 25.2 cm

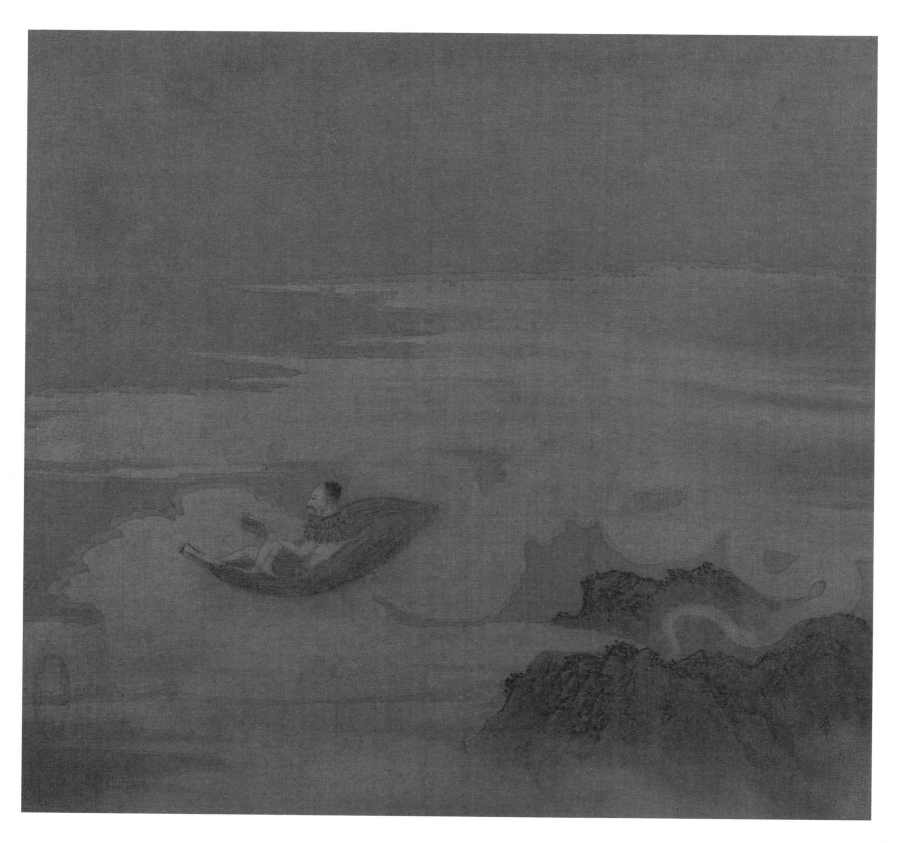

新148941

宋 佚名
莲舟仙渡图页

27 | 绢本　纵21.4厘米 横23.5厘米

Xin148941

Anonymous, Song dynasty
Daoist Immortal Crossing the River in a Lotus Raft
Album leaf, silk
21.4 × 23.5 cm

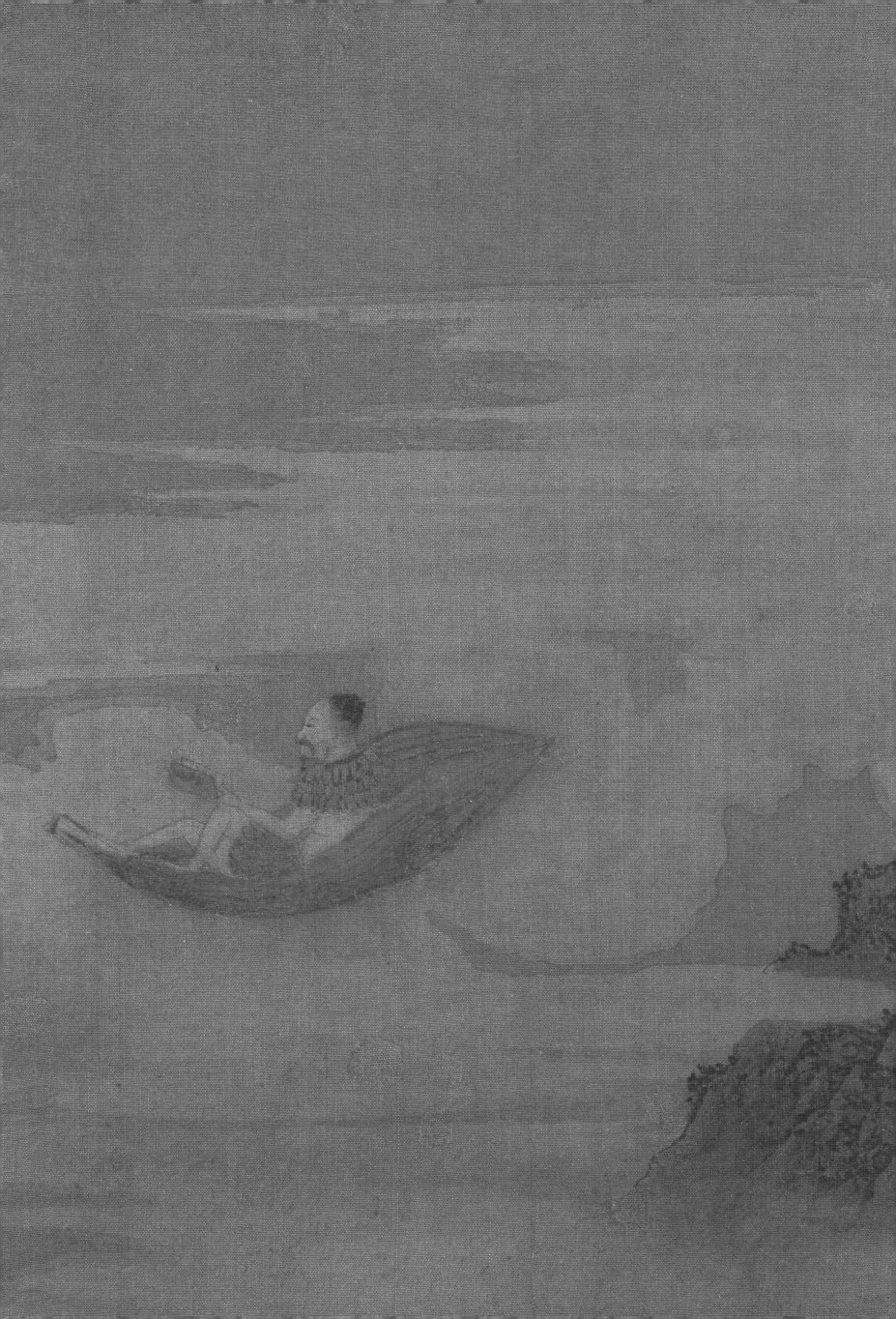

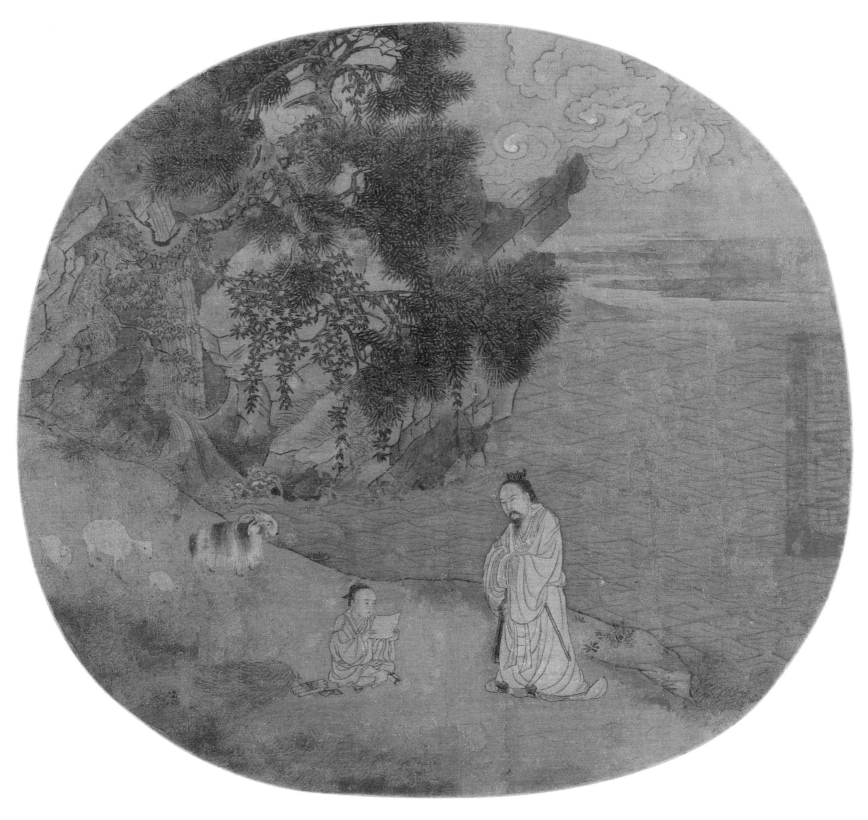

新17779 3/20
宋 佚名
初平牧羊图页
28 | 绢本　纵23.5厘米　横24.6厘米
Xin17779 3/20
Anonymous, Song dynasty
Chuping Herding Sheep
Album leaf, silk
23.5 × 24.6 cm

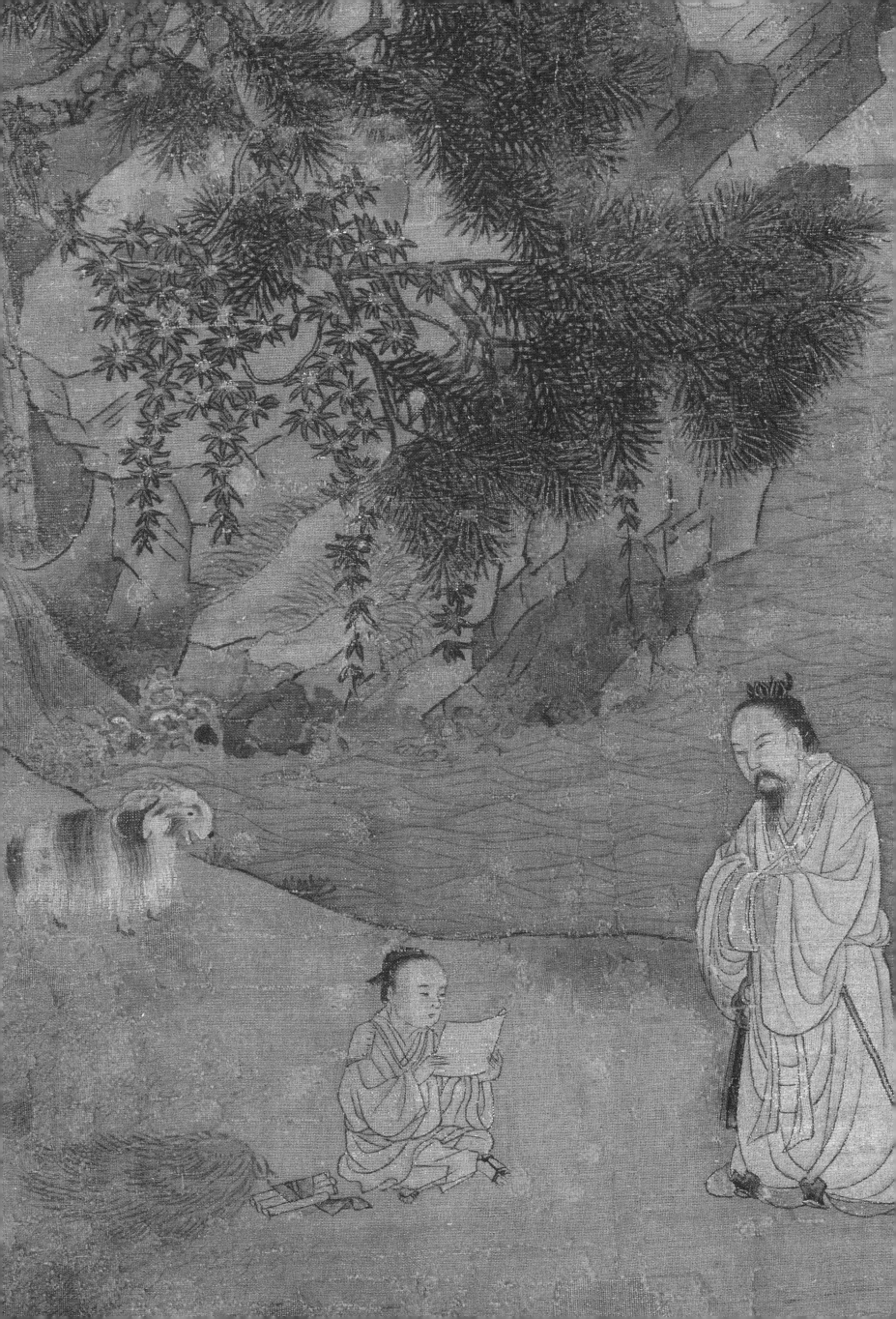

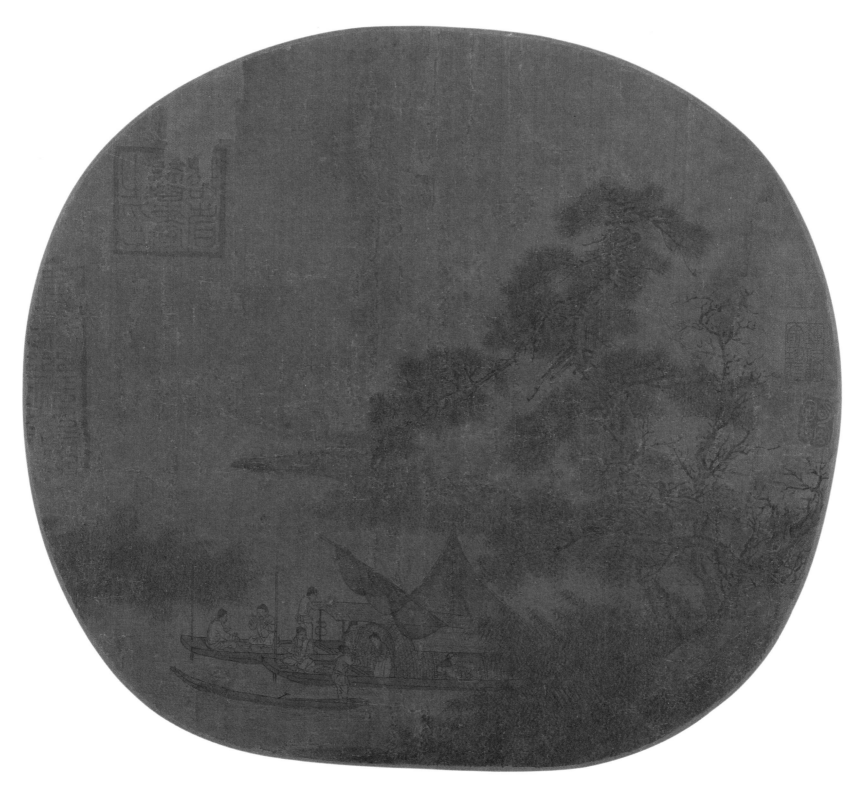

新87182

宋 佚名
渔乐图页

29 | 绢本　纵23.7厘米　横25.3厘米
Xin87182
Anonymous, Song dynasty
The Pleasure of Fishing
Album leaf, silk
23.7 × 25.3 cm

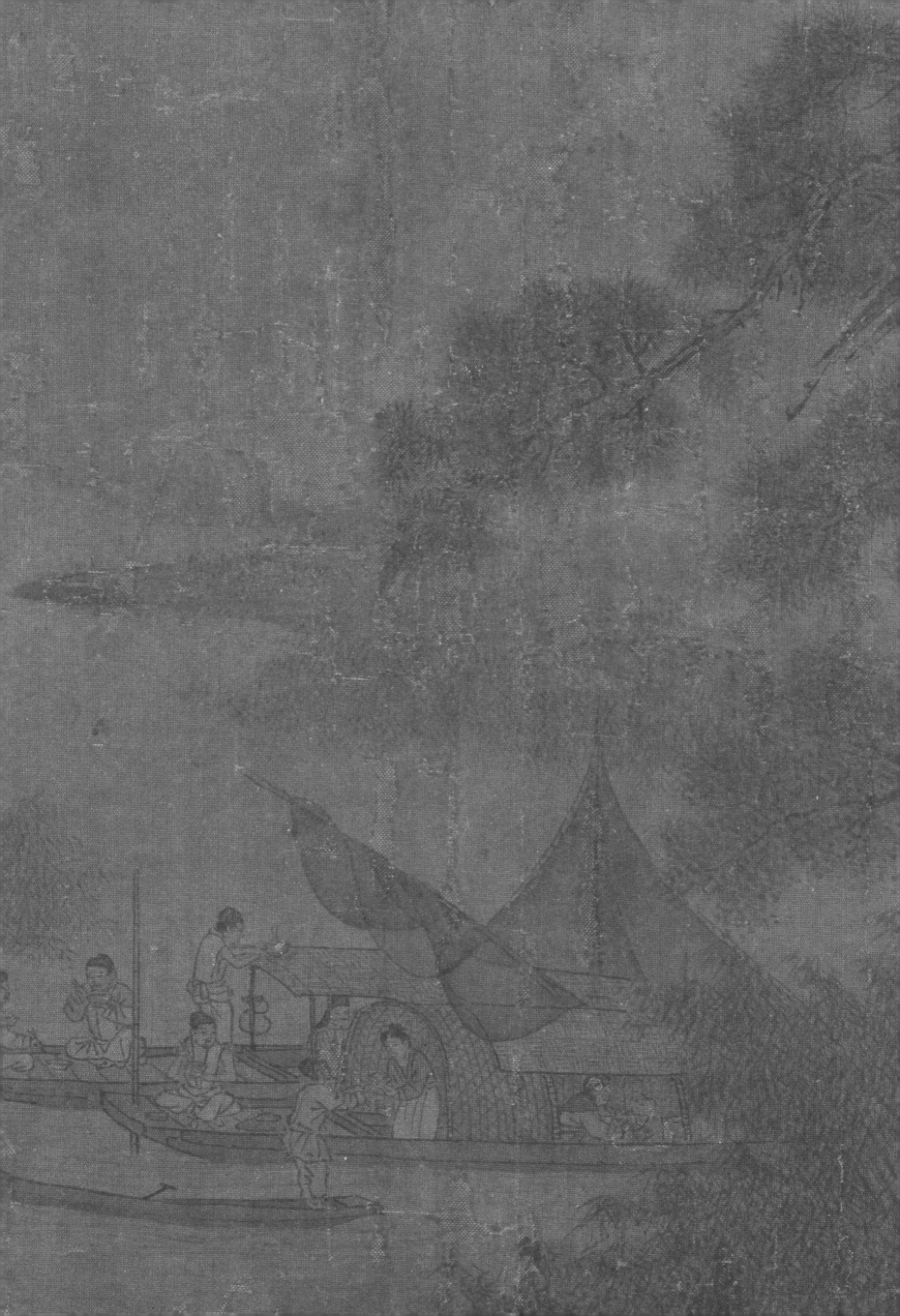

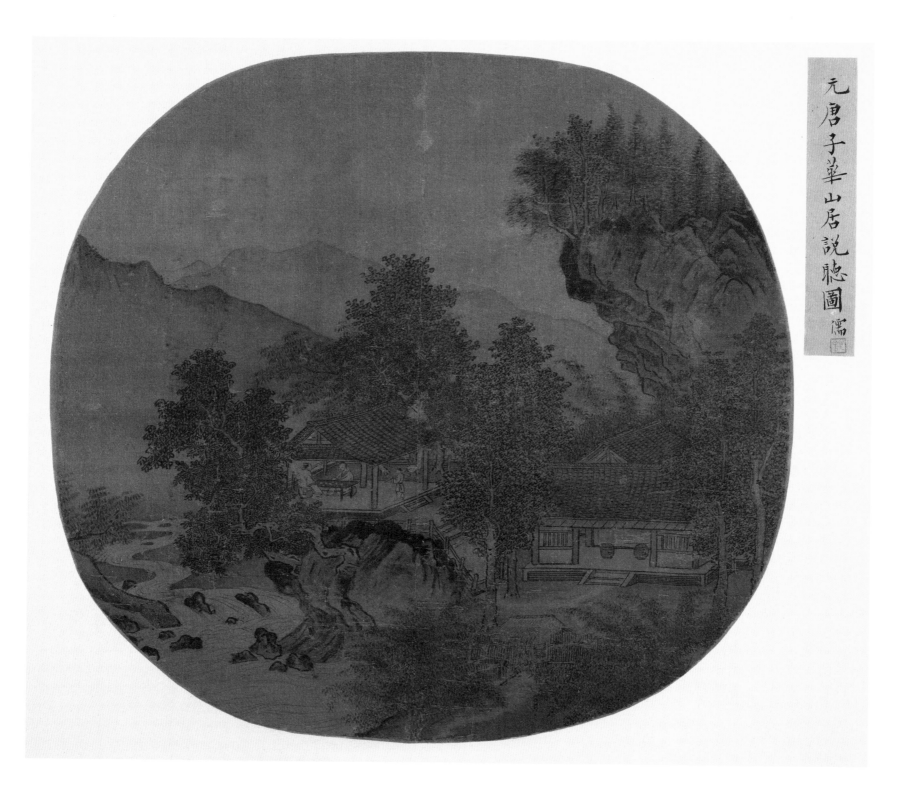

元唐子華山居說聽圖儒

新87183

宋 佚名
山居说听图页

30 | 绢本　纵25厘米　横25.7厘米
Xin87183

Anonymous, Song dynasty
Living in Mountain
Album leaf, silk
25 × 25.7 cm

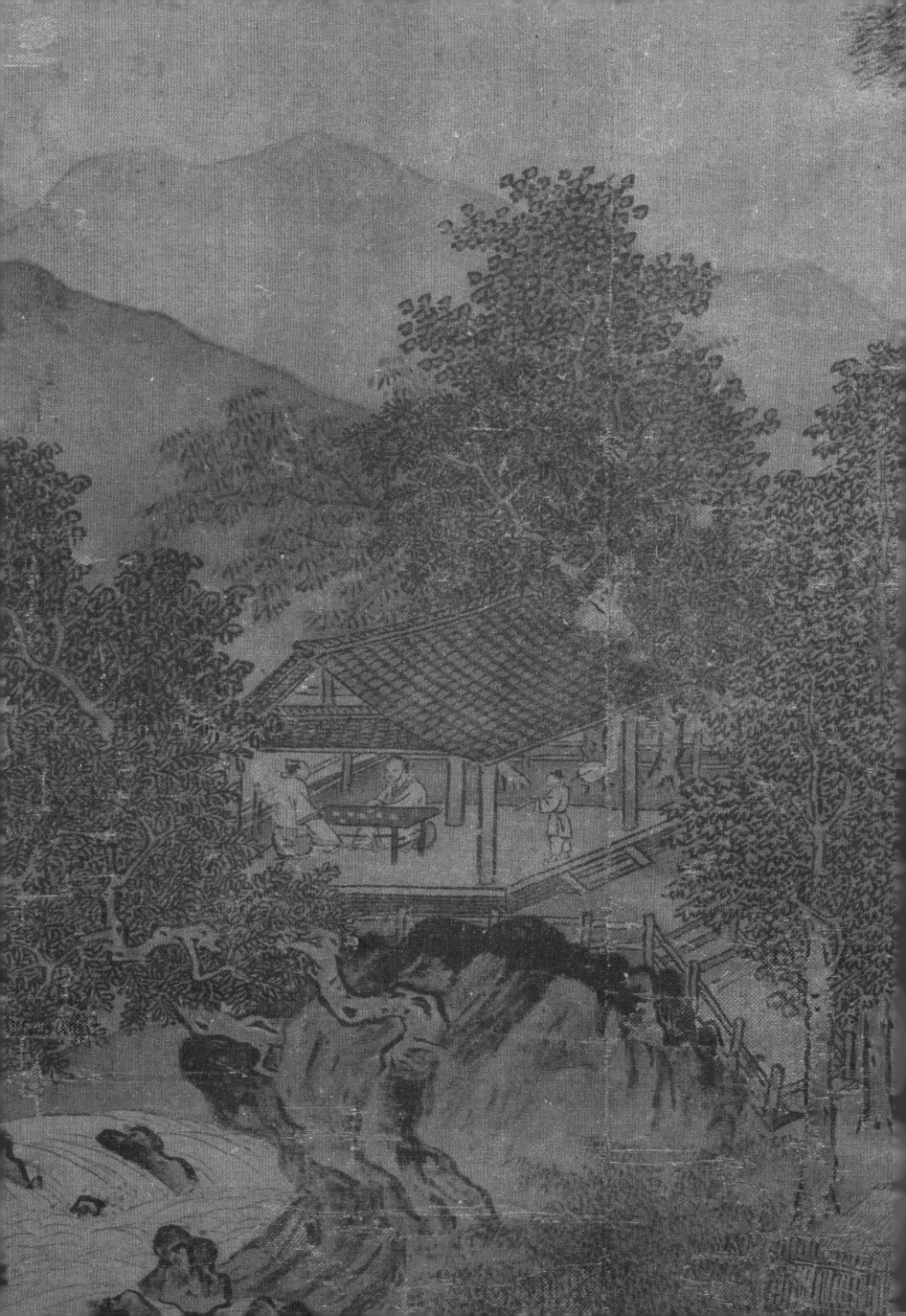

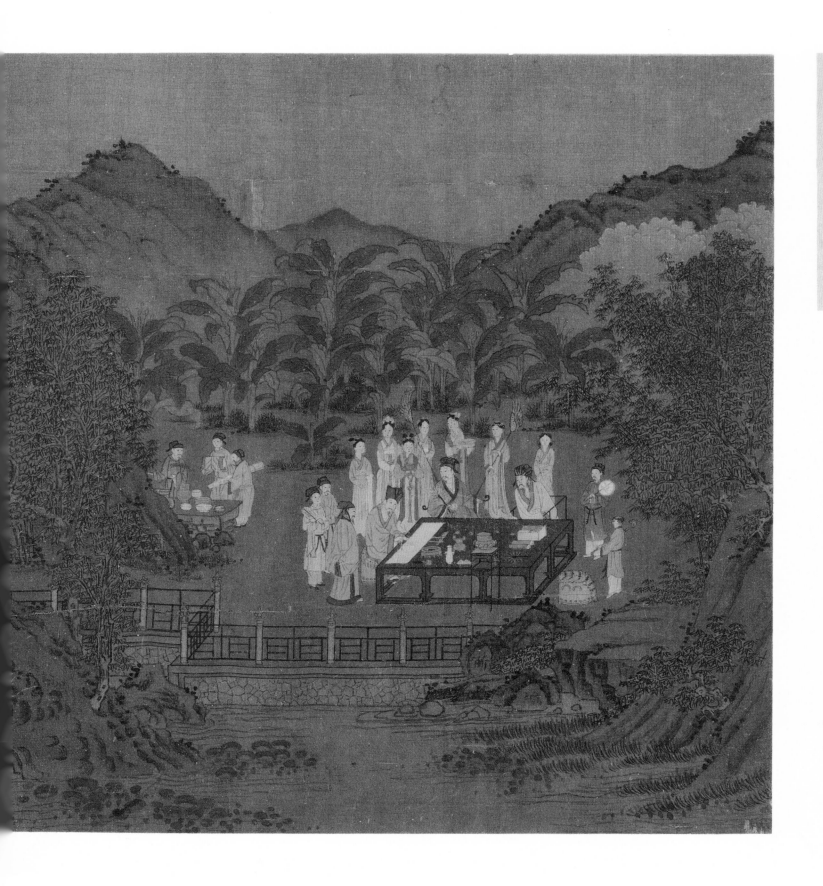

題 昌 南 唐 文 會

故6150 8/10
宋 佚名
南唐文会图页
绢本　纵30.4厘米　横29.6厘米
31 | Gu6150 8/10
Anonymous, Song dynasty
Literary Gathering in the Southern Tang Dynasty
Album leaf, silk
30.4 × 29.6 cm

南唐雖僻立亦自
尚文規籍琳徠祥
雲圖書左右搜東
瀛前搜法西雅後
開師位置增精密
晚年�蜀為

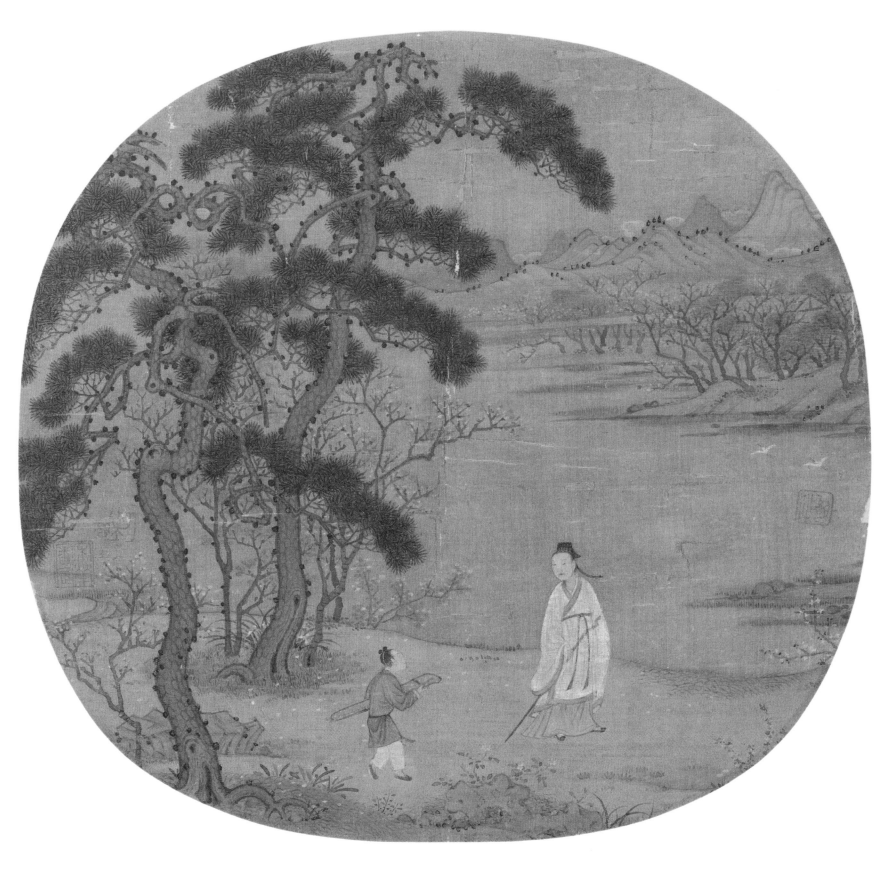

故6158 7/16
宋 佚名
松荫策杖图页

32 绢本　纵28厘米　横28.7厘米

Gu6158 7/16

Anonymous, Song dynasty
Walking with a Stick in the Shade of Pines
Album leaf, silk
28 × 28.7 cm

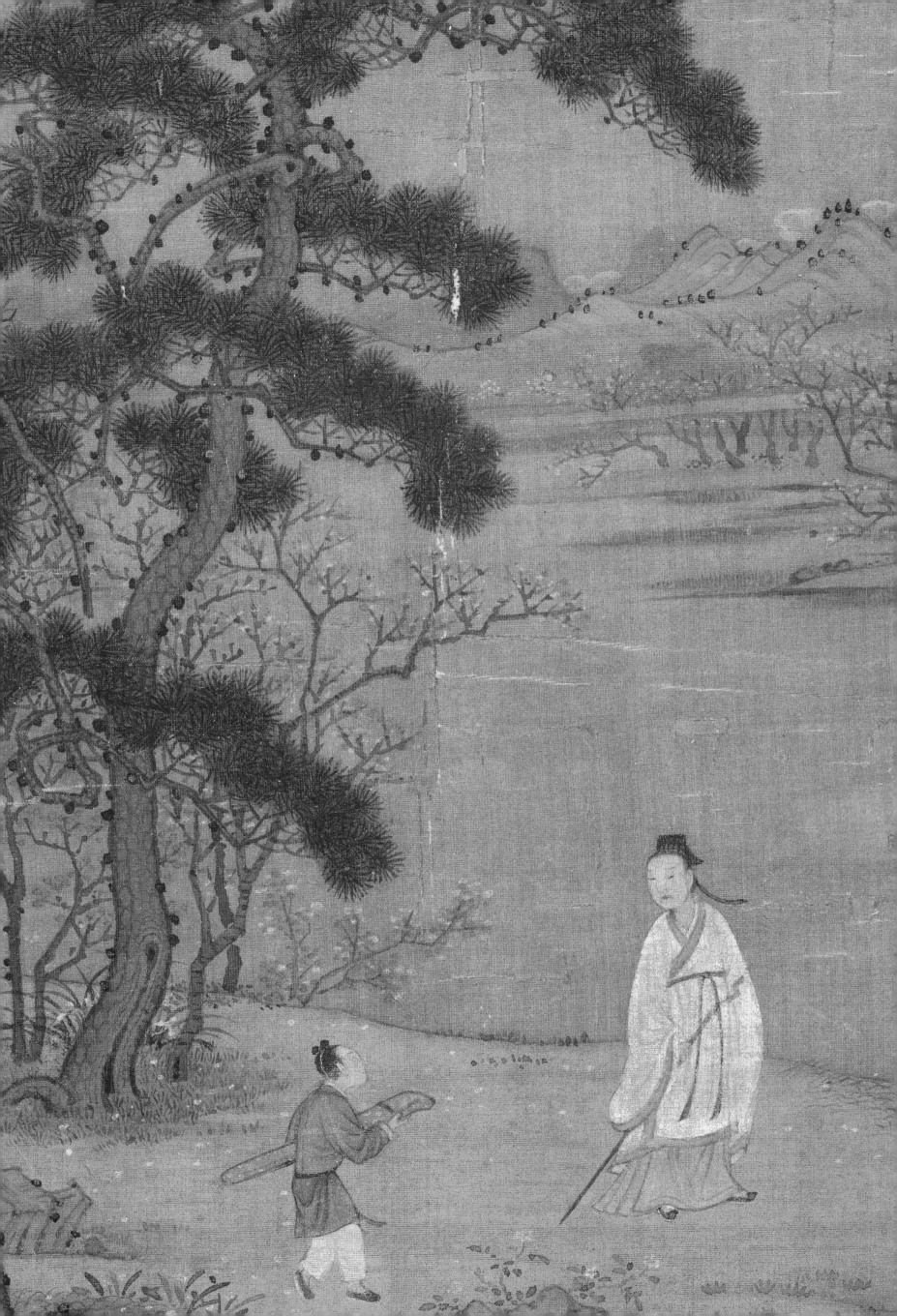

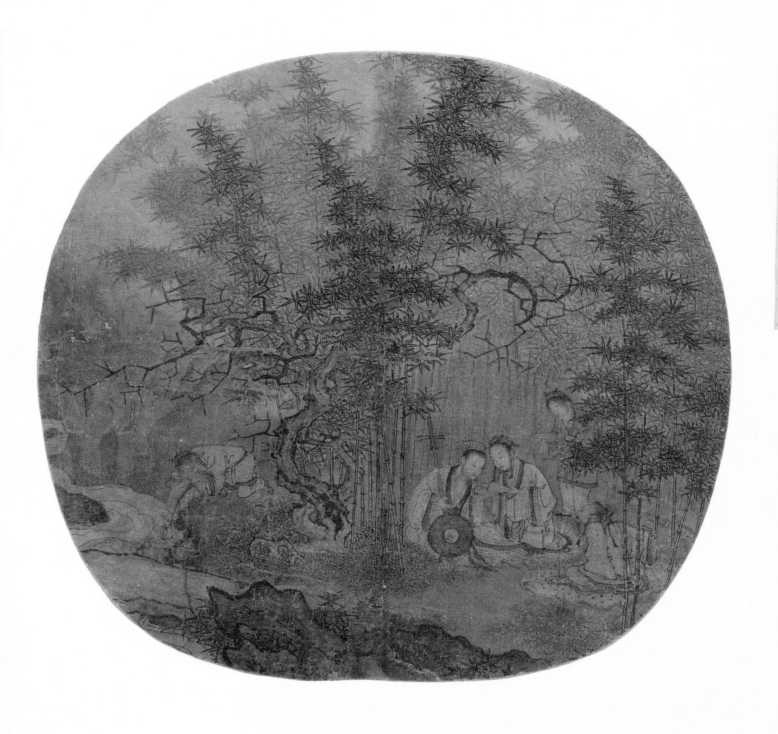

李唐竹林撥阮

故6151 9/10

宋 佚名
竹林拨阮图页

33 绢本　纵22.7厘米 横24.5厘米

Gu6151 9/10

Anonymous, Song dynasty
Playing Ruan in Bamboo Grove
Album leaf, silk
22.7 × 24.5 cm

長夏江

村當易名俱成

人物矢高清竹

林不作醺々醉

却攡鋼絲寄遠

情

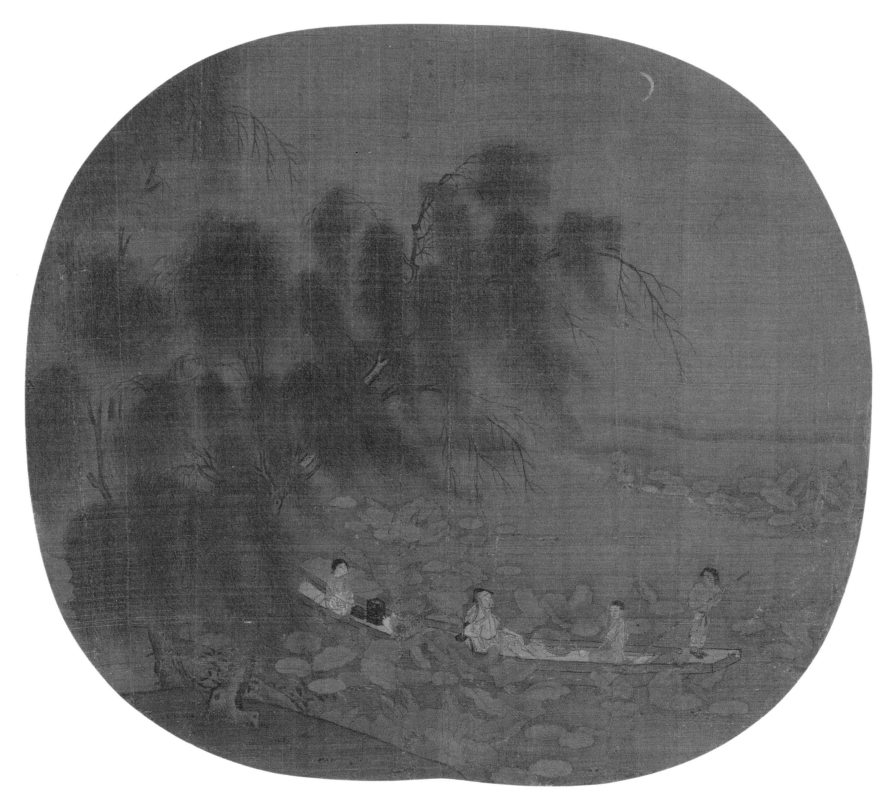

新147425 2/12

宋 佚名

柳塘泛月图页

34 | 绢本　纵23.2厘米　横28.1厘米

Xin147425 2/12

Anonymous, Song dynasty
Boating on Willow Pond in Moonlight
Album leaf, silk
23.2 × 28.1 cm

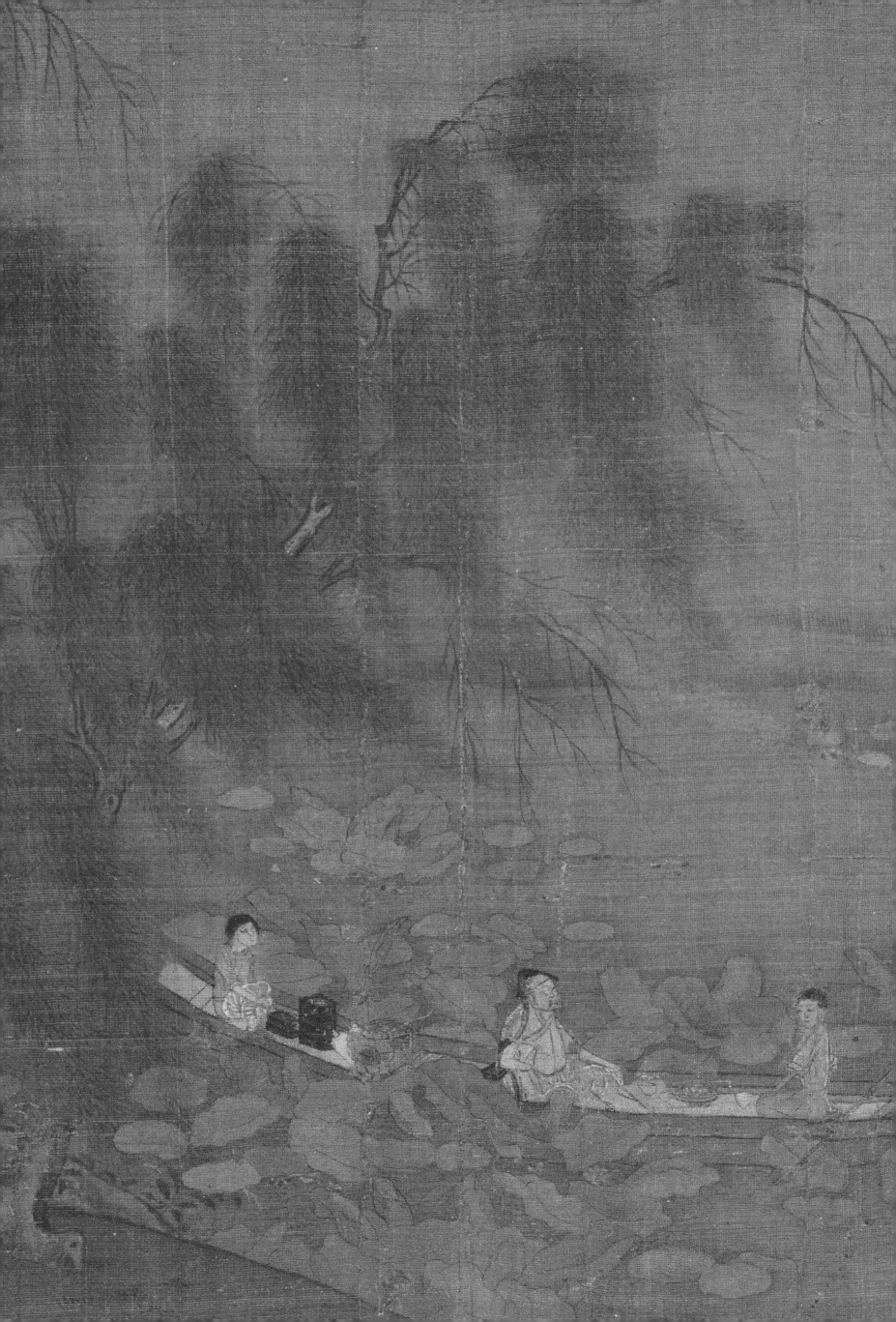

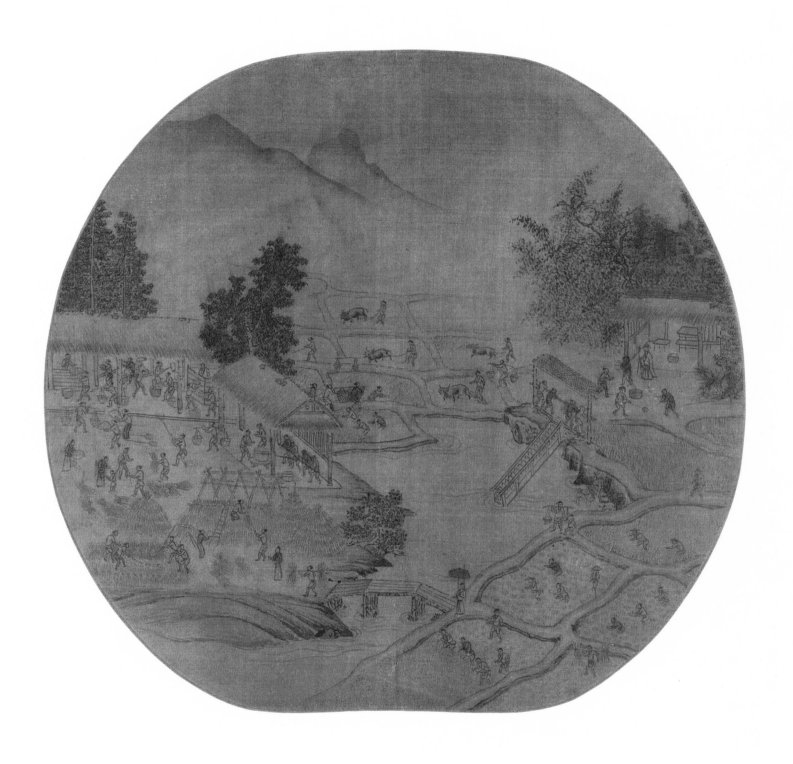

新147427 12/12

宋 佚名
耕获图页

35 | 绢本　纵25.7厘米　横24.8厘米

Xin147427 12/12
Anonymous, Song dynasty
Farming and Harvest
Album leaf, silk
25.7 × 24.8 cm

農之務兮勿休歲之豐兮有慶若然則耕為天
下之急務食係天下之大命遂陳之無逸之篇
播以良耜之詠且夫春陽脉動雨足一犁嘉穀盈
篝浸水之湄粒粒茲萌萬頃千畦是時也布穀
催耕草嫩犢肥東作方殷相土所宜或鞭牛而耕
春或把鋤而翻涅或襏襫於別墅或桔槔於前
溪逮夫綠野陰濃麥秋天氣競抜新秧歡呼挿
蒔井布棊分芃芃生意然而良苗之秀方敷糧
秀之害易肆抜而去之惟恐不亟夫之耘兮竹笠
蓑衣婦之饁兮壺漿簞食潦則泥淖之塗足旱
則轆轤之衒尾至若稻花盈疇風搖翠浪寶穡
西成農夫之望令之刈穫兮有期向之辛勤兮
萬狀向之下田兮貪耒而耕令之出門兮腰鐮而
往拾穗則許兒童築場則賴丁壯或積粟以計
歲粮或炊秔以供曉餉或為酒以介壽眉或薦
新以荅神貺噫嘻粒粟之飽我農之功一輸於
債戶而無幾再趣於官賦而巳窮三督於兵餉
而盡空手執耒耜而有雷腹之餒身居田野而
無斗粟之春安得天下游手之夫盡轉而為務
本之農

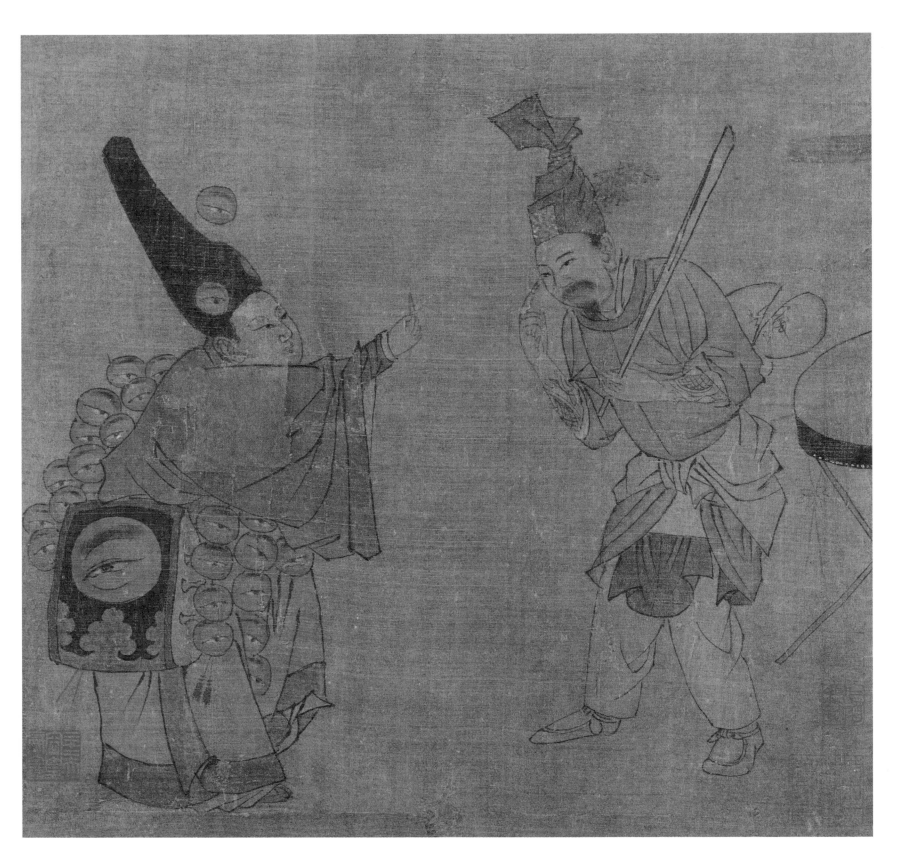

新92267

宋 佚名
杂剧（卖眼药）图册页

36 | 绢本　纵23.8厘米　横24.5厘米

Xin92267
Anonymous, Song dynasty
Selling Eye-ointment
Album leaf, silk
23.8 × 24.5 cm

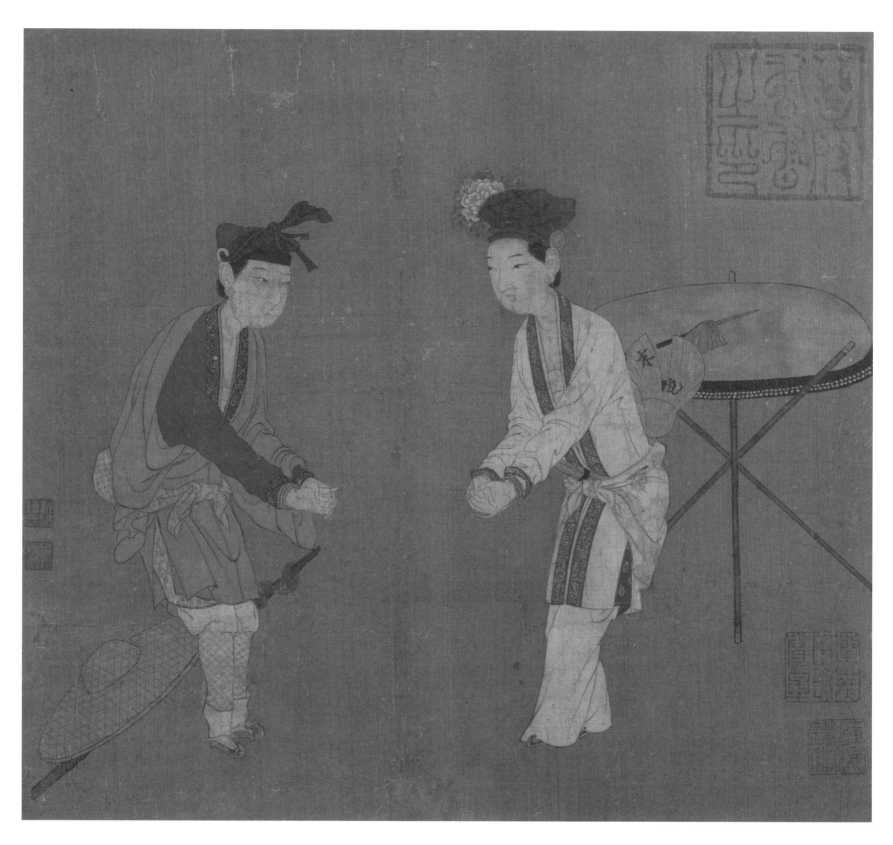

新92266

宋 佚名
杂剧（打花鼓）图册页

37 | 绢本　纵24厘米　横24.3厘米

Xin92266

Anonymous, Song dynasty
Playing Flower-drum
Album leaf, silk
24 × 24.3 cm

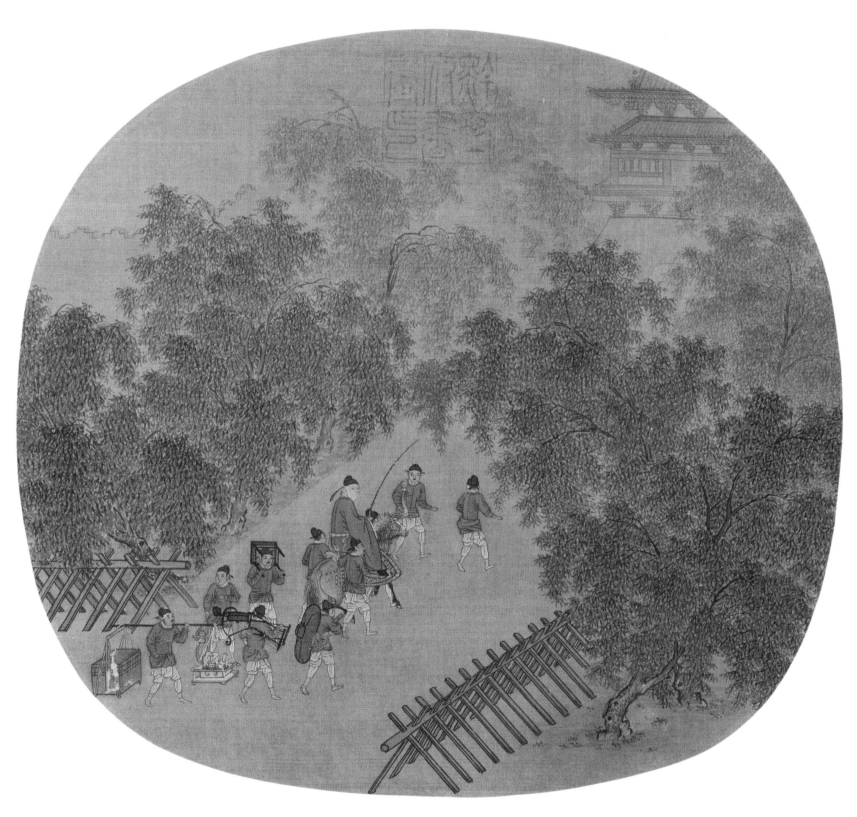

故6158 15/16

宋 佚名
春游晚归图页

38 | 绢本　纵24.2厘米　横25.3厘米

Gu6158 15/16

Anonymous, Song dynasty
Returning at Dusk from Spring Outing
Album leaf, silk
24.2 × 25.3 cm

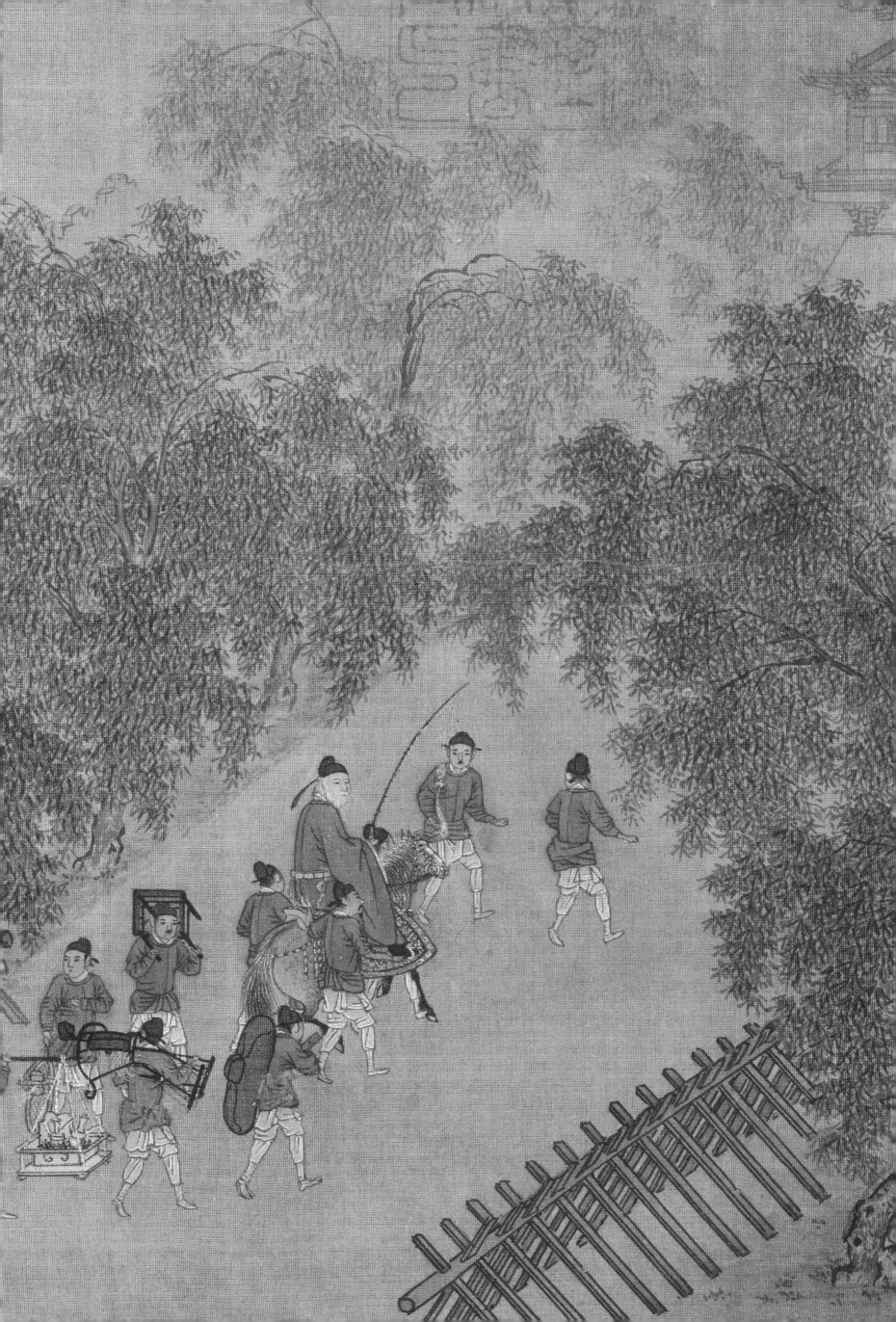

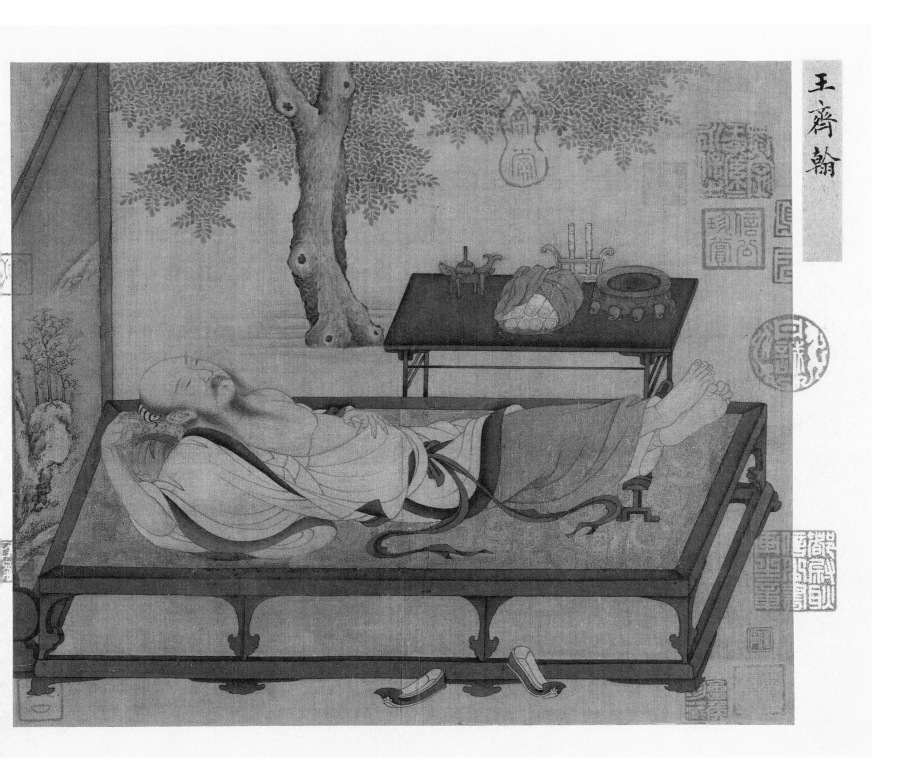

王齊翰

宋 佚名
槐荫消夏图页

39 绢本　纵25厘米　横28.5厘米
Xin147426　2/14

Anonymous, Song dynasty
Enjoying the Cool in Summer under the Shade of a Locust Tree
Album leaf, silk
25 × 28.5 cm

王齊翰善人物氣度不凡迥出風埃物
表其勘書諸圖徽宗藏之內府去皆首
尾標題重加珍賞審此信為冥然當不
止上德謹輩益驅爭先印方駕顧陸
諸人夫豈多讓
襄平晚子耿信公識

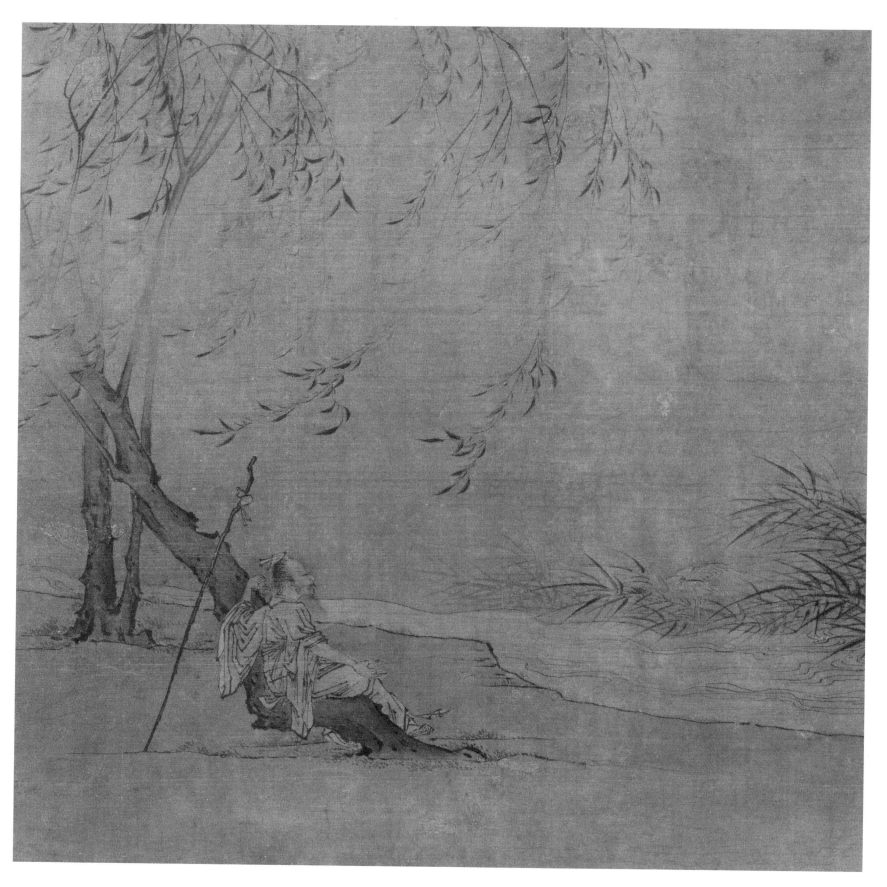

新13845 3/15

宋 佚名
柳荫高士图页

40 绢本　纵29.4厘米　横29厘米

Xin13845 3/15

Anonymous, Song dynasty
Hermit in the Shade of a Willow Tree
Album leaf, silk
29.4 × 29 cm

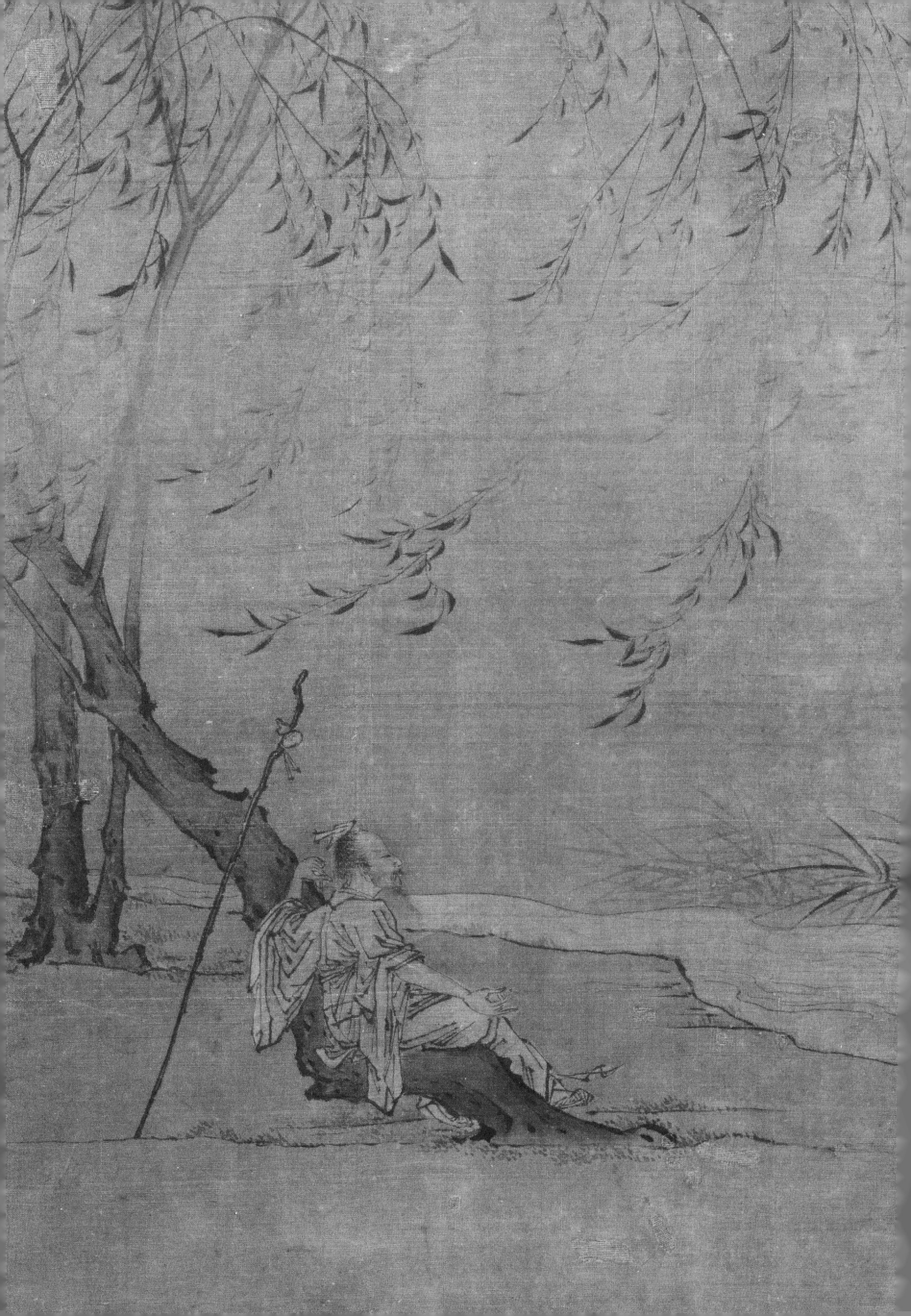

新147426 12/14

宋 佚名
松荫间憩图页

绢本　纵23.6厘米　横22.5厘米

41

Xin147426 12/14
Anonymous, Song dynasty
Taking a Rest in the Shade of a Pine
Album leaf, silk
23.6 × 22.5 cm

梁楷初師賈師古而筆力秀
勁譽擅出藍宜其不落院格
為一時琛壺也

耿信公

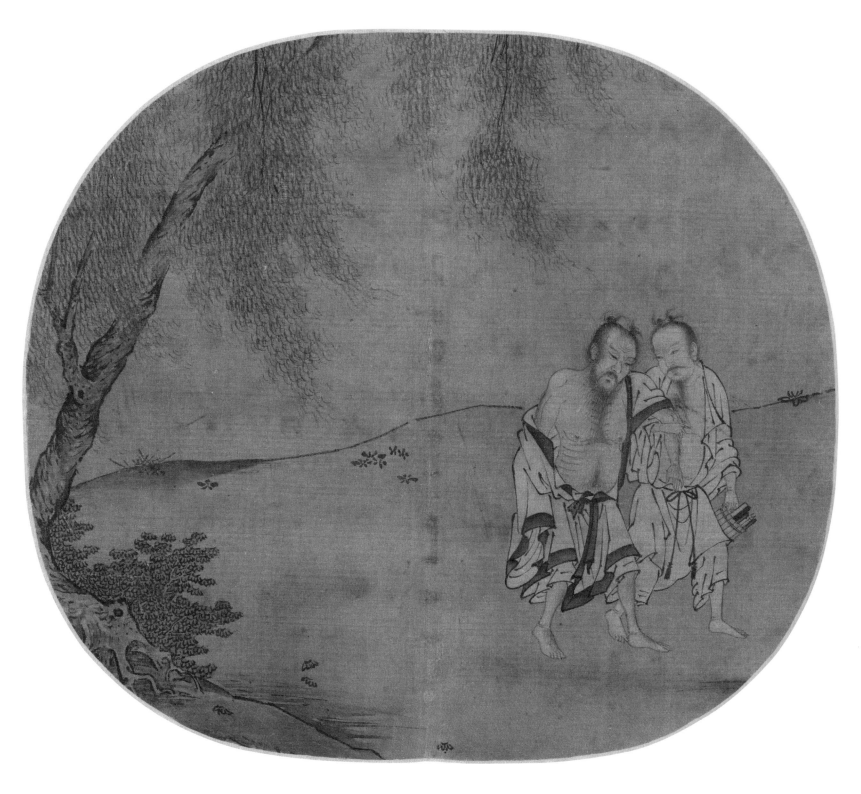

新156348

宋 佚名
柳荫醉归图页

42 | 绢本　纵23厘米　横24.8厘米

Xin156348

Anonymous, Song dynasty
*Two Tipplers Returning Home
In the Shade of a Willow Tree*

Album leaf, silk
23 × 24.8 cm

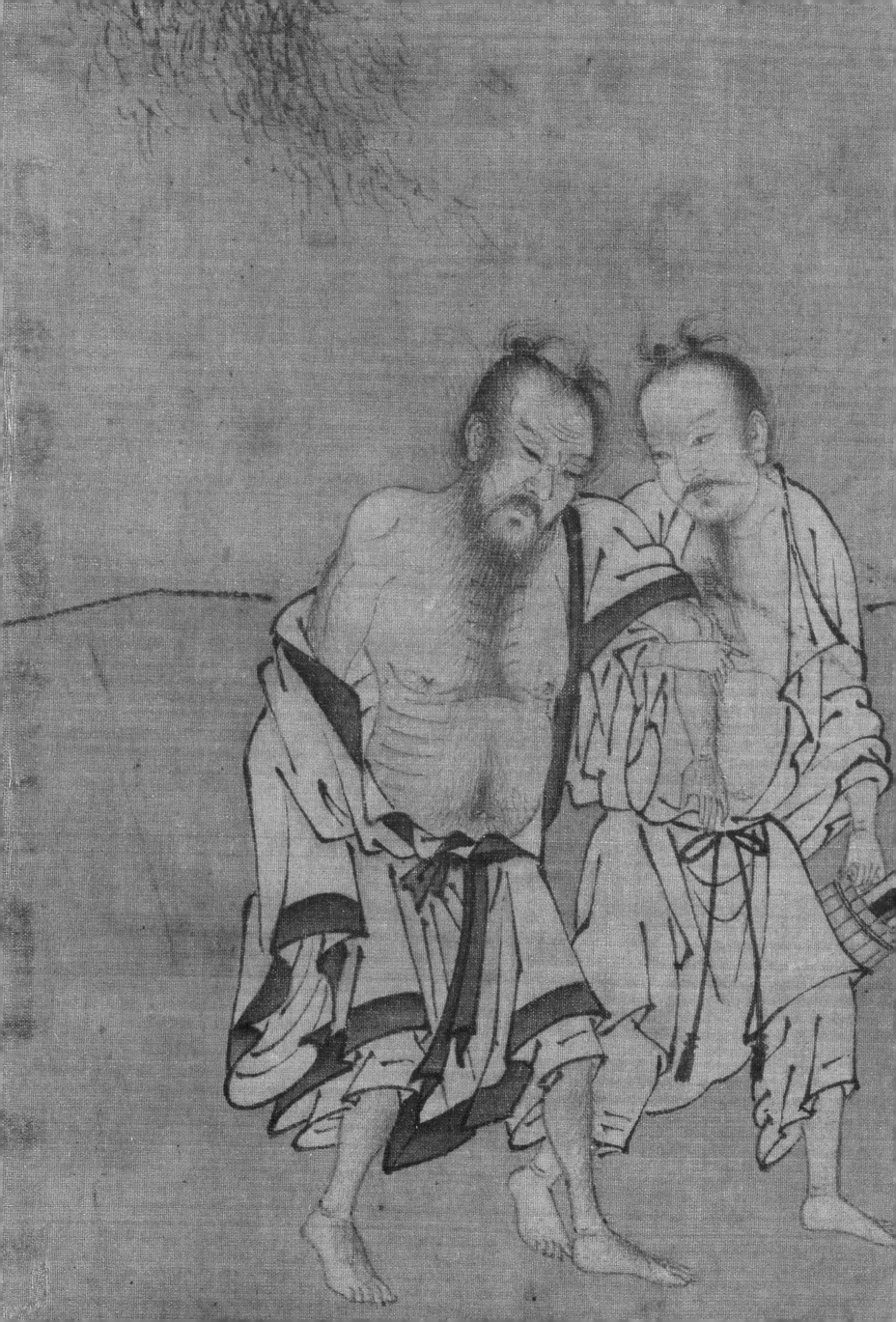

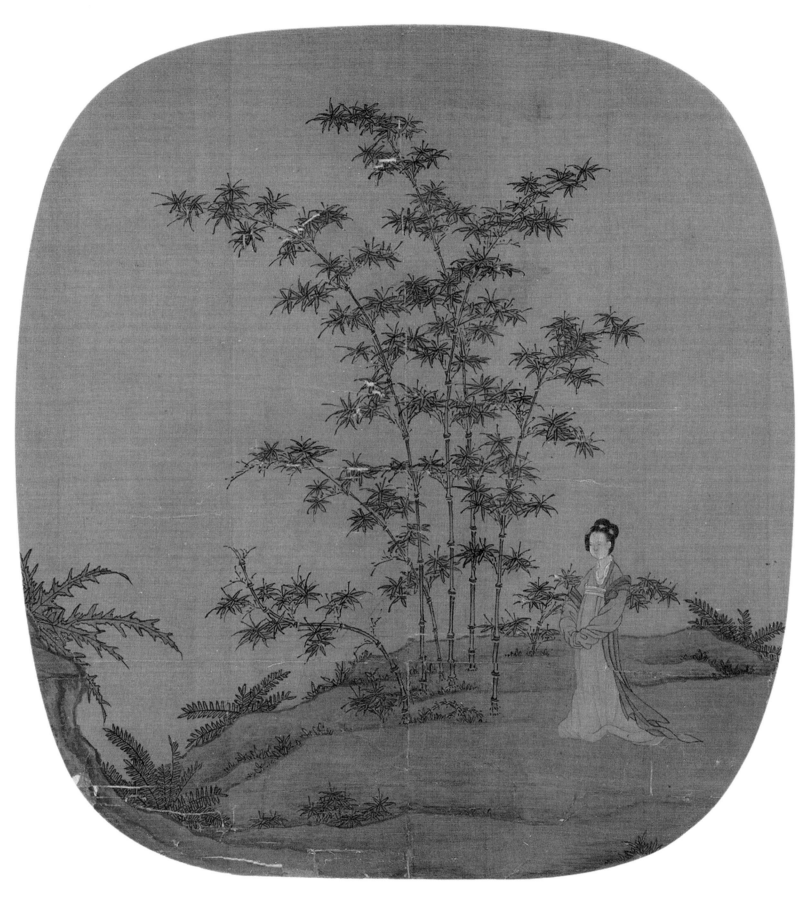

故6158 8/16

宋 佚名
天寒翠袖图页

43 绢本　纵25.7厘米　横21.6厘米

Gu6158 8/16

Anonymous, Song dynasty
Lady Standing by Wintry Bamboo

Album leaf, silk
25.7 × 21.6 cm

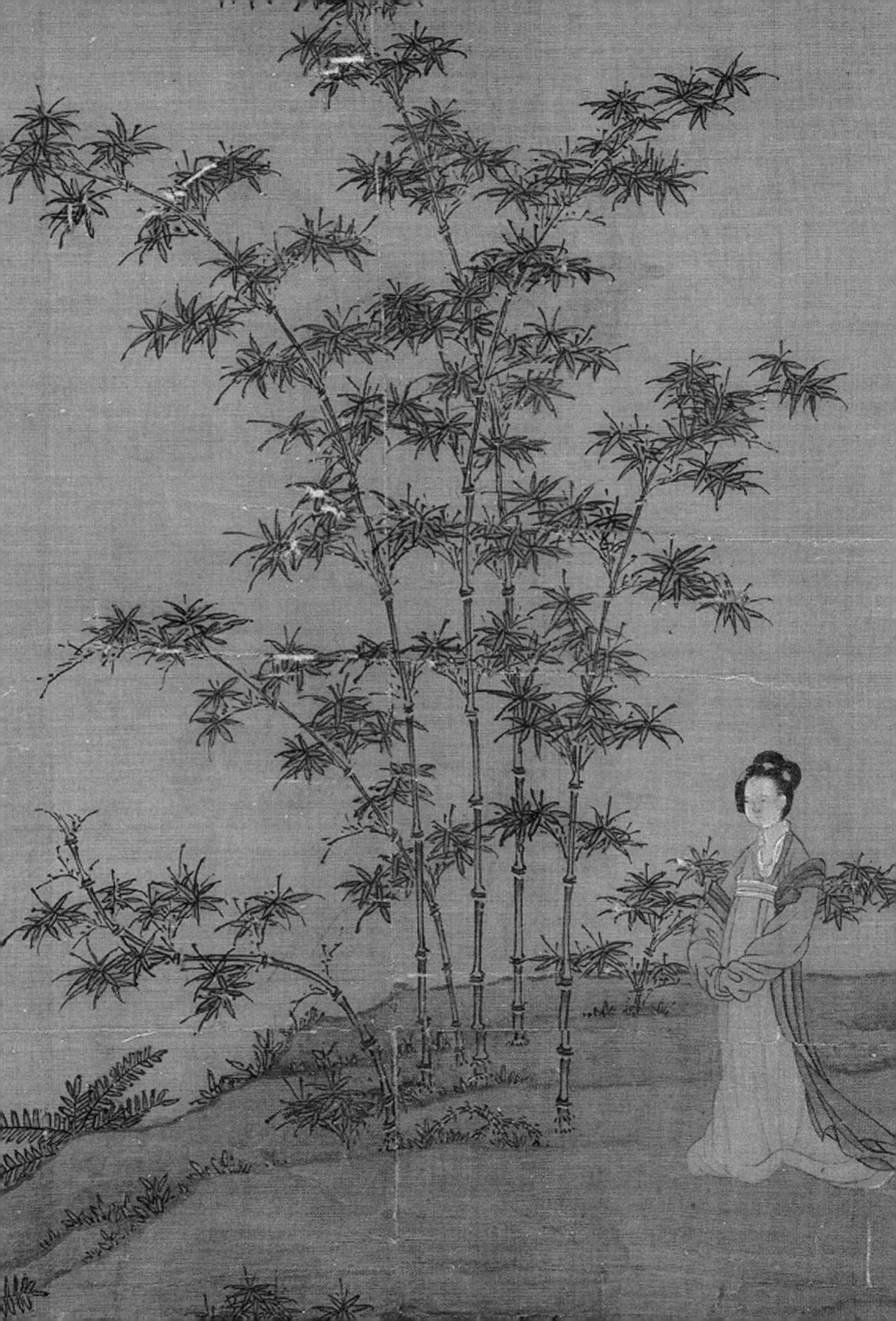

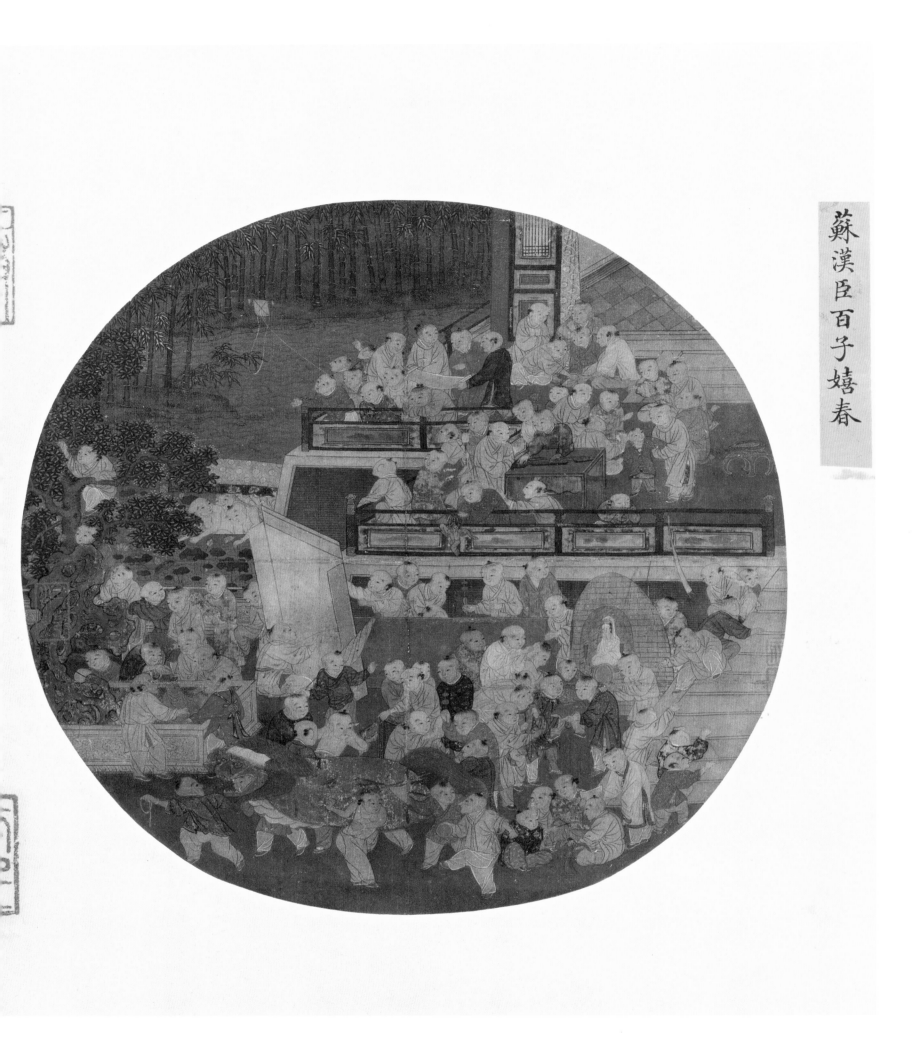

故6151 4/10

宋 佚名
百子嬉春图页

44 | 绢本 纵26.6厘米 横27.7厘米

Gu6151 4/10

Anonymous, Song dynasty
Hundred Boys Playing in Spring
Album leaf, silk
26.6 × 27.7 cm

春苑風
和靄戲塲狰獰
頭角絃圭璋問
他粉本泛何得
応在魯論第五
章

新147428 10/12

宋 佚名
秋庭婴戏图页

45 | 绢本　纵23.7厘米　横24厘米

Xin147428 10/12

Anonymous, Song dynasty
Children Playing in Autumnal Garden

Album leaf, silk
23.7 × 24 cm

奪檑署力
見童僕別一将
之氣已降讀書及第
不學賈爭強術臘徒
成逢設使平然屐平
水可能擎石硪
其缸

宋 佚名
小庭婴戏图页

46 | 绢本　纵25.8厘米　横25.3厘米
Anonymous, Song dynasty
Boys Playing in the Garden
Album leaf, silk
25.8 × 25.3 cm

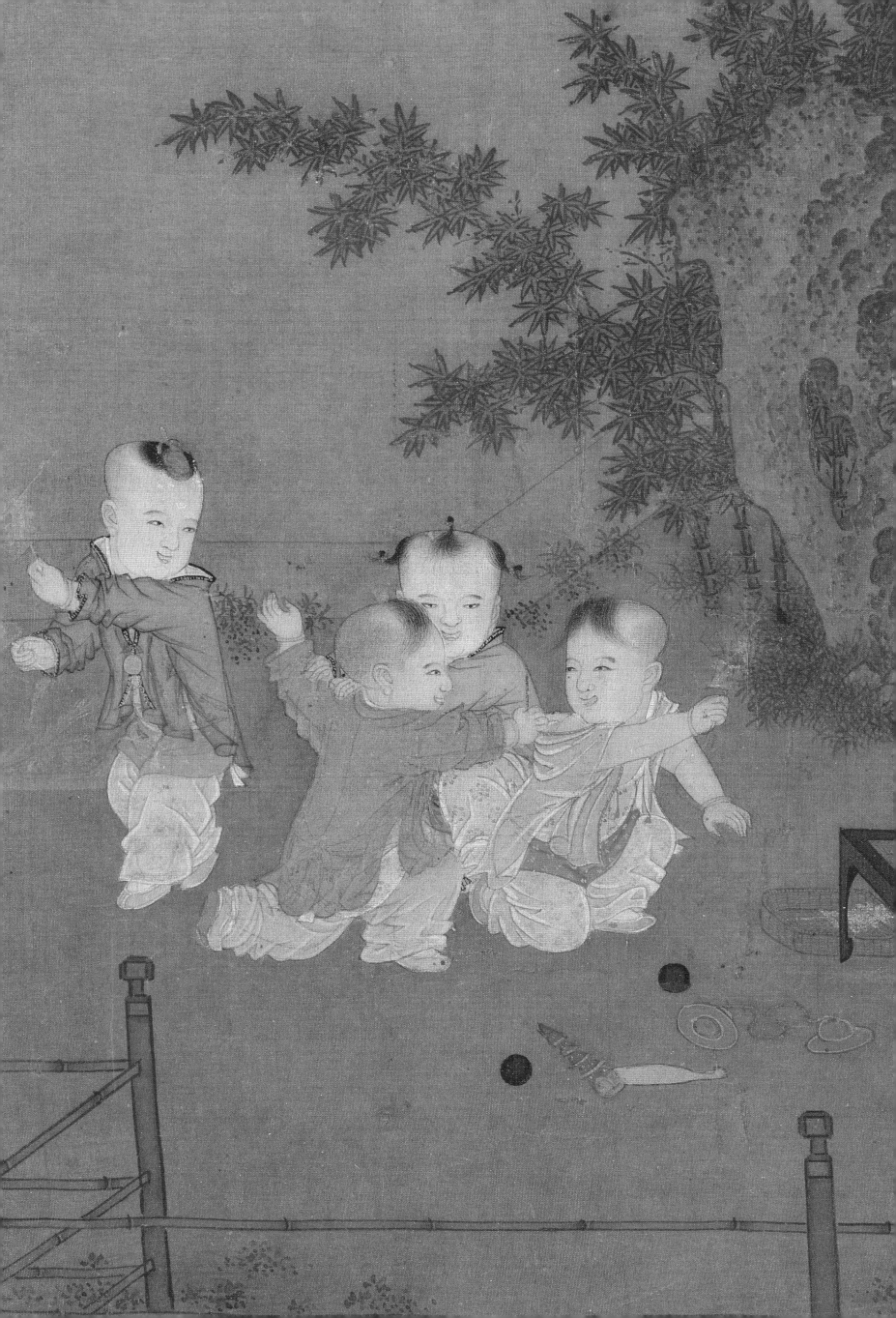

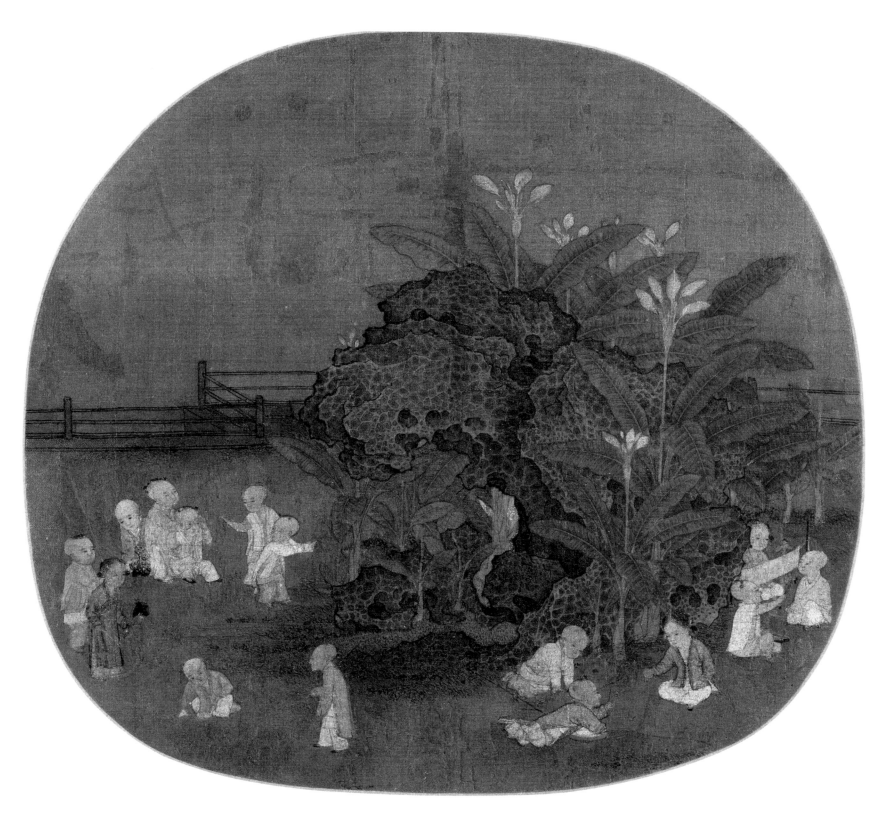

新119840

宋 佚名
蕉石婴戏图页

绢本　纵23.7厘米　横25厘米

47

Xin119840

Anonymous, Song dynasty
Children Playing by Rocks and Plantains

Album leaf, silk
23.7 × 25 cm

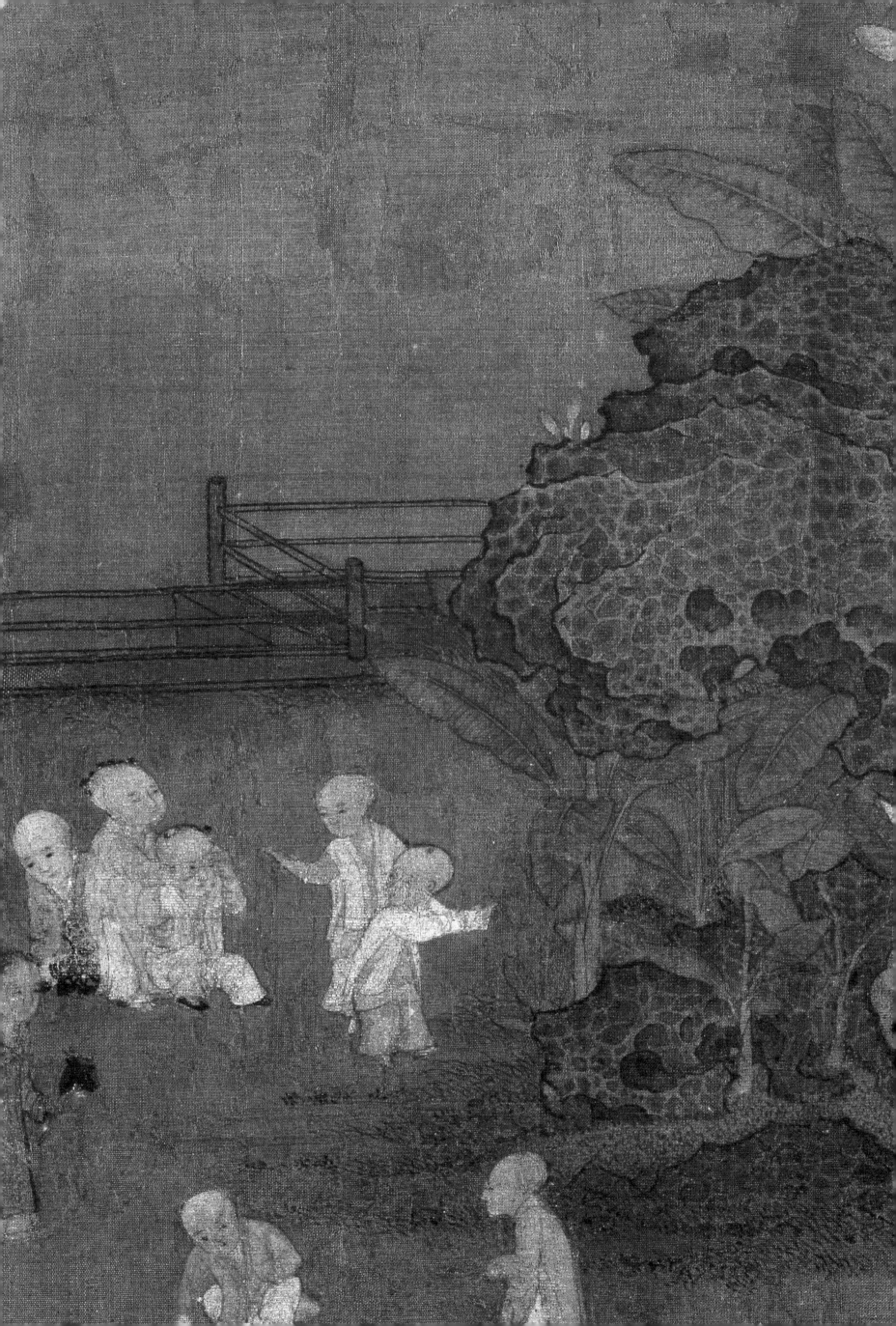

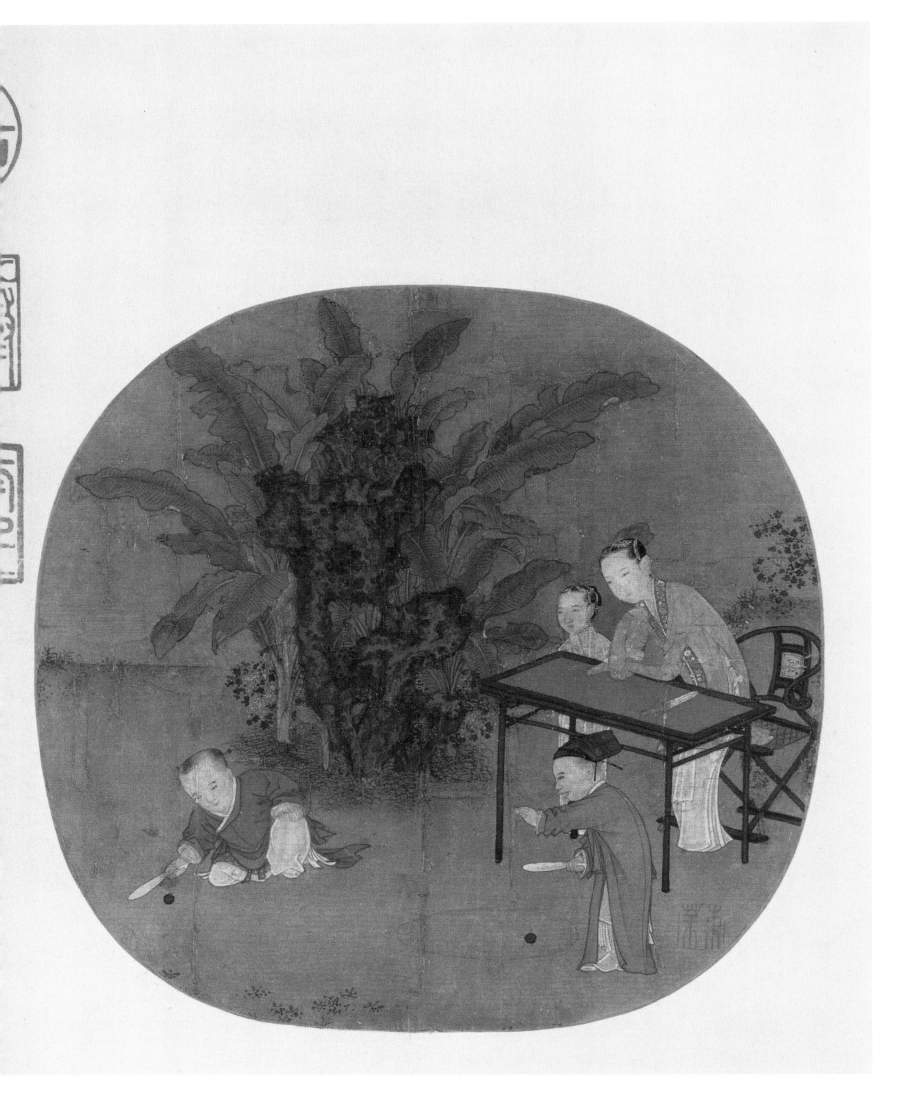

新147428 5/12

宋 佚名
蕉荫击球图页

48 绢本　纵25厘米 横24.5厘米

Xin147428 5/12

Anonymous, Song dynasty
Playing Ball Games in the Shade of Plantains
Album leaf, silk
25 × 24.5 cm

漢臣人物稱

精工多作貨郎官市

事此幅尤看其別撰蕉

陰絿擊雙童戲其母憑

案俯慈顧弗為畫荻教識

字繪形曲肖寓意失不

及前幀李迪藝興我无

邊體民心慎其嘆隅

告諸吏

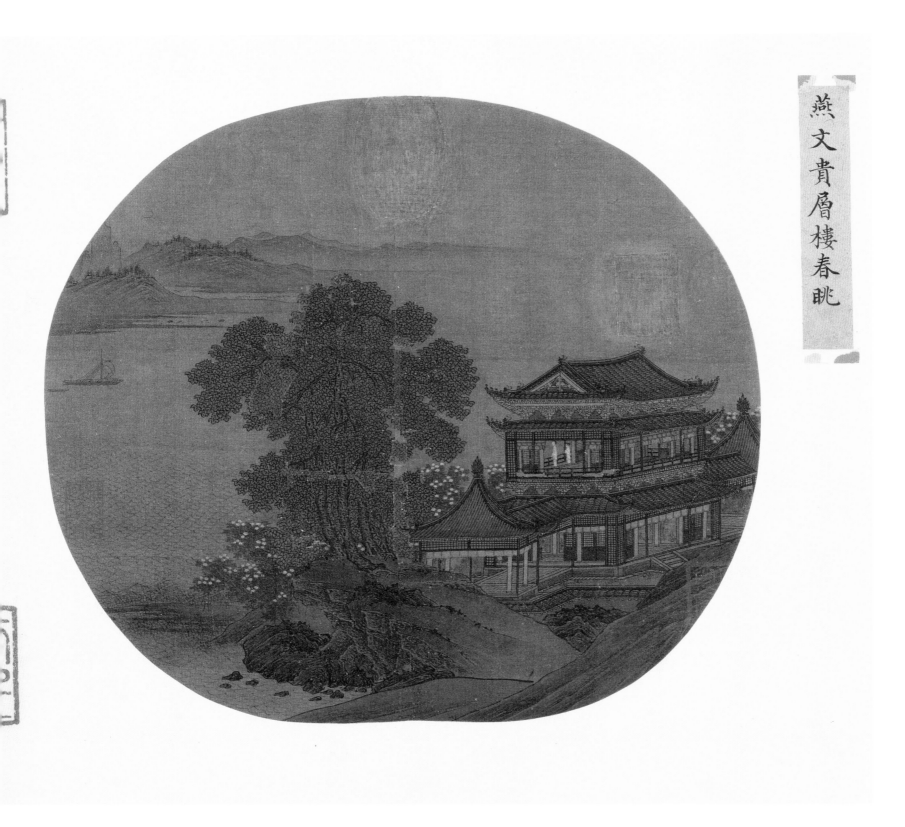

燕文貴層樓春眺

故6150 5/10

宋 佚名
層樓春眺圖頁

绢本　纵23.7厘米　横26.4厘米

49

Xin6150 5/10

Anonymous, Song dynasty
Viewing Spring Scenery from a Pavilion
Album leaf, silk
23.7 × 26.4 cm

渡海傳竒

蹟孝人與葉舟

幅圓見神韻幨尺旦

風流繞砌紅將叢

叢林綠漸稠欣窮

青好霎相共上

層樓

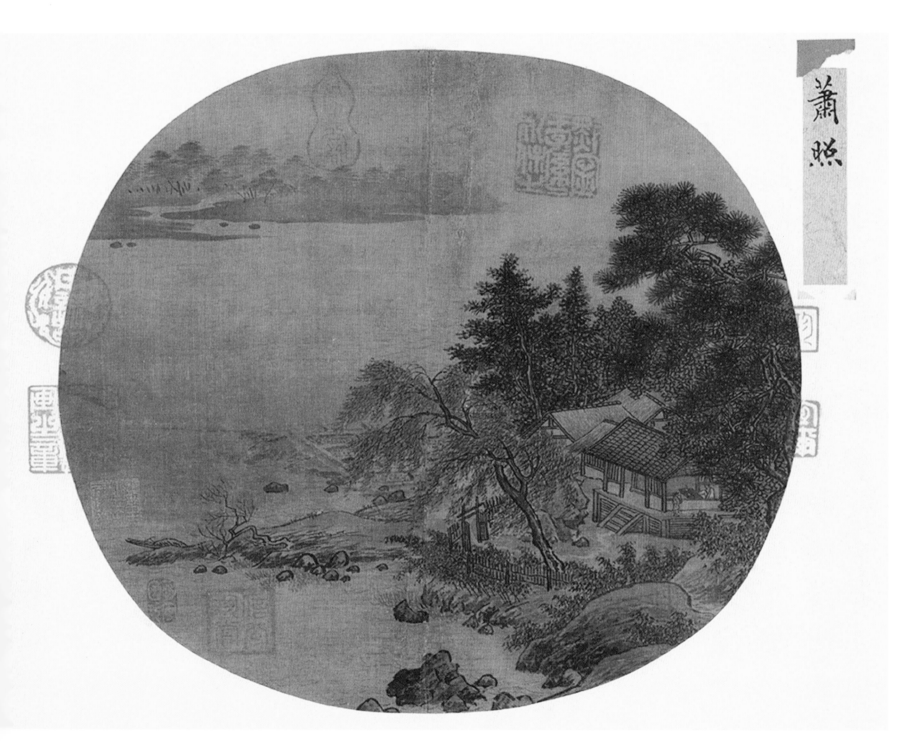

新147426 9/14

宋 佚名
柳堂读书图页

绢本　纵24.5厘米　横22.5厘米

50

Xin147426 9/14

Anonymous, Song dynasty
Reading in Willow Pavilion

Album leaf, silk
24.5 × 22.5 cm

筆墨淋漓有蒼莽古野之
致蕭熙與李晞古可稱以之

合

耿昭忠題

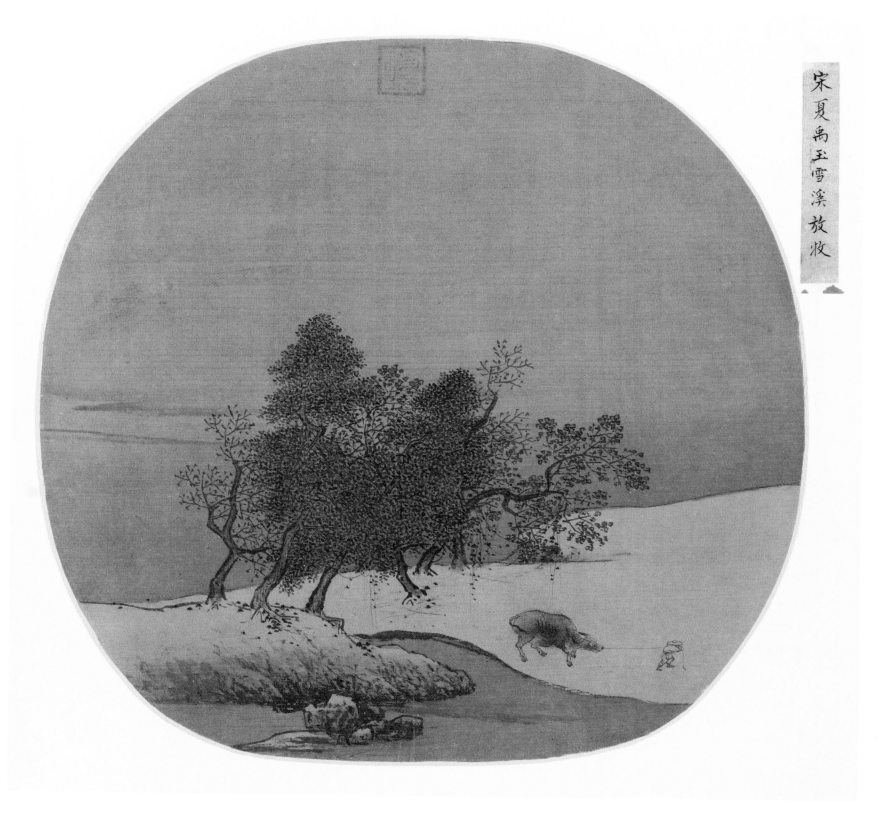

宋夏禹玉雪溪放牧

新13845 4/15
宋 佚名
雪溪放牧图页
绢本　纵25.7厘米　横26.5厘米
Xin13845 4/15
Anonymous, Song dynasty
Herding Cattle in Winter
Album leaf, silk
25.7 × 26.5 cm

51

新13844 1/14

宋 佚名
雪山行骑图页

52 | 绢本　纵29厘米 横23.1厘米

Xin13844　1/14

Anonymous, Song dynasty
Traveler on Donkey's Back through Snowy Mountains

Album leaf, silk
29 × 23.1 cm

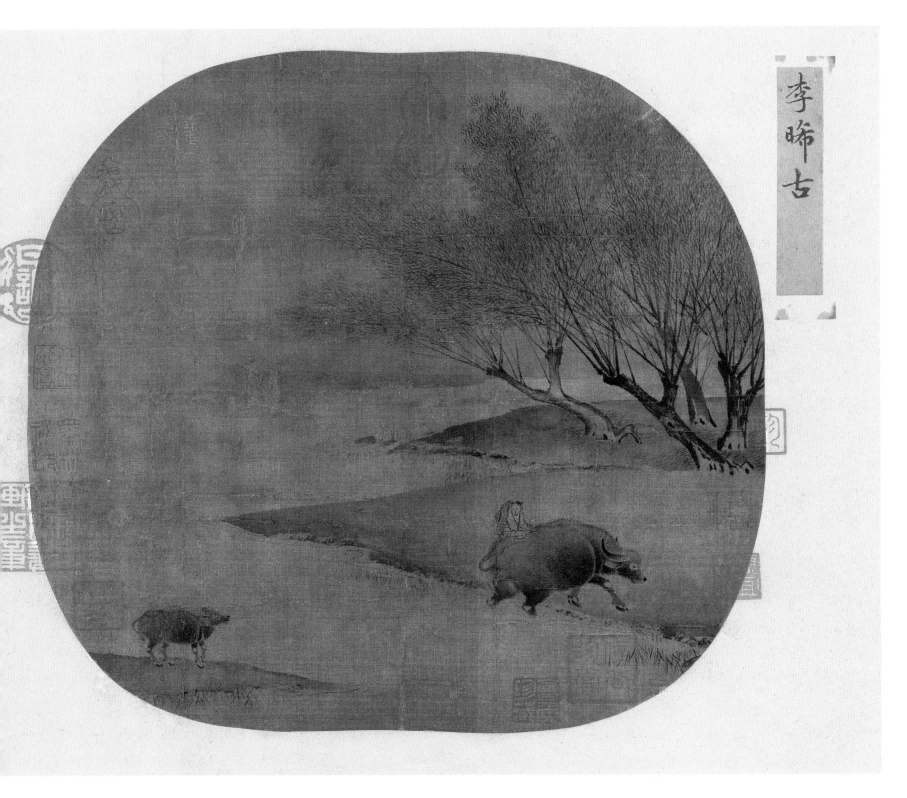

李晞古

新147426 8/14

宋 佚名
归牧图页

53 绢本　纵24厘米　横23.4厘米

Xin147426 8/14

Anonymous, Song dynasty
Return from Herding
Album leaf, silk
24 × 23.4 cm

川原清曠林木蕭疎暮靄烟霏

狀出歸牧時景象審此風格當

是李晞古匠心渾化窠

耿信公

宋 佚名
骑士猎归图页

54　绢本　纵22.3厘米　横25.2厘米

Gu6151 2/10
Anonymous, Song dynasty
Return from Hunting
Album leaf, silk
22.3 × 25.2 cm

射得艳羊驮马
上凌风意气自
然粗韬弓挺箭
仍猎去莫学胡
骠牵歌图

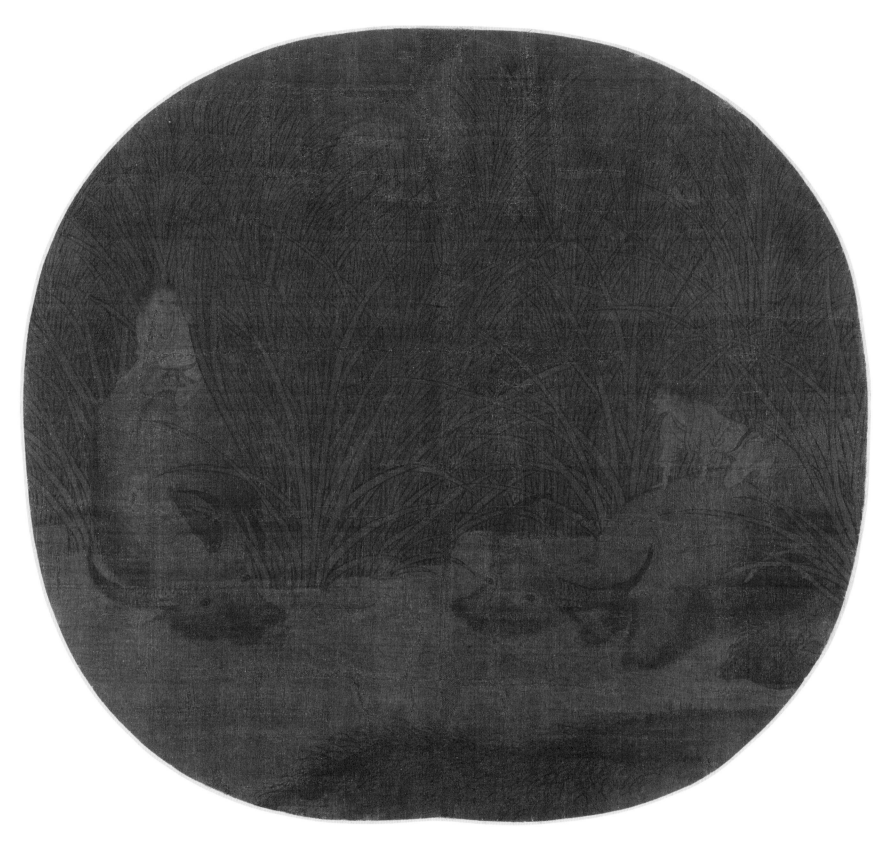

新188240 1/15

宋 佚名
双童牧牛图页

55 绢本　纵24.5厘米　横24.9厘米

Xin188240 1/15

Anonymous, Song dynasty
Two Boys Herding Cattle

Album leaf, silk
24.5 × 24.9 cm

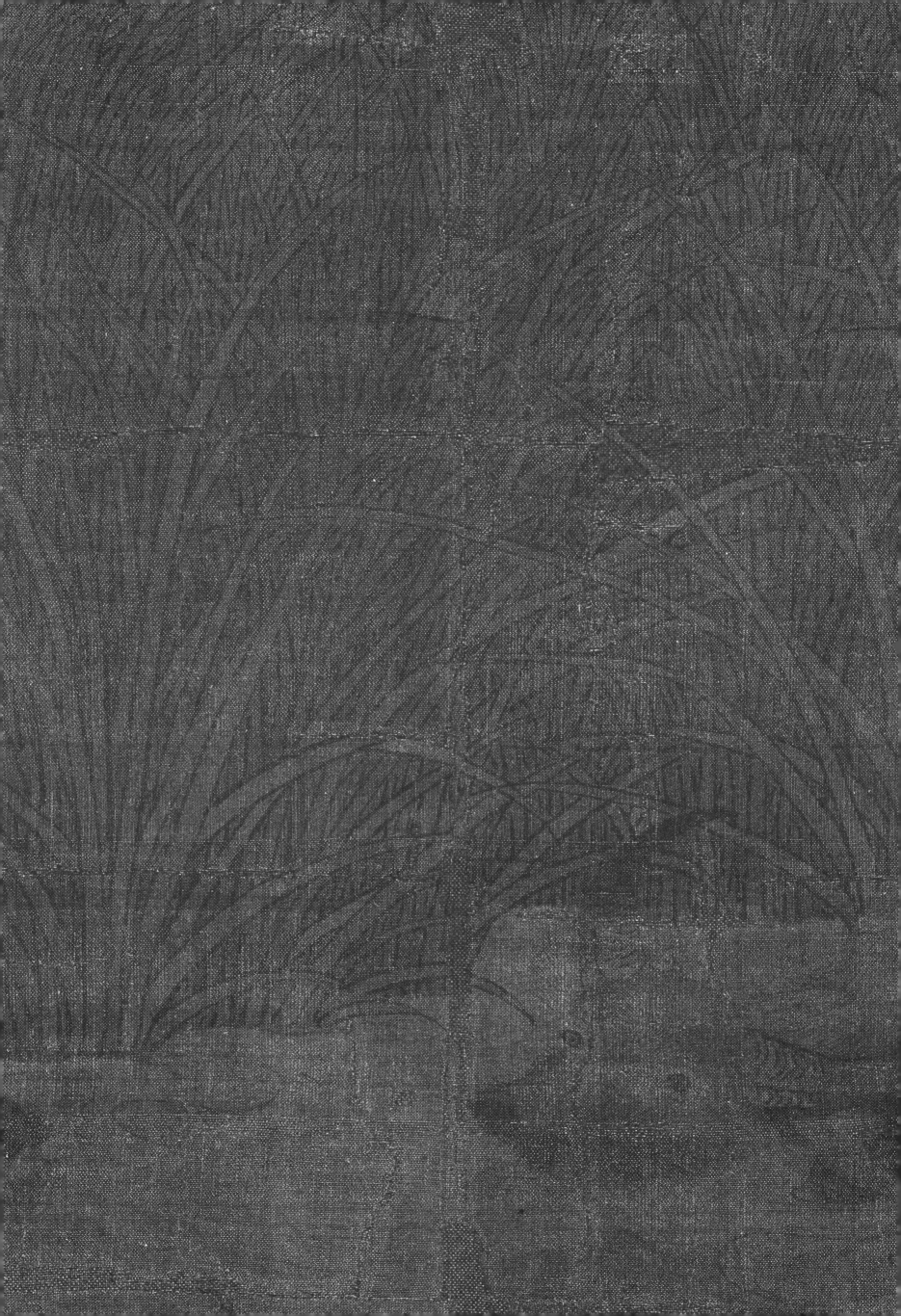

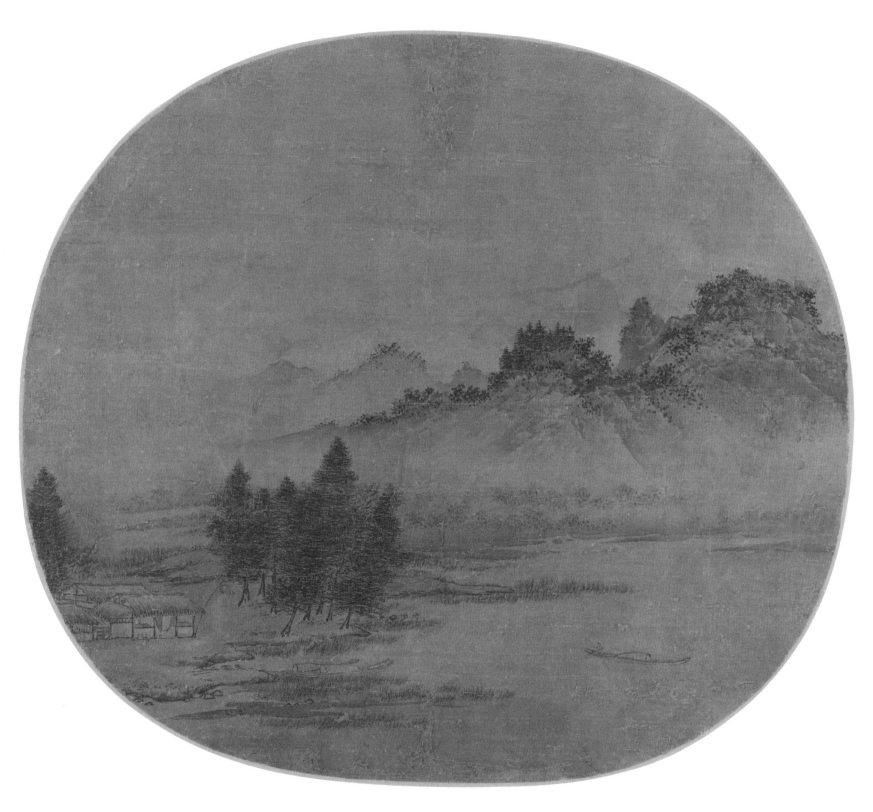

新147424 6/12

宋 佚名
水村烟霭图页

56 | 绢本 纵23.6厘米 横25.3厘米

Xin147424 6/12

Anonymous, Song dynasty
Waterside Village in Mist

Album leaf, silk
23.6 × 25.3 cm

128

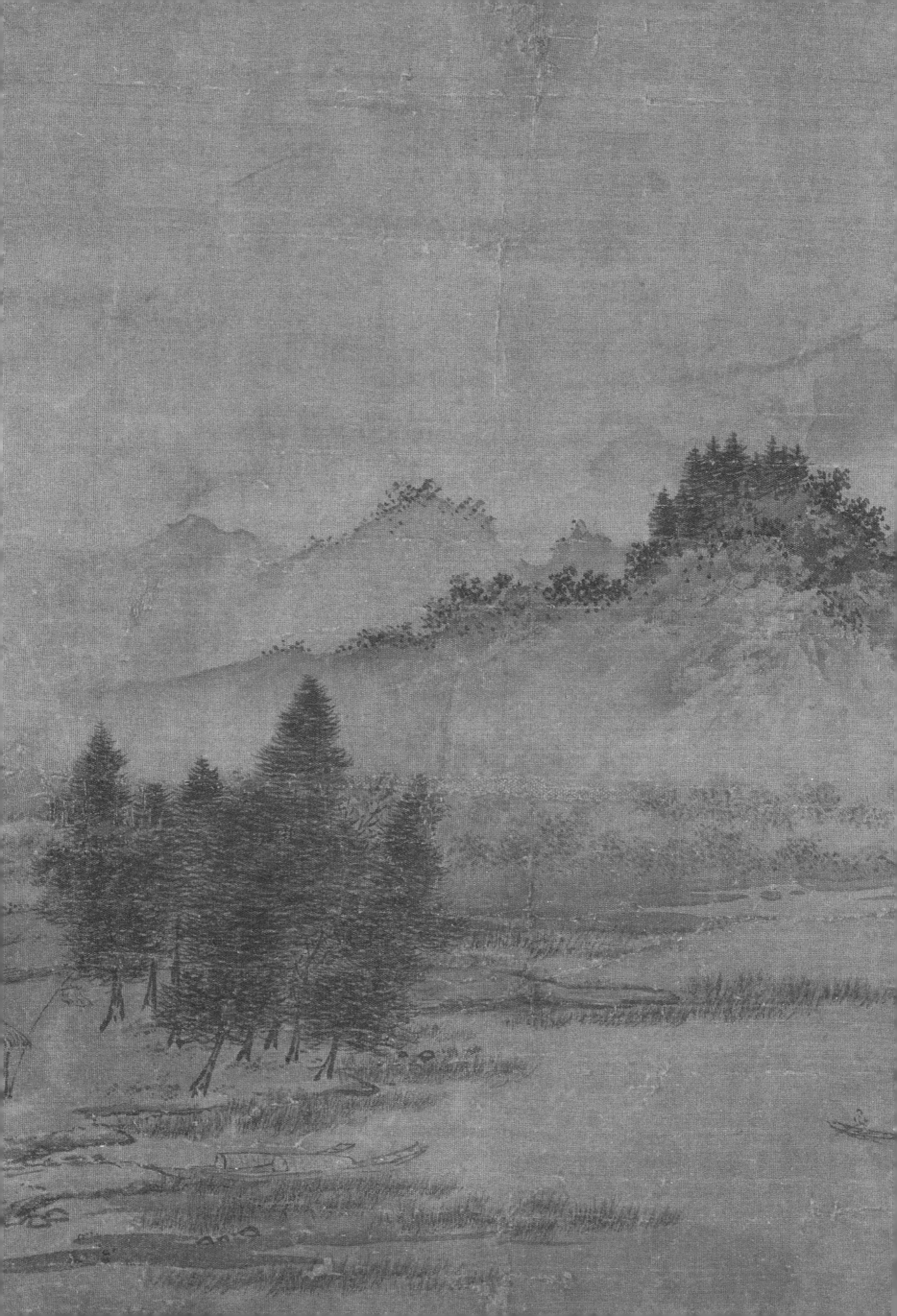

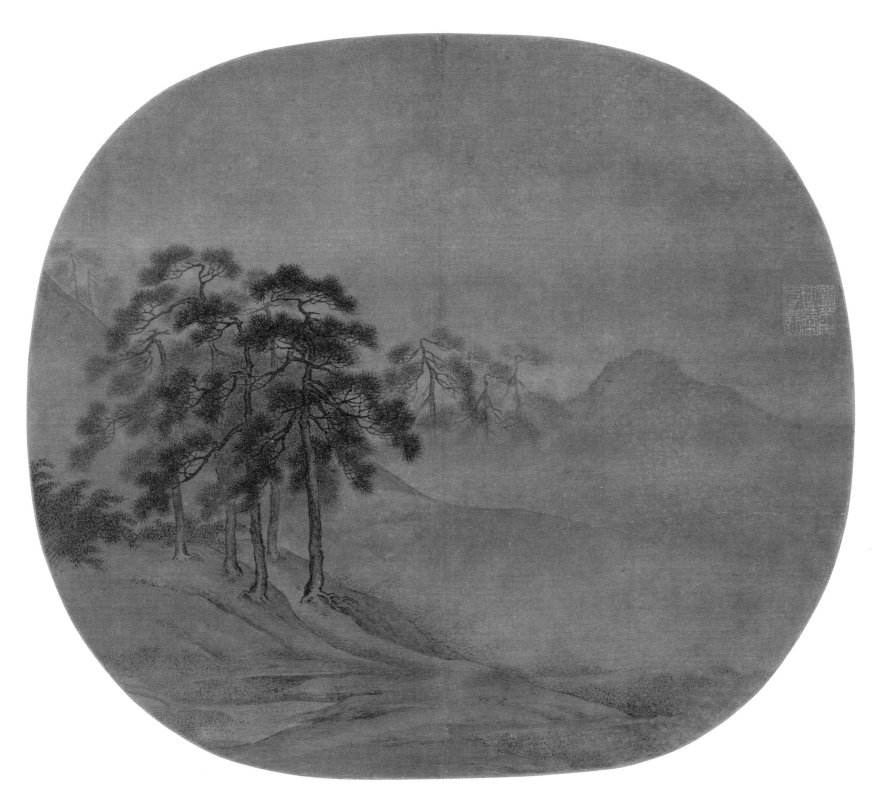

新147427 5/10

宋 佚名
松冈暮色图页

绢本 纵24.1厘米 横25.9厘米

57

Xin147427 5/10

Anonymous, Song dynasty
Pines at Twilight

Album leaf, silk
24.1 × 25.9 cm

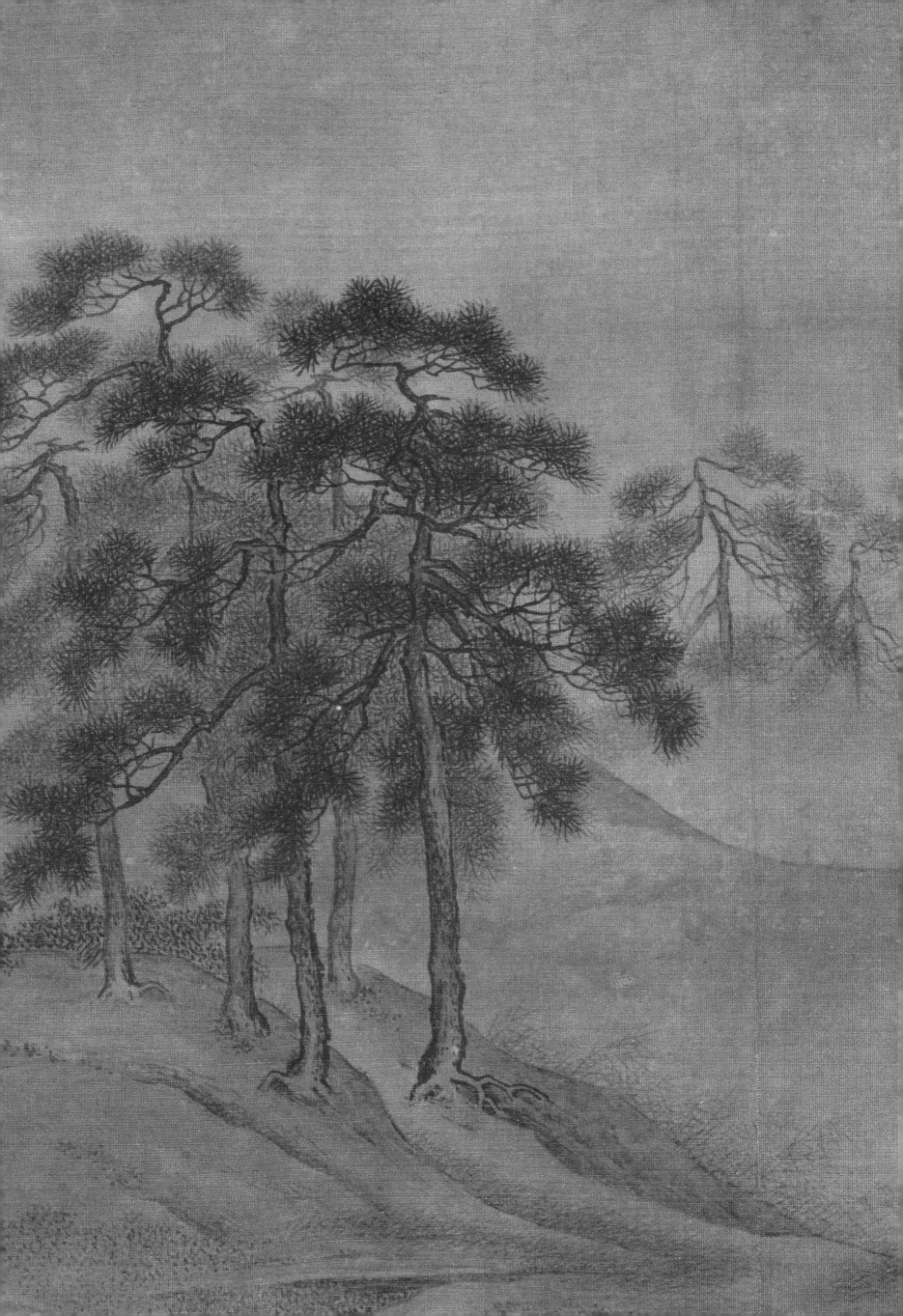

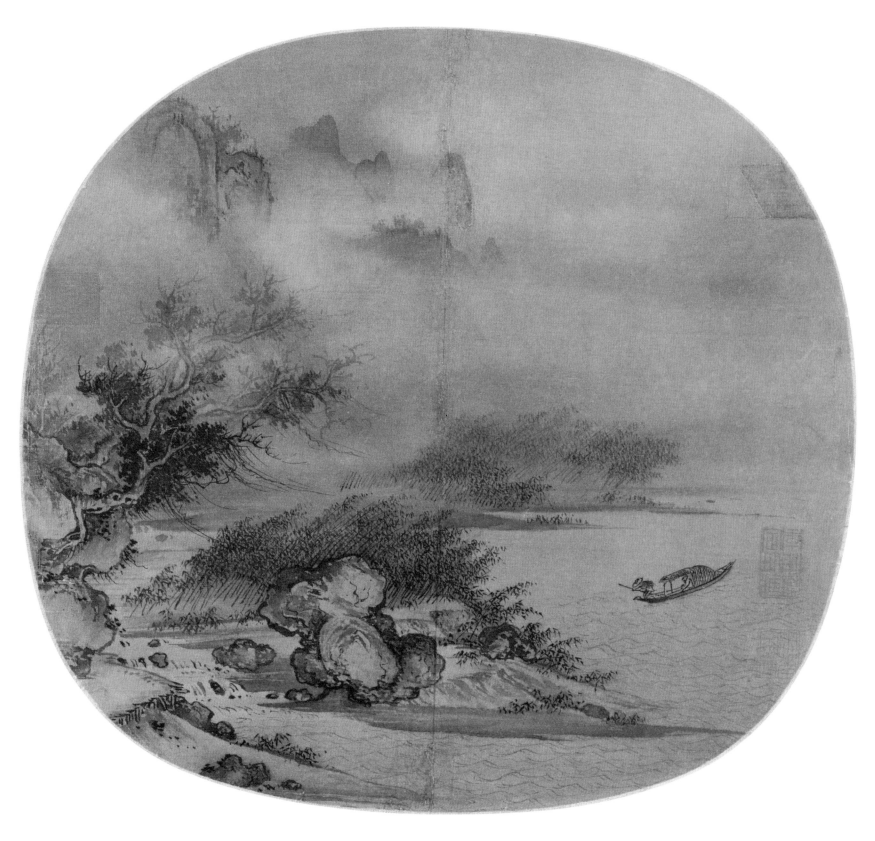

新147424 4/12

宋 佚名
风雨归舟图页
58 | 绢本 纵25.6厘米 横26.2厘米

Xin147424 4/12
Anonymous, Song dynasty
Boat Returning in a Rainstorm
Album leaf, silk
25.6 × 26.2 cm

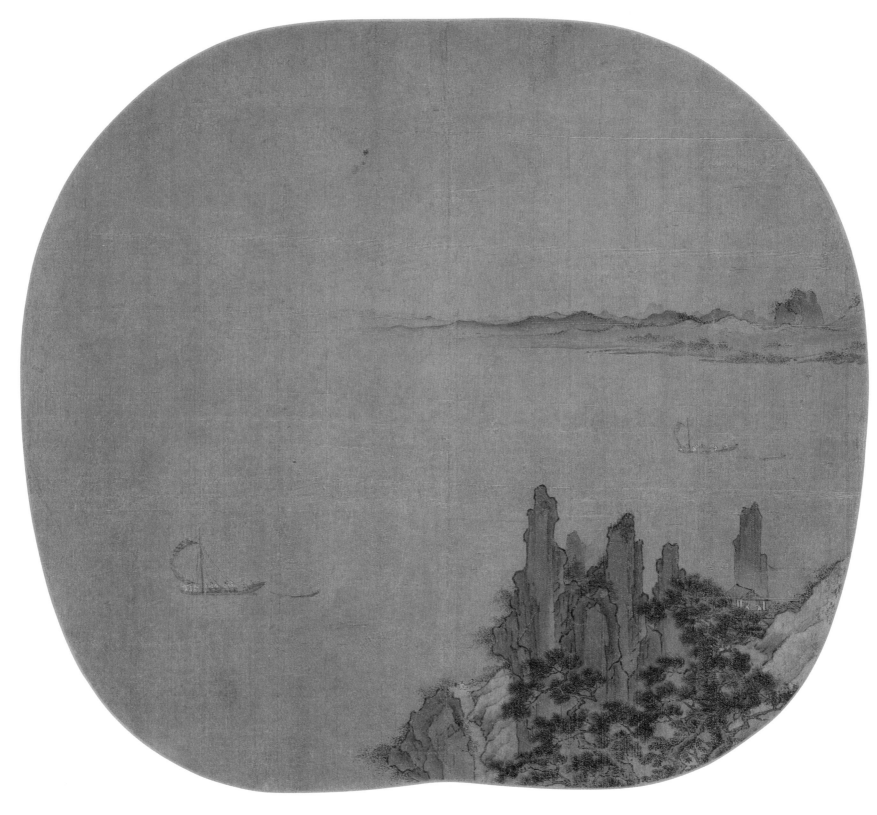

新147501

宋 佚名
江上青峰图页

59 | 绢本　纵24.5厘米　横26.2厘米

Xin147501

Anonymous, Song dynasty
Verdant Peaks by a River
Album leaf, silk
24.5 × 26.2 cm

郭熙春江帆饱

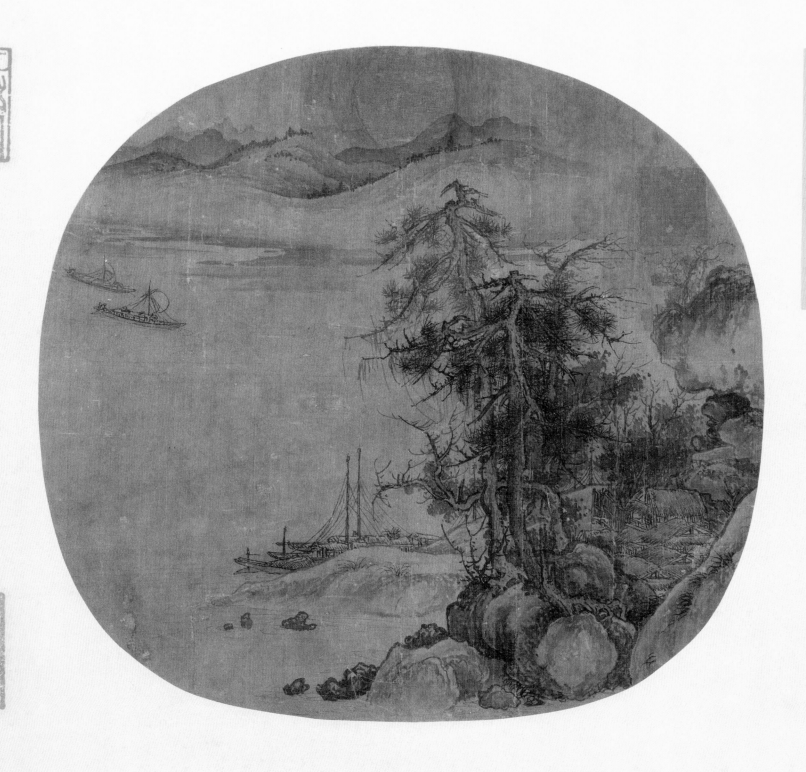

新6150 6/10

宋 佚名
春江帆饱图页

60 | 绢本 纵25.8厘米 横27厘米

Xin6150 6/10

Anonymous, Song dynasty
Full Sails on Spring River

Album leaf, silk
25.8 × 27 cm

春水放舟

舟去帆趣潮游

可知事逢順須念

盛當憂盡有具深

意觀無待遠求神

登誠獨出証止

法譽丘

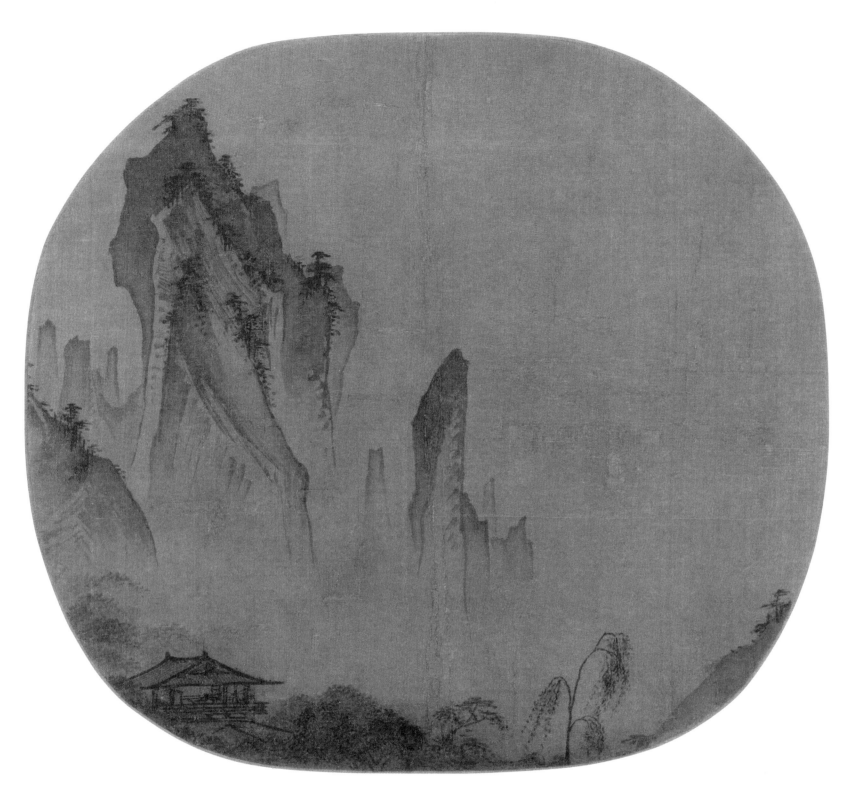

新147427 1/12

宋 佚名
山腰楼观图页

61 | 绢本　纵23.7厘米　横22.6厘米

Xin147427 1/12
Anonymous, Song dynasty
Pavilion in the Mountain
Album leaf, silk
23.7 × 22.6 cm

仙丹傳頂壽無涯

豈許蜉蝣浪得知

行到水邊尤可愛

立居松上更相宜

陽宋直殿

137

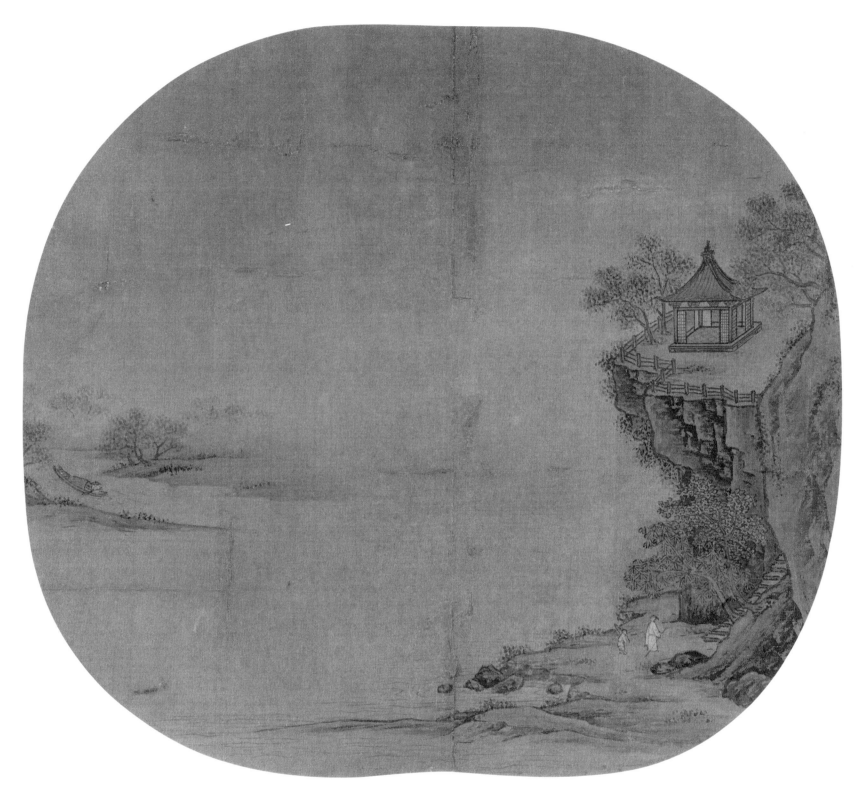

新147425 8/12

宋 佚名
木末孤亭图页

62 │ 绢本　纵23.3厘米　横24.6厘米

Xin147425 8/12

Anonymous, Song dynasty
Lofty Pavilion in the Woods

Album leaf, silk
23.3 × 24.6 cm

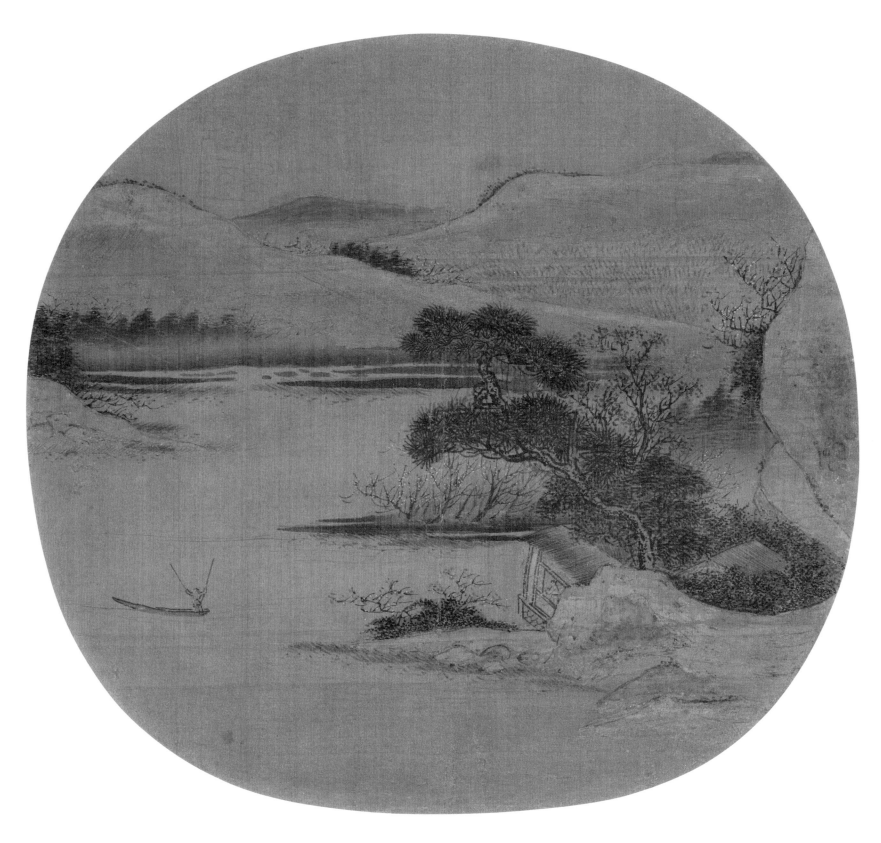

新147425 11/12

宋 佚名
春山渔艇图页

63 绢本　纵21厘米　横21.5厘米

Xin147425 11/12

Anonymous, Song dynasty
Fishing Boat in Spring Mountains
Album leaf, silk
21 × 21.5 cm

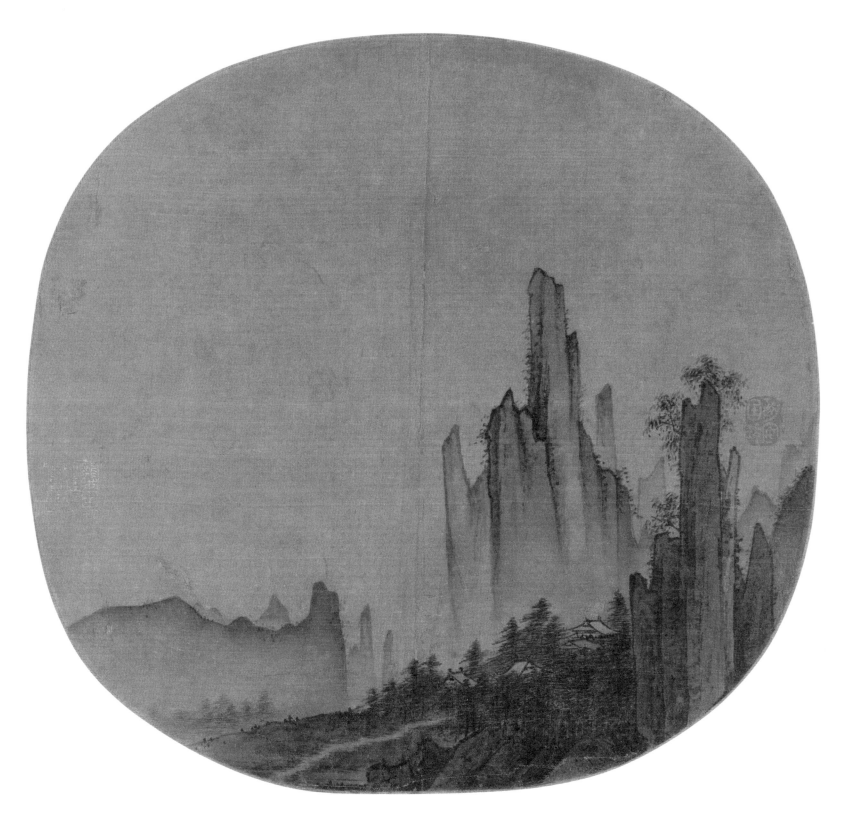

新147427 4/10

宋 佚名
五云楼阁图页

64 | 绢本　纵23.2厘米　横23.2厘米

Xin147427 4/10
Anonymous, Song dynasty
Mountain Peaks in Clouds
Album leaf, silk
23.2 × 23.2 cm

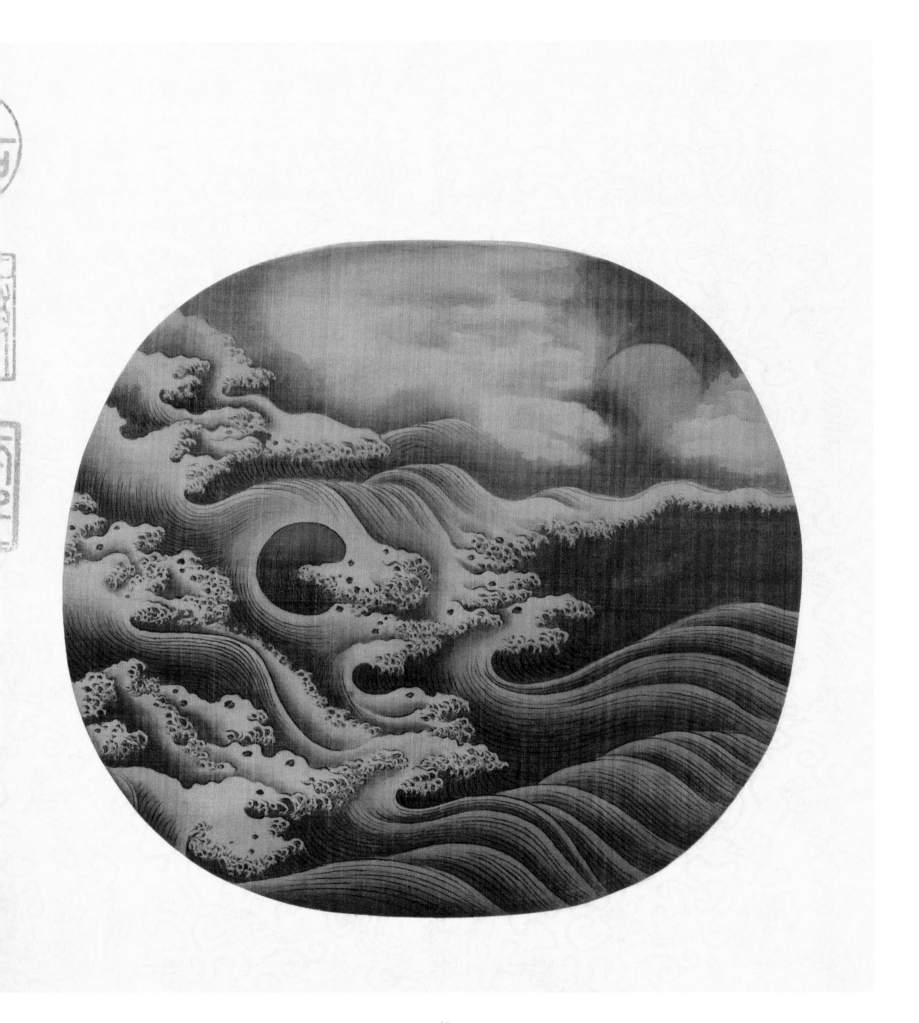

新147430 3/21

宋 佚名
沧溟涌日图页

65 | 绢本　纵23.4厘米　横24.7厘米

Xin147430 3/21

Anonymous, Song dynasty
Sunrise at Sea

Album leaf, silk
23.4 × 24.7 cm

溶滴望無
極連雲漾赤輪
榑桑定何處少海
波波泯際濱壛墻
不獲賞端拱豈
知人

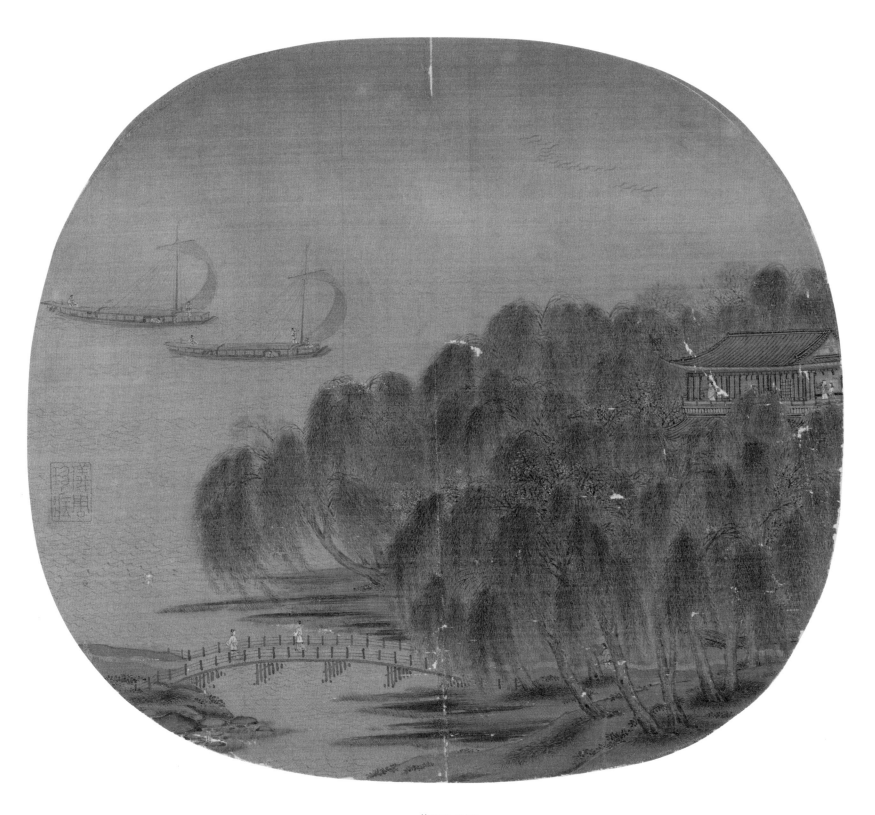

故6158 16/16

宋 佚名
柳阁风帆图页

66 | 绢本　纵25.2厘米　横26.7厘米

Gu6158 16/16

Anonymous, Song dynasty
Willow Pavilion and Wind-filled Sails

Album leaf, silk
25.2 × 26.7 cm

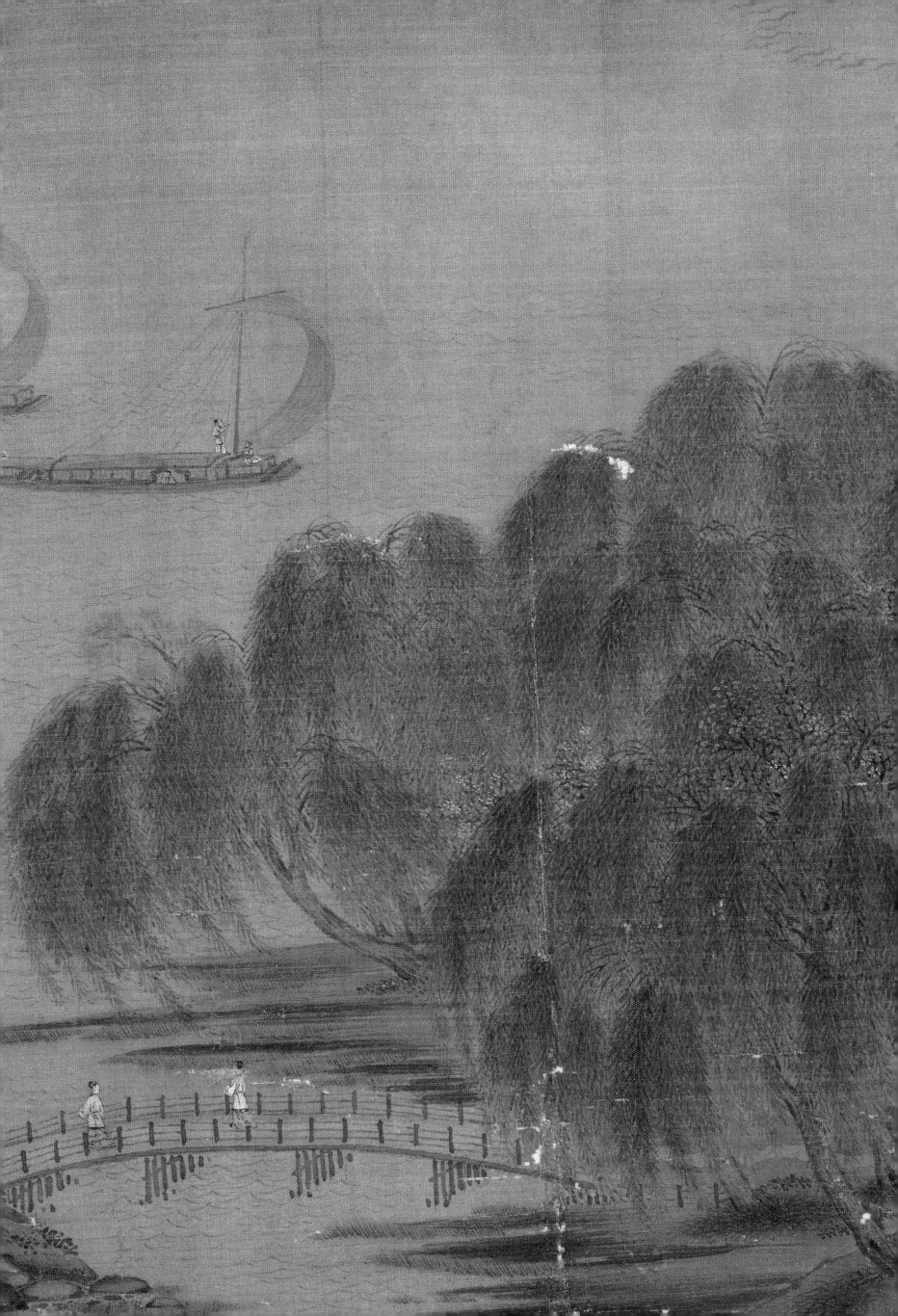

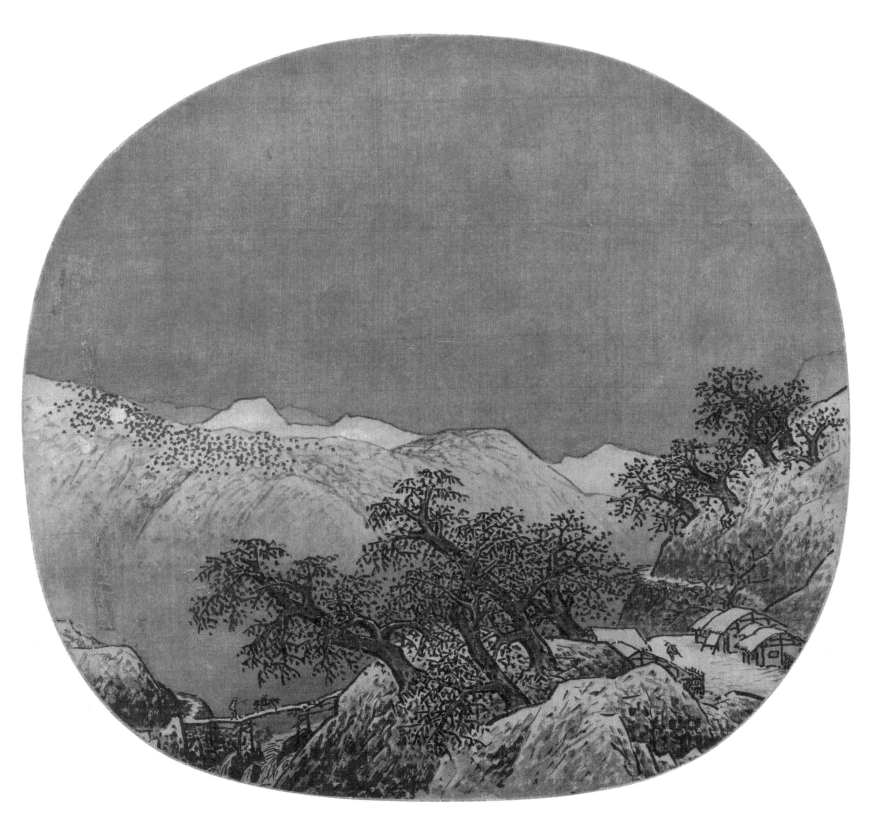

新13845 6/15

宋 佚名
云关雪栈图页

67 | 绢本　纵25.2厘米　横26.5厘米

Xin13845 6/15

Anonymous, Song dynasty
Cantilevered Roads in Snow-covered Mountain
Album leaf, silk
25.2 × 26.5 cm

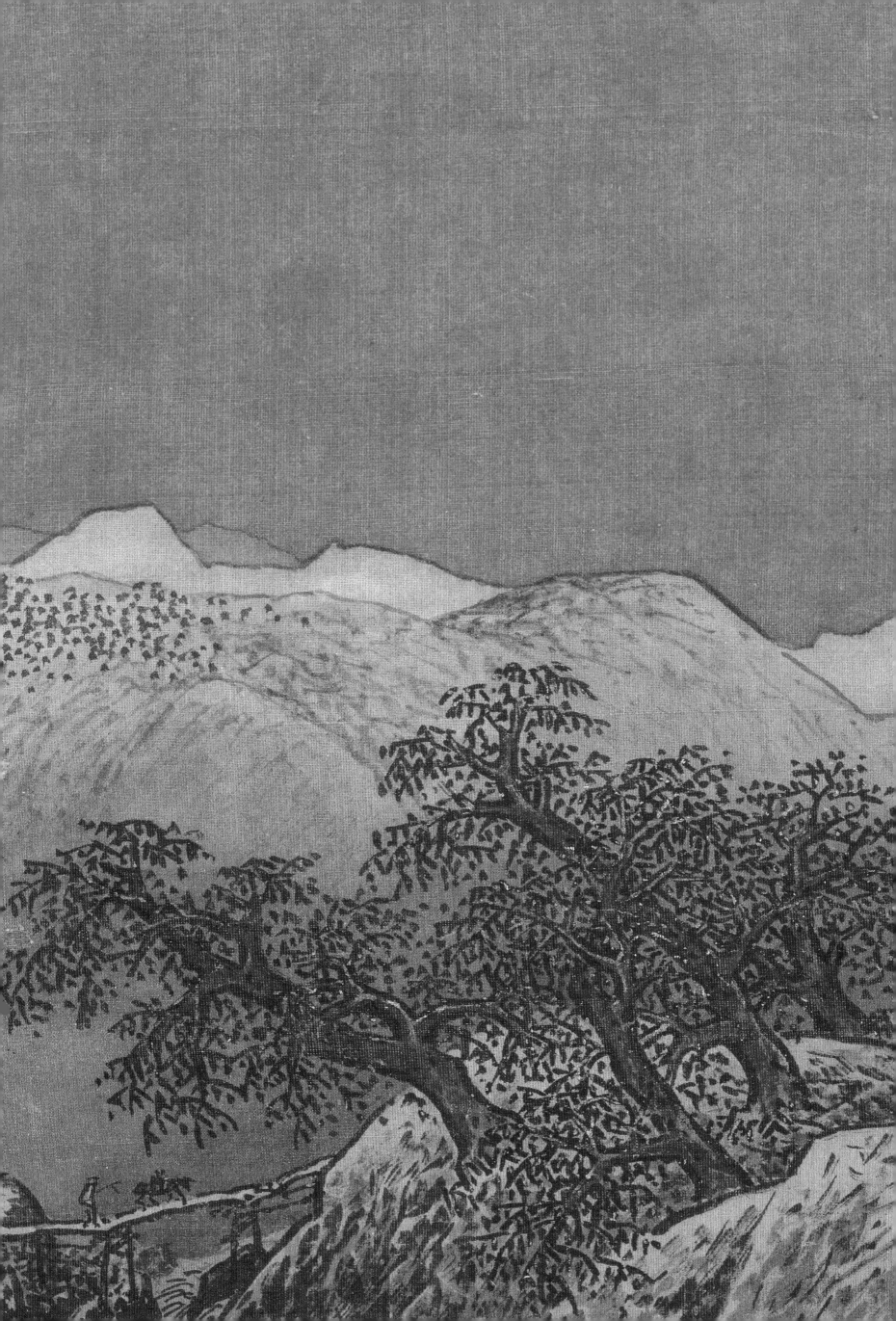

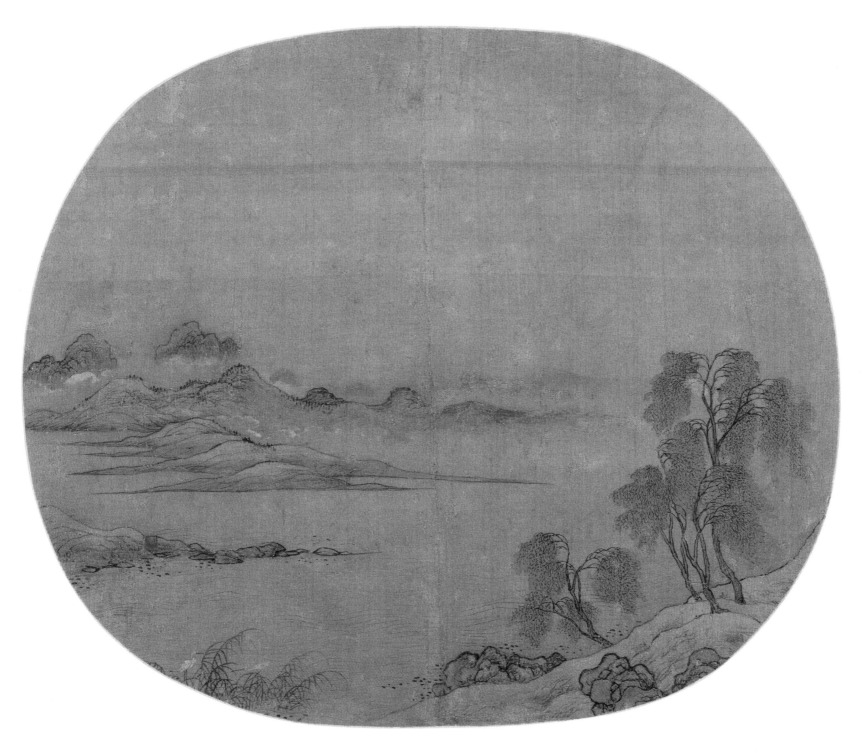

新17779 5/20

宋 佚名
柳溪春色图页

68 | 绢本 纵22厘米 横24.8厘米

Xin17779 5/20

Anonymous, Song dynasty
Willow Stream in Spring

Album leaf, silk
22 × 24.8 cm

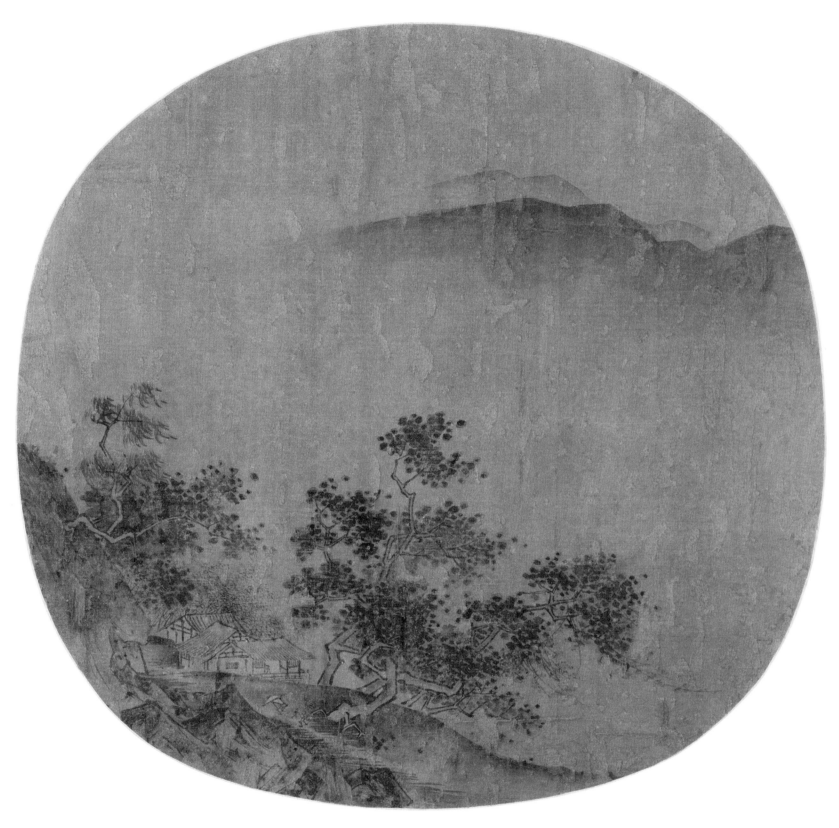

新17779 14/20

宋 佚名
山水人物图页

69 绢本 纵25.3厘米 横25.3厘米

Xin17779 14/20

Anonymous, Song dynasty
Landscape and Figure
Album leaf, silk
25.3 × 25.3 cm

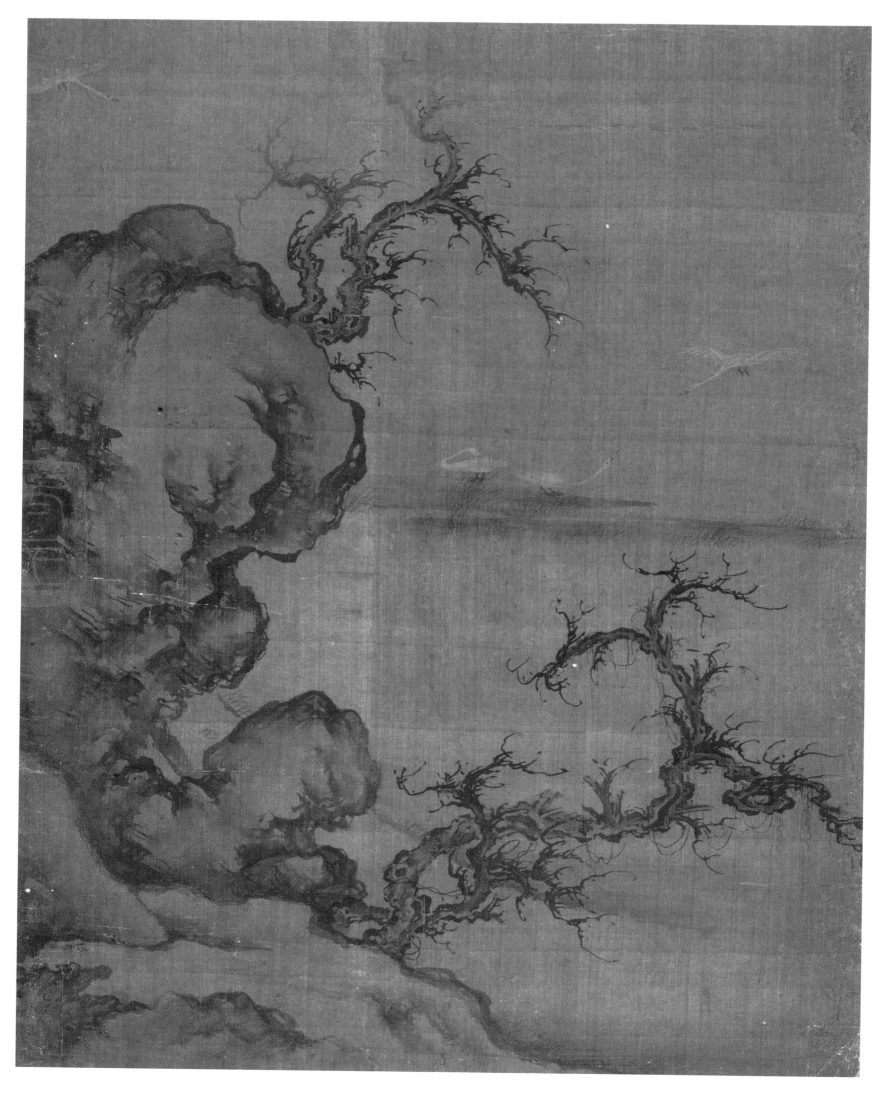

新147305

宋 佚名
岩桧图页

70 | 绢本　纵50.5厘米　横39.2厘米

Xin147305

Anonymous, Song dynasty
Juniper on Cliff
Album leaf, silk
50.5 × 39.2 cm

新119841

宋 佚名
山水图页

71 绢本　纵23厘米　横24.8厘米

Xin119841
Anonymous, Song dynasty
Landscape
Album leaf, silk
23 × 24.8 cm

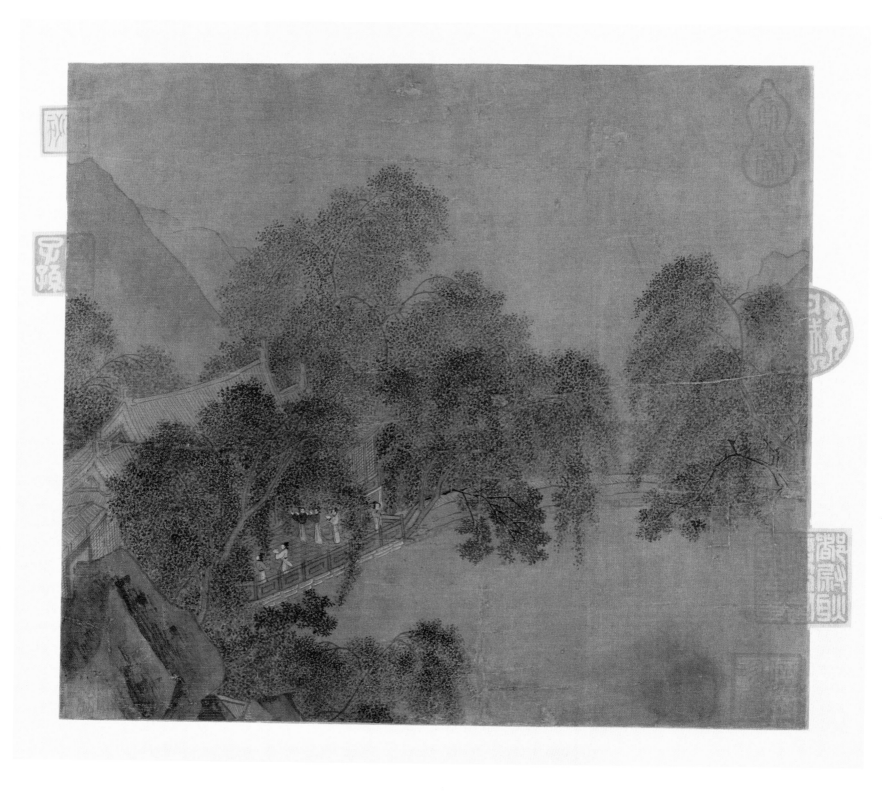

新13844 3/14

宋 佚名
杨柳溪堂图页

72 | 绢本　纵22.5厘米　横24.5厘米

Xin13844 3/14
Anonymous, Song dynasty
Living in the Shade of Willows
Album leaf, silk
22.5 × 24.5 cm

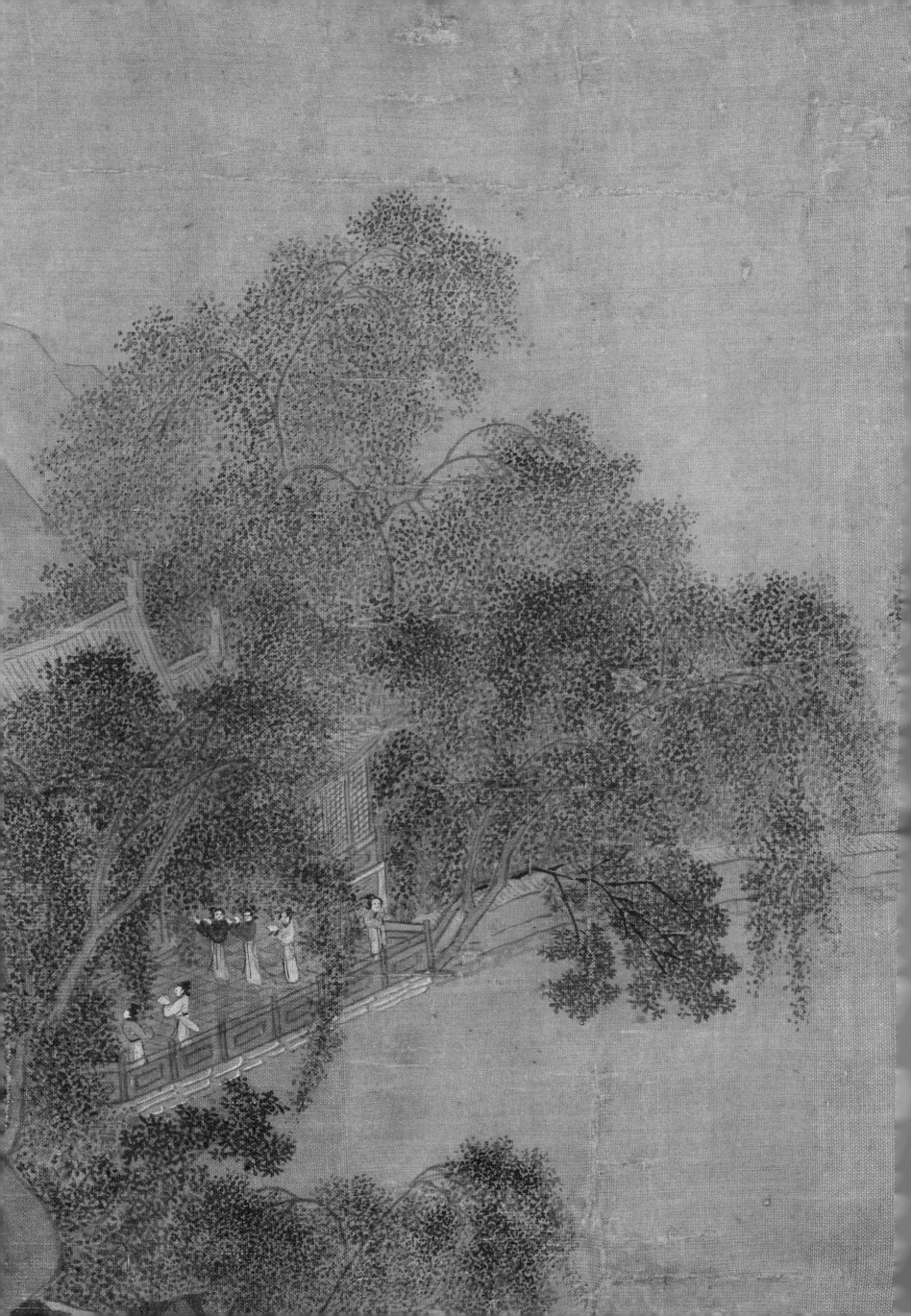

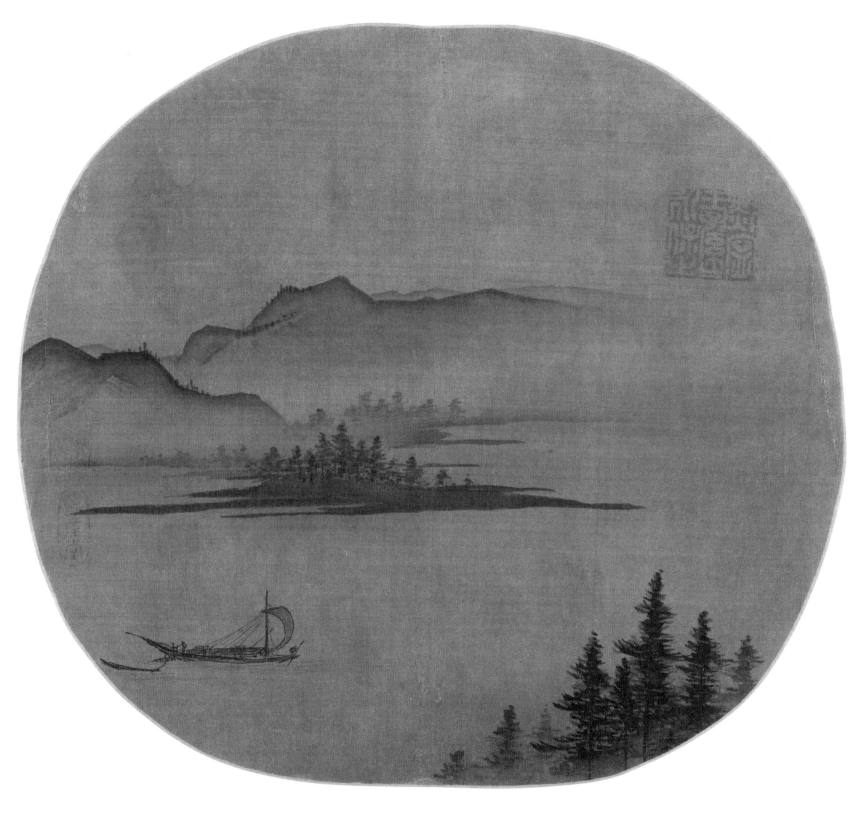

新156347

宋 佚名
清溪风帆图页

73　绢本　纵24.6厘米　横25.6厘米
Xin156347
Anonymous, Song dynasty
Sailing on Clear Stream
Album leaf, silk
24.6 × 25.6 cm

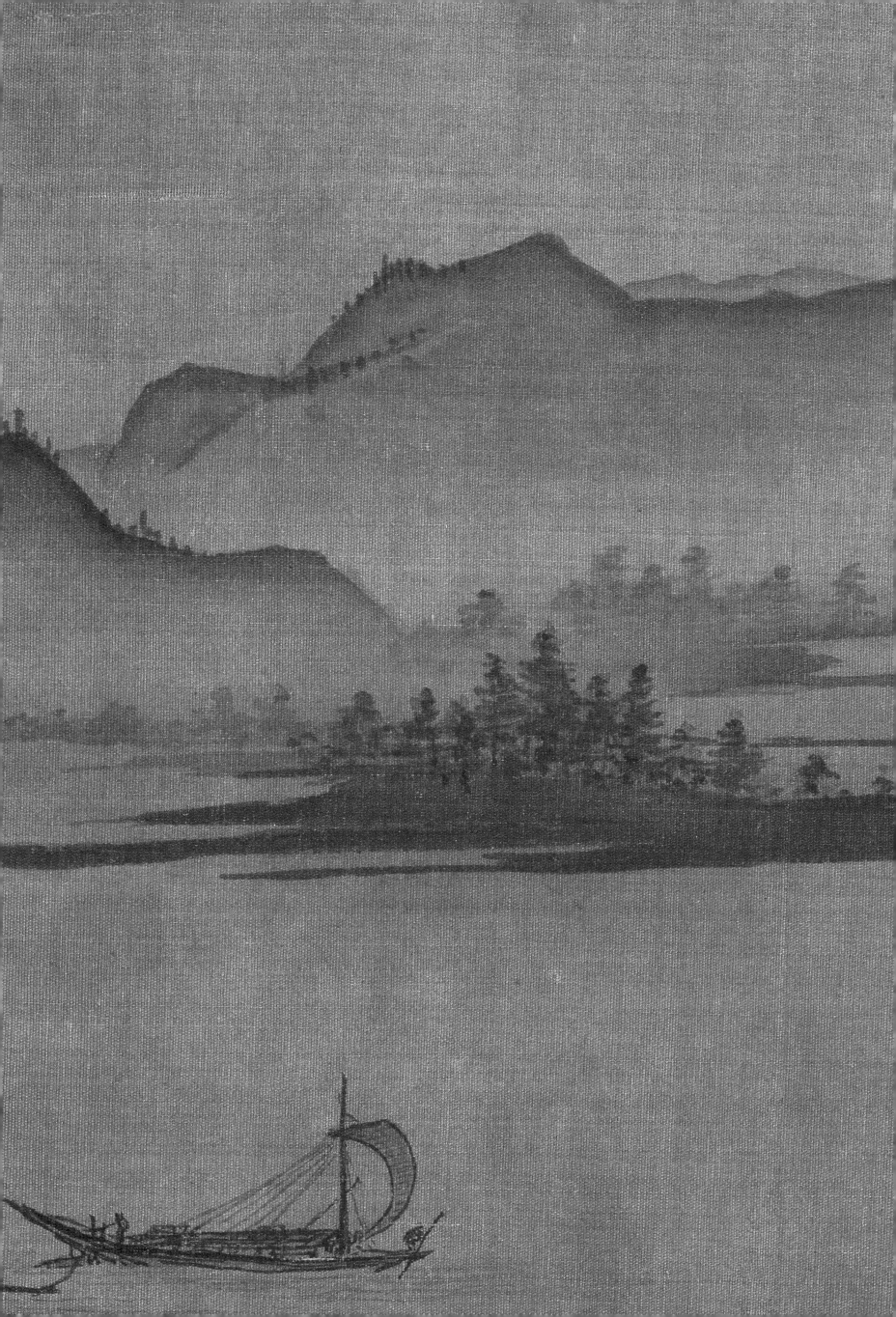

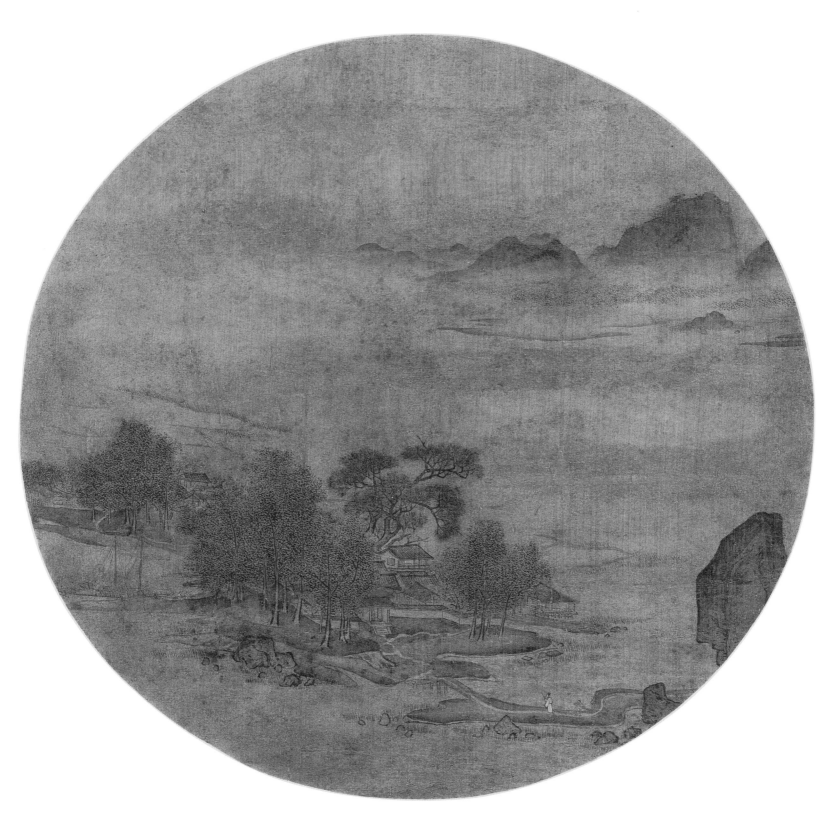

新17779 7/20

宋 佚名
水村楼阁图页

74

绢本　纵23.5厘米　横23.5厘米

Xin17779 7/20

Anonymous, Song dynasty
Waterside Village

Album leaf, silk
23.5 × 23.5 cm

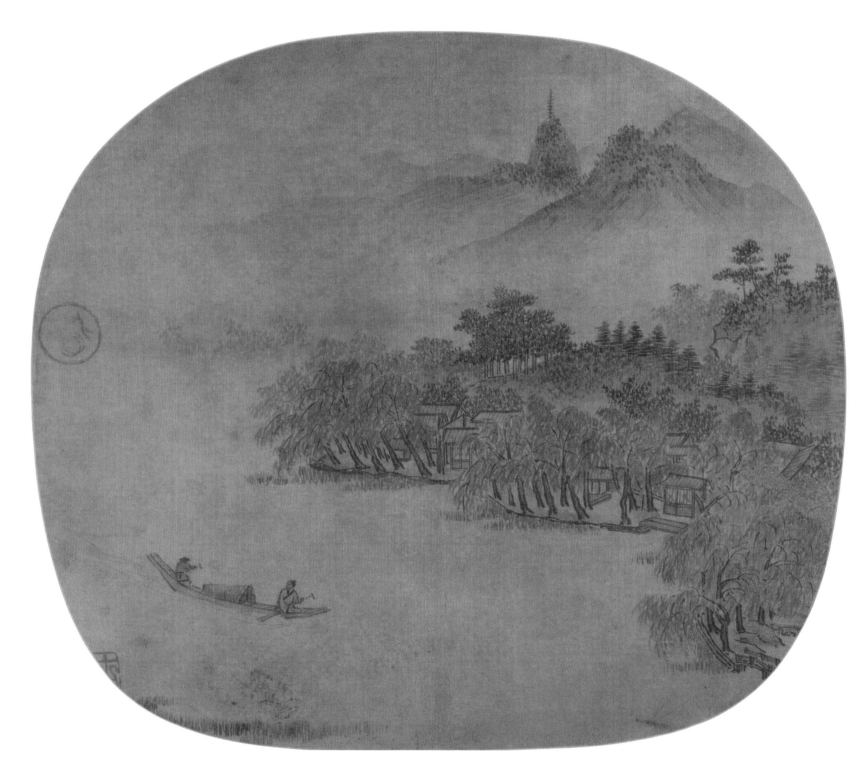

新147502

宋 佚名
西湖春晓图页

75 | 绢本　纵23.6厘米　横25.8厘米
Xin147502

Anonymous, Song dynasty
West Lake in the Early Morning
Album leaf, silk
23.6 × 25.8 cm

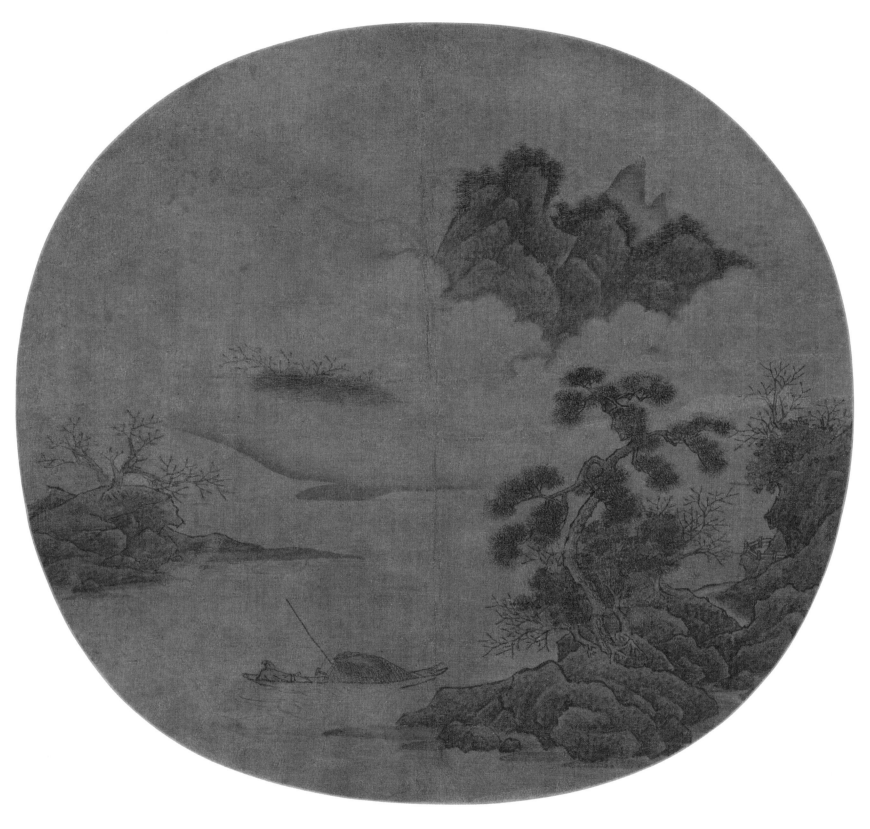

新147503

宋 佚名

松溪放艇图页

76 | 绢本　纵24.6厘米　横25.5厘米

Xin147503

Anonymous, Song dynasty
Boating on a Stream with Pines on the Bank
Album leaf, silk
24.6 × 25.5 cm

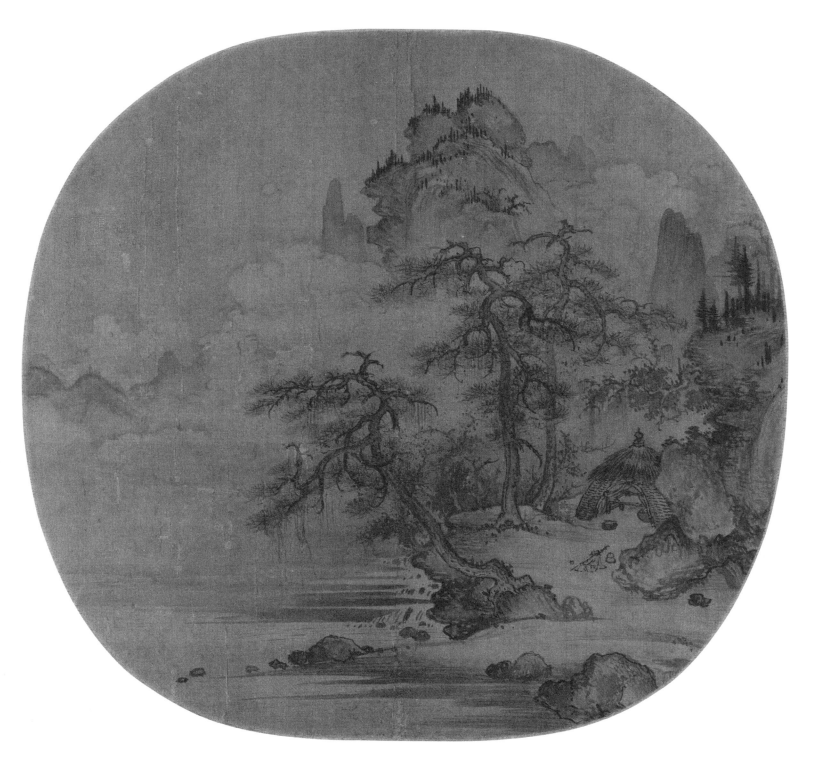

新147427 8/12

宋 佚名
青山白云图页

77 | 绢本 纵22.9厘米 横23.9厘米
Xin147427 8/12
Anonymous, Song dynasty
Green Mountains, White Clouds
Album leaf, silk
22.9 × 23.9 cm

青山曉兮白雲飛
青山暮兮白雲歸
青松茂兮明月輝
了不了兮誰得知

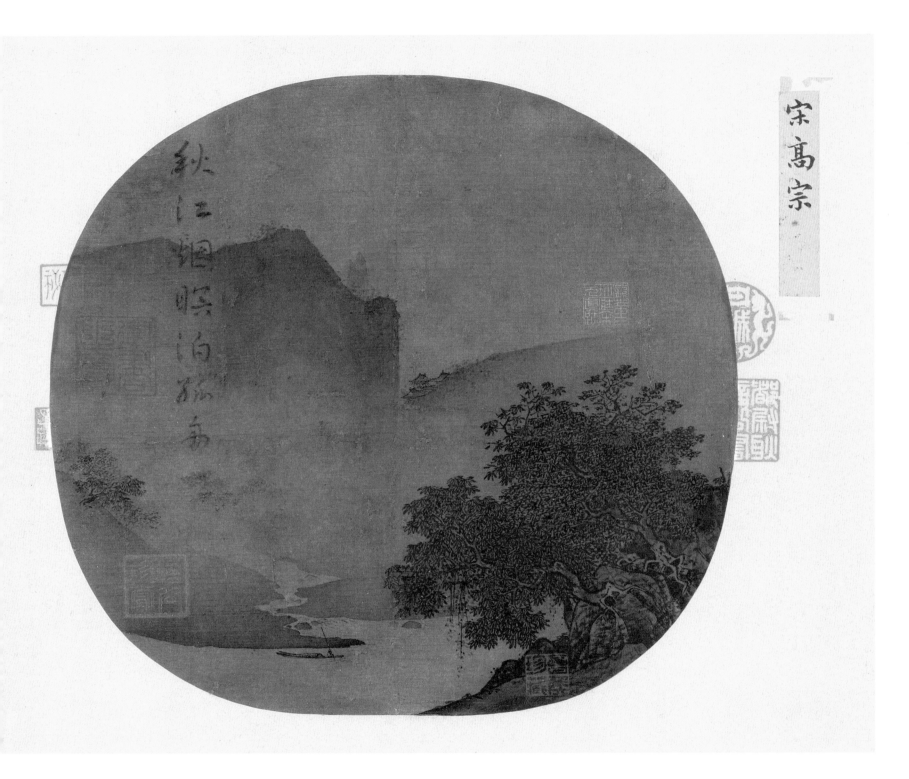

高宗画意趣天成尺幅中能曠

遠綿邈極晦明隱顯之態誠画

院諸人所不能逮題識炳然尤

稱神品

襄平耿昭忠書

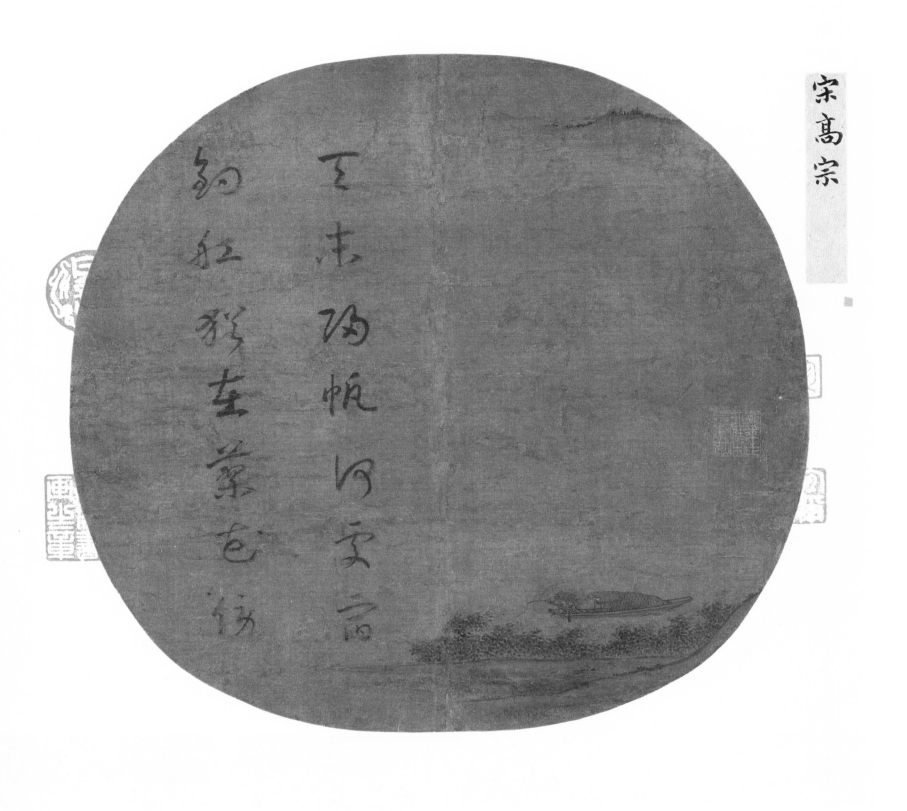

新147426 7/14

宋 佚名
天末归帆图页

79 绢本　纵25.5厘米　横24.2厘米
Xin147426 7/14

Anonymous, Song dynasty
Boat Returning from Afar
Album leaf, silk
25.5 × 24.2 cm

清曠蕭疎其絶似抗羲之致由其脫畧毫楮筆愈簡而筆愈遠景愈少而意愈長如詩中淵明琴中賀若此磊磊拳一所能望見蓋宋高宗出其天縱游神筆墨之表胸中造化不覺勃勃腕間画家用意布置惟恐不多者視此能無自失　耿昭忠識

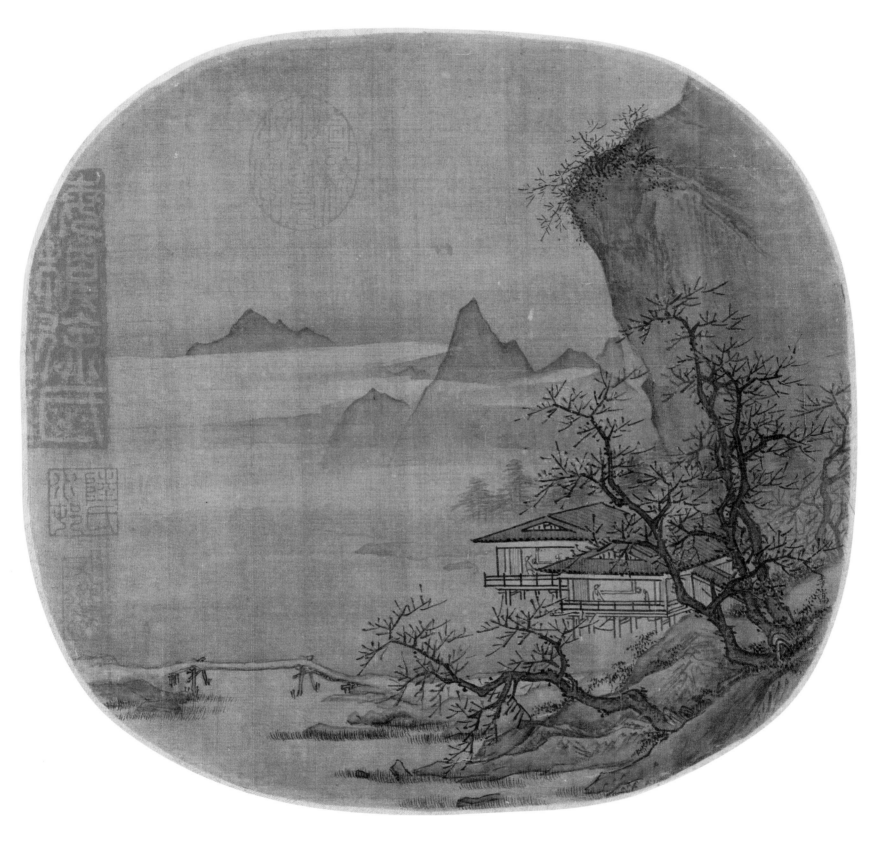

新147429 5/12

宋 佚名
溪山水阁图页

80 | 绢本　纵24.2厘米　横24.7厘米

Xin147429 5/12

Anonymous, Song dynasty
Waterside Pavilion at the Foot of Mountains
Album leaf, silk
24.2 × 24.7 cm

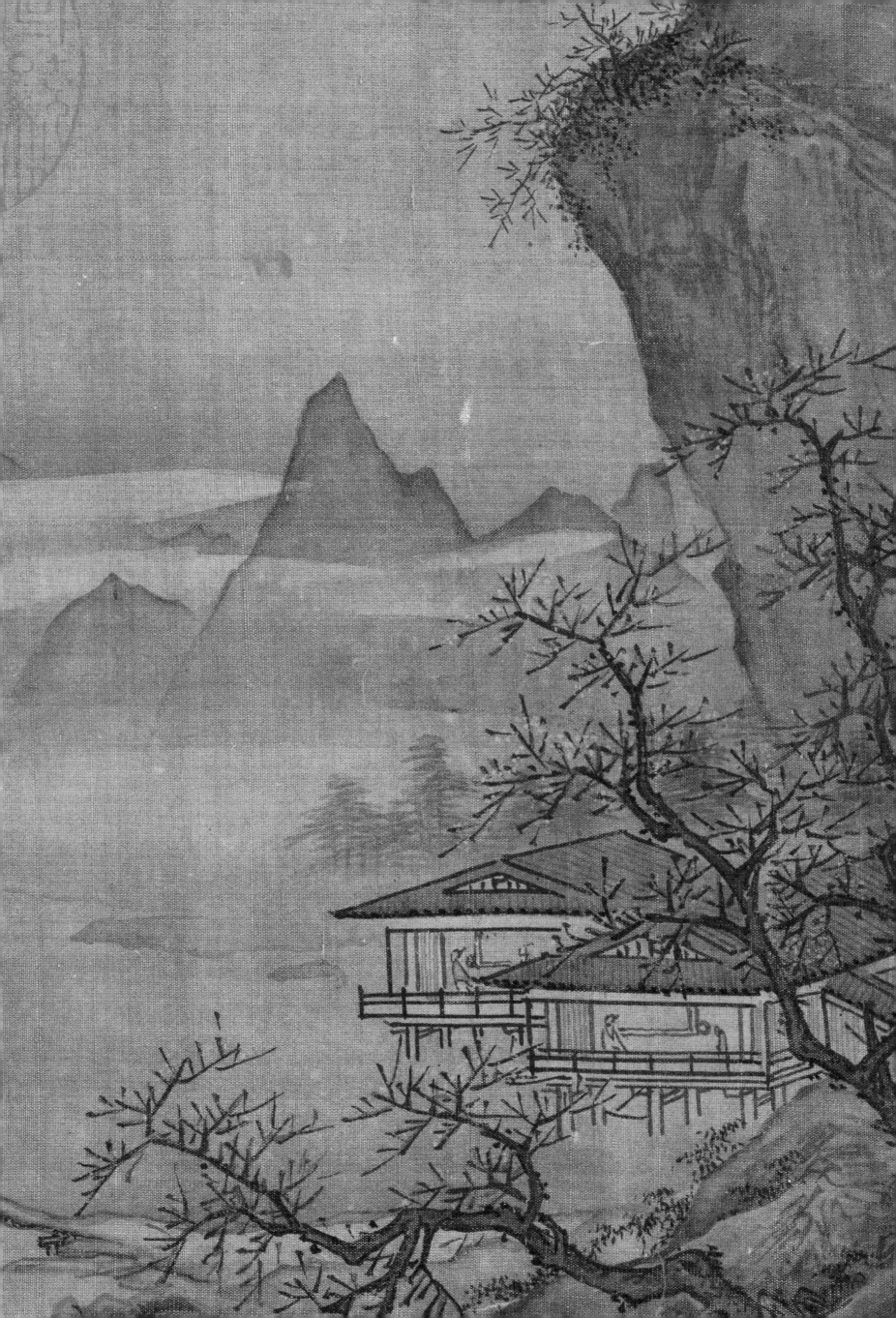

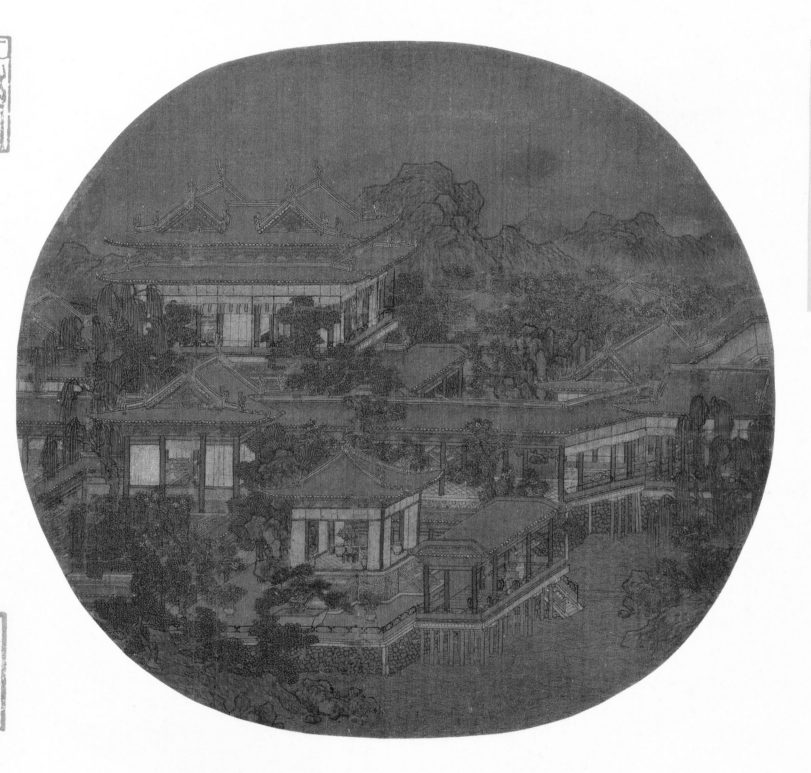

趙伯駒蓬瀛仙館

故6151 1/10
宋 佚名
蓬瀛仙館图页

81 | 绢本 纵26.4厘米 横27.9厘米
——————————————
Gu 6151 1/10
Anonymous, Song dynasty
Penglai Daoist Temple
Album leaf, silk
26.4 × 27.9 cm

參差仙
館頼蓬瀛臨水
依山風物清可
望不可即之霞
畫家別有寄深
情

新147424 11/12

宋 佚名
仙山楼阁图页

82 绢本　纵23厘米　横23.4厘米

Xin147424 11/12

Anonymous, Song dynasty
Palace on the Mountain of Immortals
Album leaf, silk
23 × 23.4 cm

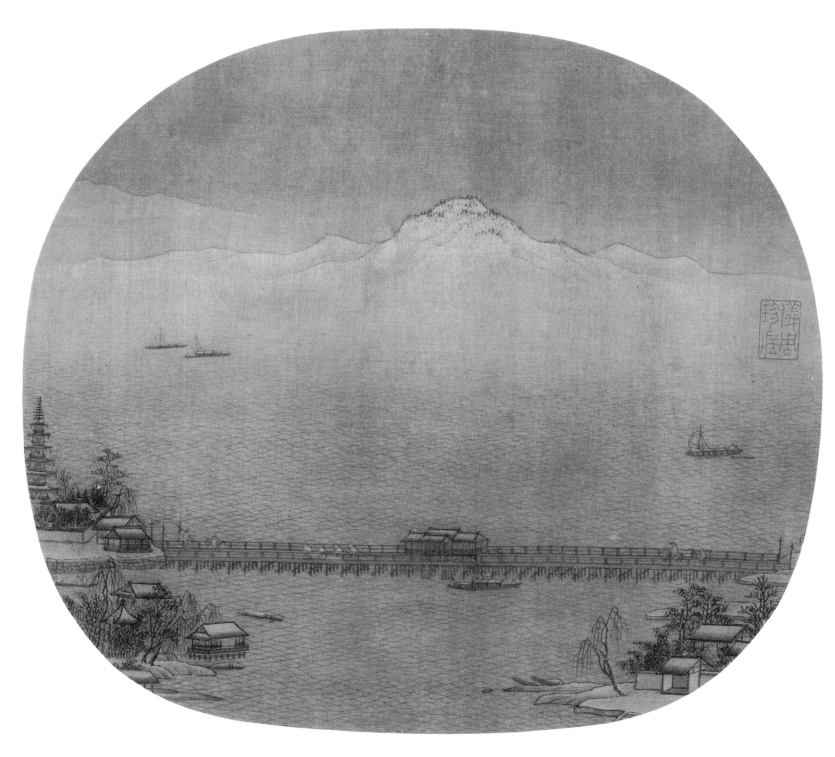

故6158 11/16

宋 佚名
长桥卧波图页

83 | 绢本 纵24厘米 横26.2厘米

Gu6158 11/16

Anonymous, Song dynasty
Long Bridge across a River
Album leaf, silk
24 × 26.2 cm

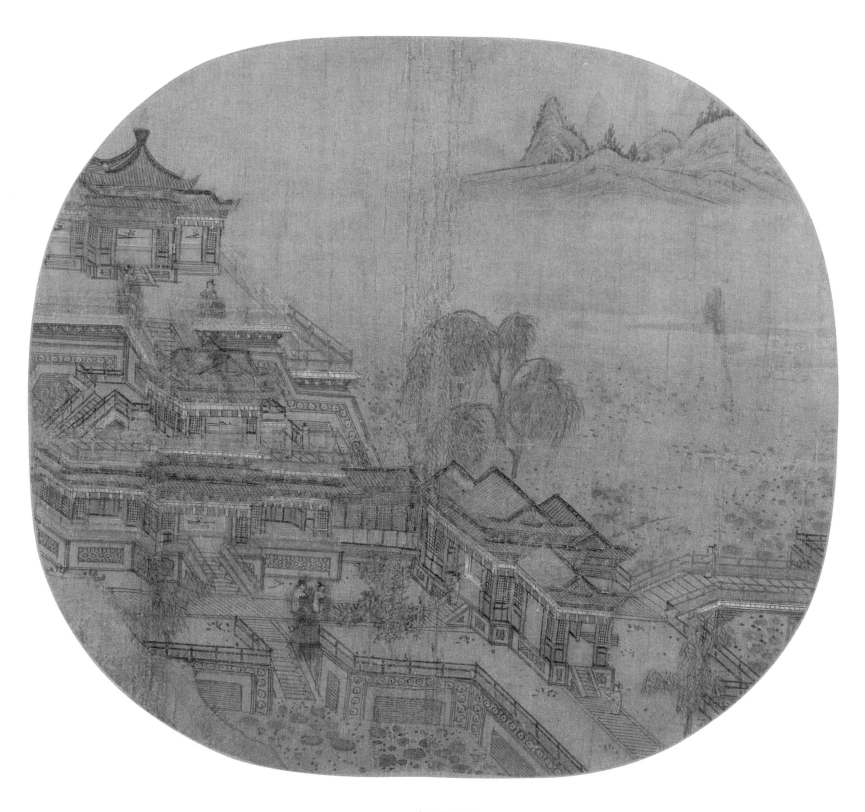

新17779 2/20

宋 佚名

江山殿阁图页

84 | 绢本　纵23.2厘米　横24.3厘米

Xin17779 2/20

Anonymous, Song dynasty
Waterside Palace

Album leaf, silk
23.2 × 24.3 cm

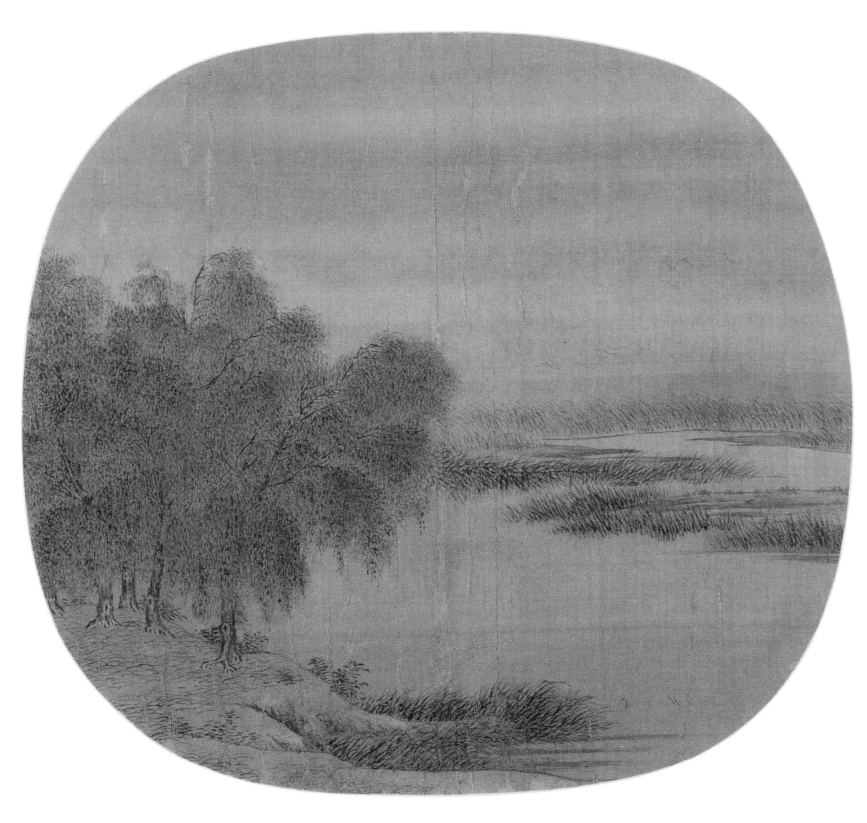

新17779 6/20

宋 佚名
柳塘秋草图页

85 | 绢本　纵23.4厘米　横24.2厘米

Xin17779 6/20
Anonymous, Song dynasty
Willow Pond and Autumn Grass
Album leaf, silk
23.4 × 24.2 cm

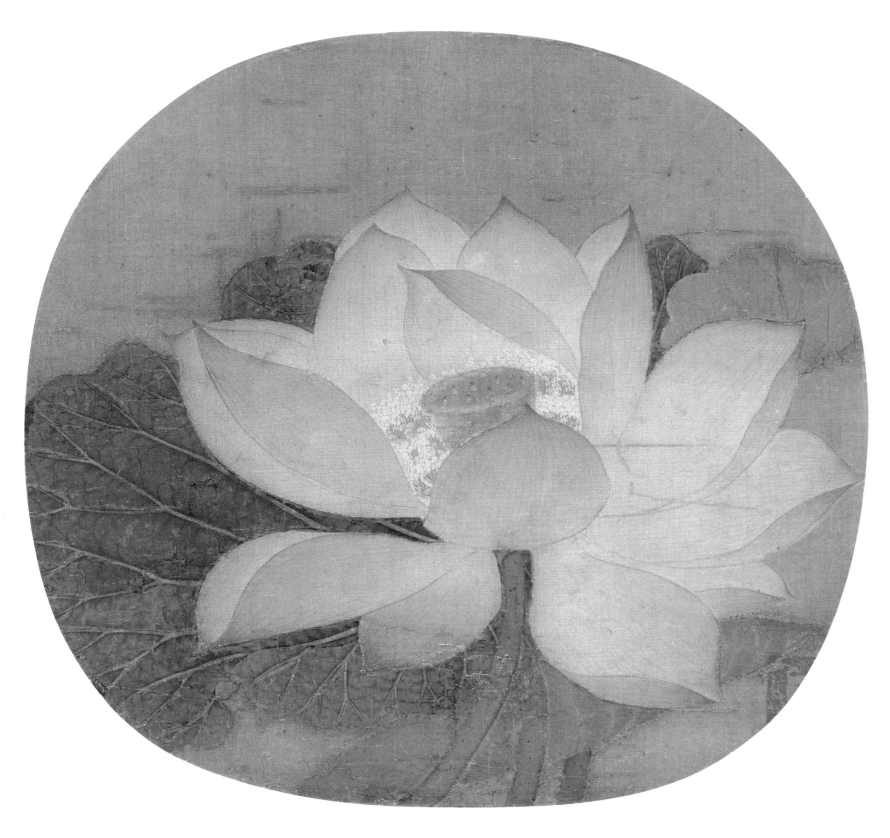

新1474265 3/12

宋 佚名
出水芙蓉图页

86 绢本　纵25厘米　横23.8厘米

Xin1474265 3/12
Anonymous, Song dynasty
Lotus in Bloom
Album leaf, silk
25 × 23.8 cm

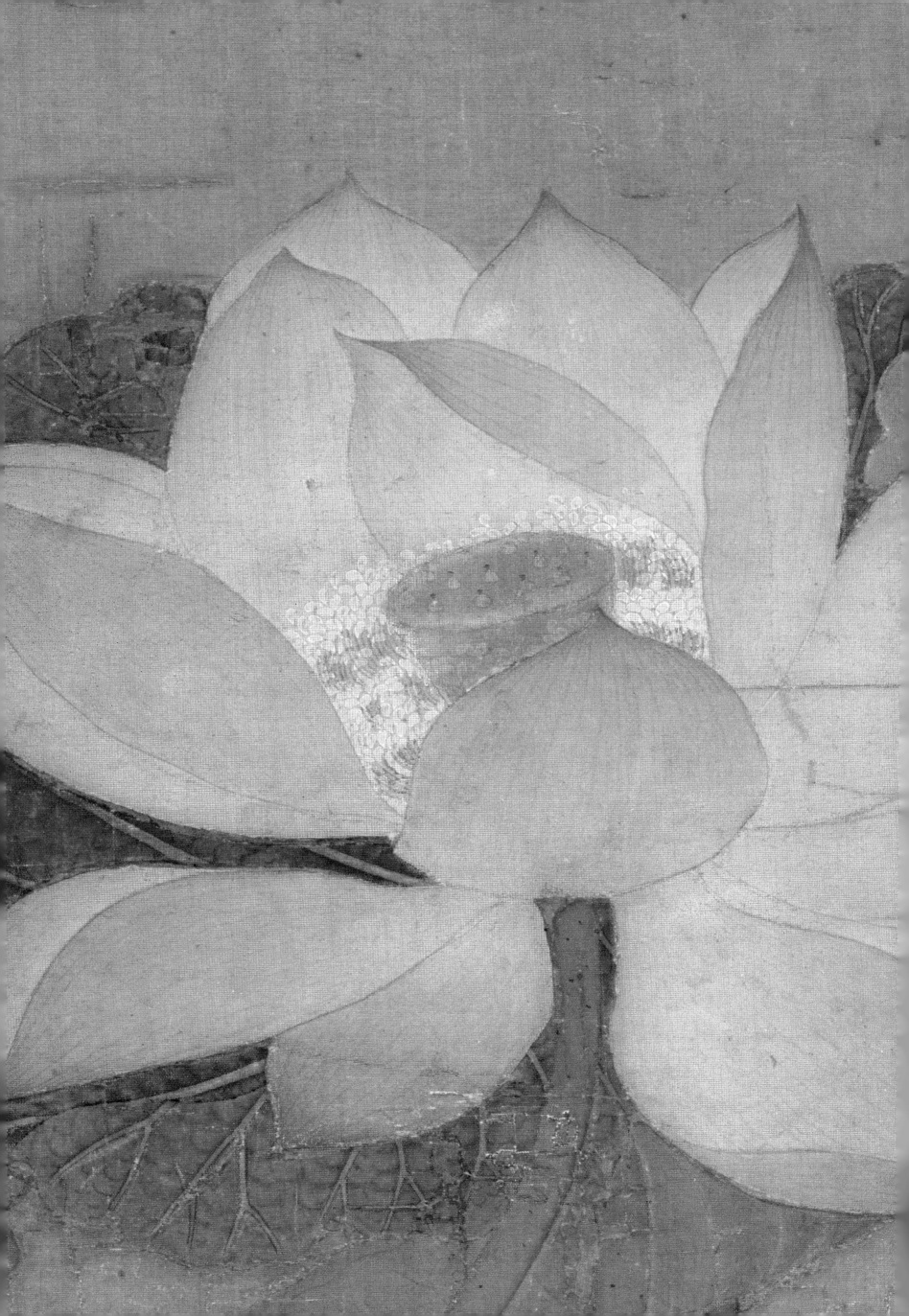

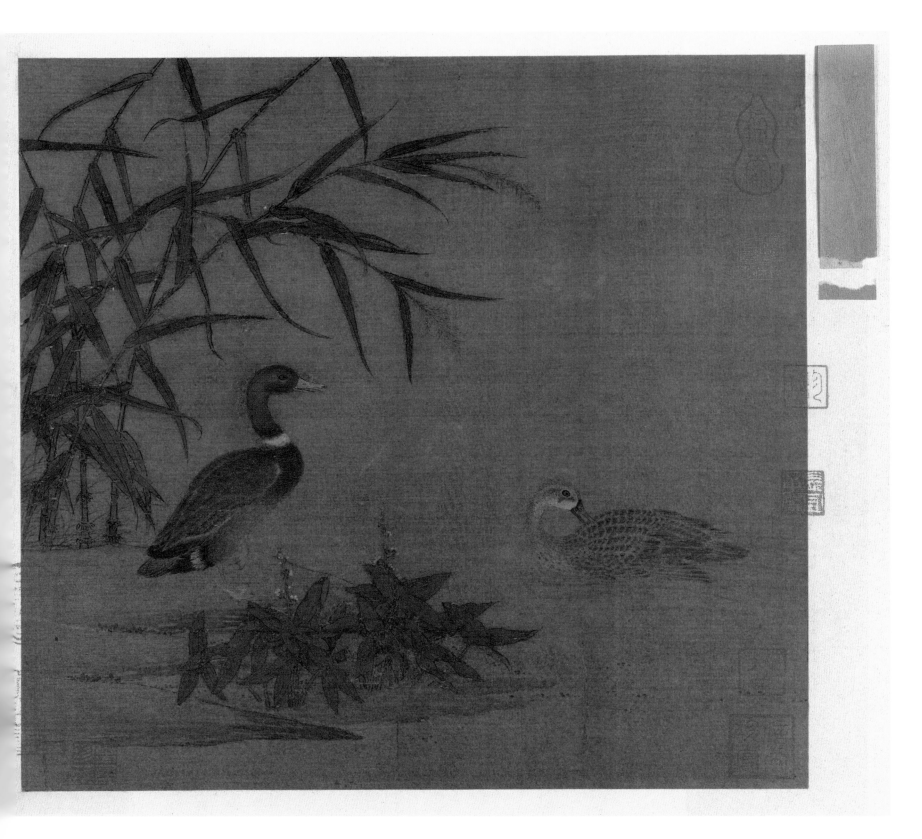

新147426 3/14

宋 佚名
溪芦野鸭图页

87 绢本　纵27厘米　横26.4厘米

Xin147426 3/14
Anonymous, Song dynasty
Reeds by a Stream and Wild Ducks
Album leaf, silk
27 × 26.4 cm

黃要叟鳩竹圖余素珍之此頁氣韻
精神悉之合一繪事至此深入三昧
笑　昭忠識

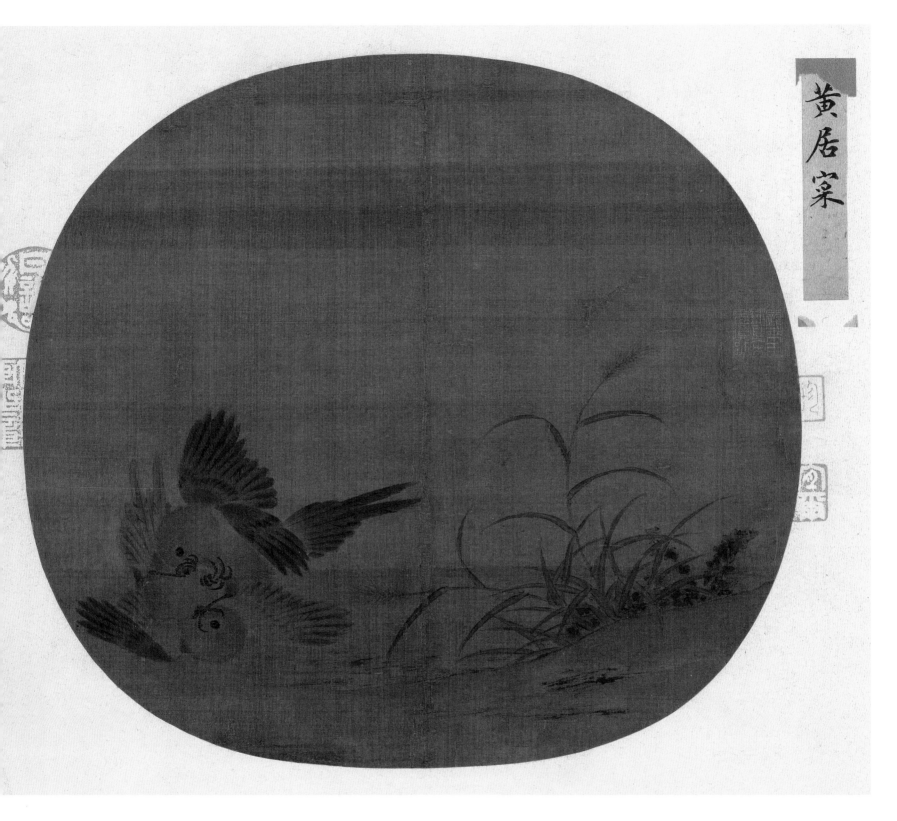

黄居寀

新147426 4/14

宋 佚名
斗雀图页
88 绢本 纵25.4厘米 横24.2厘米
Xin147426 4/14
Anonymous, Song dynasty
Sparrows Fighting
Album leaf, silk
25.4 × 24.2 cm

黄居寀能世其家學點染其蒨
澹野逸之致画史以黄家冨貴
評之未必無議

千山耿信公

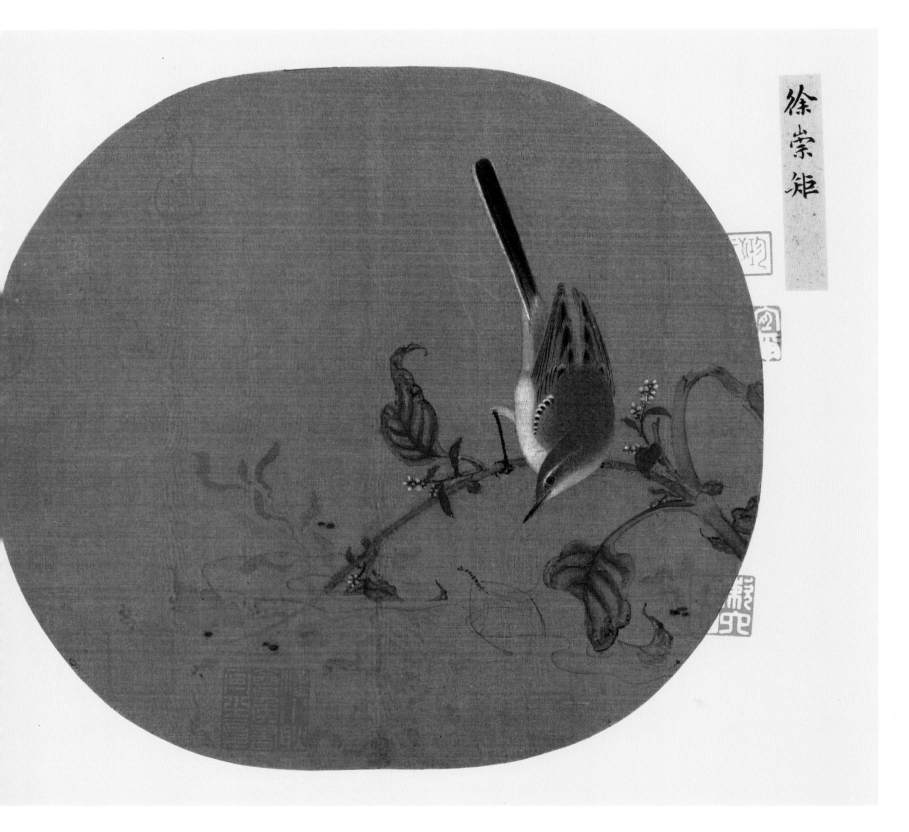

徐崇矩

新147426 5/14

宋 佚名
红蓼水禽图页

89　绢本　纵26.8厘米　横25.2厘米

Xin147426 5/14
Anonymous, Song dynasty
Red Knotweed and Water Bird
Album leaf, silk
26.8 × 25.2 cm

傳寫物態蔚有生意徐崇矩畫
惟不墜祖風直可領袖後學
襄平耿昭忠題

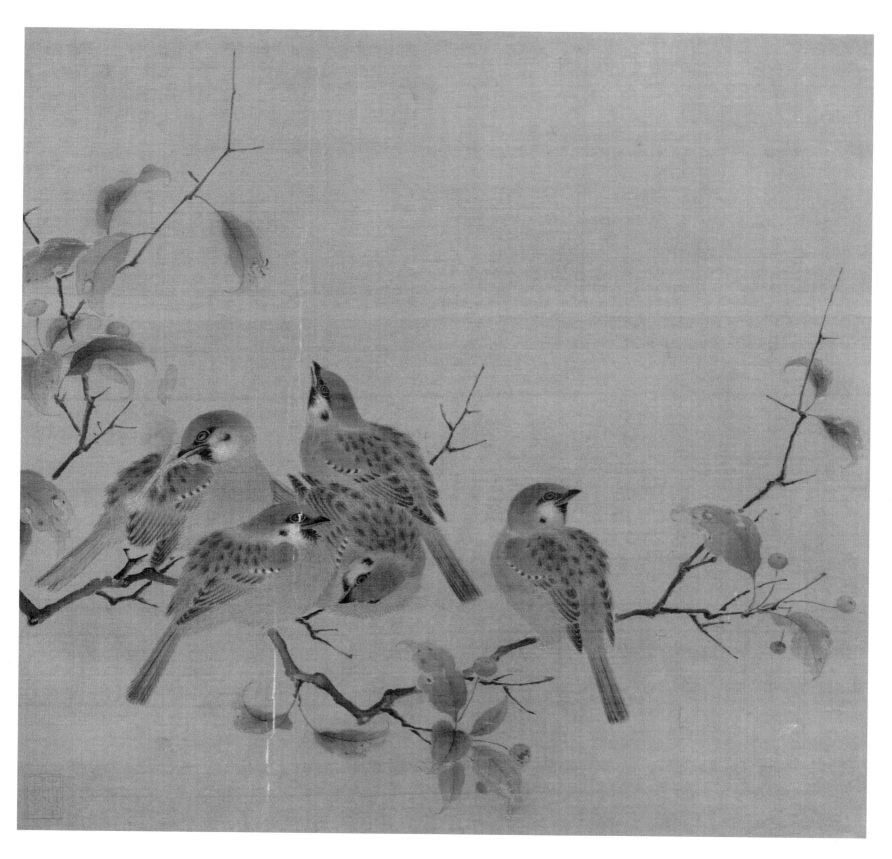

故6154 7/10

宋 佚名
瓦雀栖枝图页
绢本　纵29.1厘米　横28.6厘米

90

Gu6154 7/10
Anonymous, Song dynasty
Sparrows Perching on a Begonia Branch
Album leaf, silk
29.1 × 28.6 cm

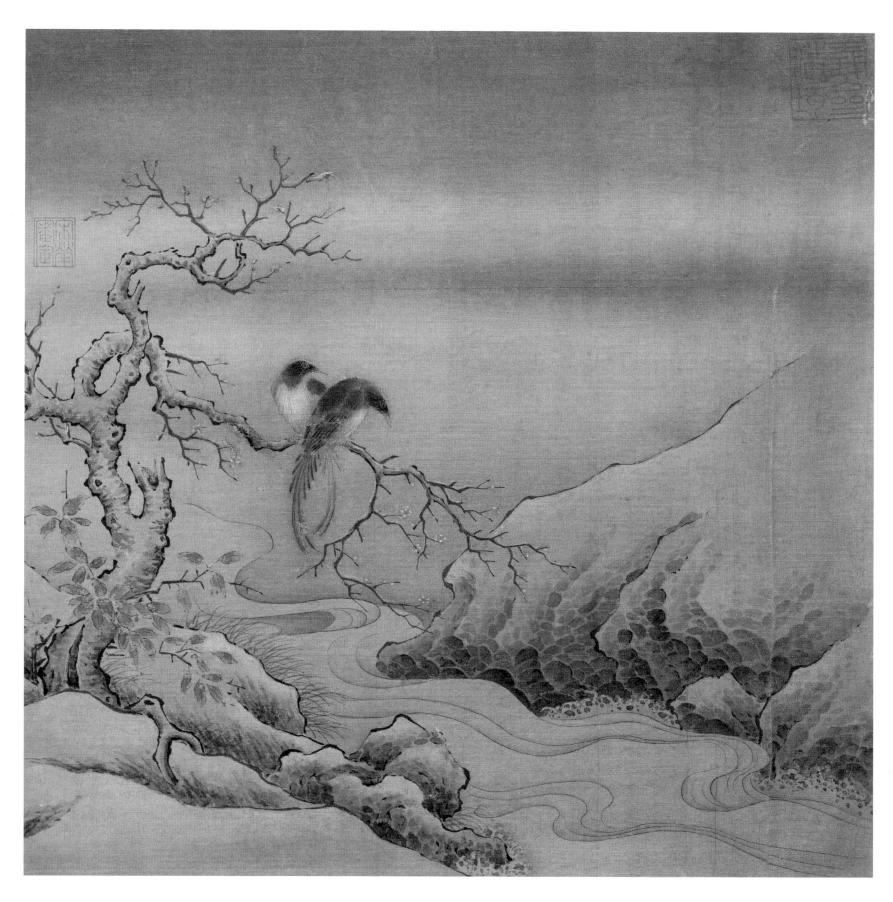

故6154 8/10

宋 佚名

乌桕文禽图页

91　绢本　纵27.5厘米　横26.9厘米

Gu6154 8/10

Anonymous, Song dynasty
Two Graceful Birds Perching on a Tallow Branch

Album leaf, silk
27.5 × 26.9 cm

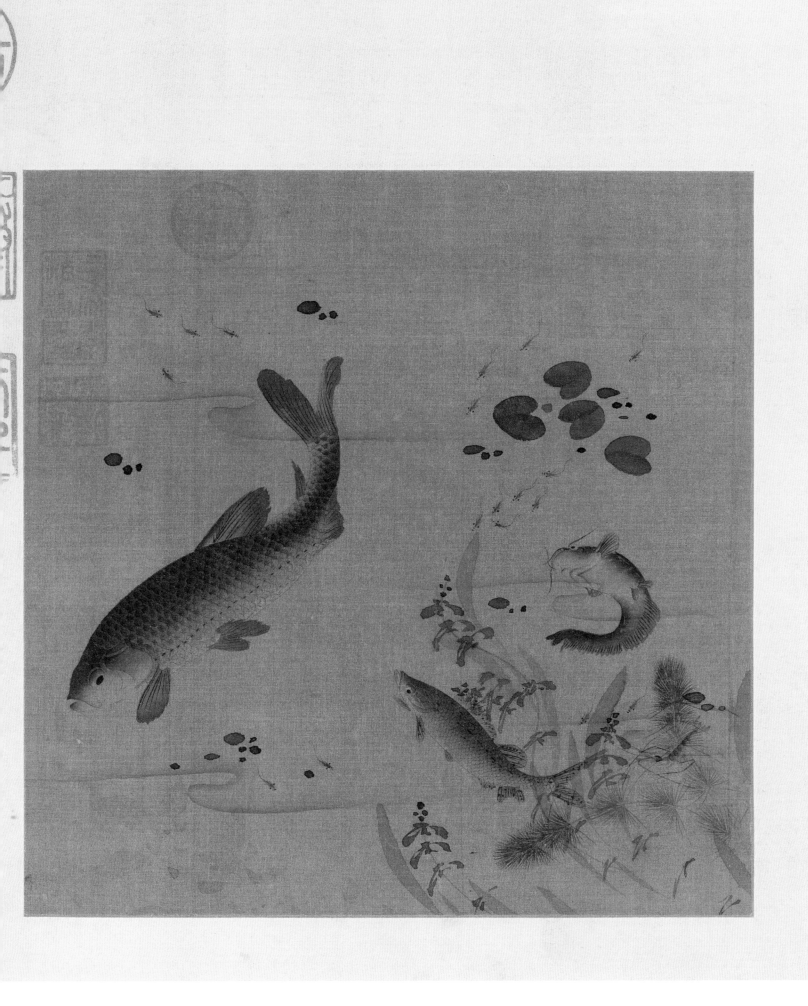

新147428 12/12
宋 佚名
春溪水族图页

92 绢本　纵25.5厘米　横24.3厘米

Xin147428 12/12
Anonymous, Song dynasty
Fish Swimming among Aquatic
Plants in Spring Stream
Album leaf, silk
25.5 × 24.3 cm

莊惠曾論知弗知傳為
竒語亦竒試為駁曰
我非子便是若云彼豈
斯春水初生具素文
鮮犖泳愛文瀫漫甞意
淺色鮮耳頒類濠梁博
辯時
戊申仲秋鴻毛

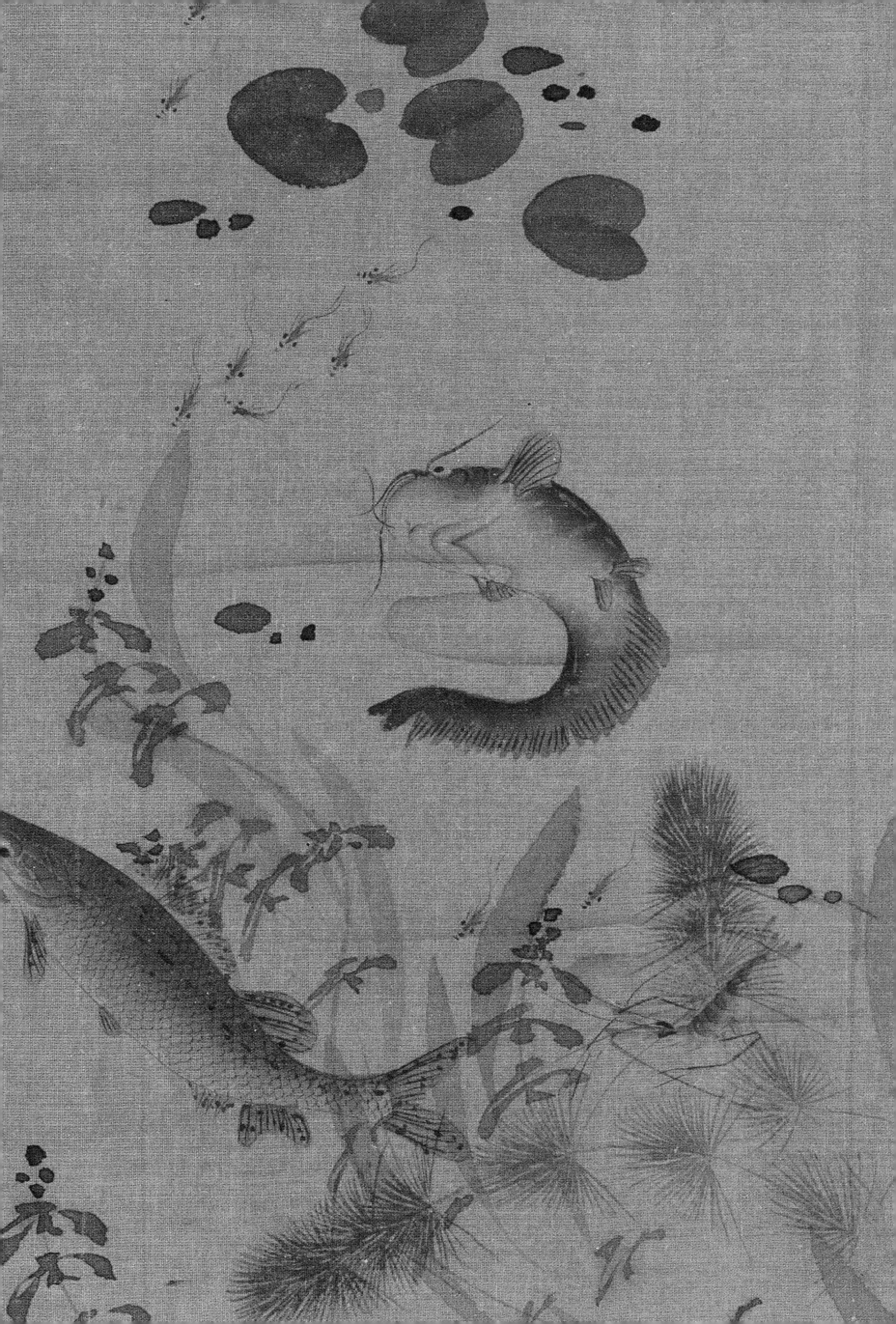

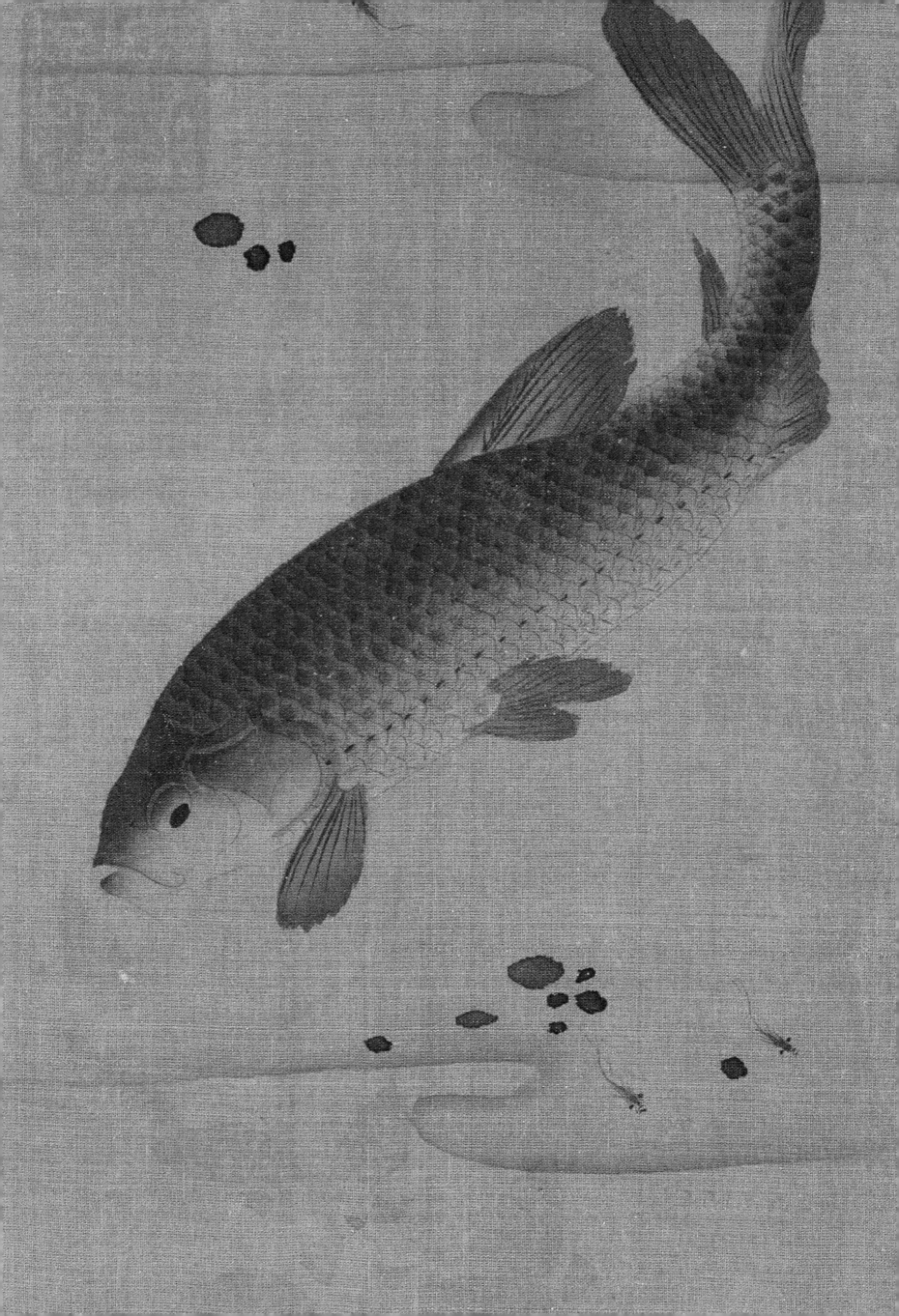

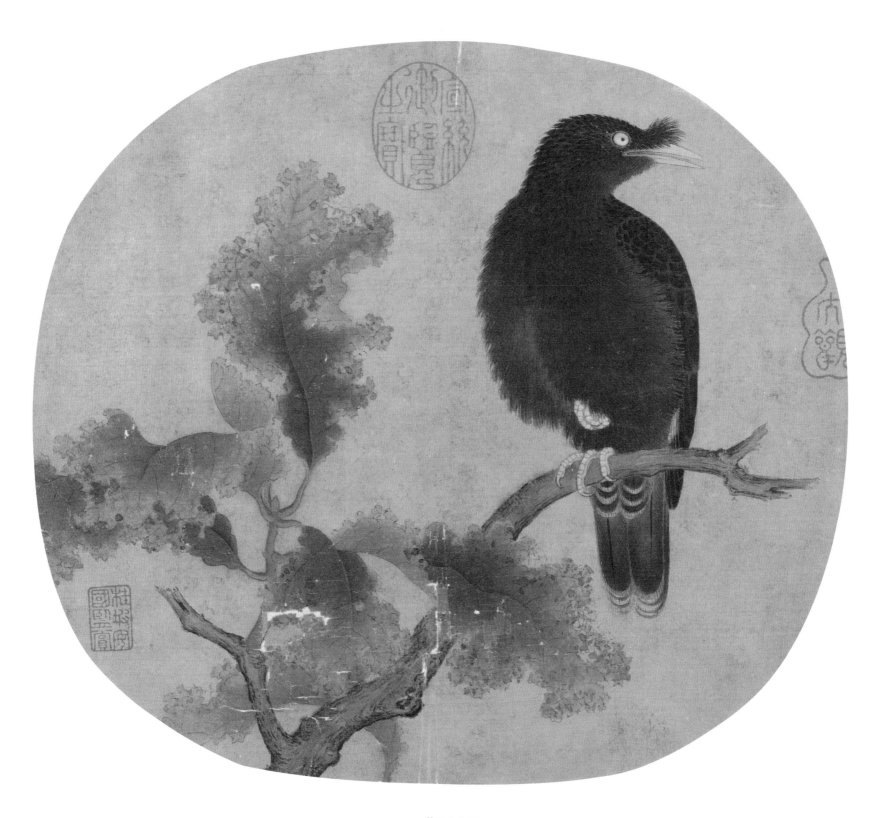

故6158 1/16

宋 佚名
秋树鸜鹆图页

93 绢本 纵26.5厘米 横25厘米

Gu6158 1/16

Anonymous, Song dynasty
Mynah Perching on the Branch of an Autumn Tree
Album leaf, silk
26.5 × 25 cm

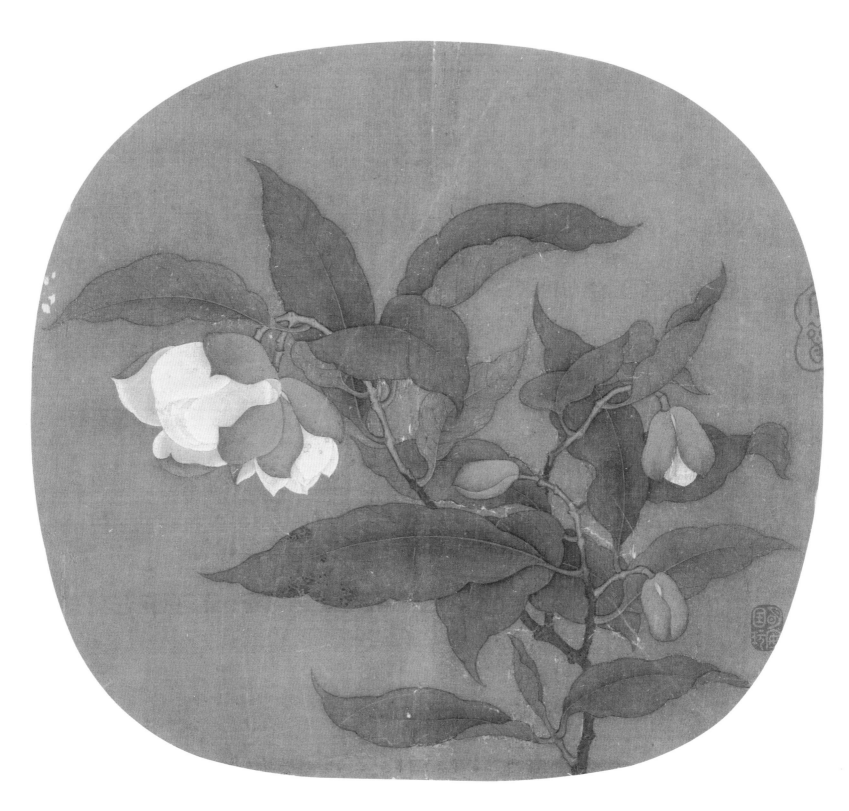

故6158 2/16
宋 佚名
夜合花图页

94 绢本　纵25.4厘米　横24.5厘米

Gu6158 2/16
Anonymous, Song dynasty
Silk Tree Flowers
Album leaf, silk
25.4 × 24.5 cm

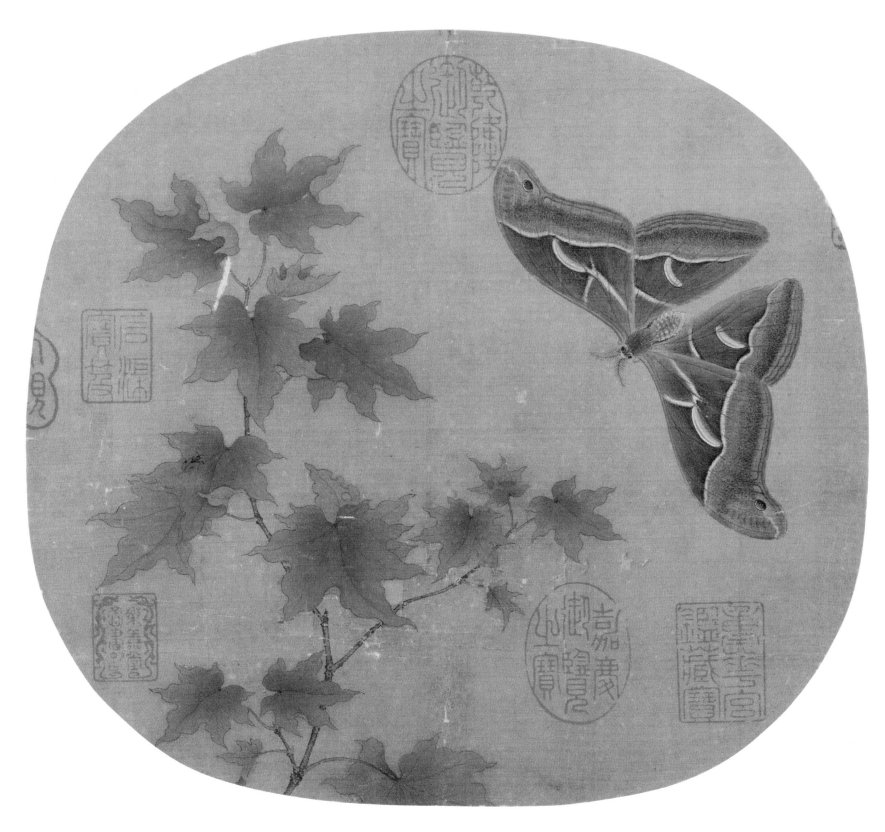

故6158 12/16

宋 佚名
青枫巨蝶图页

95 绢本　纵24.2厘米　横23厘米

Gu6158 12/16

Anonymous, Song dynasty
Flying Butterfly and Green Maple
Album leaf, silk
24.2 × 23 cm

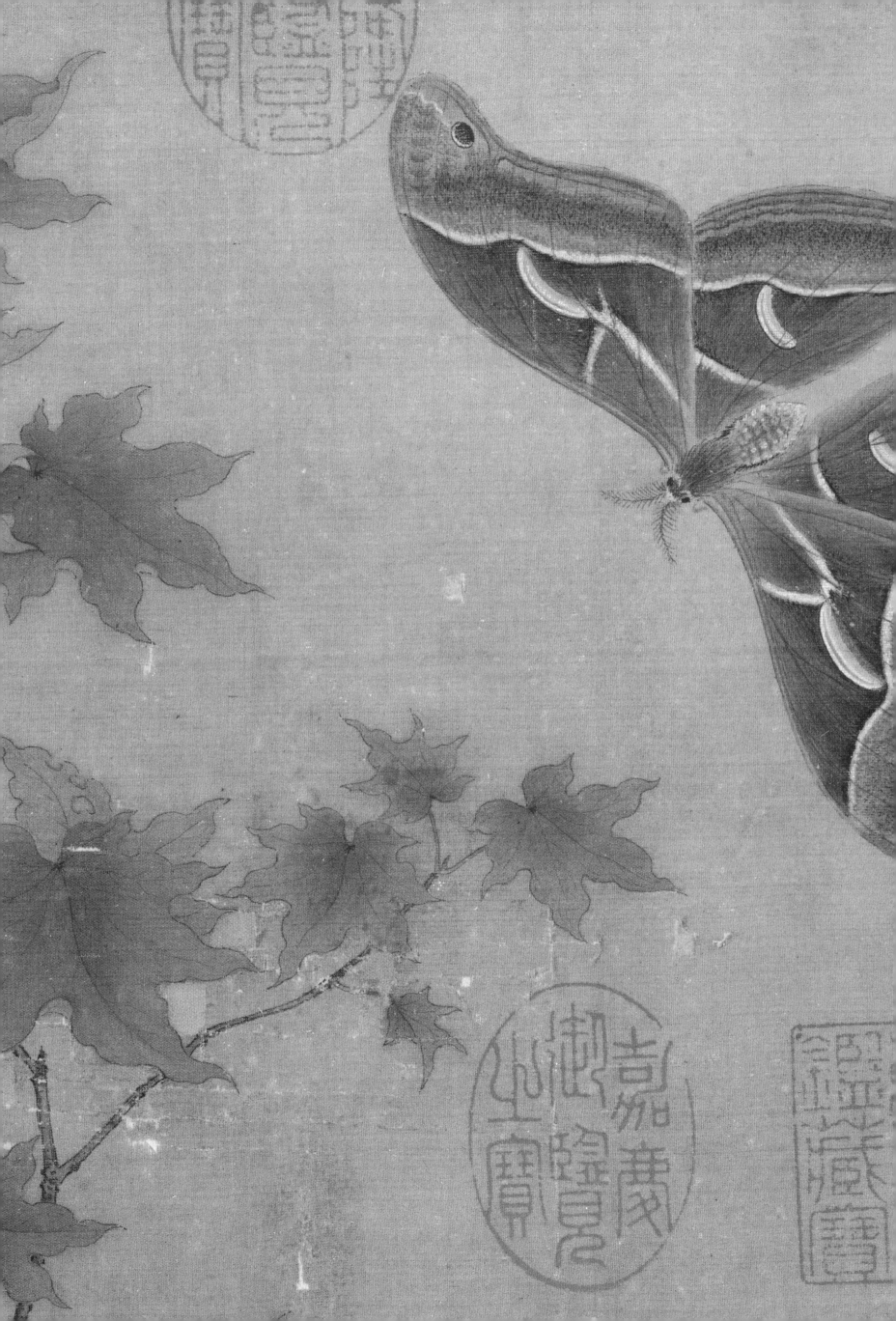

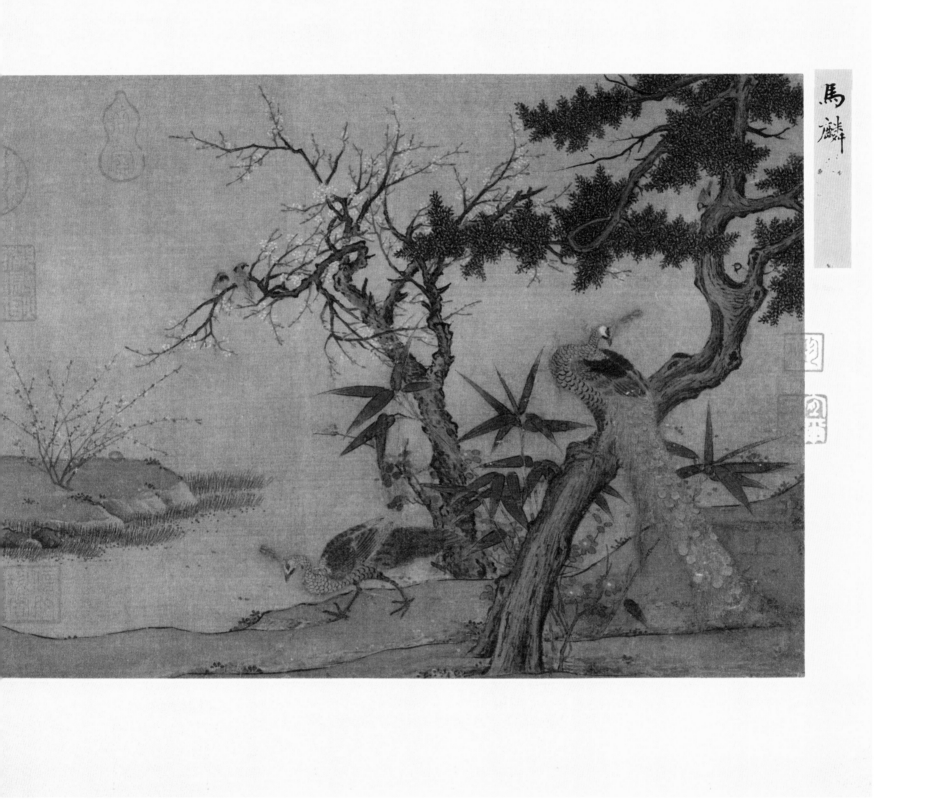

新147426 14/14

宋 佚名
红梅孔雀图页

绢本　纵24厘米　横31.6厘米

96

Xin147426 14/14
Anonymous, Song dynasty
Red Plum Blossoms and Peacocks
Album leaf, silk
24 × 31.6 cm

此图花木翎鸟极其精工画髓评
云远欲其子浮誉多指己画题作
马麟夫岂其然

千山信公

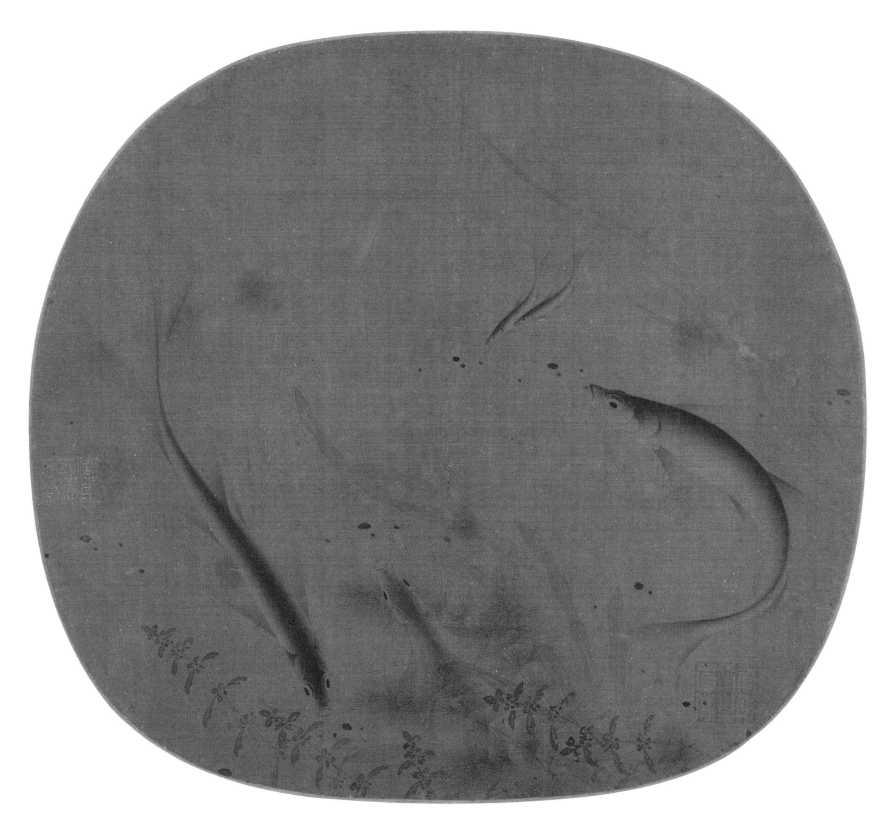

宋 佚名
群鱼戏藻图页

97 绢本　纵25.5厘米　横24.5厘米

Xin147424 8/12
Anonymous, Song dynasty
School of Fish among Aquatic Plants
Album leaf, silk
25.5 × 24.5 cm

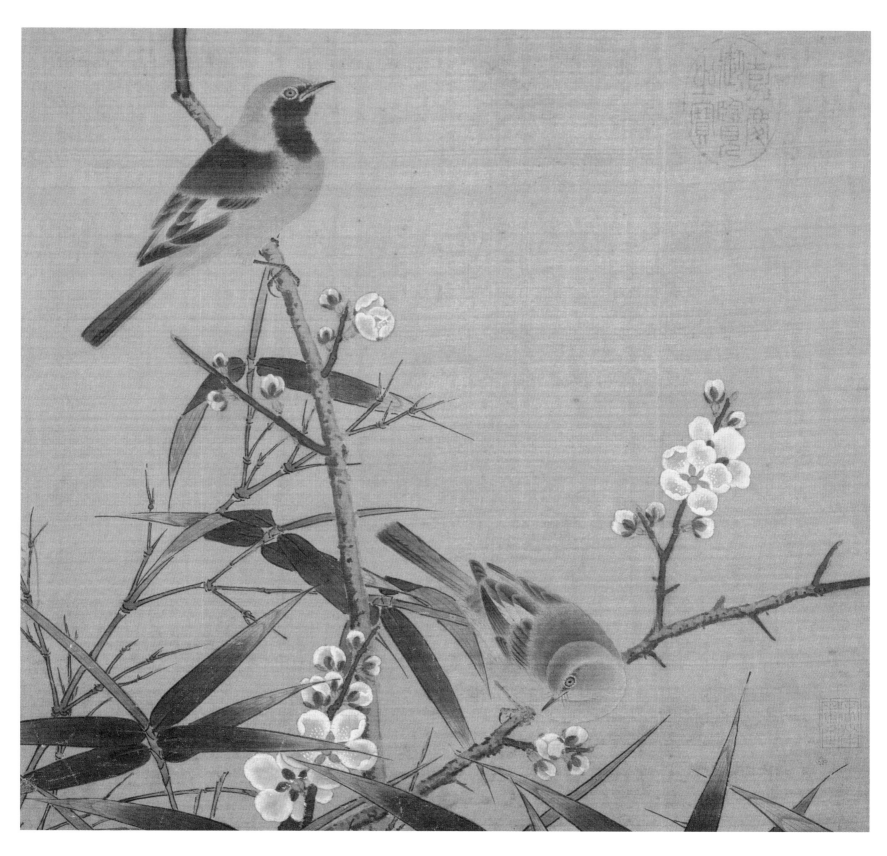

故6154 1/10

宋 佚名
梅竹双雀图页

98 | 绢本　纵26.5厘米　横26厘米

Gu6154 1/10

Anonymous, Song dynasty
Two Titmouses Perching on Plum
Branches in Bamboo Grove
Album leaf, silk
26.5 × 26 cm

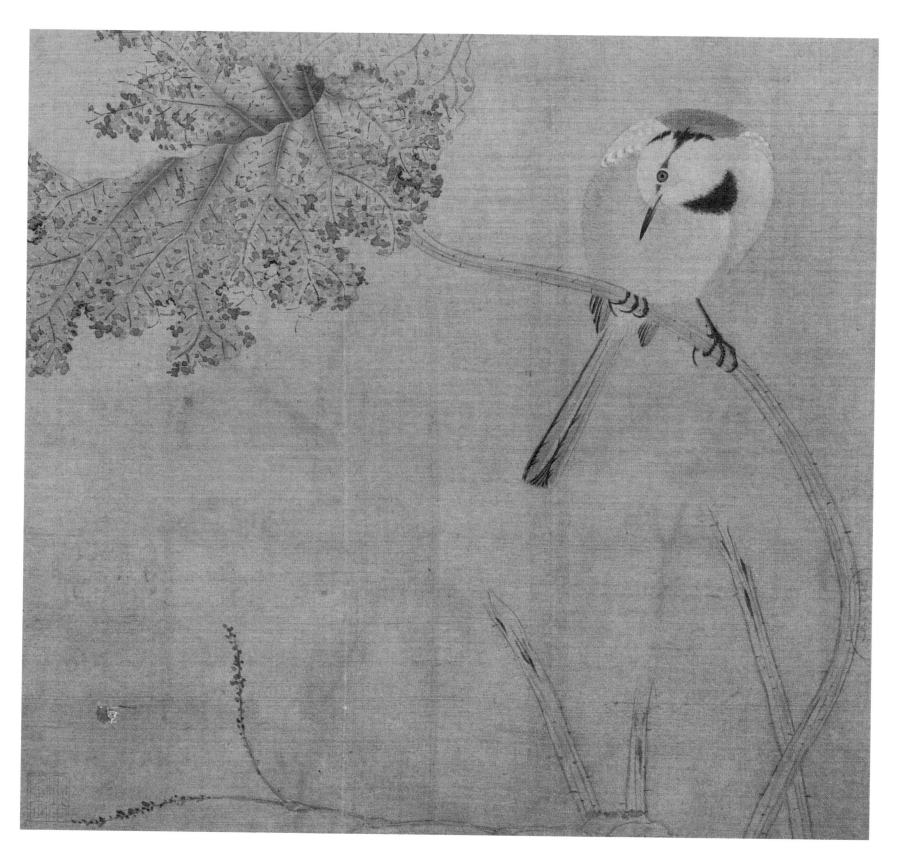

故6154 5/10

宋 佚名
鹡鸰荷叶图页

99 | 绢本　纵26.5厘米　横26厘米

Gu6154 5/10

Anonymous, Song dynasty
Wagtail and Withered Lotus Leaf
Album leaf, silk
26.5 × 26 cm

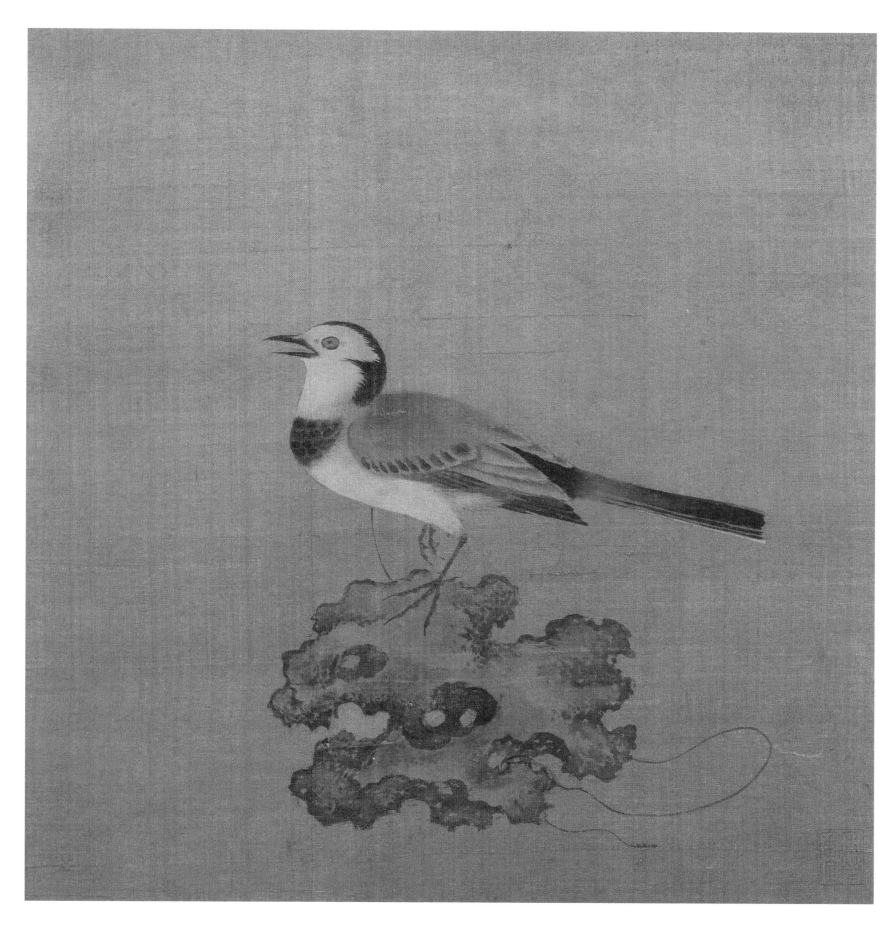

故6154 3/10

宋 佚名
绣羽鸣春图页

100 | 绢本　纵25.7厘米　横24.1厘米
Gu6154 3/10

Anonymous, Song dynasty
Beautiful Bird Singing in Spring
Album leaf, silk
25.7 × 24.1 cm

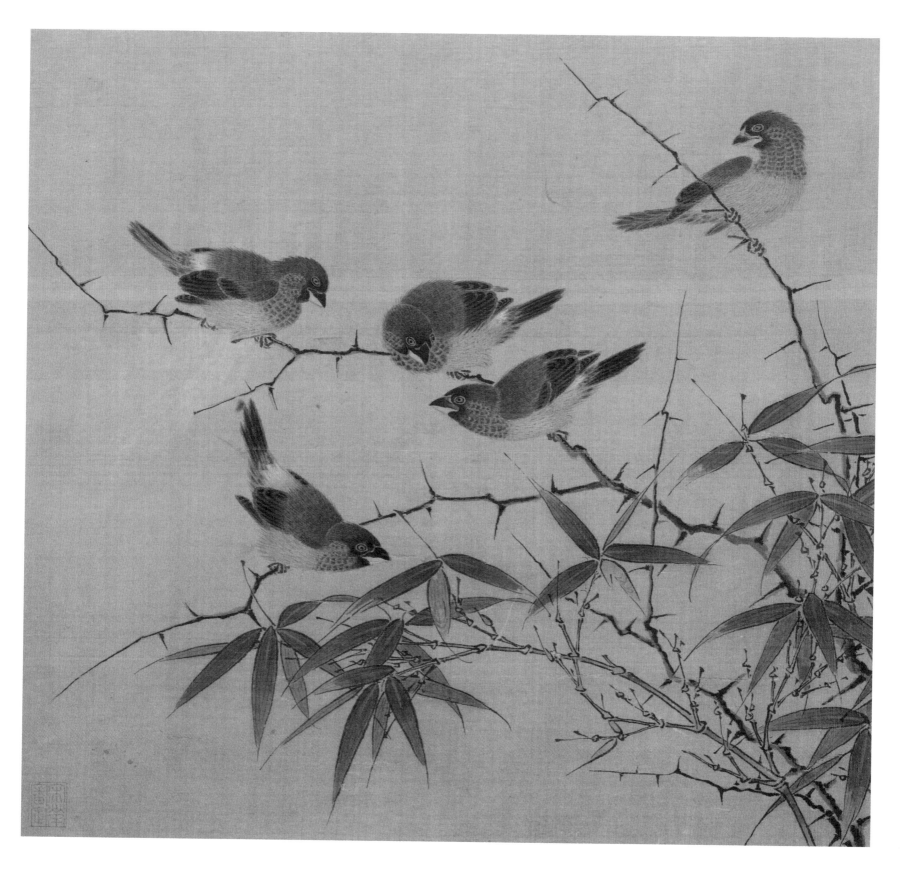

故6154 6/10

宋 佚名

霜筱寒雏图页

101 | 绢本 纵28.7厘米 横28.2厘米

Gu6154 6/10

Anonymous, Song dynasty
Young Sparrows and Bamboos in Cold Weather
Album leaf, silk
28.7 × 28.2 cm

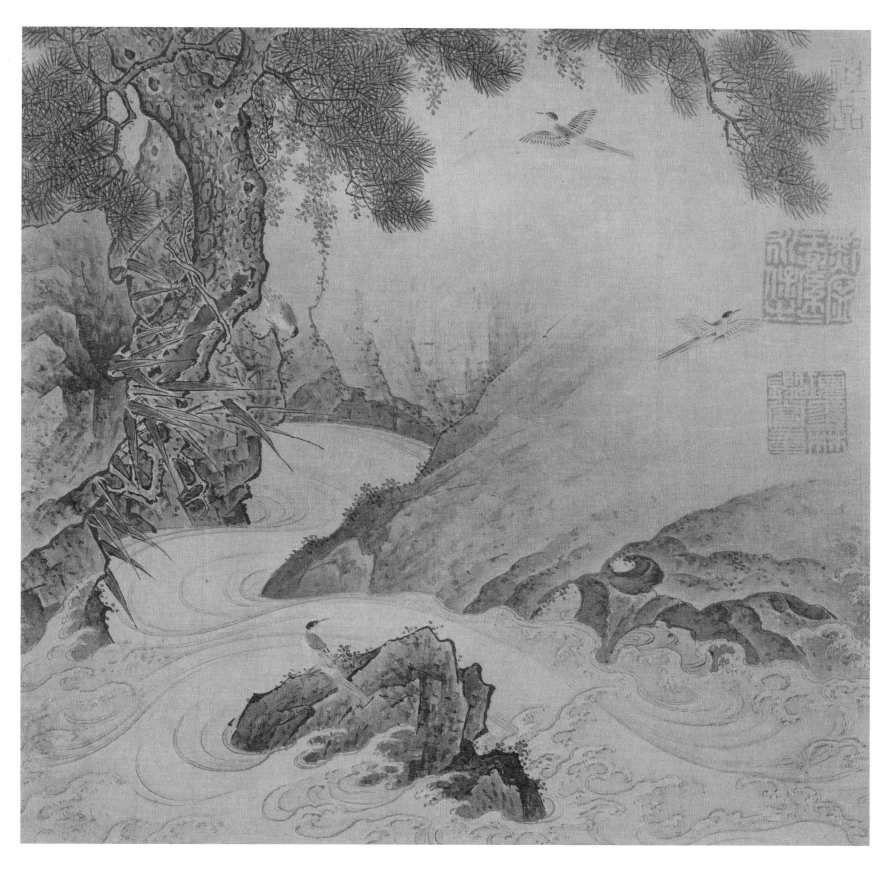

新17779 8/20

宋 佚名
松涧山禽图页

102 | 绢本　纵25.3厘米　横25.3厘米

Xin17779 8/20

Anonymous, Song dynasty
Titmouses, Mountain Stream and Pine
Album leaf, silk
25.3 × 25.3 cm

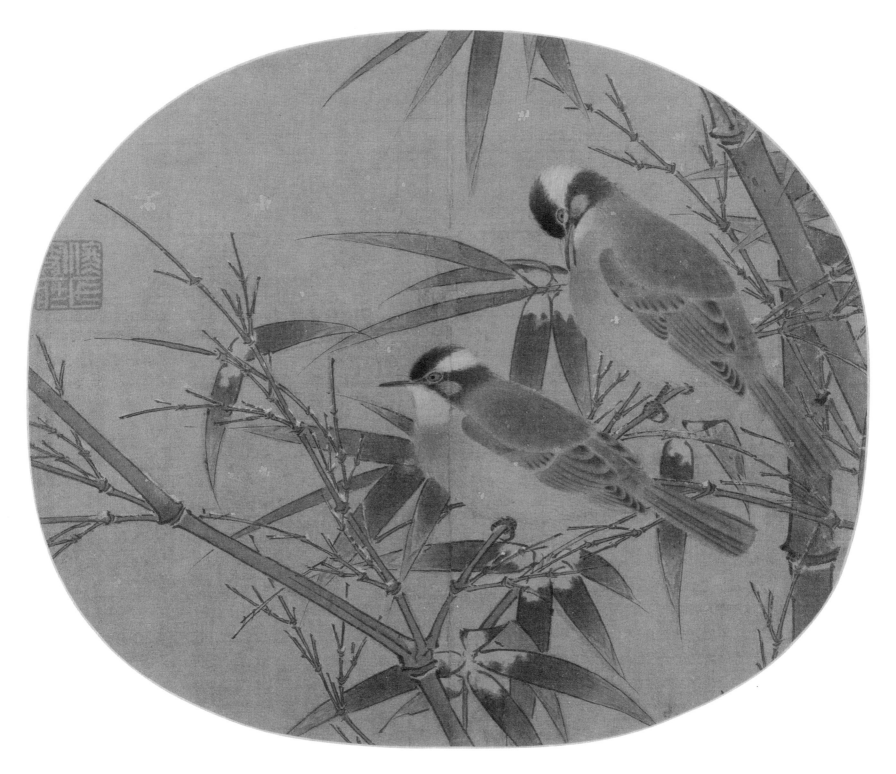

新17779 12/20

宋 佚名
白头丛竹图页

103 绢本　纵25.4厘米　横29厘米

Xin17779 12/20
Anonymous, Song dynasty
Grey Starlings and Green Bamboos
Album leaf, silk
25.4 × 29 cm

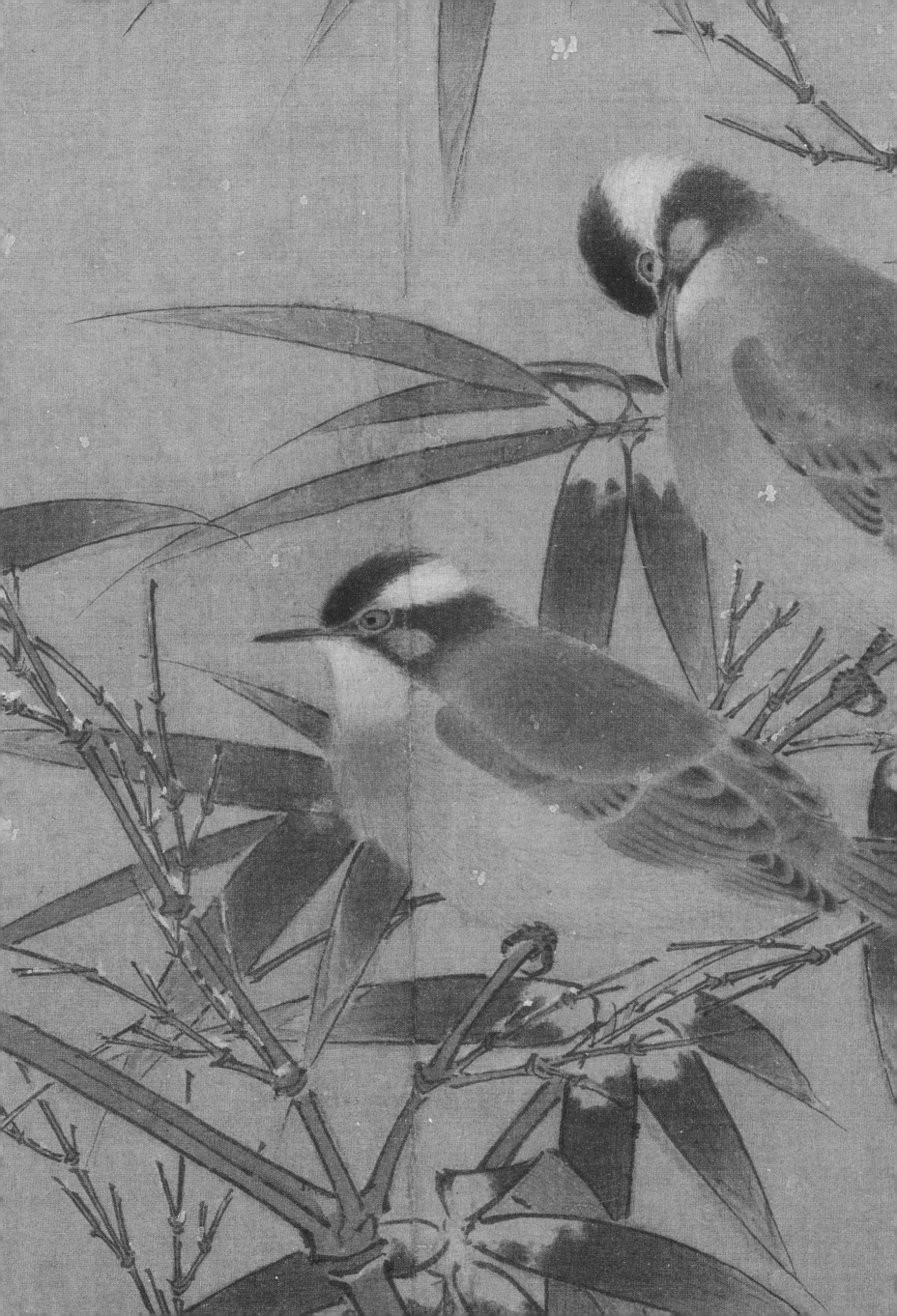

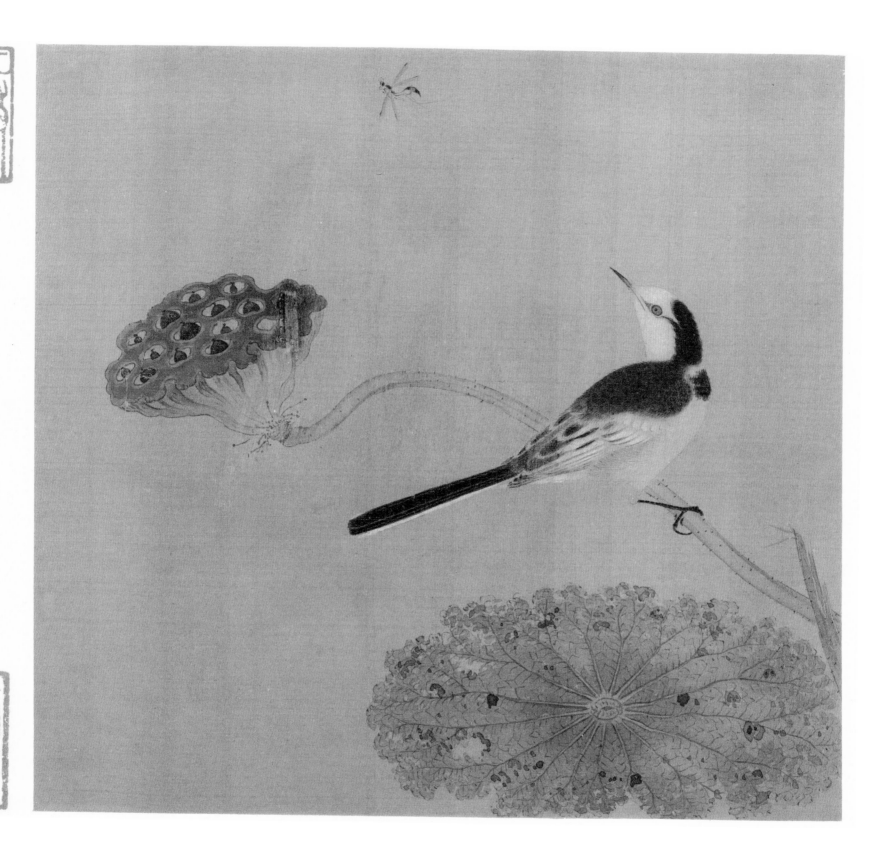

宋 佚名
疏荷沙鸟图页

104 绢本　纵25厘米　横25.6厘米

Gu6151 6/10
Anonymous, Song dynasty
Withered Lotus and Little Bird
Album leaf, silk
25 × 25.6 cm

葉敗花殘枝上
枯何来汀鳥立
斯須伊人意字
南遷代以寫其
瞻爰止鳥

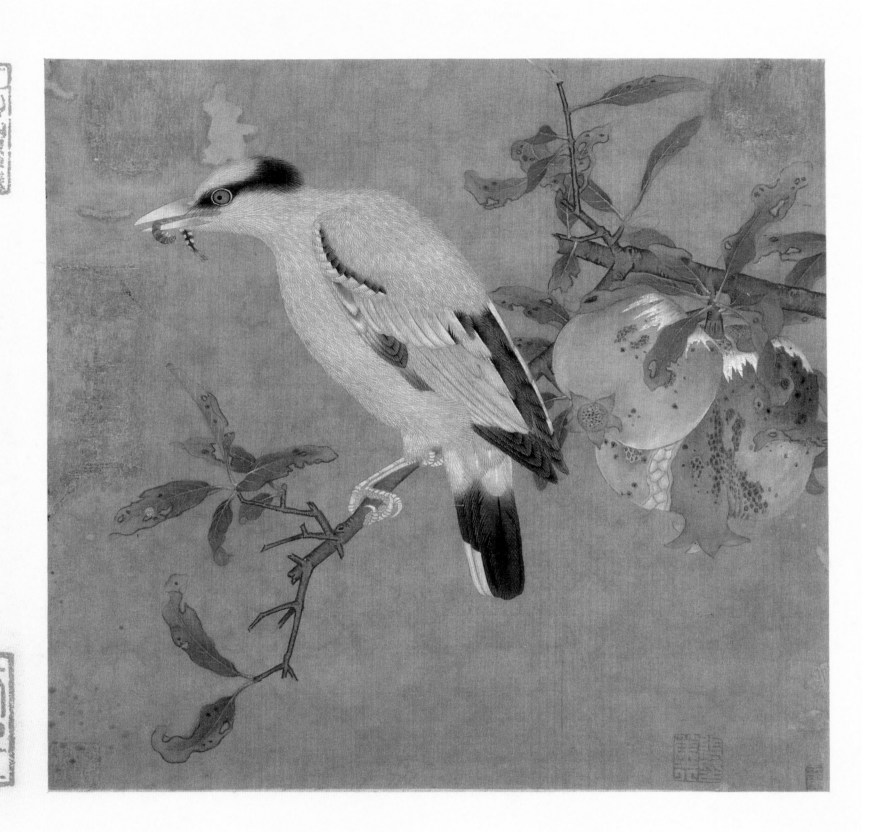

故6151 8/10

宋 佚名
榴枝黄鸟图页

绢本　纵24.6厘米　横25.4厘米

105

Gu6151 8/10

Anonymous, Song dynasty
Yellow Bird Perching on Pomegranate Branch

Album leaf, silk
24.6 × 25.4 cm

榴子熟時鶯轉時
野蔬衡巧集橫枝
笑他自喜權俗骨
忘肯有人弹挾
之
辛亥清和涿鬼

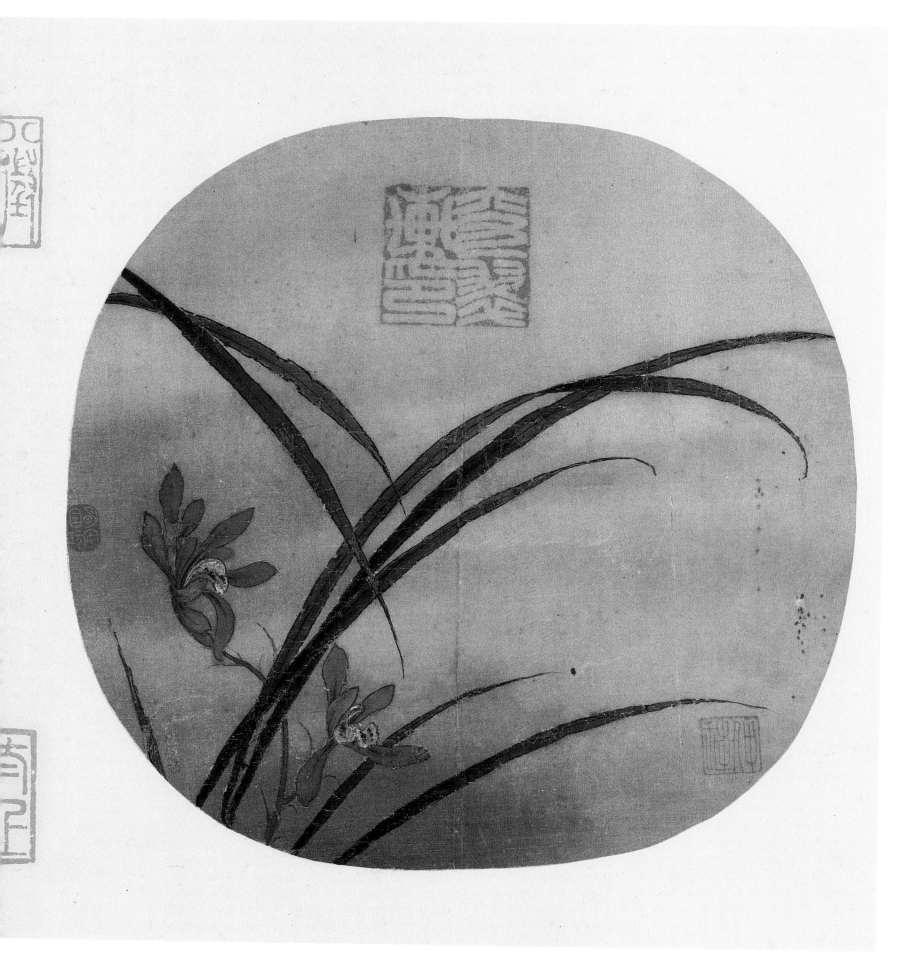

故6152 6/10

宋 佚名
秋兰绽蕊图页

絹本　纵25.3厘米　横25.8厘米

106

Gu6152 6/10

Anonymous, Song dynasty
Sword-leaved Cymbidium in Blossom

Album leaf, silk
25.3 × 25.8 cm

寫蘭反楚

騷東呈終古矣

底後其為秋陳

葉護次蕋意出

常人表或遠代

其子

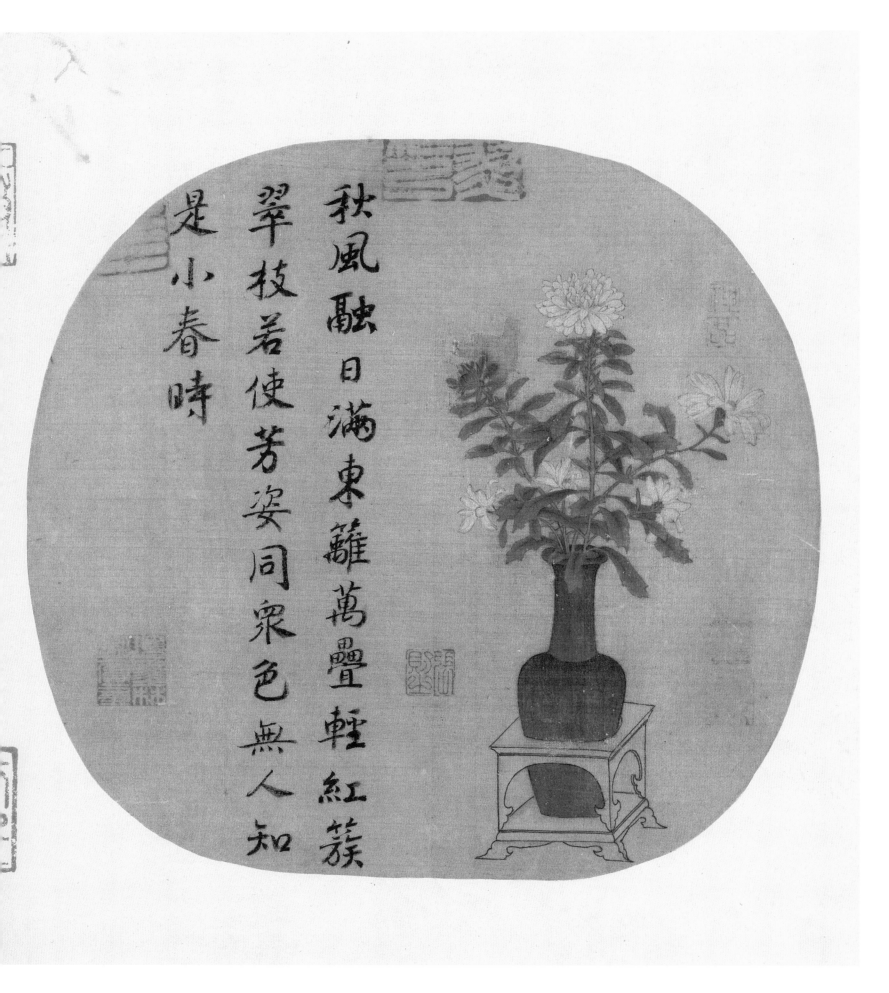

秋風融日滿東籬萬疊輕紅簇
翠枝若使芳姿同眾色無人知
是小春時

故6152 10/10
宋 佚名
胆瓶秋卉图页

107 | 绢本　纵26.5厘米　横27.5厘米
Gu6152 10/10
Anonymous, Song dynasty
Vase with Autumn Flowers
Album leaf, silk
26.5 × 27.5 cm

花以菊而紅
葉則迥然異自題
屬東籬殊難解用意
徒以設色工選藻許
其厠 辛亥清和
御題

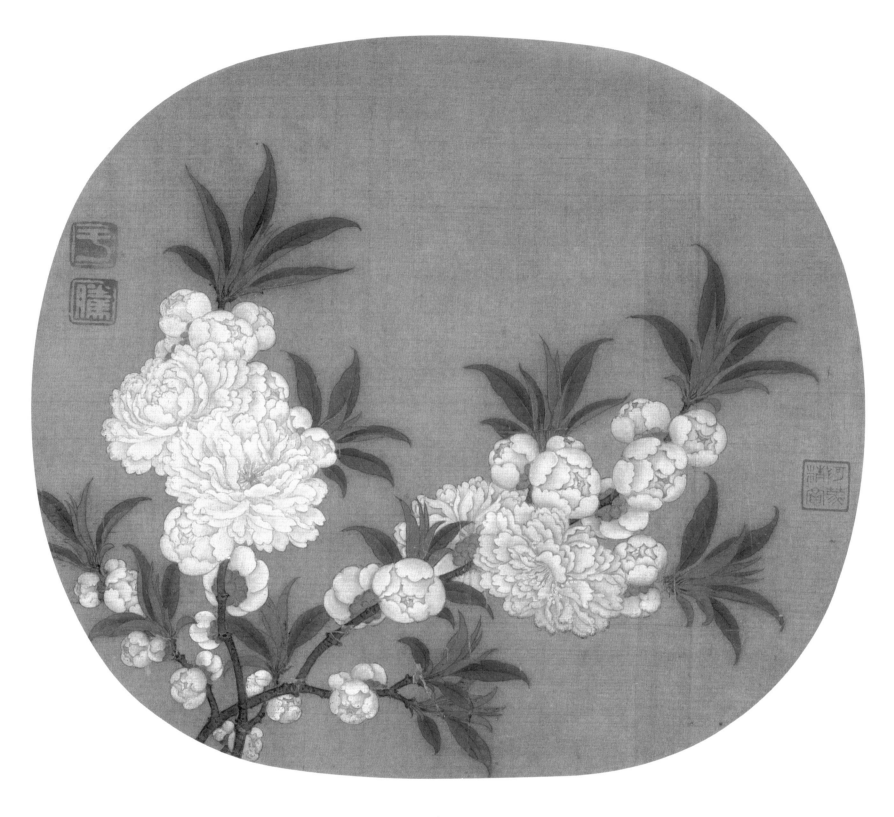

新70985

宋 佚名
碧桃图页

绢本　纵24.8厘米　横27厘米

108

Xin70985

Anonymous, Song dynasty
Peach Blossoms

Album leaf, silk
24.8 × 27 cm

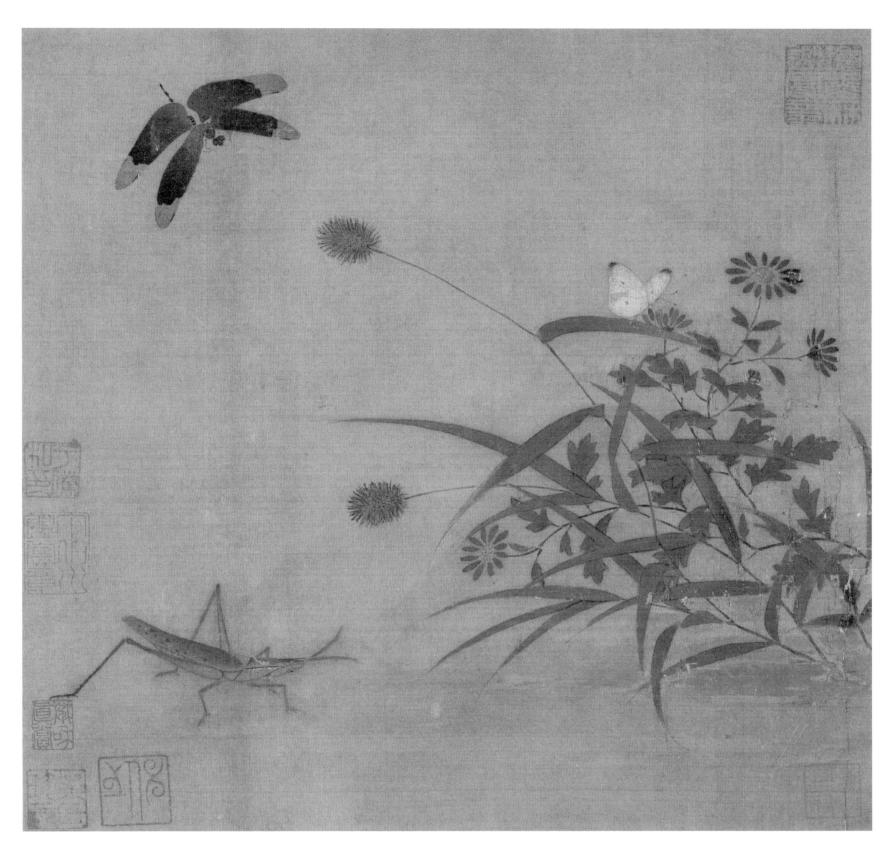

新70987

宋 佚名
写生草虫图页

109 | 绢本　纵25.5厘米　横26厘米

Xin70987
Anonymous, Song dynasty
Plants and Insects
Album leaf, silk
25.5 × 26 cm

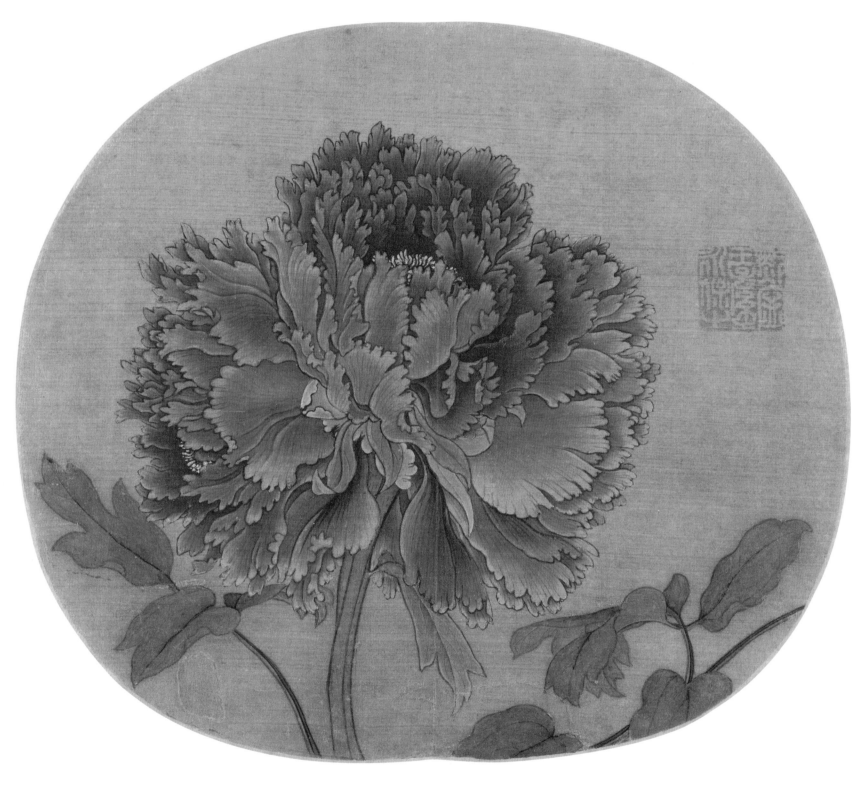

新156346

宋 佚名
牡丹图页

110 | 绢本　纵24.8厘米　横27.3厘米

Xin156346
Anonymous, Song dynasty
Peony
Album leaf, silk
24.8 × 27.3 cm

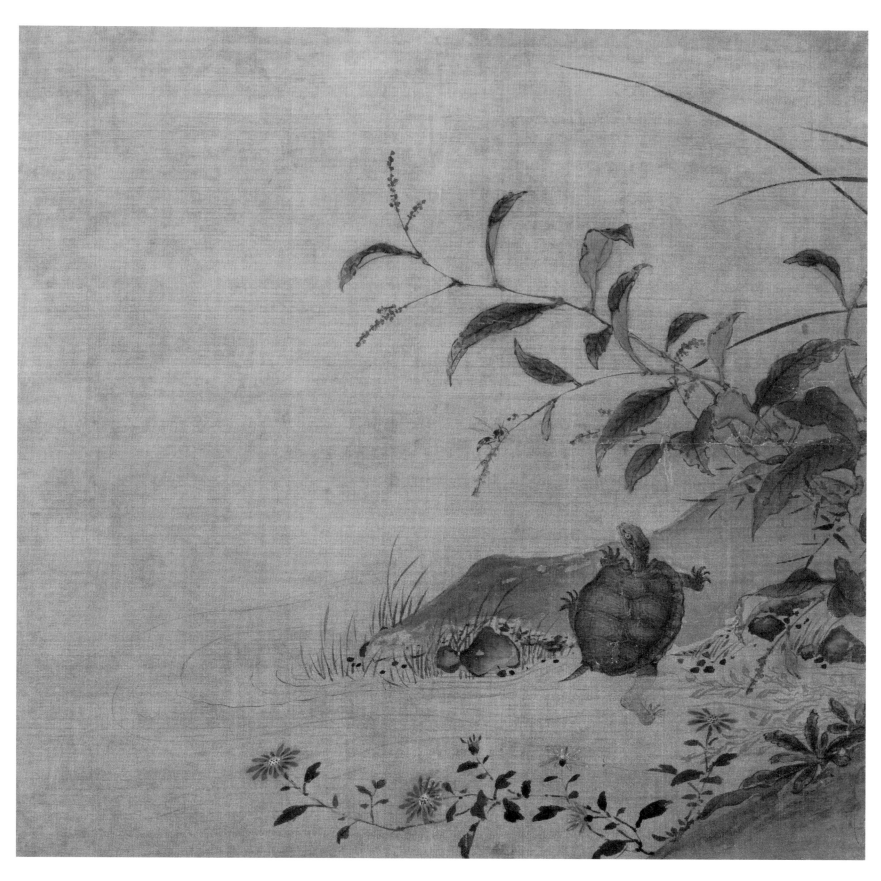

新156351

宋 佚名
蓼龟图页

111 | 绢本　纵28.4厘米　横28厘米
Xin156351
Anonymous, Song dynasty
Knotweed and Tortoise
Album leaf, silk
28.4 × 28 cm

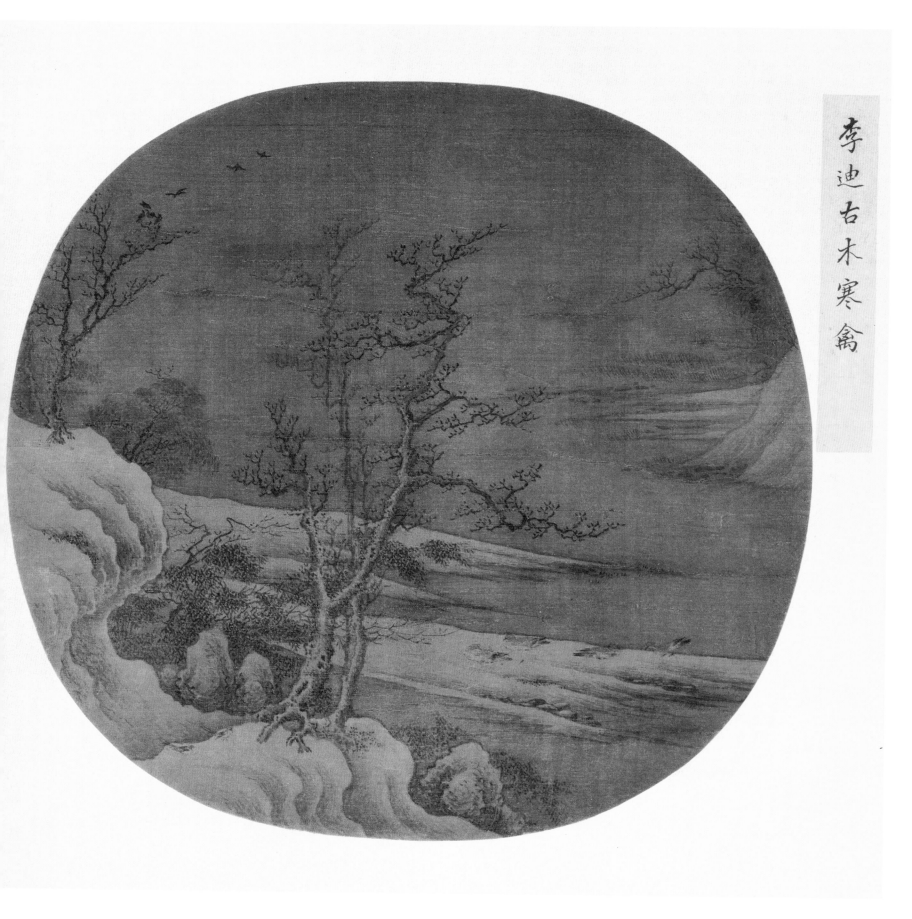

李迪古木寒禽

新147425 7/12

宋 佚名
古木寒禽图页

112 | 绢本　纵25.3厘米　横26厘米

Xin147425 7/12

Anonymous, Song dynasty
Withered Trees and Wintry Birds
Album leaf, silk
25.3 × 26 cm

鴉棲煙暝村舂急黃栗丹楓遶原

隔青蓮何事眠酒家幽情自皭清

宵立　　朱之蕃

嬝嬝風吹木葉稀蒼苔深護釣魚磯鸜鵒

盡向沙頭宿何事飛鴉暝未歸

寶林頊起元

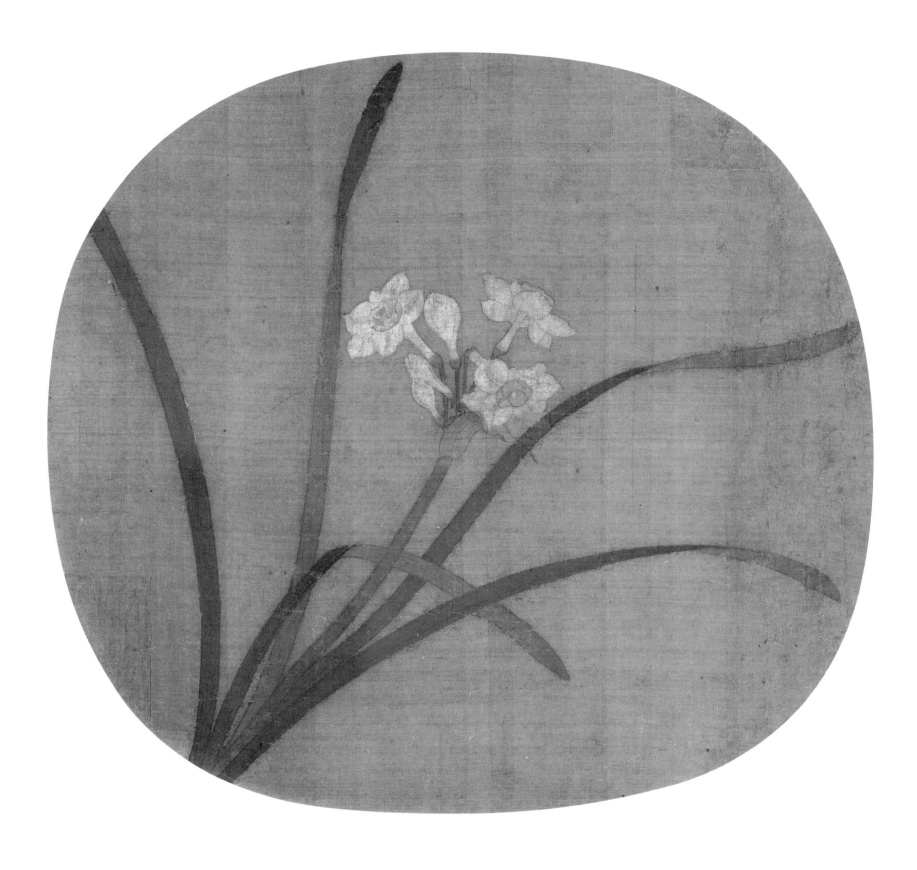

新147425 12/12

宋 佚名
水仙图页

113 | 绢本　纵24.6厘米　横26厘米

Xin147425 12/12
Anonymous, Song dynasty
Narcissus
Album leaf, silk
24.6 × 26 cm

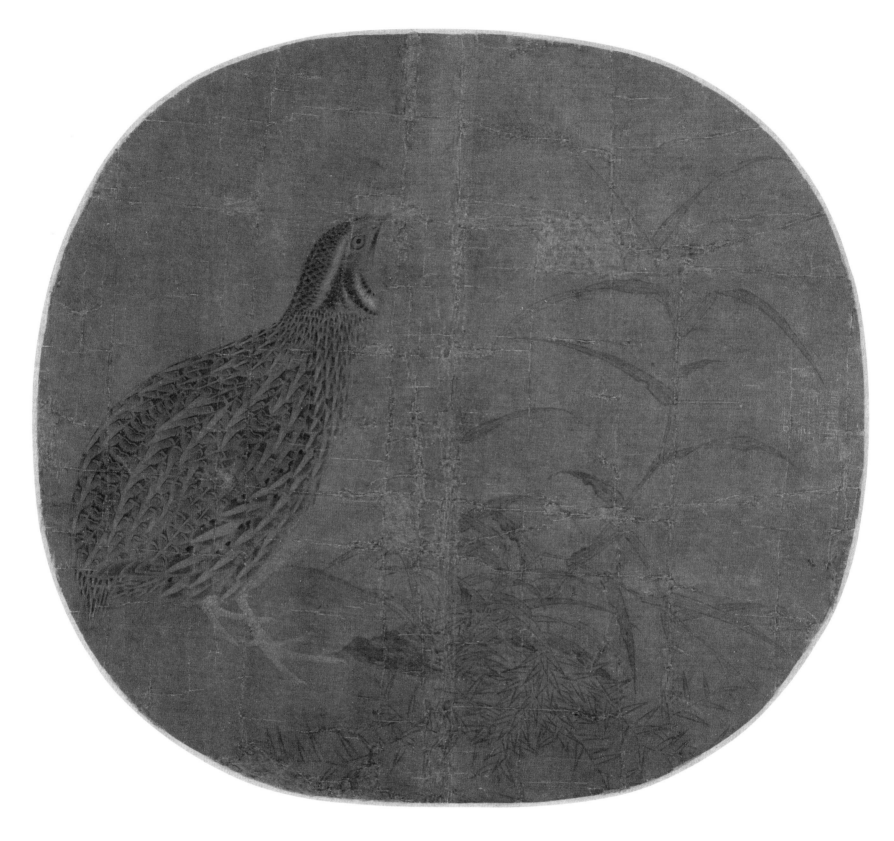

宋 佚名
鹌鹑图页

114 | 绢本　纵23.3厘米　横24厘米

Xin147424 9/12
Anonymous, Song dynasty
Quail
Album leaf, silk
23.3 × 24 cm

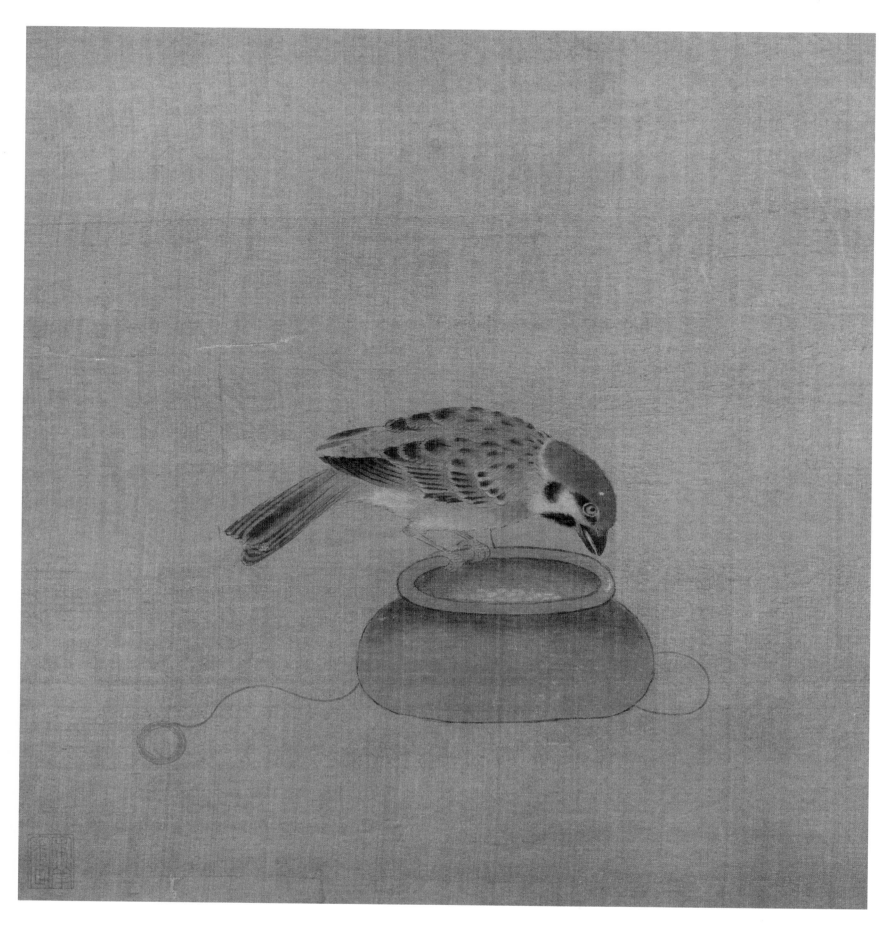

故6154 9/10

宋 佚名
驯禽俯啄图页

115 | 绢本 纵25.7厘米 横24.1厘米

Gu6154 9/10

Anonymous, Song dynasty
Tamed Sparrow Pecking at Food
Album leaf, silk
25.7 × 24.1 cm

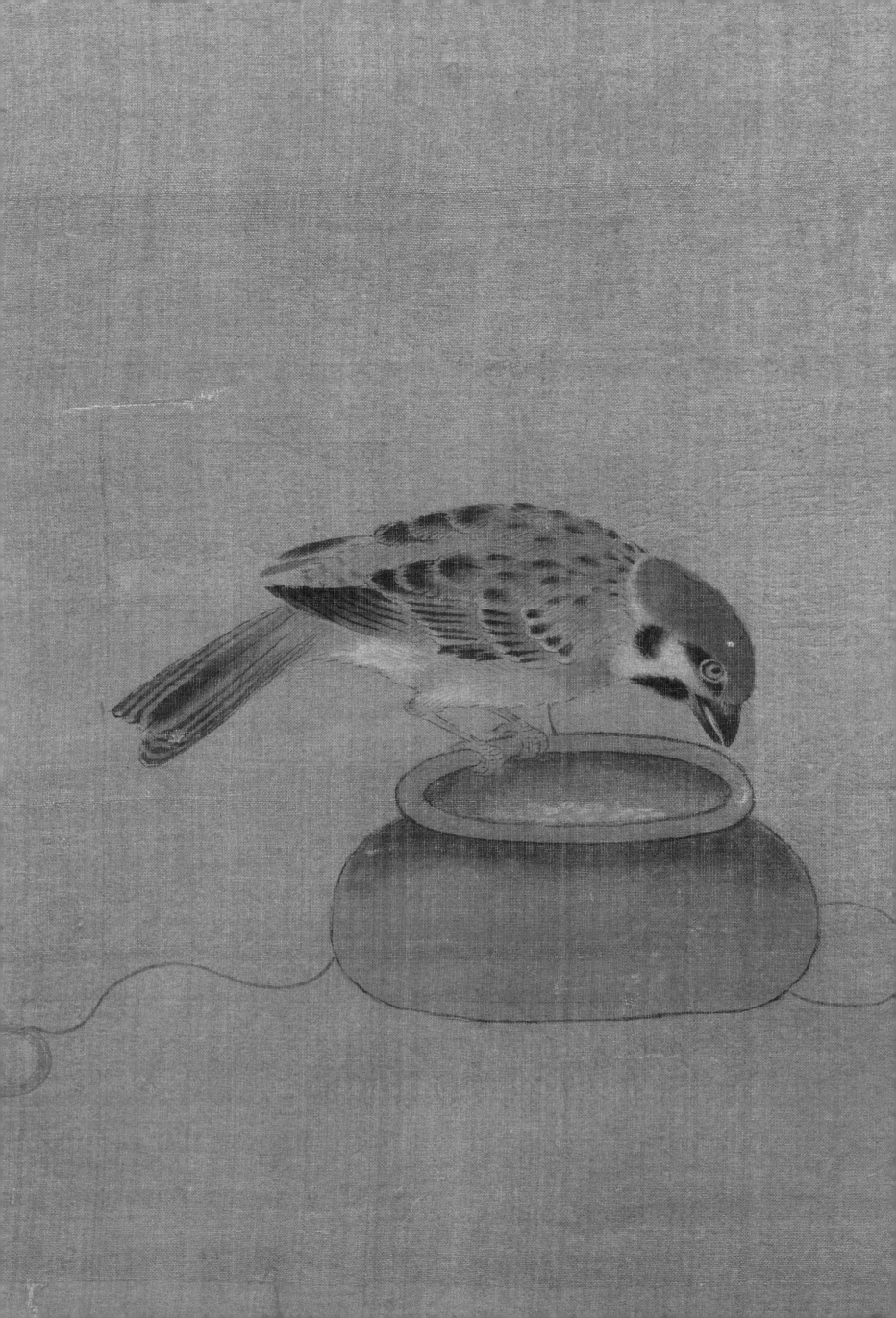

新147428 6/12

宋 佚名
无花果图页

116 绢本　纵24.8厘米　横25.3厘米

Xin147428 6/12
Anonymous, Song dynasty
Fig
Album leaf, silk
24.8 × 25.3 cm

果結如資花初

有如花者別名木饅頭

或因形弗雅綴子於葉間

纍～復若～七利名徒傳教

圖見實寮錢塘特寫斯應

寓別意也彥子與家汆

苗巾雨弗似

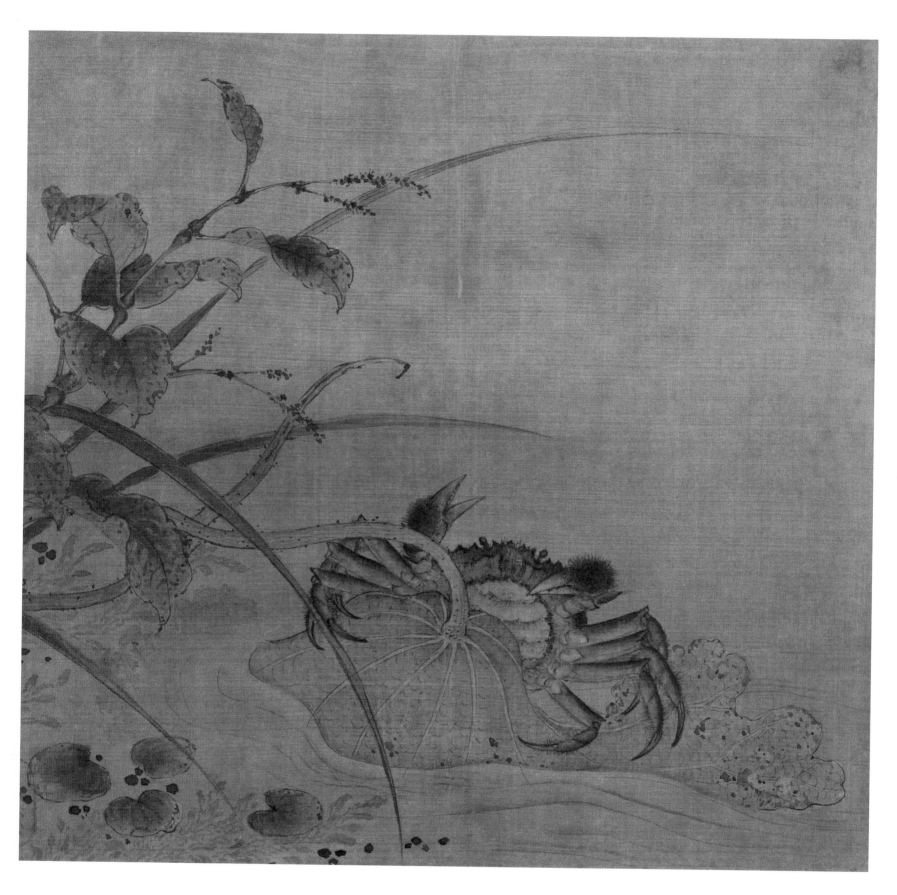

新156350

宋 佚名
荷蟹图页

117 | 绢本　纵28.4厘米　横28厘米
Xin156350

Anonymous, Song dynasty
Withered Lotus and Crab
Album leaf, silk
28.4 × 28 cm

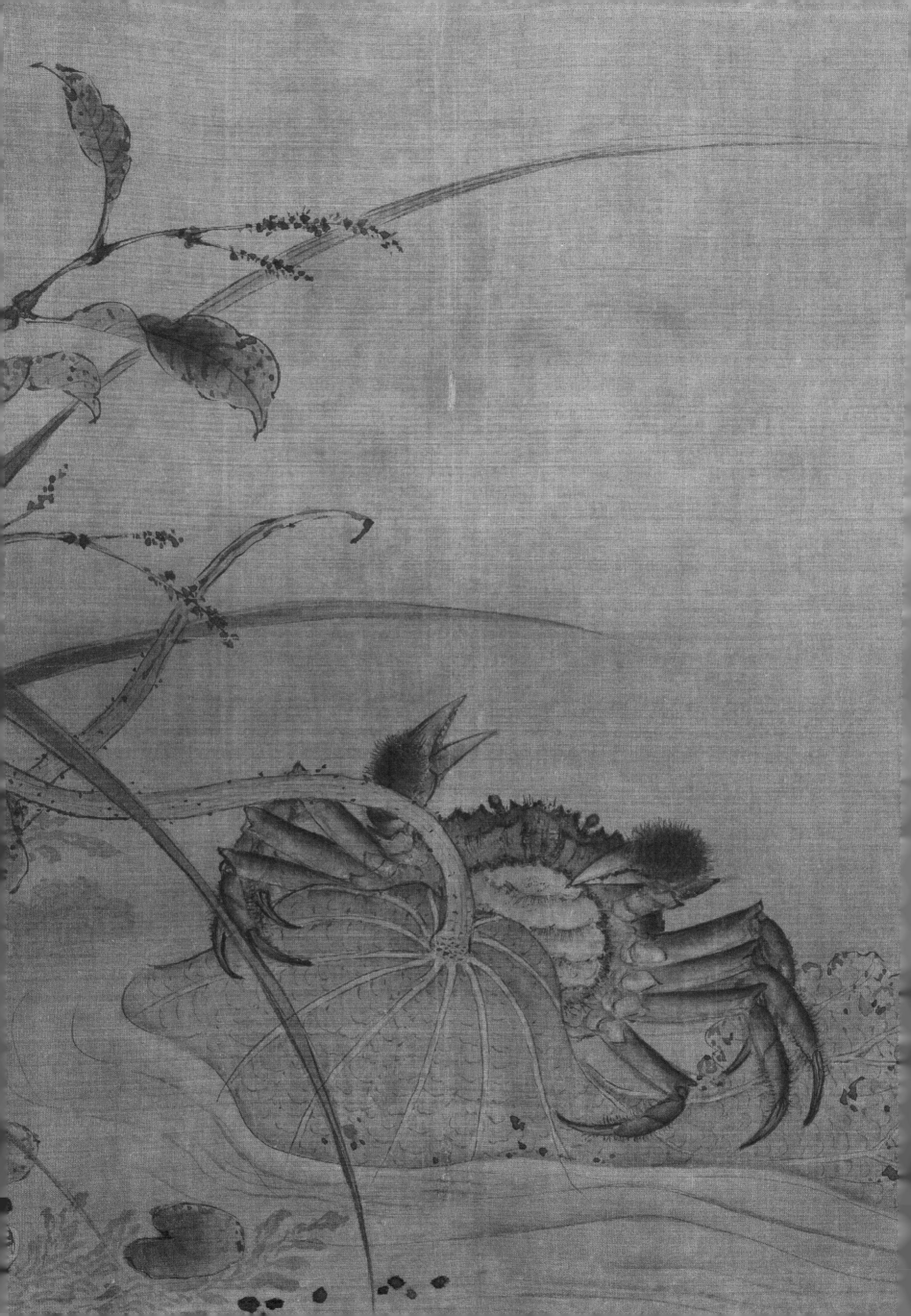

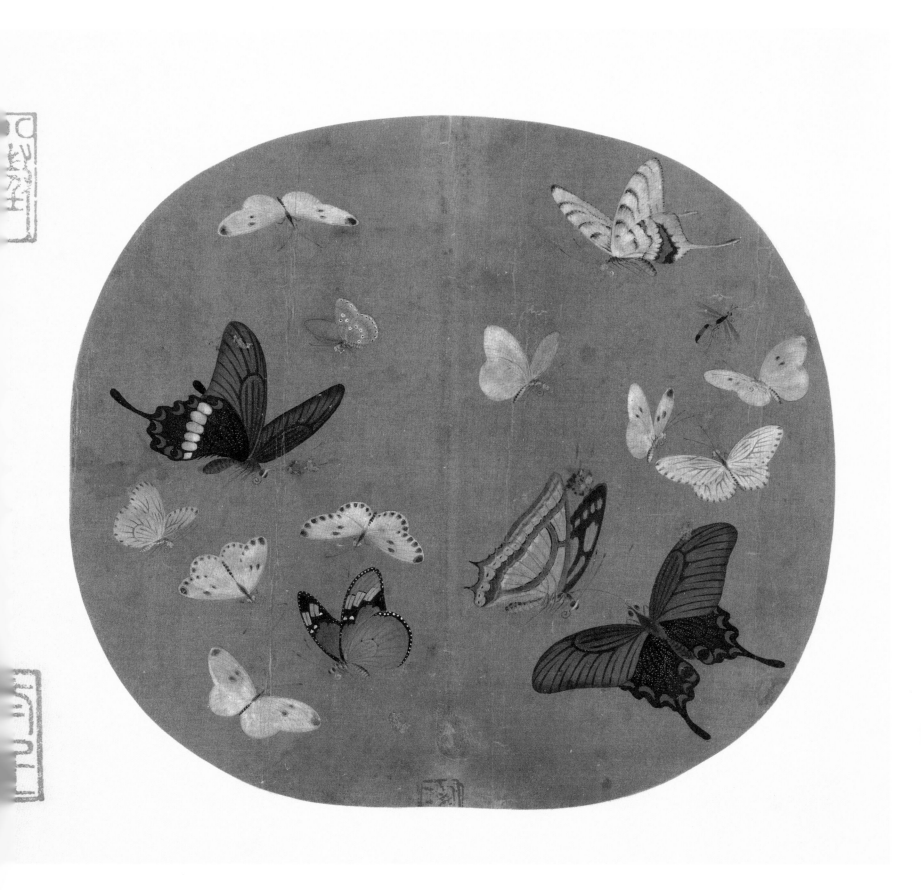

故6151 3/10
宋 佚名
晴春蝶戏图页

118 | 绢本　纵23.7厘米　横25.3厘米
Gu 6151 3/10

Anonymous, Song dynasty
Dancing Butterflies in Spring
Album leaf, silk
23.7 × 25.3 cm

嫣嫩霄
翹高復低春園
風物已昌弓宣
和盡院曾經試
何來明拈逐馬
歸

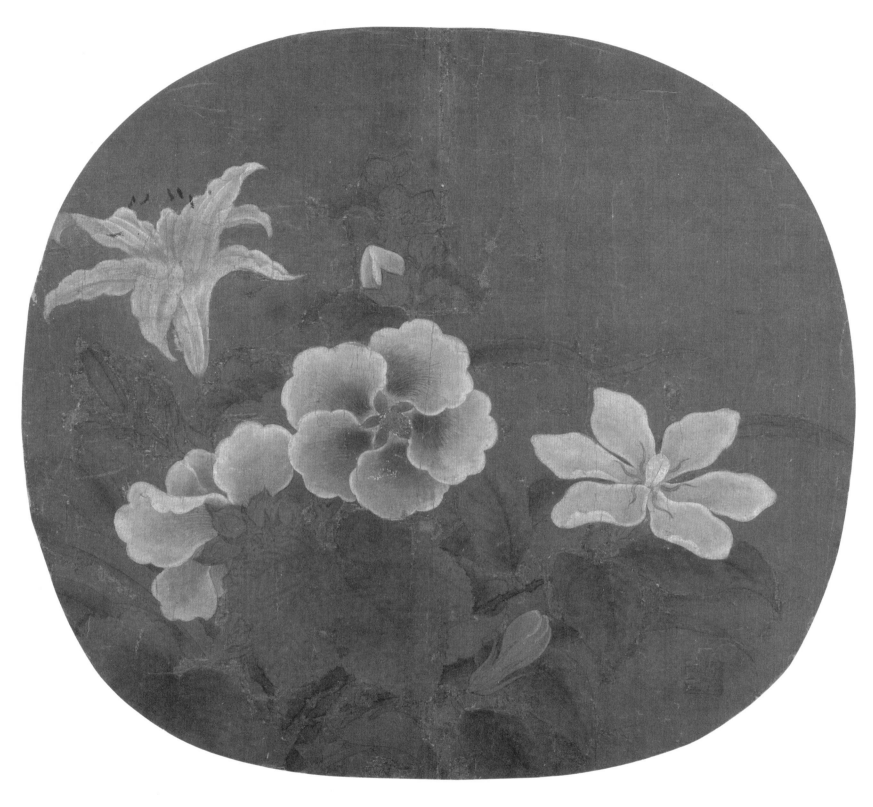

故6152 7/10

宋 佚名
夏卉骈芳图页

119 | 绢本　纵23.7厘米　横25.2厘米

Gu 6152 7/10

Anonymous, Song dynasty
Beautiful Flowers in Summer

Album leaf, silk
23.7 × 25.2 cm

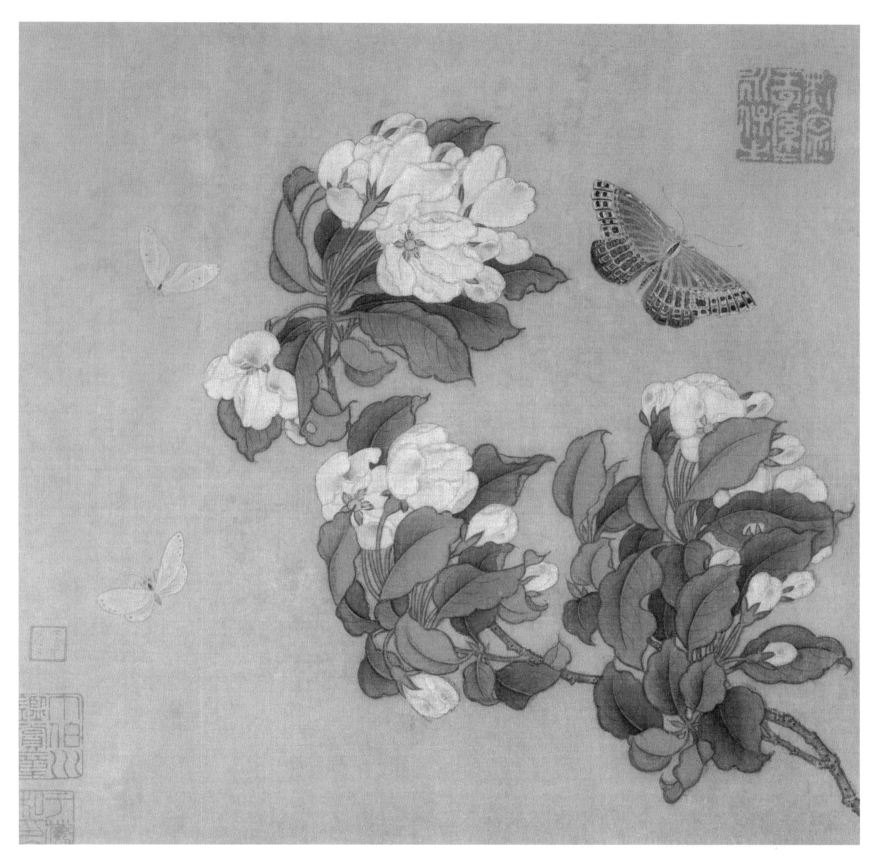

新70988

宋 佚名
海棠蛱蝶图页

120　绢本　纵25厘米　横24.5厘米

Xin70988
Anonymous, Song dynasty
Begonia and Butterflies
Album leaf, silk
25 × 24.5 cm

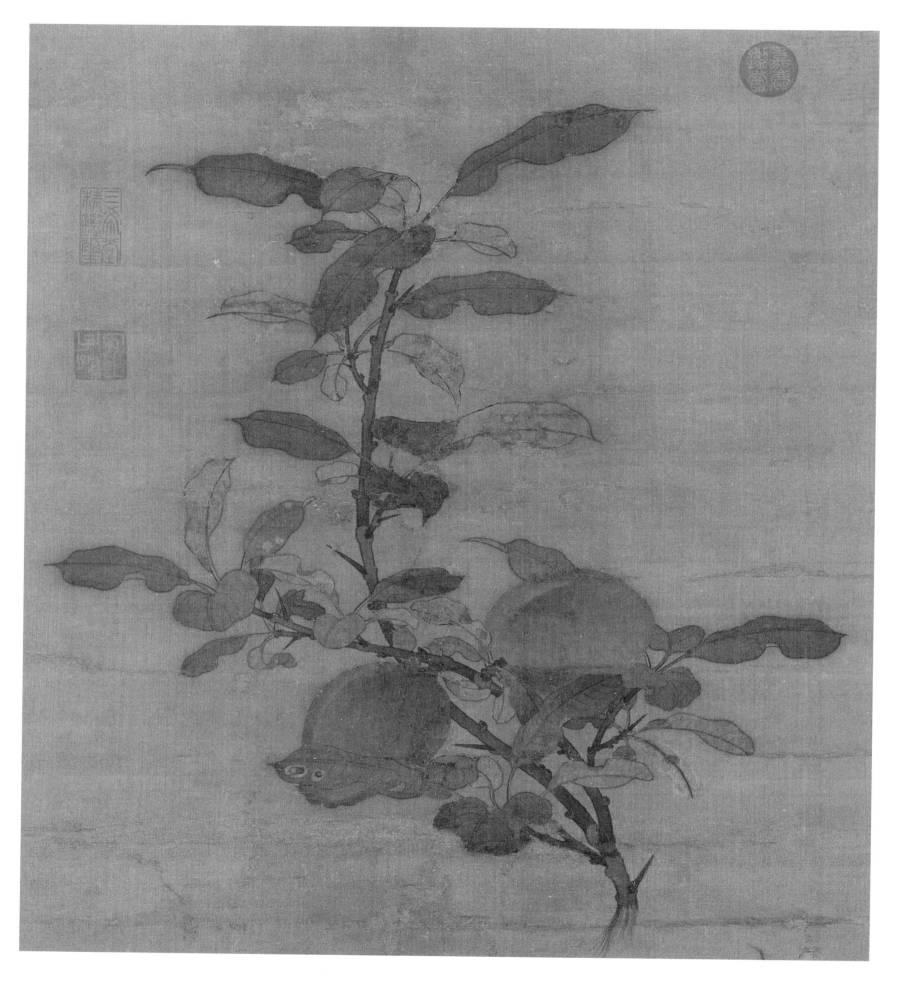

故6156 1/11

宋 佚名
折枝果图页

I2I 绢本 纵52.8厘米 横46.5厘米

Gu6156 1/11
Anonymous, Song dynasty
Sprays of Fruits
Album leaf, slik
52.8 × 46.5 cm

230

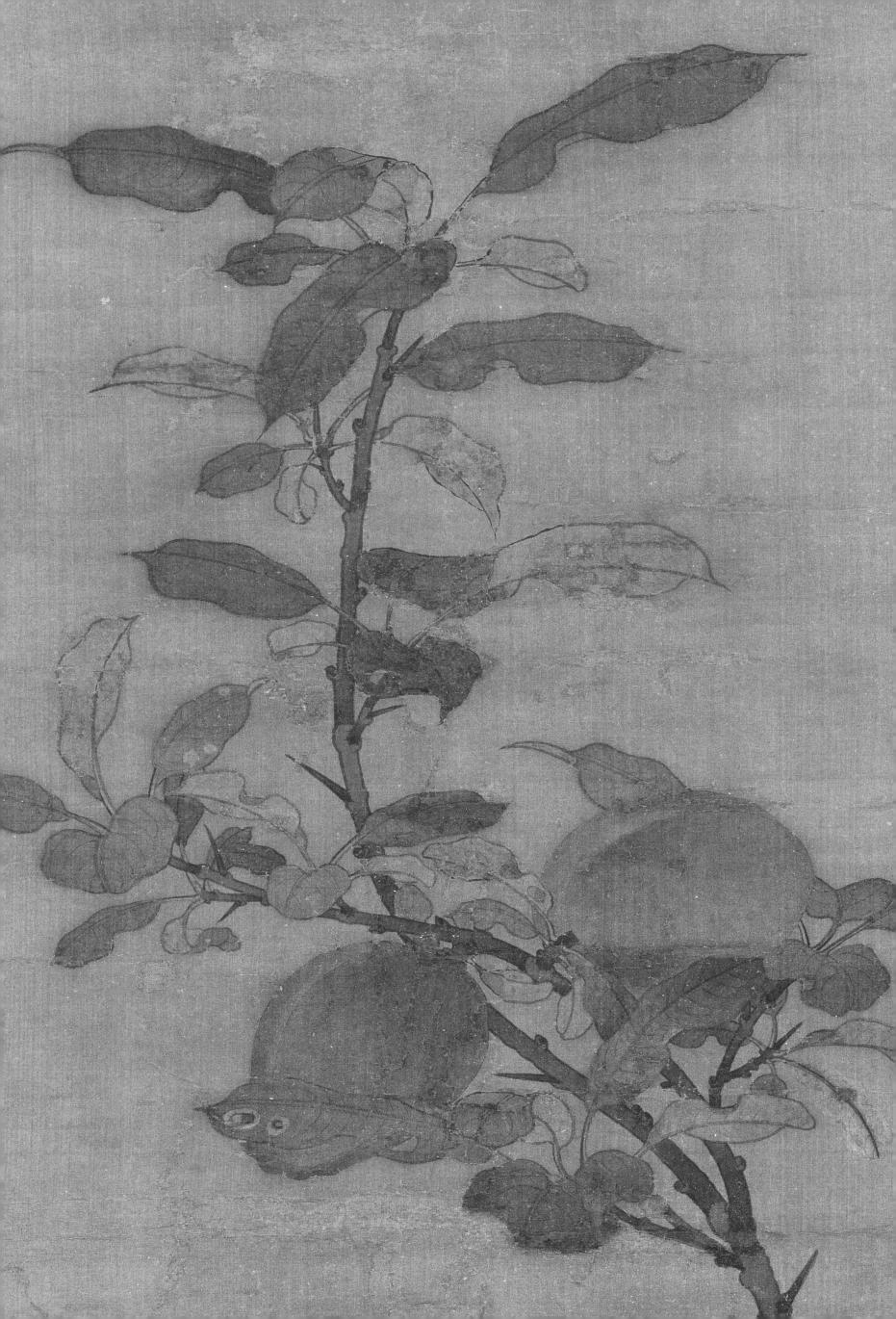

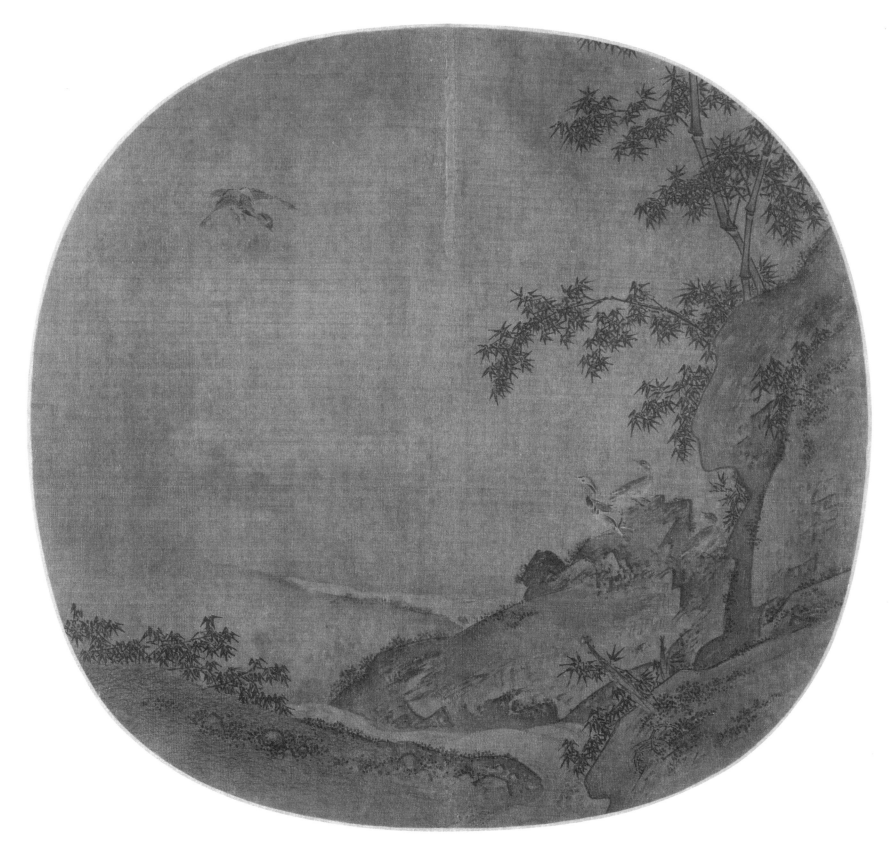

新156352

宋 佚名

竹涧鸳鸯图页

122 绢本 纵24.8厘米 横24.8厘米

Xin156352

Anonymous, Song dynasty
Mandarin Ducks under Waterside Bamboo
Album leaf, silk
24.8 × 24.8 cm

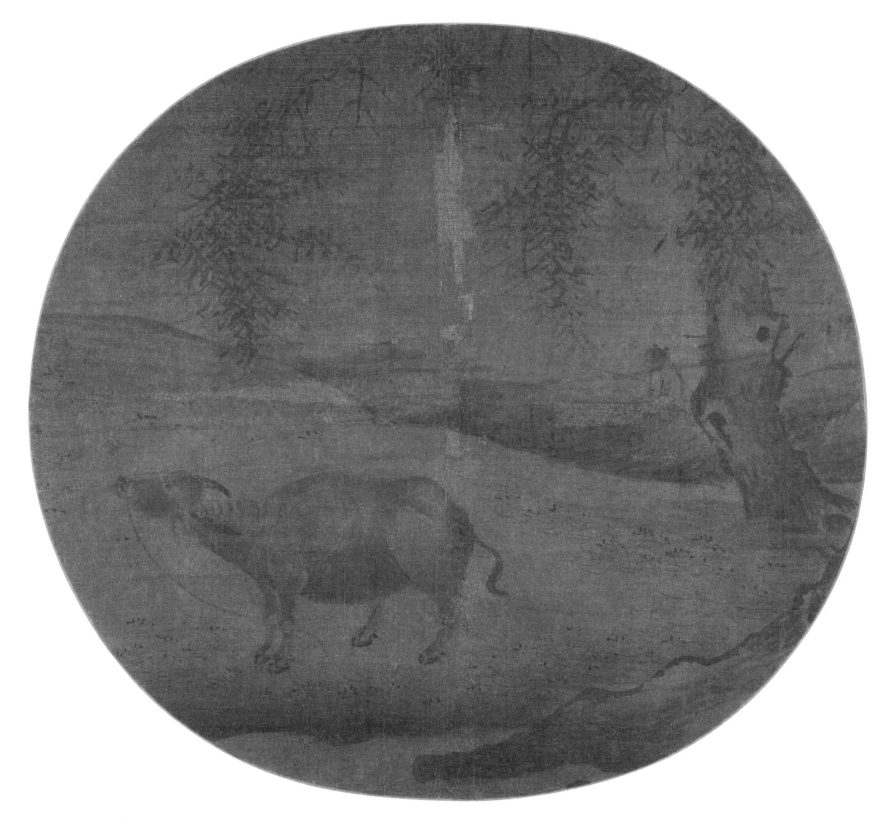

新20637

宋 佚名
柳林牧牛图页

123 | 绢本 纵23.2厘米 横24.1厘米

Xin20637

Anonymous, Song dynasty
Cowboy and Buffalo in Willow Grove

Album leaf, silk
23.2 × 24.1 cm

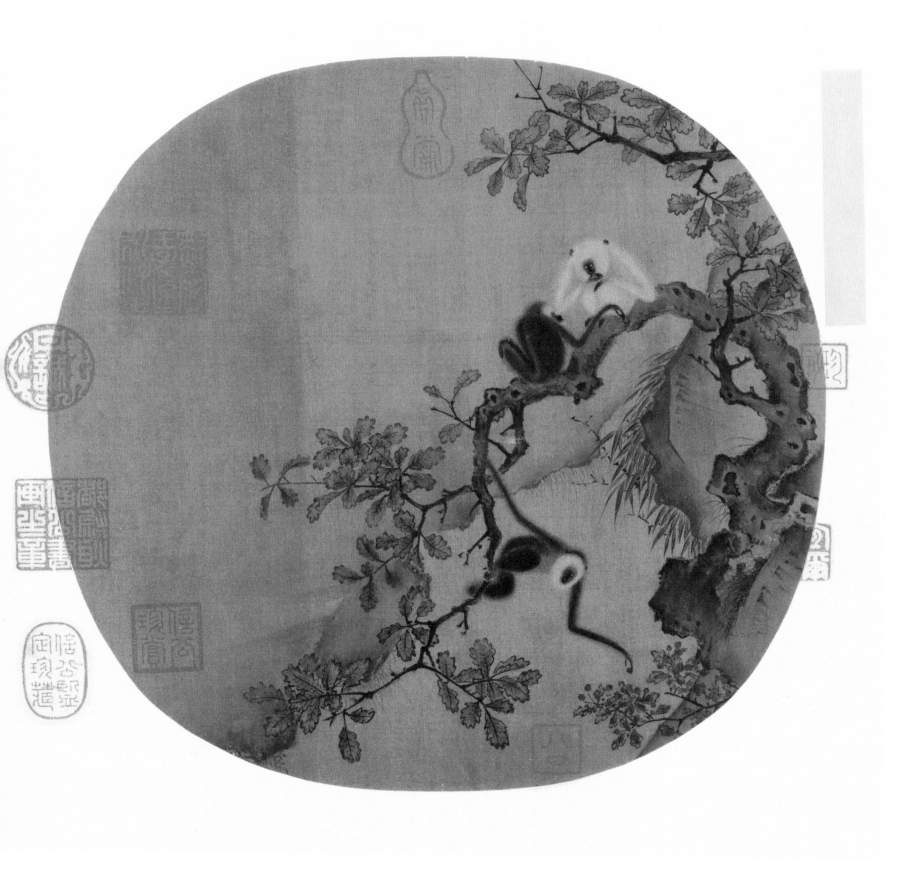

新13845　10/15

宋　佚名
猿猴摘果图页

124　绢本　纵25厘米　横25.6厘米

Xin13845　10/15
Anonymous, Song dynasty
Apes Picking Up Fruits
Album leaf, silk
25 × 25.6 cm

北宋易元吉擺脫舊習善寫山林禽
走之族曲盡物情蓋其常遊荆湖間
日与猿狌同籔伺其動靜游息之
態目擊神契狀之毫端以手相泙
職此之故
　　千山耿昭忠

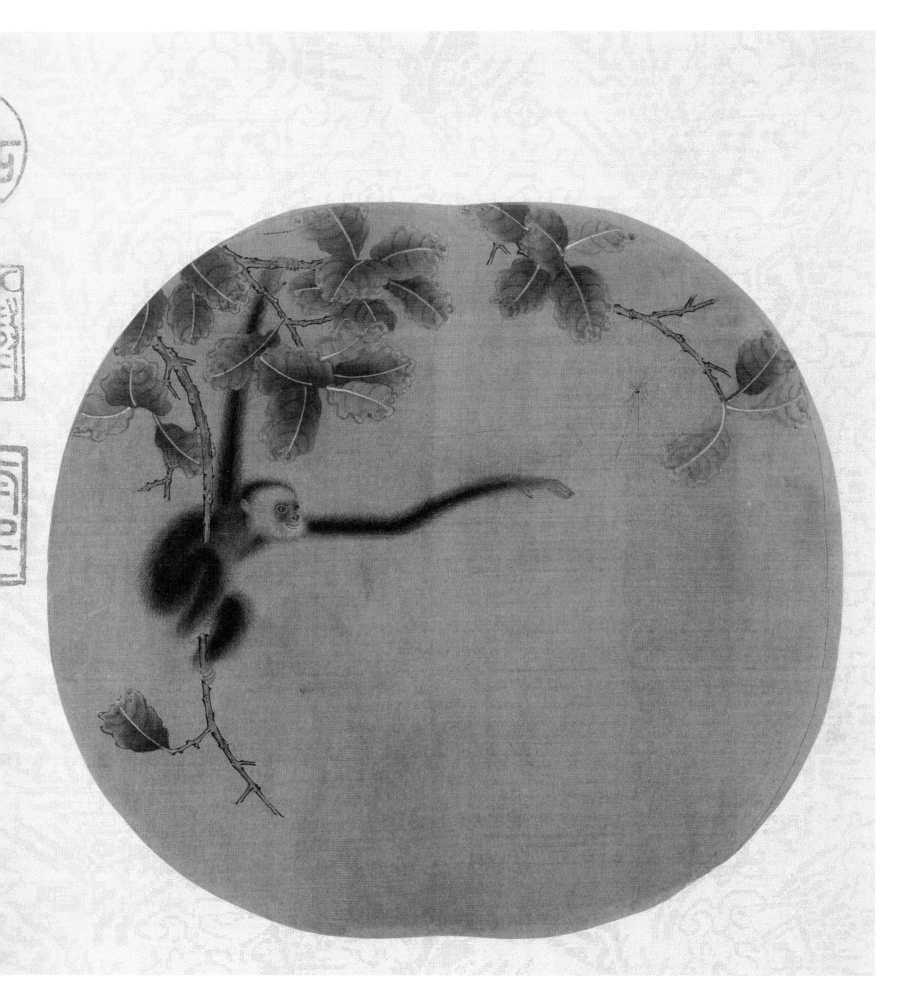

新147430 7/21

宋 佚名
蛛网攫猿图页

125 | 绢本　纵23.8厘米　横25.2厘米

Xin147430 7/21

Anonymous, Song dynasty
Ape Touching Spider Web
Album leaf, silk
23.8 × 25.2 cm

蜘蛛張其綱

捕物供腹唇黑猿

伸長臂攫綱而解紛忿

及不忍閒二者高下分如

何衆與猷有仁有弗仁

慶之非寫生直以畫

劉人

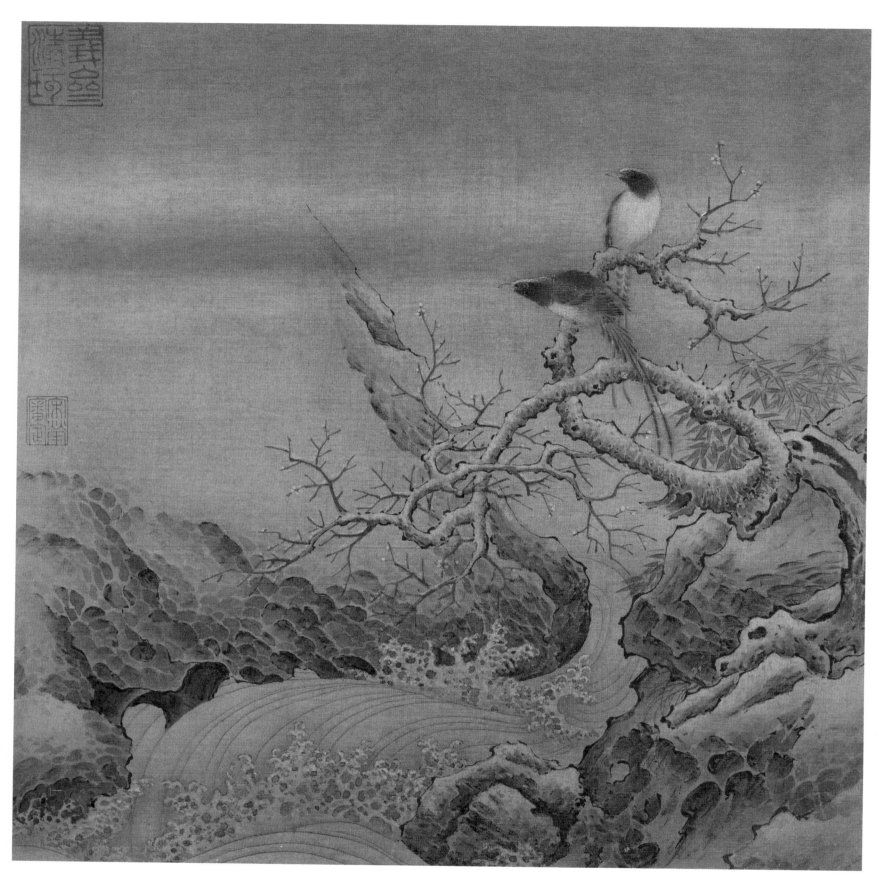

故6154 10/10
宋 佚名
霜柯竹涧图页
126 | 绢本　纵27.5厘米　横26.8厘米
Gu6154 10/10
Anonymous, Song dynasty
Perching on Waterside Tree in Winter
Album leaf, silk
27.5 × 26.8 cm

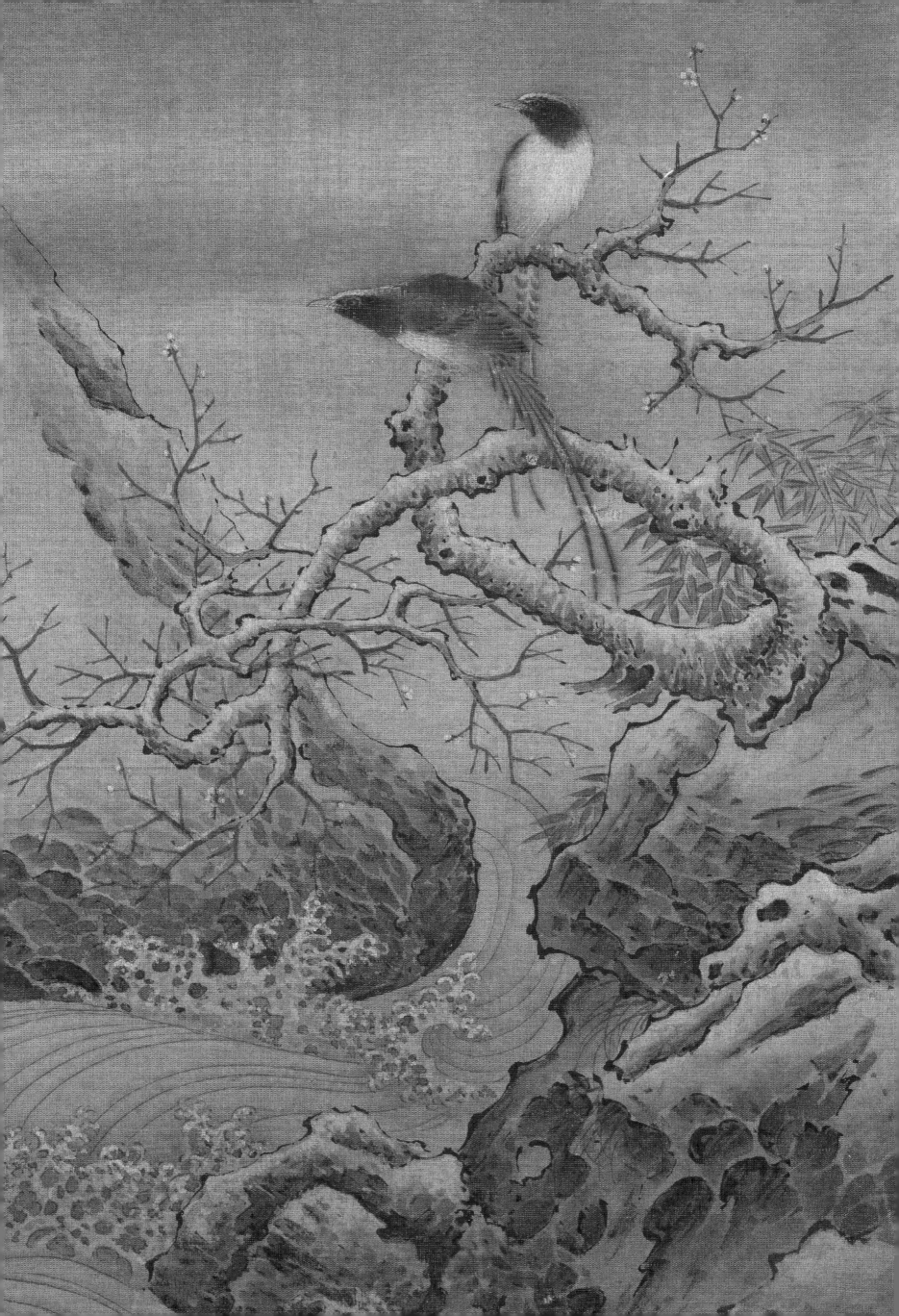

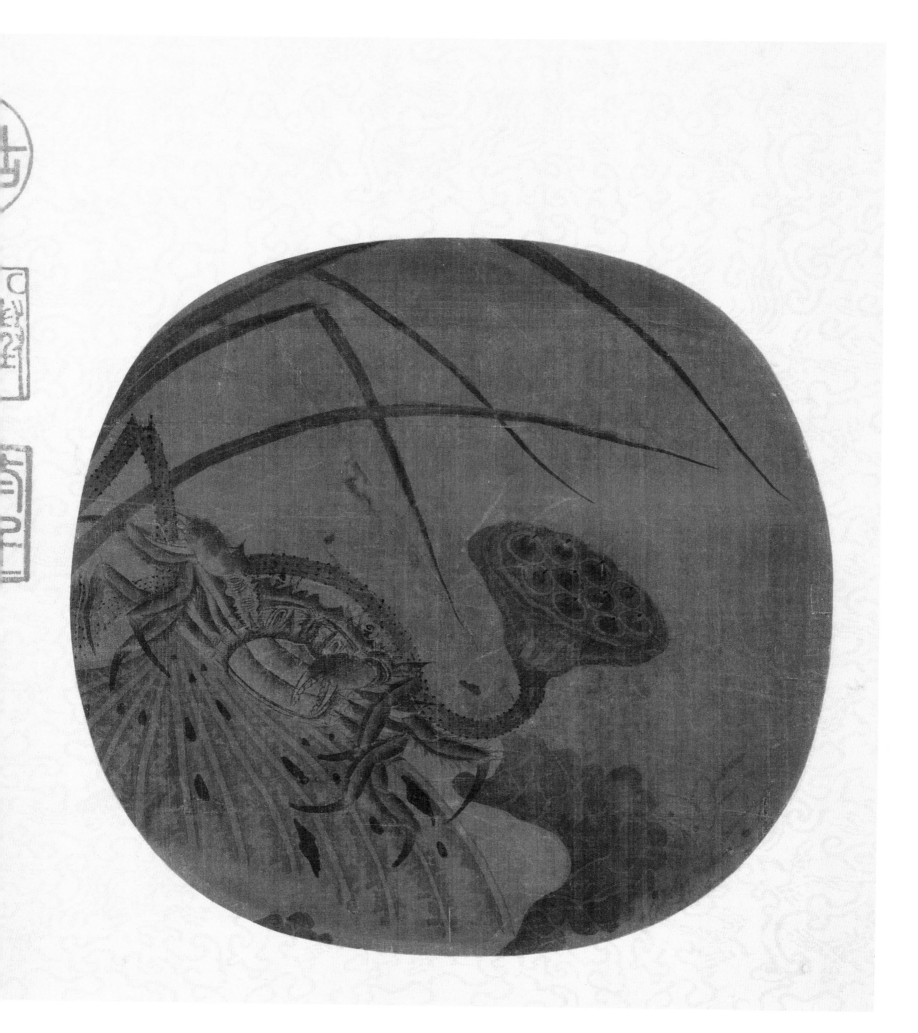

新147430 2/21

宋 佚名
晚荷郭索图页

127 绢本　纵23.9厘米　横24.7厘米

Xin147430 2/21

Anonymous, Song dynasty
Withered Lotus
Album leaf, silk
23.9 × 24.7 cm

泛来鳌蟹
善横行稻熟
秋风意气生甲
介向稷气所畏
如何每入膳
人烹

新156349

宋 佚名

霜柏山鸟图页

128 | 绢本　纵25.4厘米　横24.2厘米

Xin156349

Anonymous, Song dynasty
Tallow Tree and Mountain Birds in Winter
Album leaf, silk
25.4 × 24.2 cm

新148940

宋 佚名
丛菊图页

129 | 绢本 纵24厘米 横25.1厘米

Xin148940

Anonymous, Song dynasty
Chrysanthemums
Album leaf, silk
24 × 25.1 cm

新147430 5/21

宋 佚名
寒塘凫侣图页

绢本　纵16.6厘米　横20.8厘米

130

Xin147430 5/21

Anonymous, Song dynasty
Duck Couple in Spring Pond

Album leaf, silk
16.6 × 20.8 cm

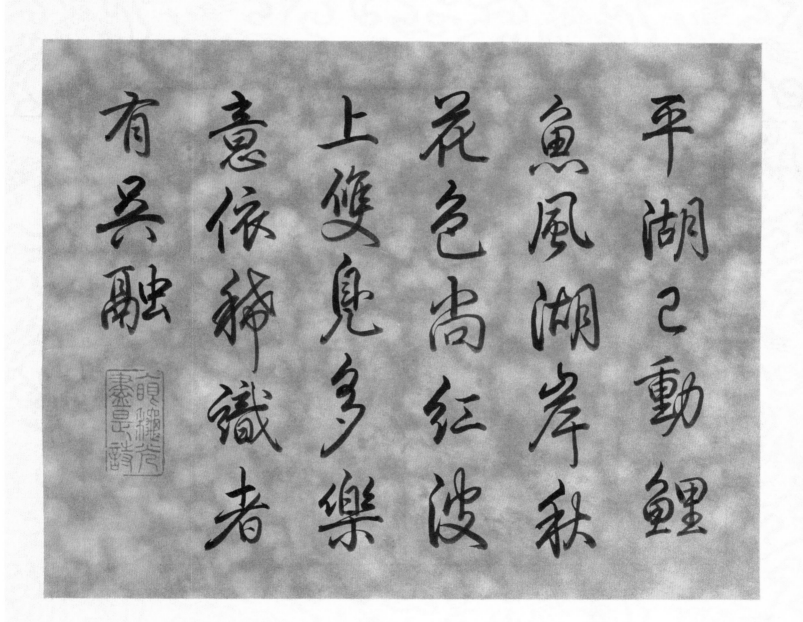

平湖已動鯉
魚風湖岸秋
花色尚紅波
上雙鳧多樂
意依稀識者
有吳融

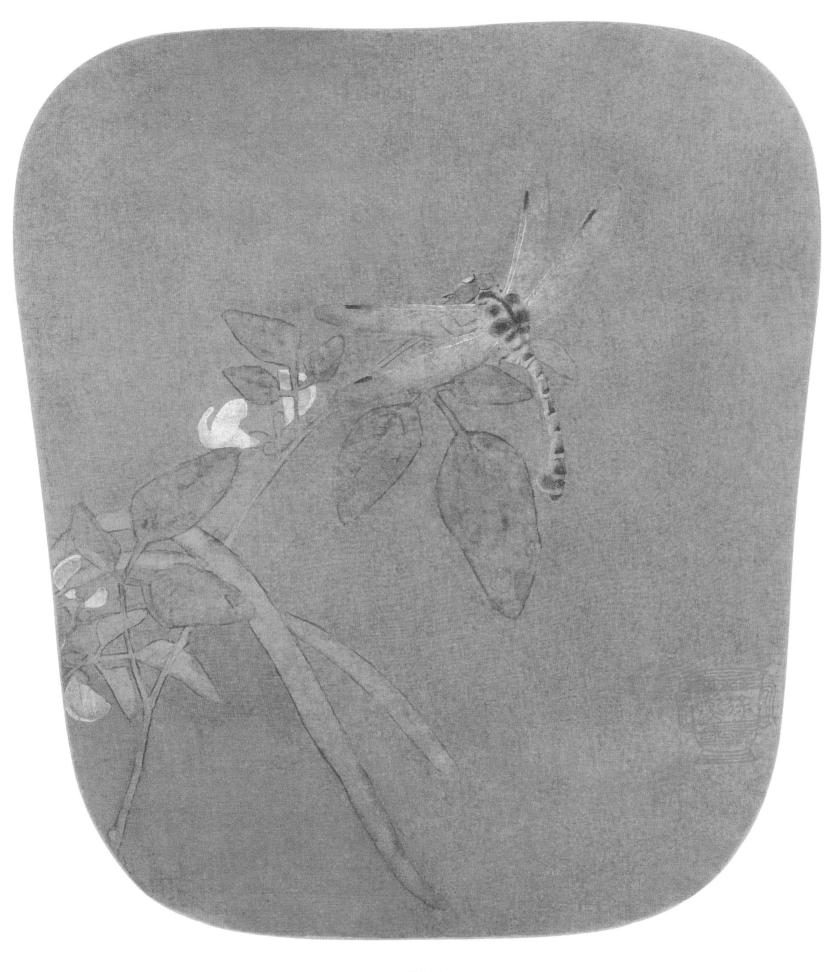

新20636

宋 佚名
豆花蜻蜓图页

131 绢本　纵27厘米　横23厘米

Xin20636

Anonymous, Song dynasty
Bean Flower and Dragonfly

Album leaf, silk
27 × 23 cm

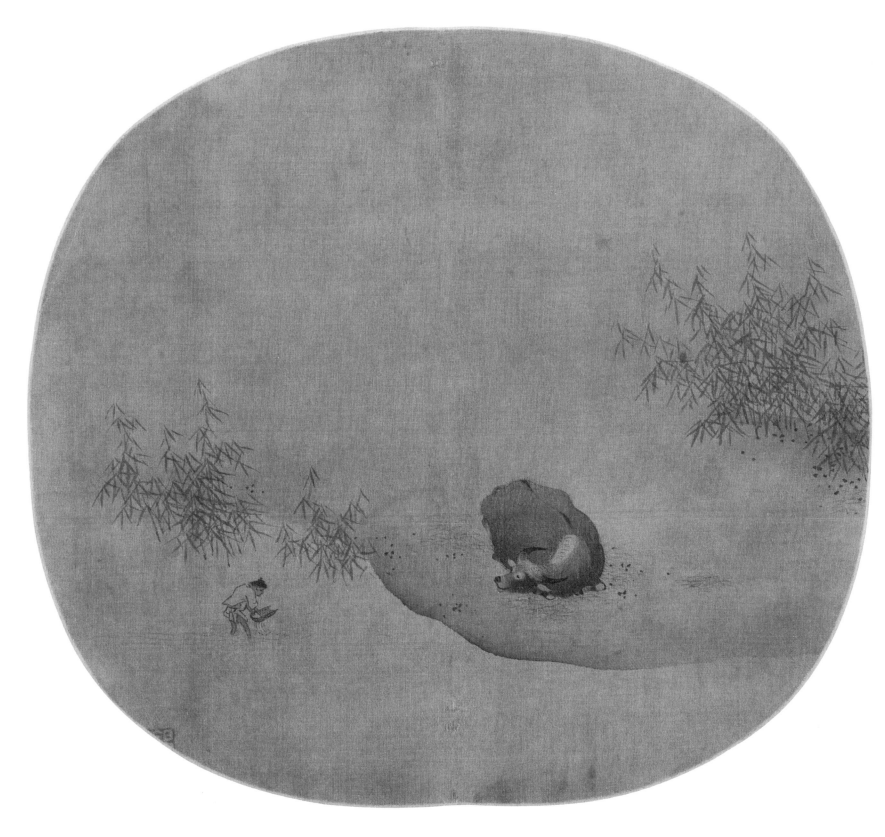

新156353

宋 佚名
牧牛图页

132 | 绢本　纵23厘米　横24厘米

Xin156353
Anonymous, Song dynasty
Cowboy and Cattle
Album leaf, silk
23 × 24 cm

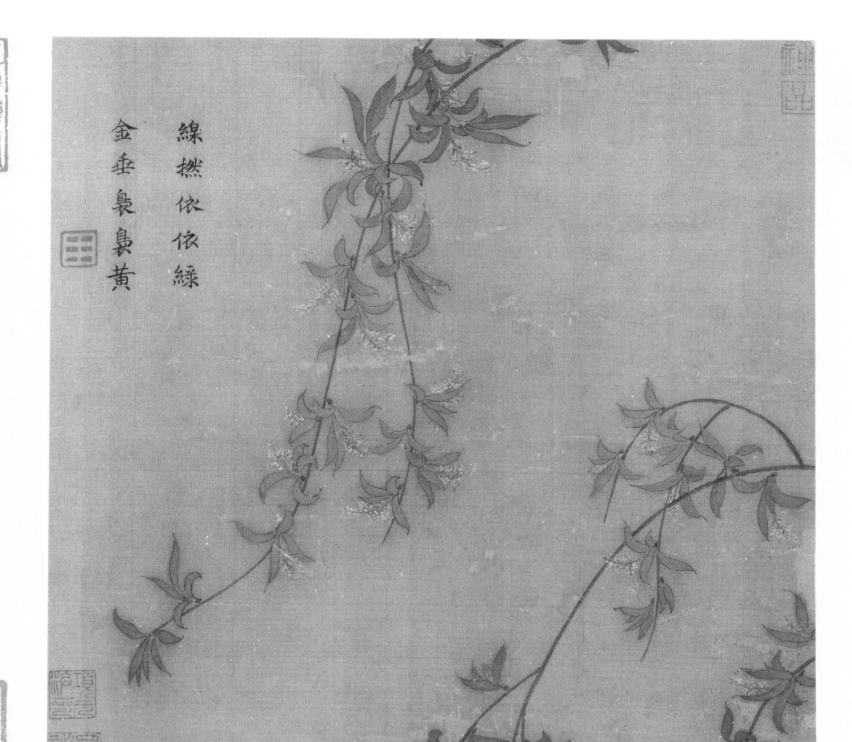

線撚依依綠
金垂裊裊黃

故6150 3/10

宋 佚名
垂杨飞絮图页

133 | 绢本　纵25.8厘米　横24.6厘米

Gu6150 3/10

Anonymous, Song dynasty
Weeping Willow and Flying Catkins
Album leaf, silk
25.8 × 24.6 cm

慶元有楊后可是
出閣西畫自女巾
伎書將帝與齋風
枝如向日雪寒不
沾泥設較謝家句
一筆當讓号

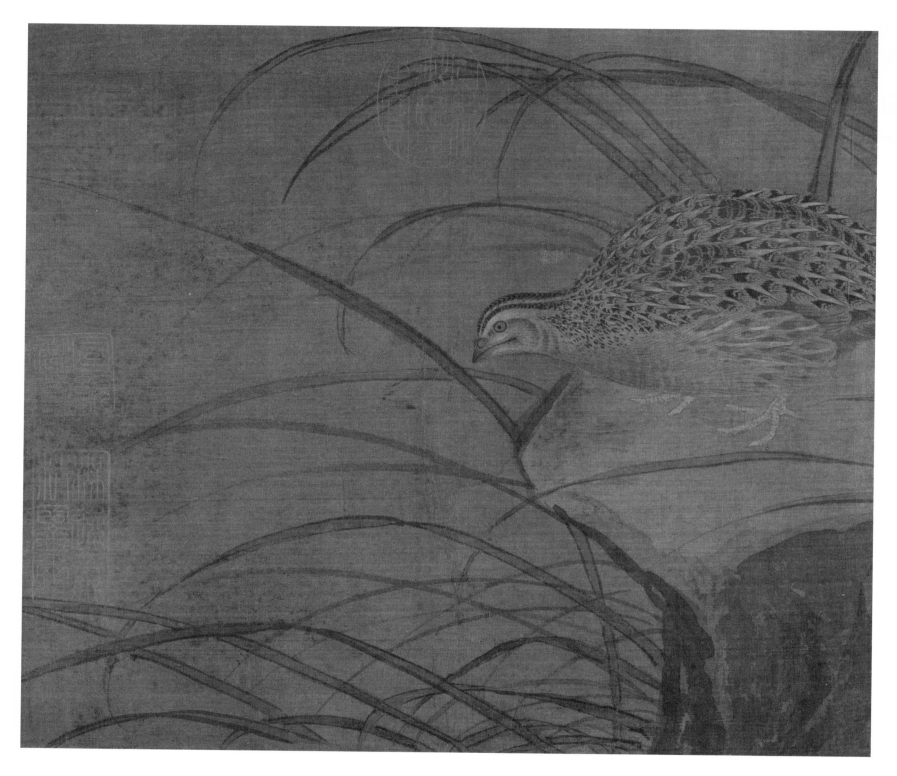

新147506

宋 佚名
鹌鹑图页

I34 绢本　纵22.9厘米　横26.1厘米

Xin147506

Anonymous, Song dynasty
Quail

Album leaf, silk
22.9 × 26.1 cm

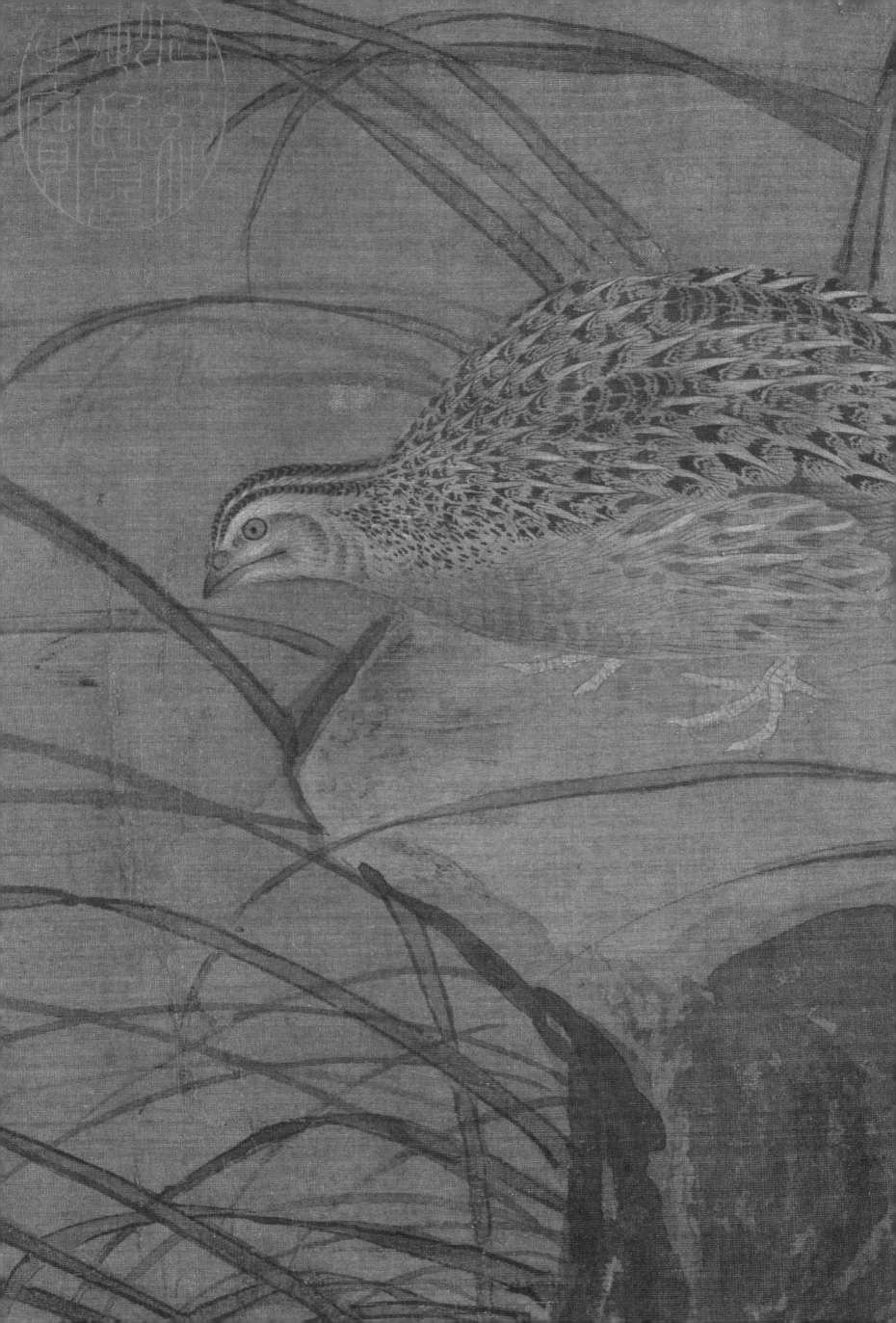

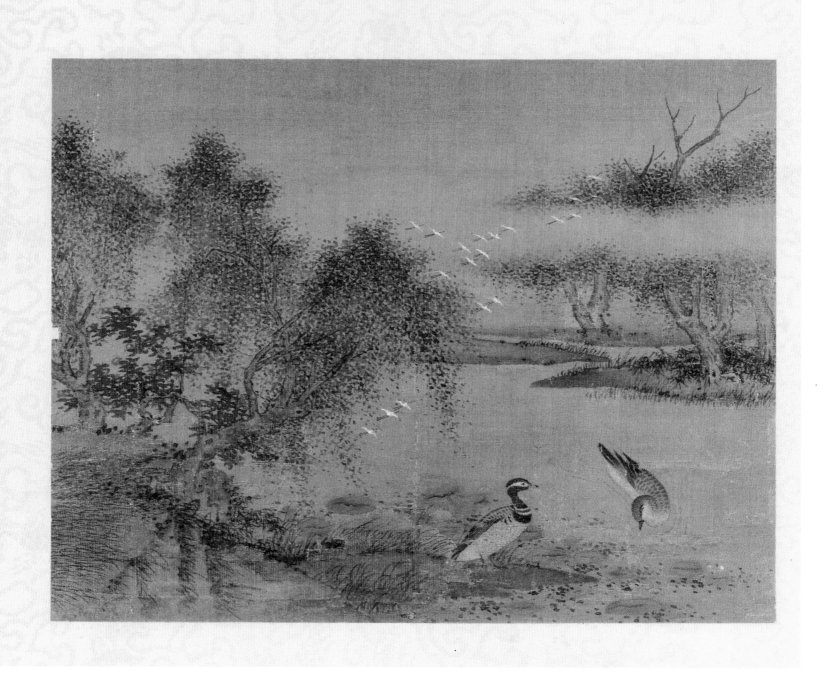

新147430 4/21

宋 佚名
荷塘鸂鶒图页

135 绢本 纵16.8厘米 横21厘米

Xin147430 4/21
Anonymous, Song dynasty
Mandarin Ducks on Lotus Pond
Album leaf, silk
16.8 × 21 cm

花鳥汎來屬創南
水舍夏卉熙晴潭
鴛鴦無礙稱其紫
弟子有時朦彼盞水
咱相呼如解勅沙棠
式度自能語瀁灘
落罩尋常子何涉
西臺紀怪談

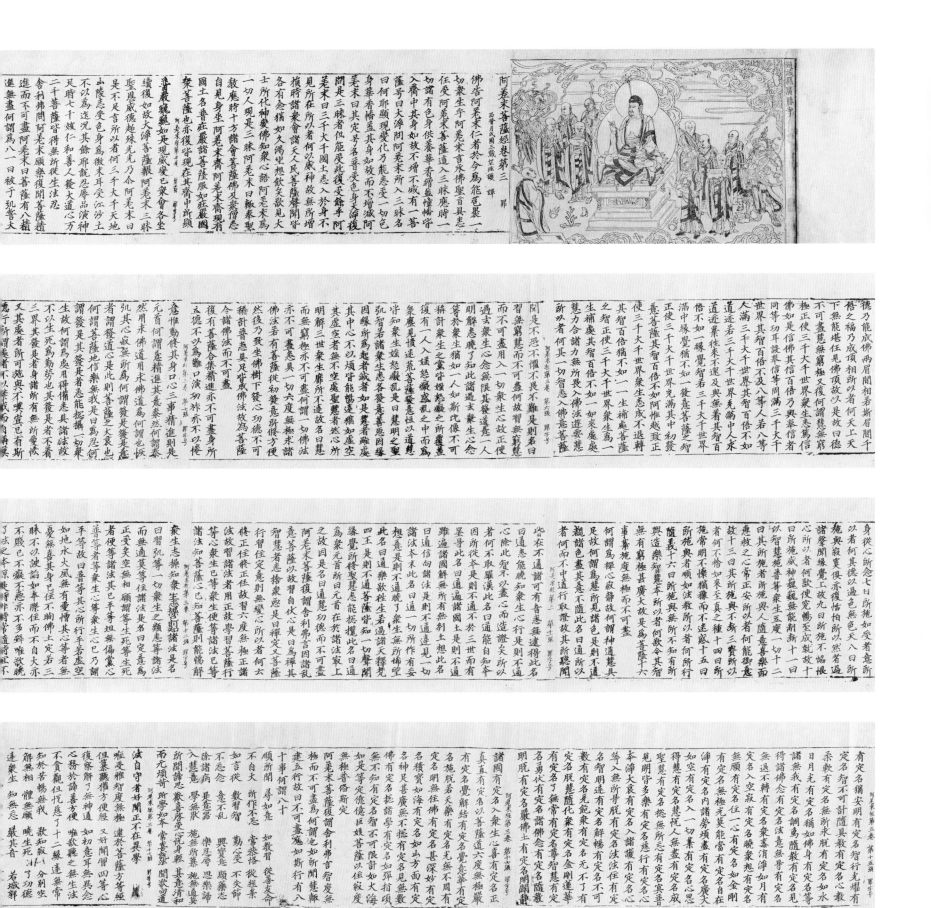

新153385

宋

木版印赵城县阿差末菩萨经卷

136 | 纸本　纵29厘米　横960.2厘米

Xin153385

Anonymous, Song dynasty
Block-printed Aksayamati Sutra of Zhaocheng

Handscroll, paper
29 × 960.2 cm

此篇為《阿差末菩薩經》卷第三之寫本，經文密布、分為四段橫列，每段自右至左豎行書寫，字跡多處漫漶難辨。茲就可辨認之文字迻錄如下：



以名曰被弘誓何名生死用為勞菩故故所以有不計知數當成佛道
亦不思念於若不計知劬勞何以
名曰為普不計久遠長遠無量劫故
菩薩稱為一切之秊方便所更益數

一日至十五歲乃至三十日合為一月
十二月乃一歲如是轉進至千萬歲阿
若百千萬歲發意乃見一佛如此數劫之各
沙劫乃名若江河沙等一佛之數精
央數不可計一切人各皆發心各
哉及一事其未知不可稱計如是
人各如荷功乃具足一切大人相一切大
不用發意乃勸助如來擅長合集心各
者何無懈何況精進而不可盡水火等
勤勉開是精進一心要近而不可盡為

第二段

又其處者離諸忍習俗兼德本諸稱
寂滅不興亦又其處者普現如道德
所作消息趣又其處見諸法入世俗
諸天人皆發意是其處隨時入正真道慧
可盡道法而隨一切處無諸諸法忍
二千天子志得充滿菩薩道忍
三昧一切衆習意為覆載為之所
動持一切所行菩薩言諸菩薩
行不離慧所行功德惡因是為之盡
一切興無極处是为欲盡何無盡

第三段

衆生故斯號名曰善權方便寂然悟
怕三昧之業此為聖戒已如三昧心
建立者依初得從佛慧而答諸
法永無所求亦是曰智慧華執定意又
無陷非法忍慧修習便能悟習心坦
佛諸音猶如金剛善思惟念復慧善
定轉無所斷是曰智慧無處愛三昧心念
權又離愛欲相庄嚴是曰智權以濟衆
權曉無本末亦無根原是為清淨此
於三昧諸佛上意為清淨是曰智慧住

第四段

何名求菩薩經卷第三

阿差末菩薩經卷第三

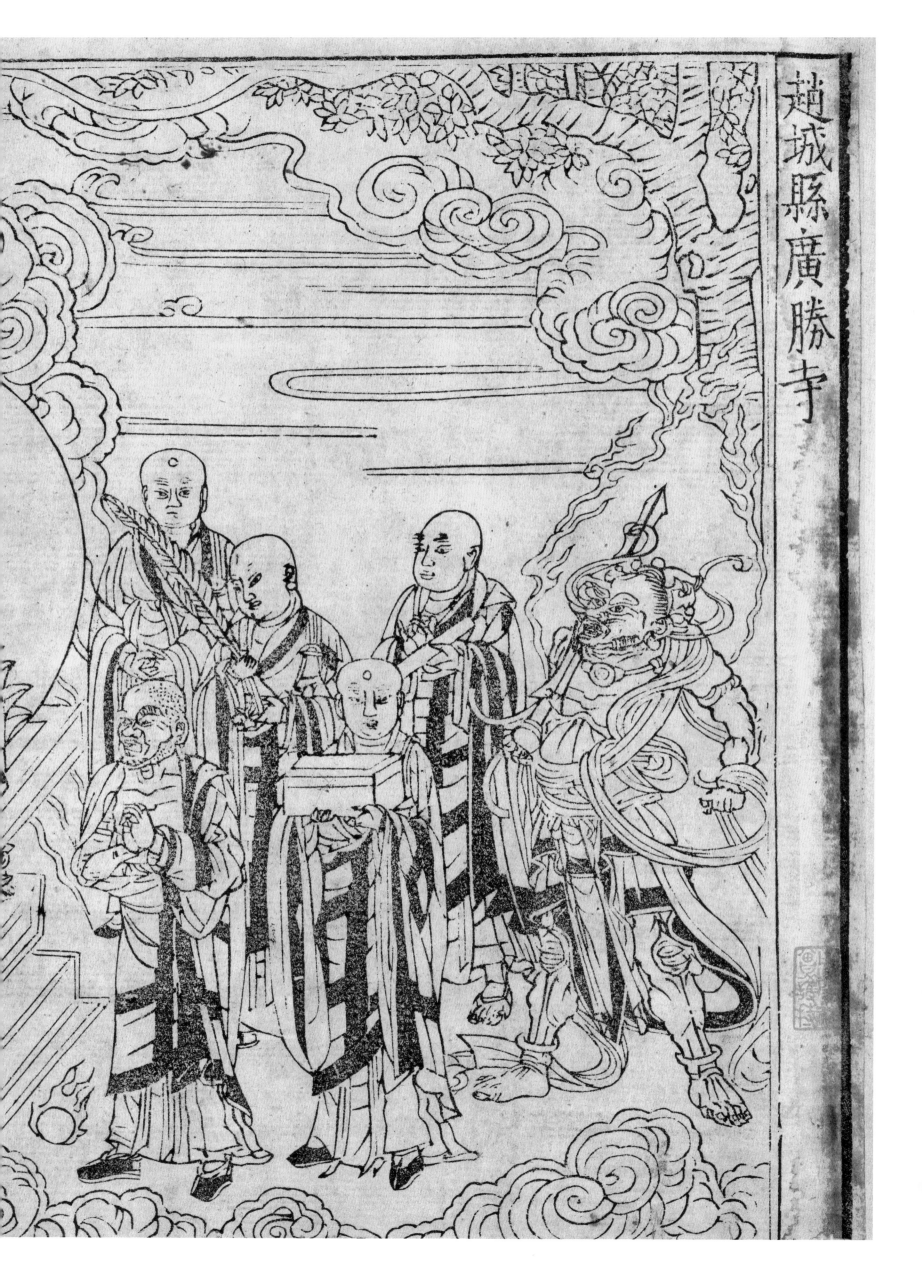

趙城縣廣勝寺

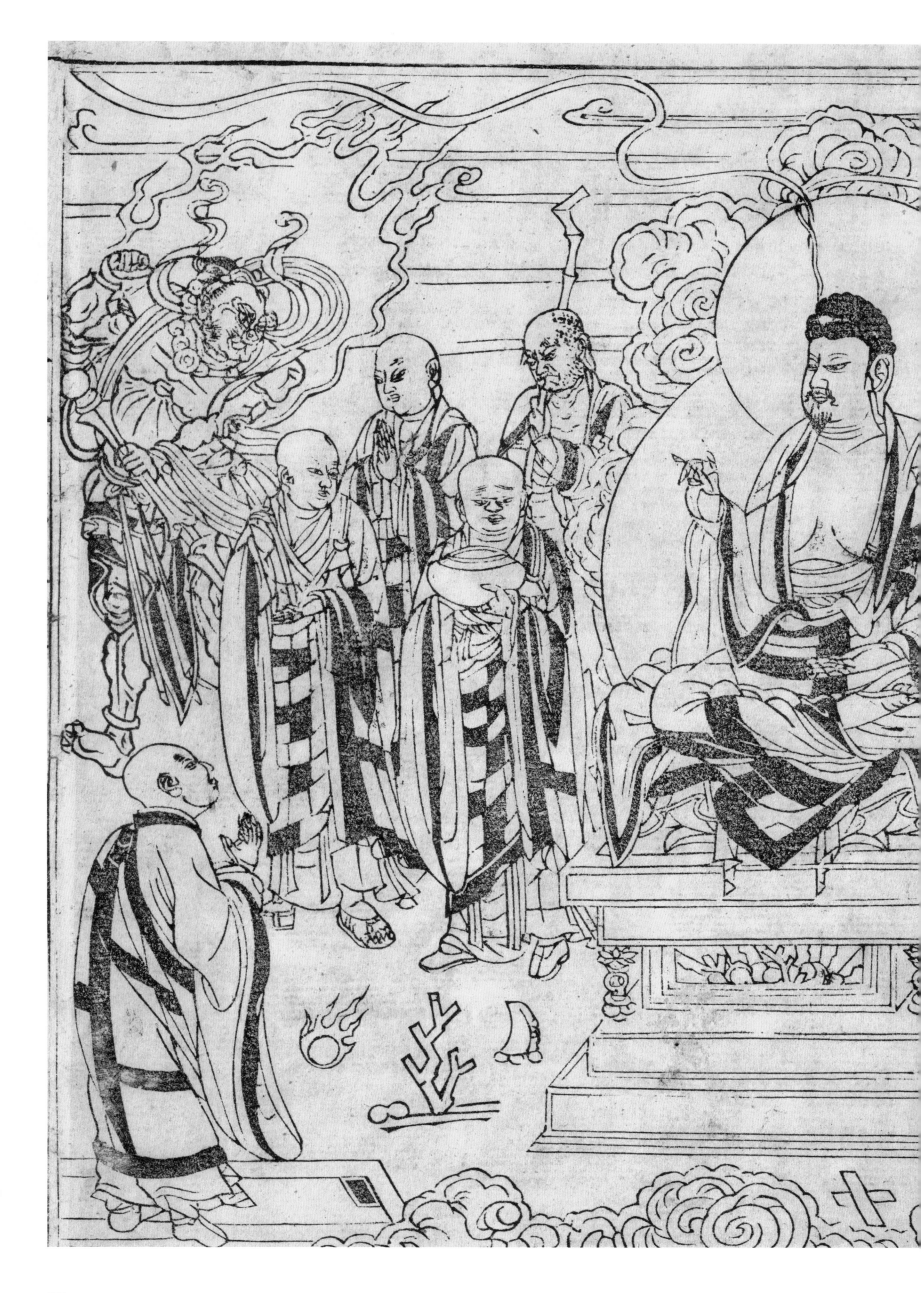

大宋新譯三藏聖教序
御製

新176125
宋 佚名
赵城版画经卷
纸本　纵25.2厘米　横30厘米
Xin176125
Anonymous, Song dynasty
Printed Illustration of Zhaocheng Sutra
Handscroll, paper
25.2×30 cm

137

大乘寶月童子問法經

西天譯經三藏朝散大夫試鴻臚少卿傳法大師臣法護奉詔譯

如是我聞一時佛在王舍城鷲峰山中，與大苾芻眾五千人俱，一心恭行菩提行。無能勝菩薩等，八萬四千那由他等百千菩薩眾俱。苾芻一心入王舍大城，遇見世尊即下龍象而為禮足，諸天神等恭敬圍繞。苾芻因事故乘大龍象出王舍大城，遇見世尊即下龍象而為禮敬，頭面禮足，遶一匝而詣佛所，到已致敬，於無上正等正覺遠得不退。

爾時世尊告寶月童子言：善哉善哉。一切正覺童子汝今諦聽，所有名號若人信心善男子善女人正等正覺唯願世尊說十方如來所有名號...

（正文）

恒河沙等佛剎彼有世界名曰不動，為諸眾生恒說妙法...

彼有如來名曰寶幢，應正等正覺。

佛言童子此方過百千俱胝那由他多，為諸眾生恒說妙法...

大乘寶月童子問法經

大唐新譯三藏聖教序

御製

大哉我佛之教也，化導群迷，闡揚宗性。廣博宏辯，英彥莫能究其旨趣。微妙說義，庸愚豈可度其源理。幽玄真空妙有，剏包括於萬象。囊括綜法網之紀綱，濟無際之津梁。言之正教，流四生於苦海，證三乘之祕典，濟含識萬編，佛可盡迷。賜日月盈昃，寒來暑往，大則說諸善惡。細則比於恒沙含識，萬編佛可盡迷。若窺像法，如影隨形，離六情以長存。

佛說十號經

云何調御丈夫佛言大丈夫而能調御善惡二類，惡者起不善三業，而作諸惡墮地獄餓鬼傍生而得惡報。善者身口意業修行諸善獲福之報，此之善惡二法，示調御令離塗苦，令至涅槃寂滅之樂，是故名調御丈夫。

云何天人師佛言非與阿難一苾芻為師，所有恣智慧塞婆界為波卒夷及天上人間沙門婆羅門魔王外道釋梵龍天眾皆歸命依教奉行俱獲最上寂滅是故名天人師。

云何名佛智慧具足三覺圓明是故名佛。

云何名世尊佛言具一切智，所有善法戒心慧解脫知見皆悉具足，天上人間魔梵沙門婆羅門等無上菩提最上尊是故名世尊...

佛說十號經

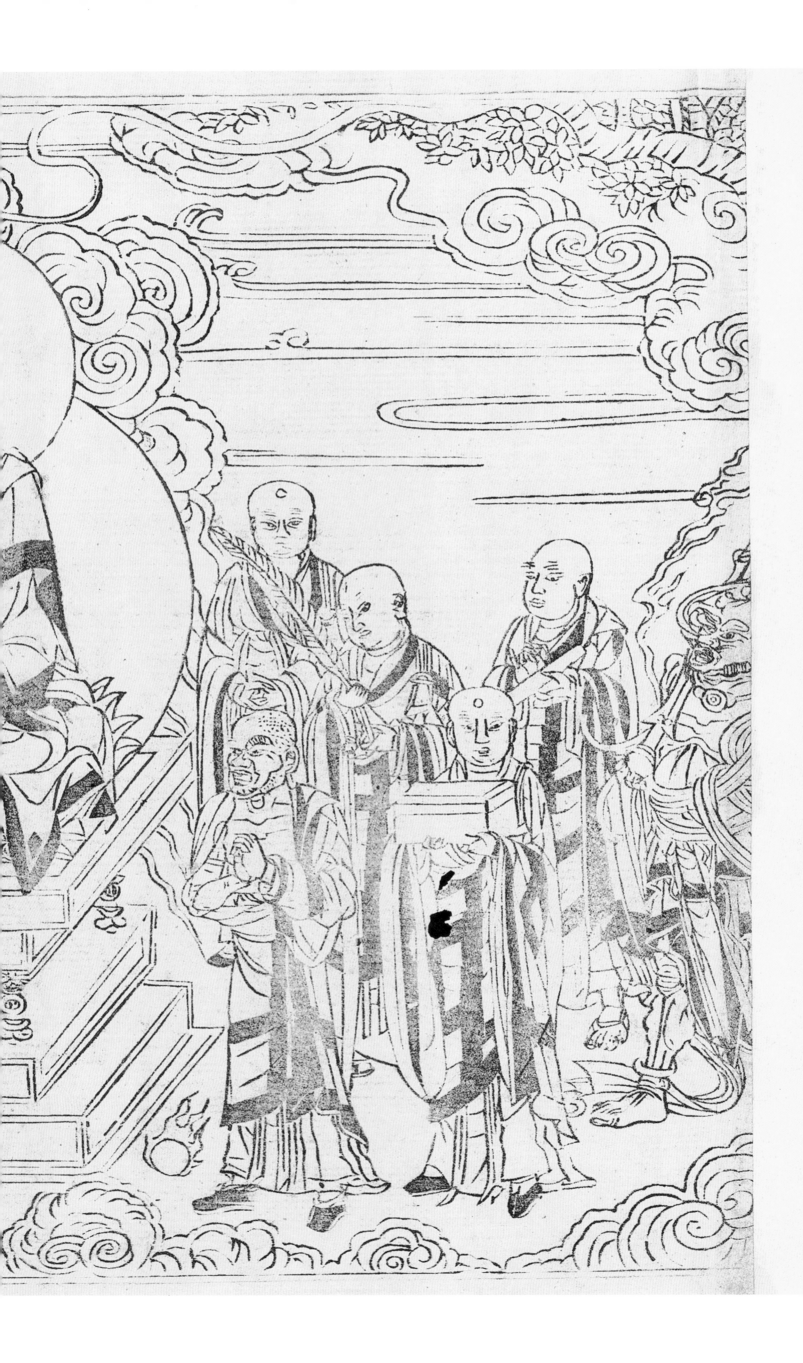

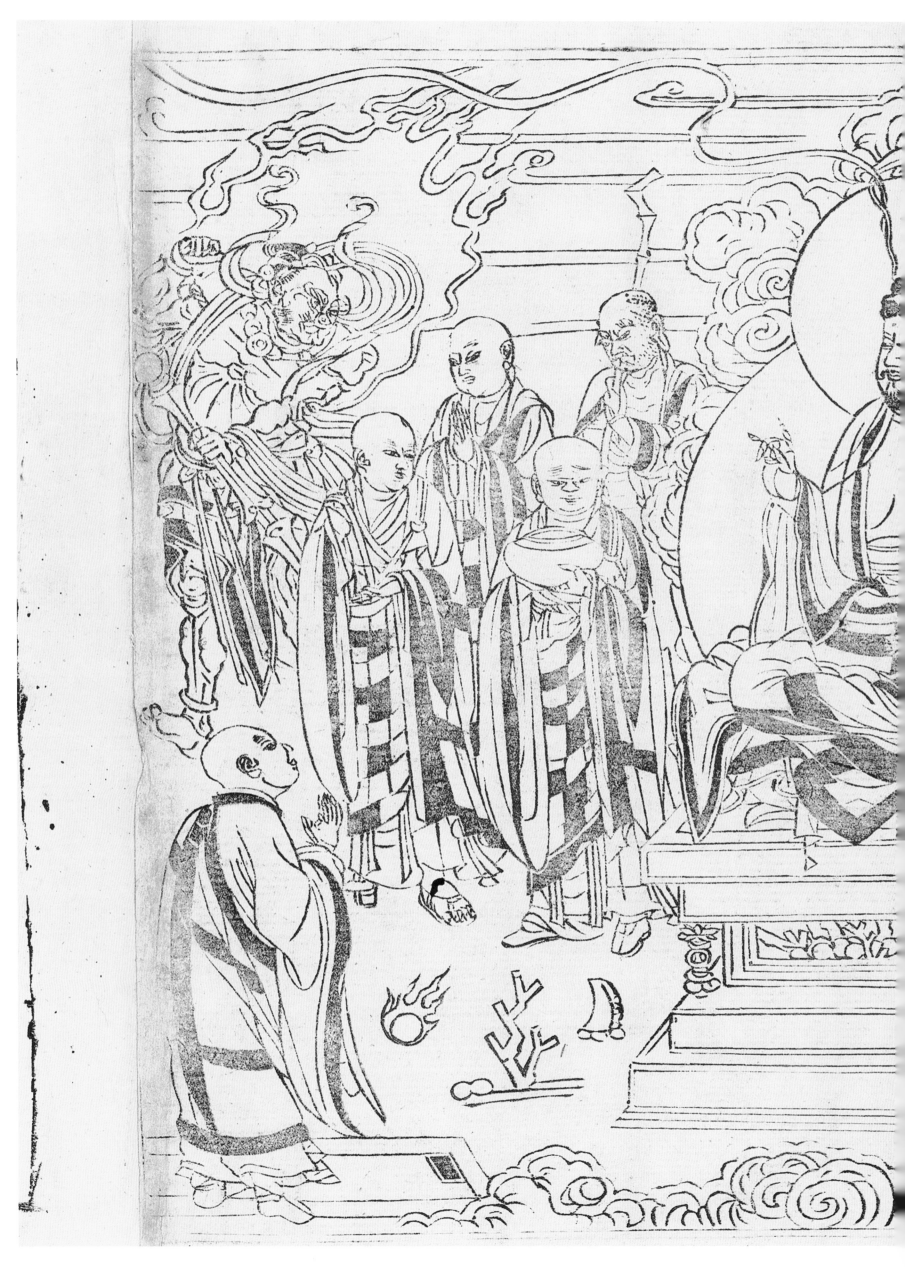

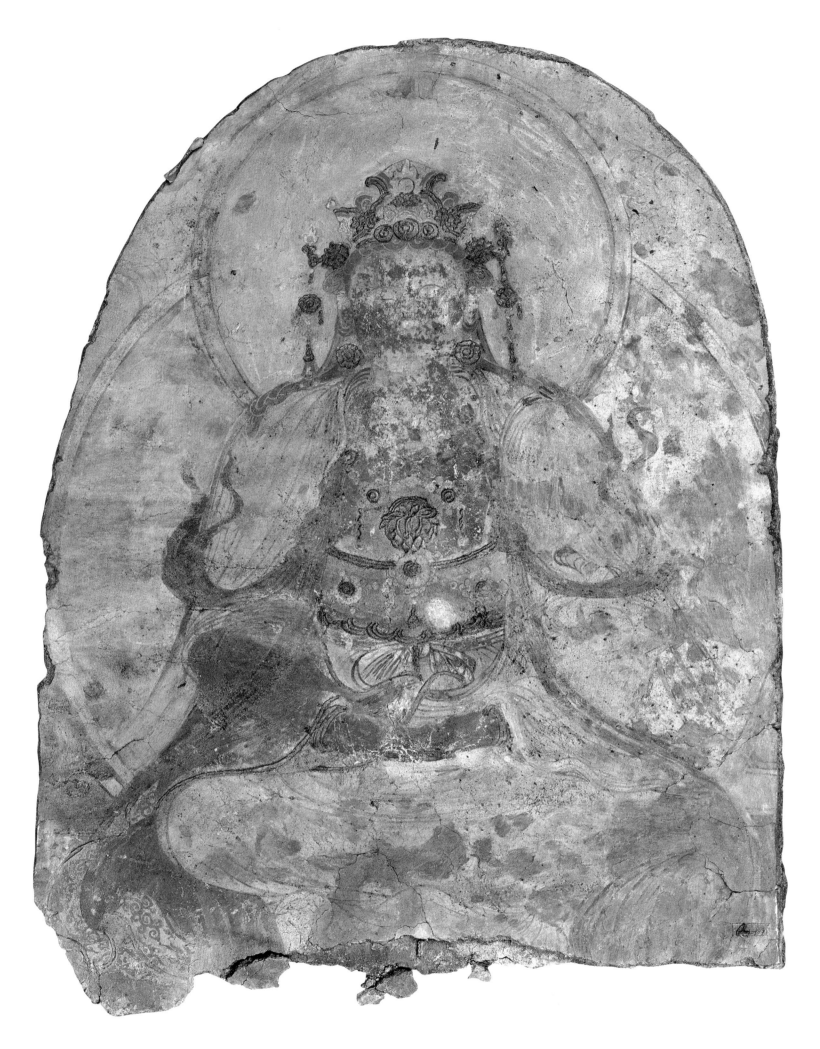

新60907

宋 佚名
持箫独立女佛壁画

138 泥质 纵117厘米 横91.5厘米

Xin60907

Anonymous, Song dynasty
Standing Goddess Holding Vertical Flute

Wall painting, plaster
117 ×91.5 cm

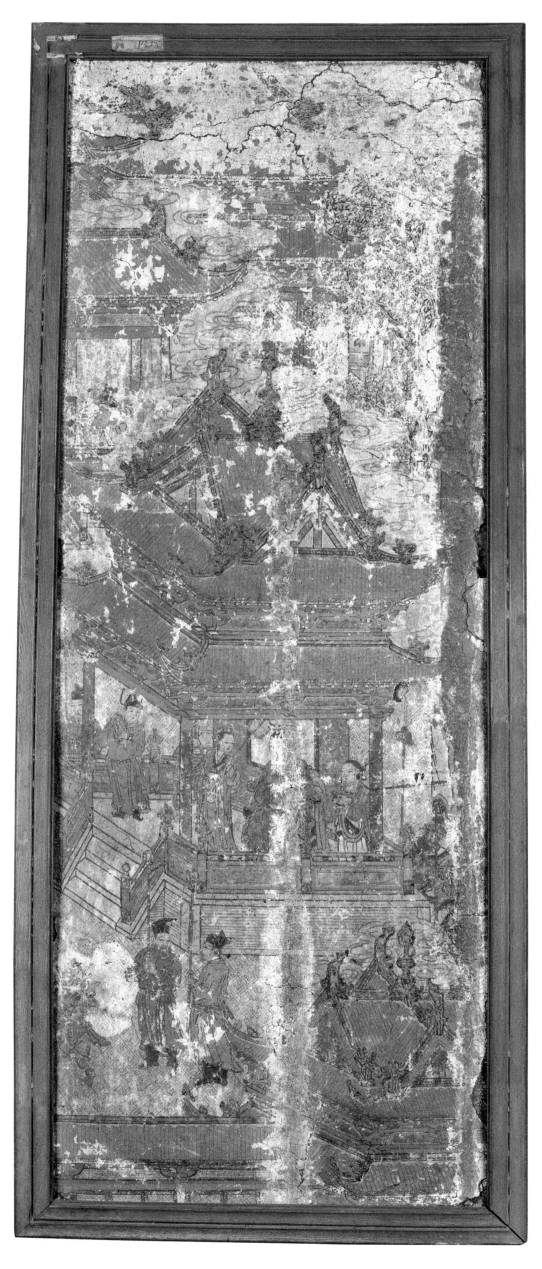

新60898

宋 佚名
人物楼台壁画

139 | 泥质 纵138厘米 横50厘米

Xin60898

Anonymous, Song dynasty
Figure and Architecture
Wall painting, plaster
138 ×50cm

新14246

宋 佚名
松云壁画

140 | 泥质　纵55.7厘米　横40.7厘米

Xin14246
Anonymous, Song dynasty
Pines in Clouds
Wall painting, plaster
55.7 ×40.7cm

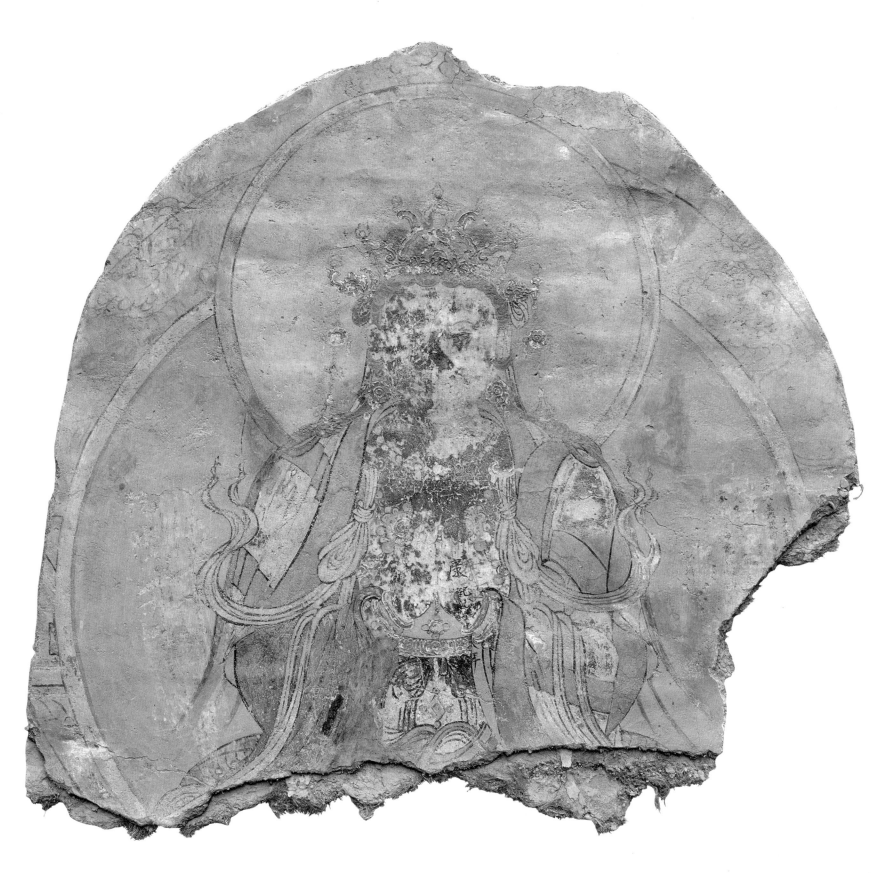

新60904

宋 佚名
观音坐像壁画

141 | 泥质　纵91.5厘米　横97厘米

Xin60904
Anonymous, Song dynasty
Seated Avalokitesvara
Wall painting, plaster
91.5×97cm

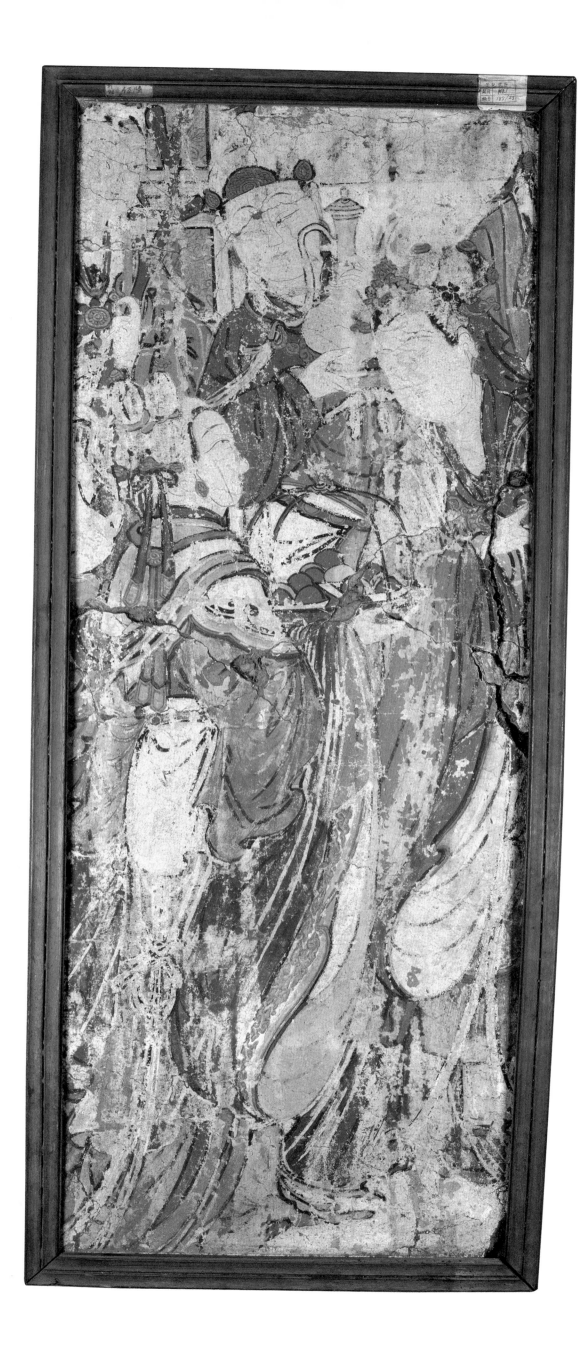

新60902

宋 佚名
三仕女立像壁画

142 泥质　纵157厘米　横60厘米

Xin60902
Anonymous, Song dynasty
Standing Ladies Holding Pot and Fruits
Wall painting, plaster
157×60cm

新60897

宋 佚名
二仕女立像壁画

143 | 泥质　纵133厘米　横43.8厘米

Xin60897

Anonymous, Song dynasty
Two Ladies

Wall painting, plaster
133×43.8cm

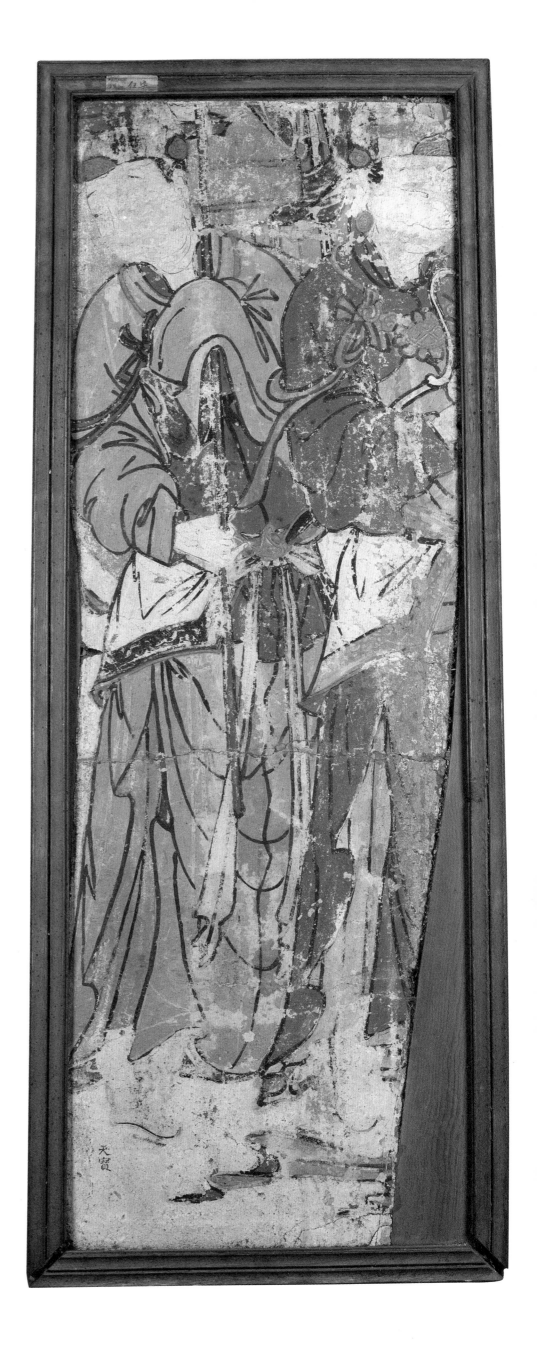

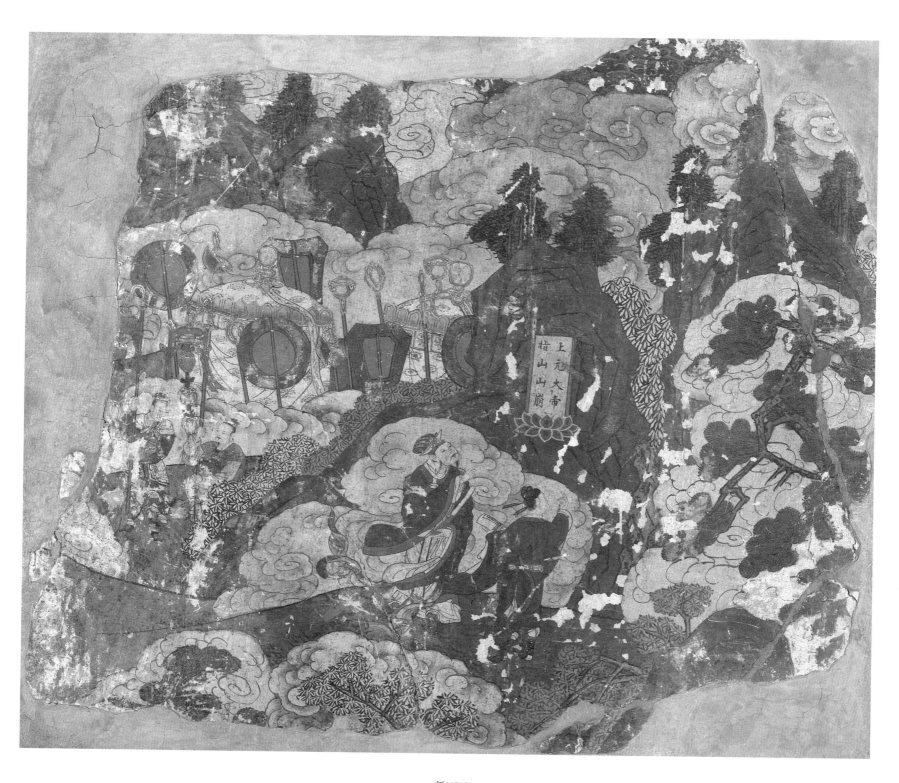

新14248

宋 佚名
上元大帝、指山山崩壁画

144 | 泥质 纵70厘米 横80厘米

Xin14248

Anonymous, Song dynasty
Shangyuan God Pointing at Mountain,
Which Collapses Immediately

Wall painting, plaster
70×80cm

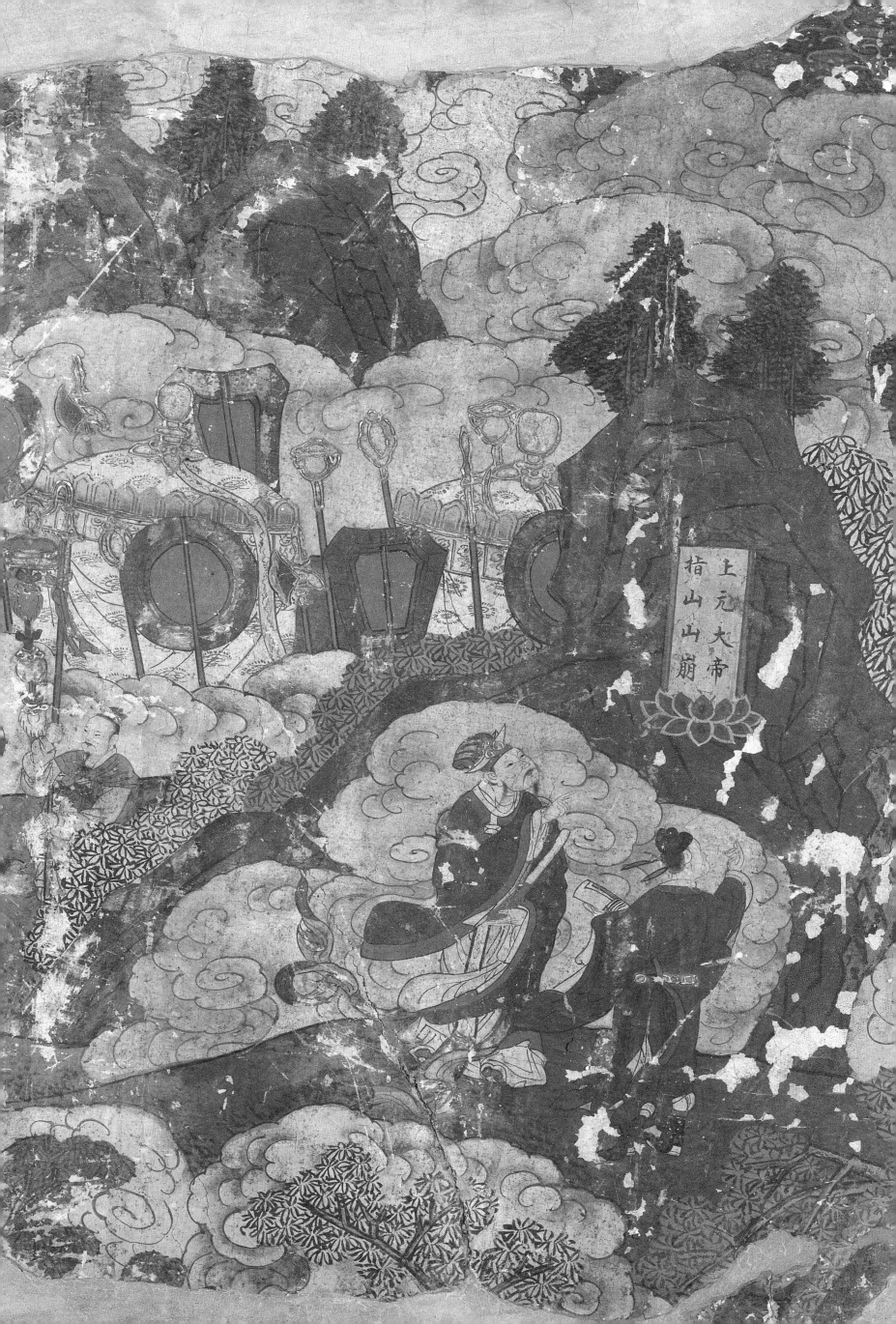

上元大帝
栢山山崩

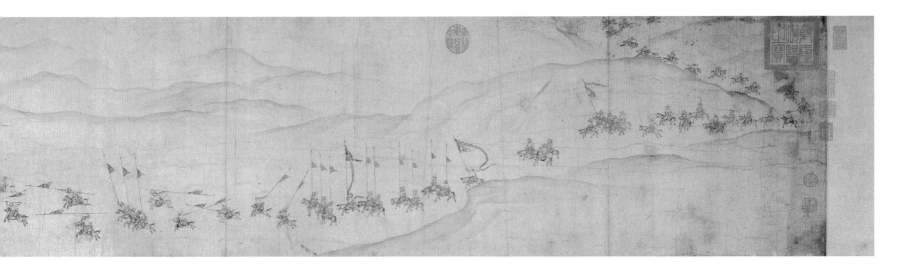

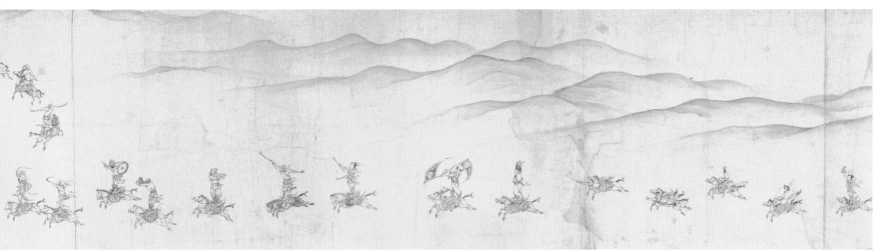

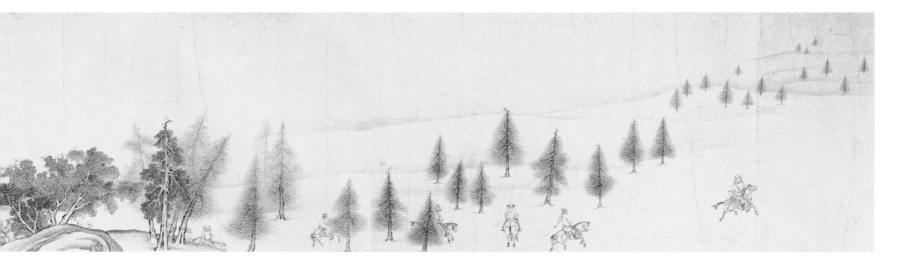

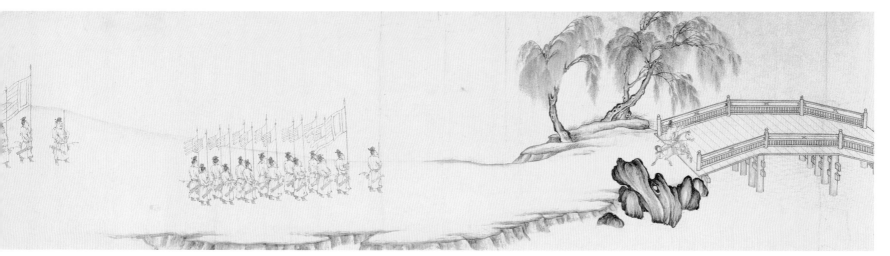

新18972

辽 陈及之（传）

便桥会盟图卷

145 | 纸本　纵36厘米　横117厘米

Xin18972

Attributed to Chen Jizhi, Liao dynasty

Meeting at the Bian Bridge

Handscroll, paper

36 × 117 cm

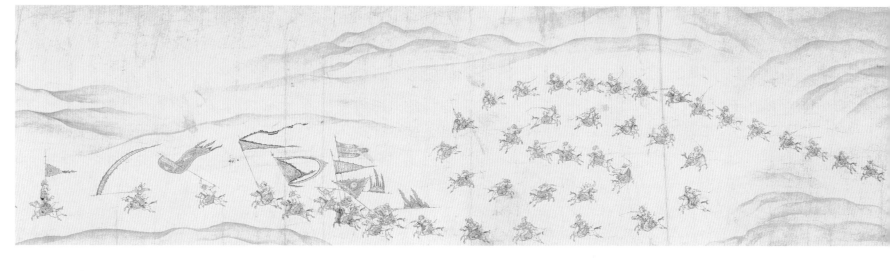

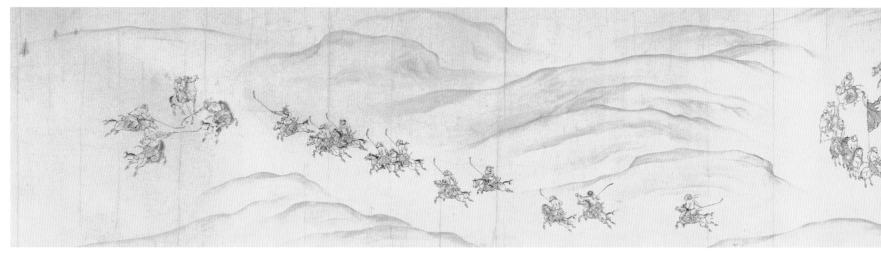

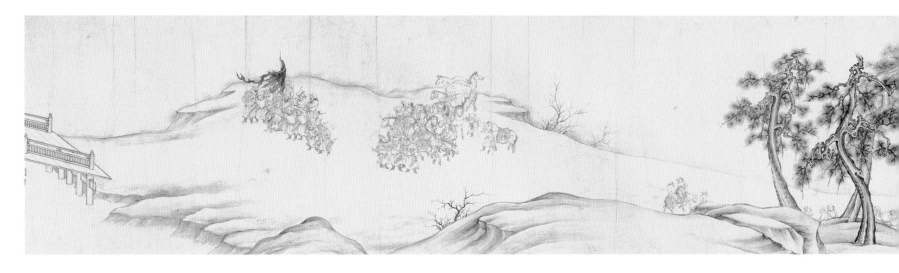

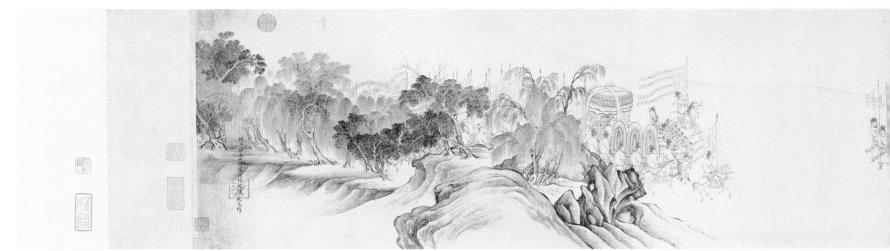

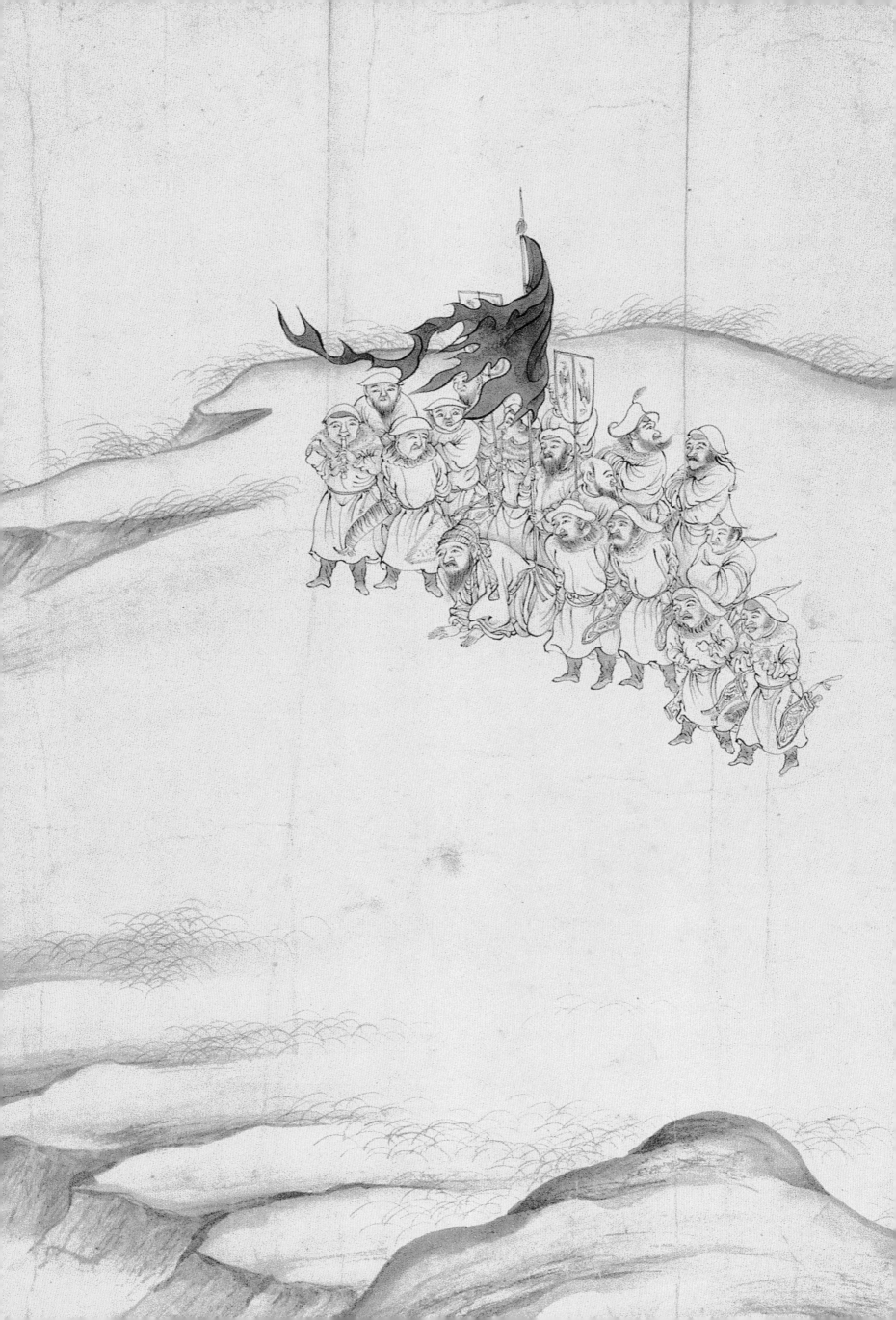

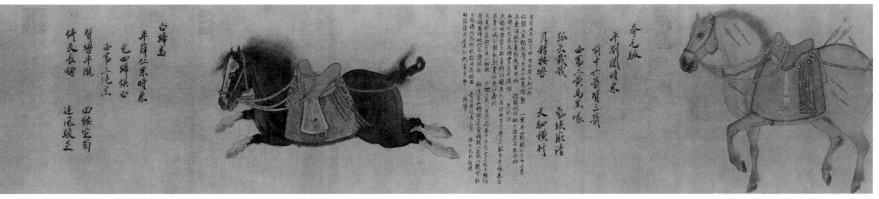

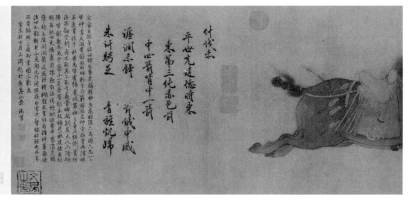

新147139

金 赵霖

昭陵六骏图卷

146 | 绢本　纵27.4厘米　横444.2厘米

Xin147139

Zhao Lin, Jin dynasty

Six Steeds of the Zhao Mausoleum

Handscroll, silk

27.4 × 444.2 cm

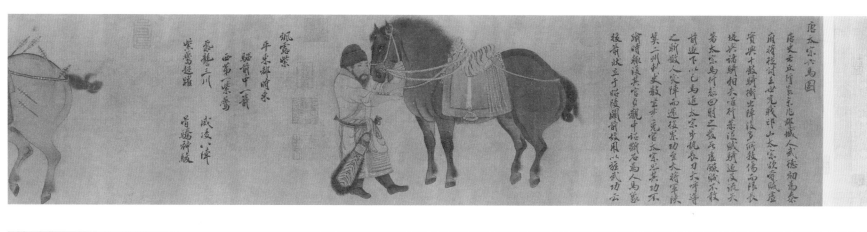

唐太宗六馬圖

颯露紫
平東都時乘
駙前中一箭
西第一乘駑

飛龍三川
紫鷰超躍
骨騰神駿

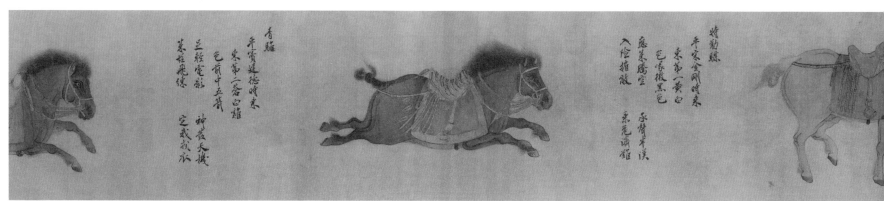

特勒驃
平東金剛時乘
未第一黄白
色毛鬃黑色

應策騰空
入陣摧敵
承情半漢
東光諭難

青騅
平竇建德時乘
東第二蒼白雜
色前中五箭
足前十五箭

蘭經電彩
葉従飛練
神發天機
定我戎衣

如用筆神妙
凜然有生氣
位乎人前神
物令婦之
毬邸不復
見如襄城王
持此圖
歎羨咄嗟之間
了無在
詔令日藝苑
垂宗時待
去宗時待
中勤士之意
惜乎徐生之意
絕無固
題三便側云開
醉中殊之意
為四字語於
康辰七月
臣曾 日

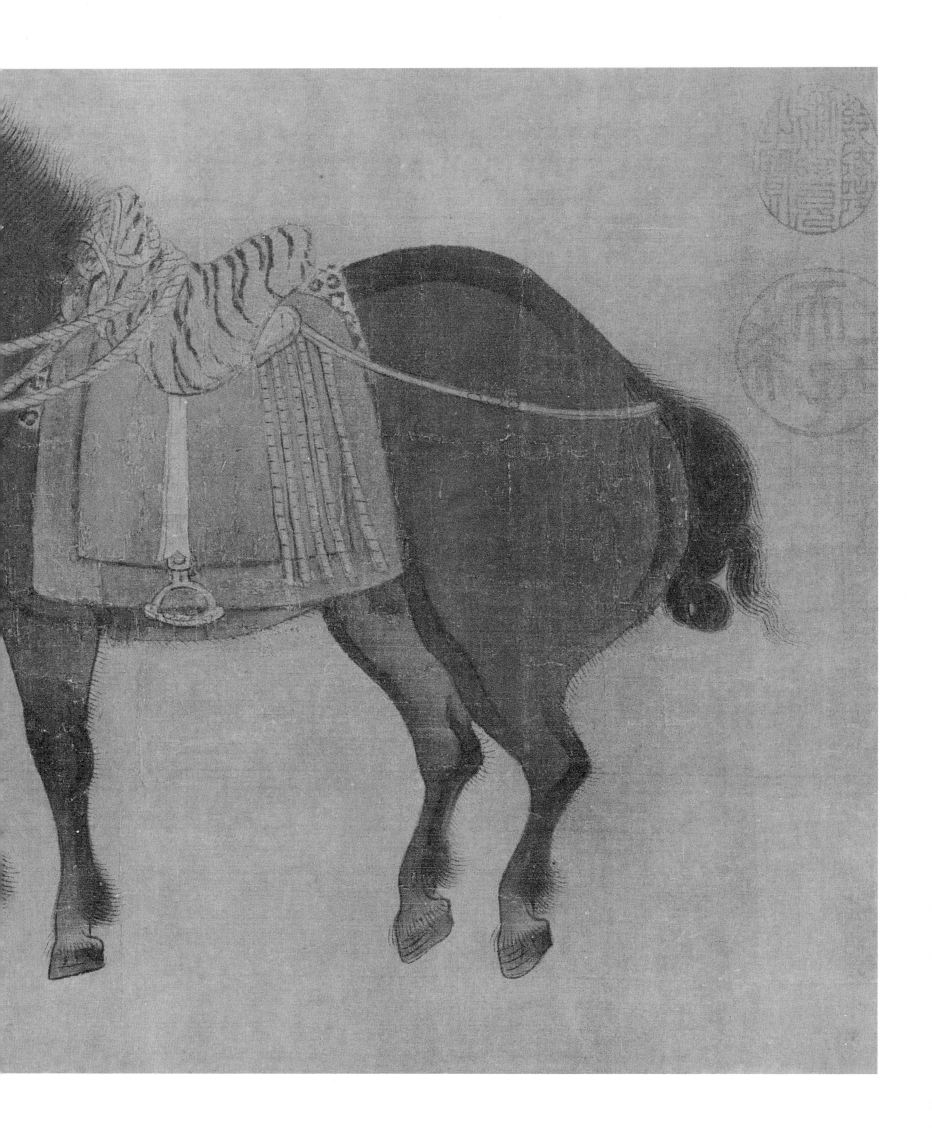

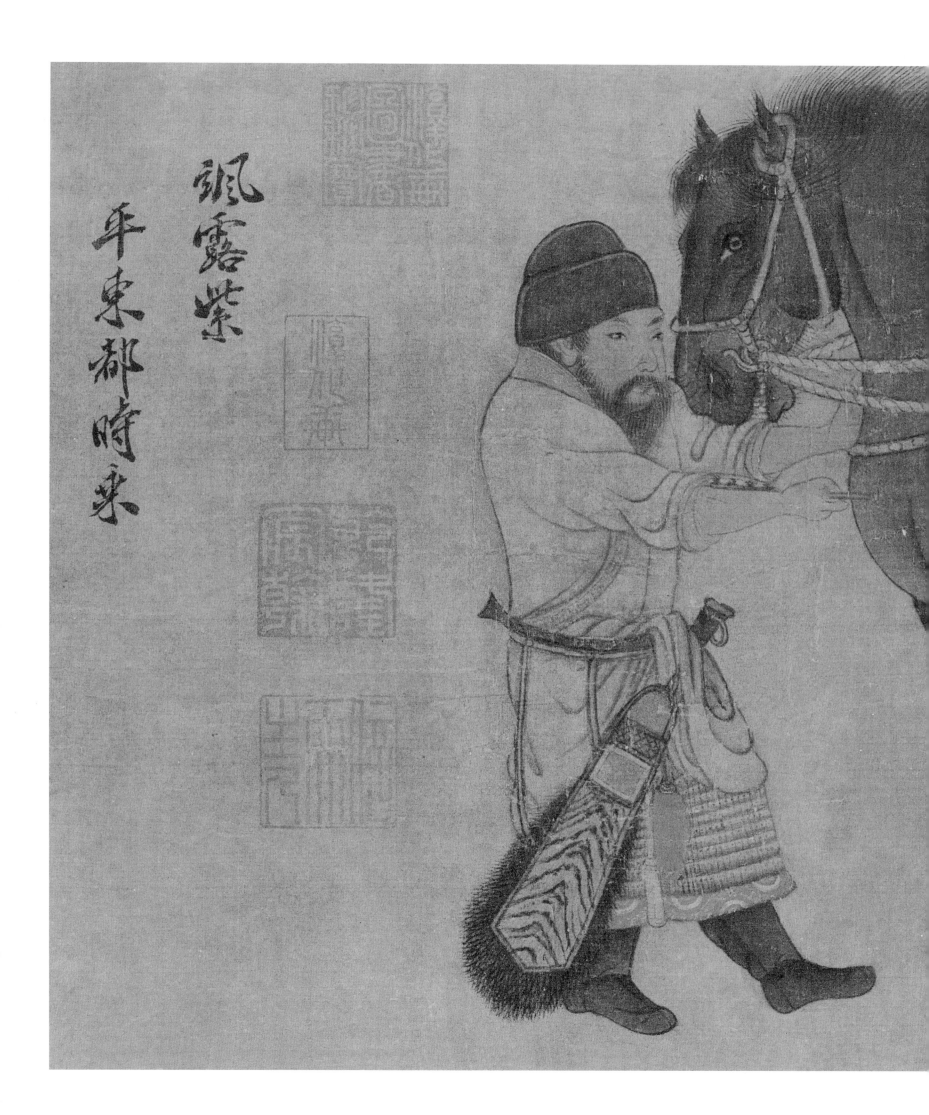

颭露紫
平東都時來

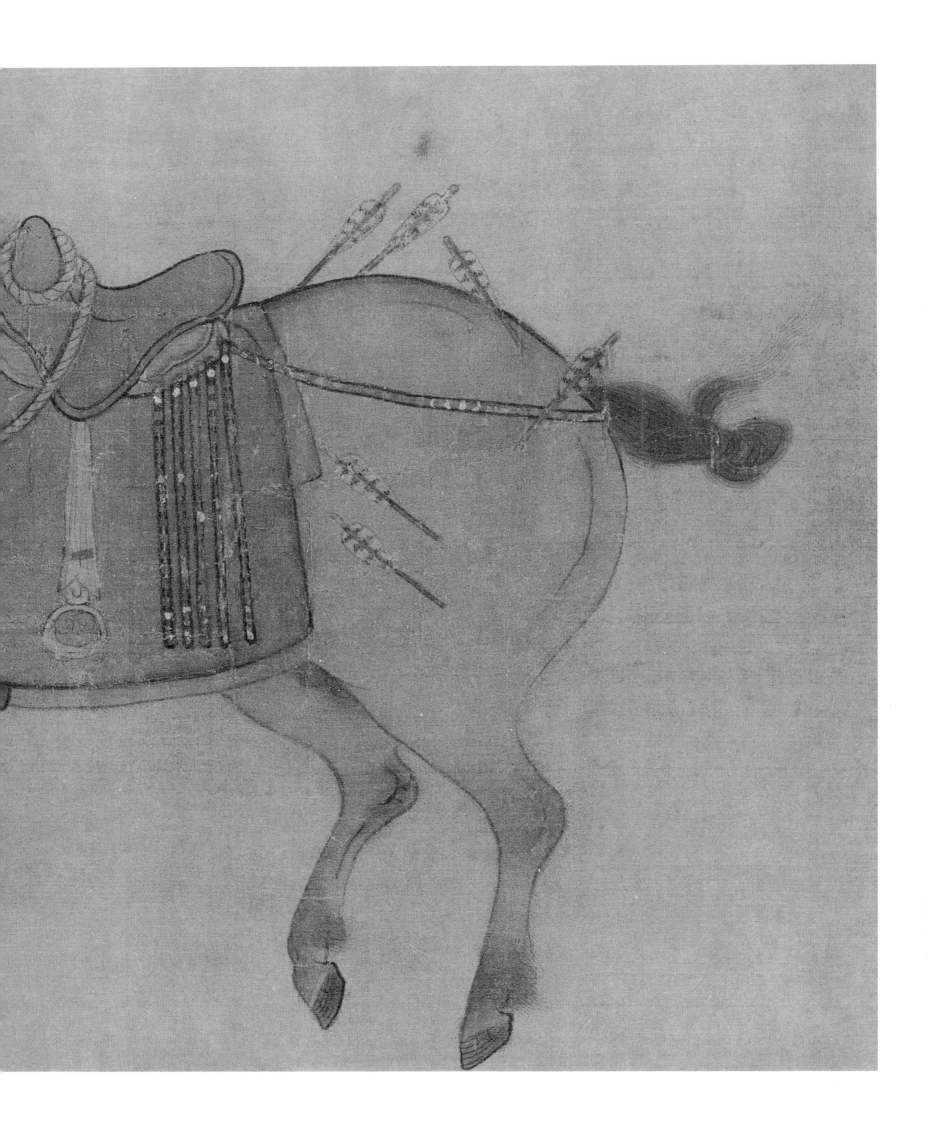

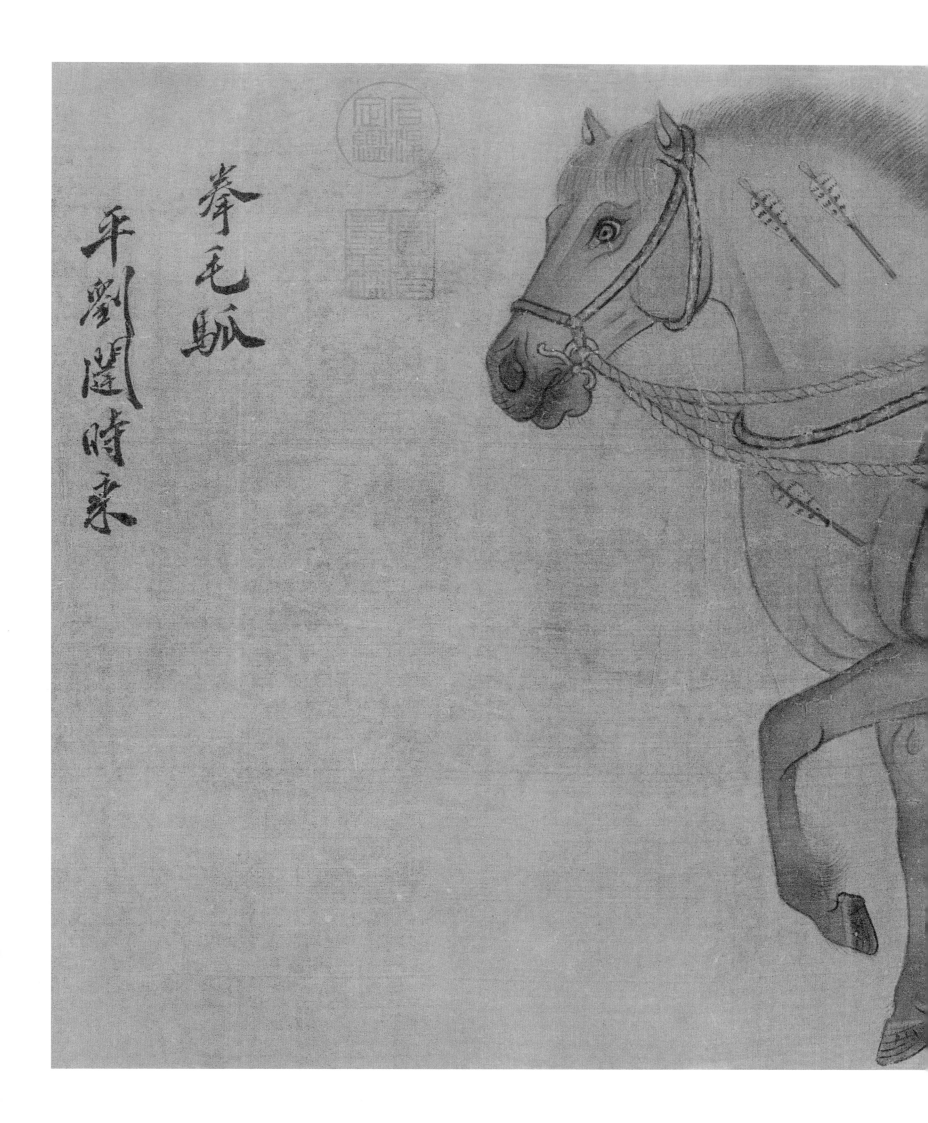

拳毛騧

平劉闇時來

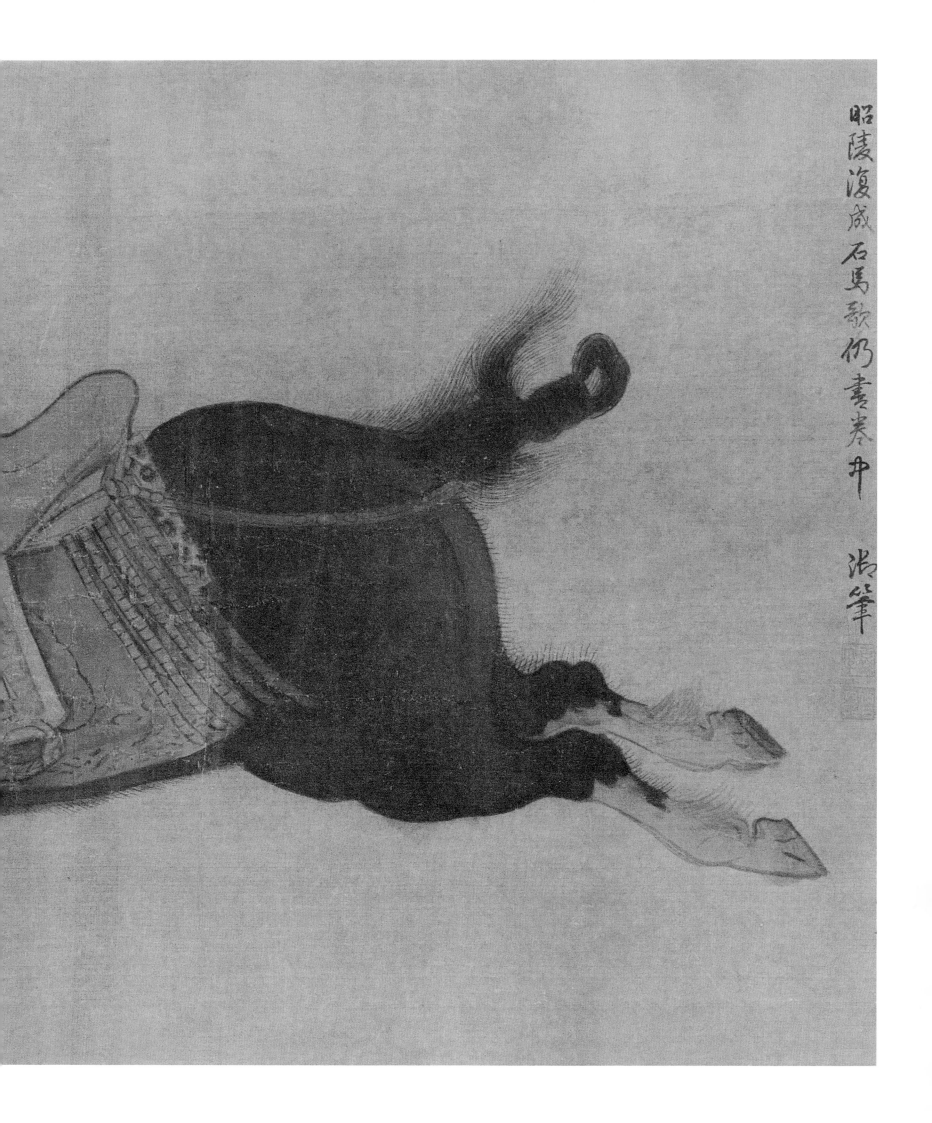

白䳍烏

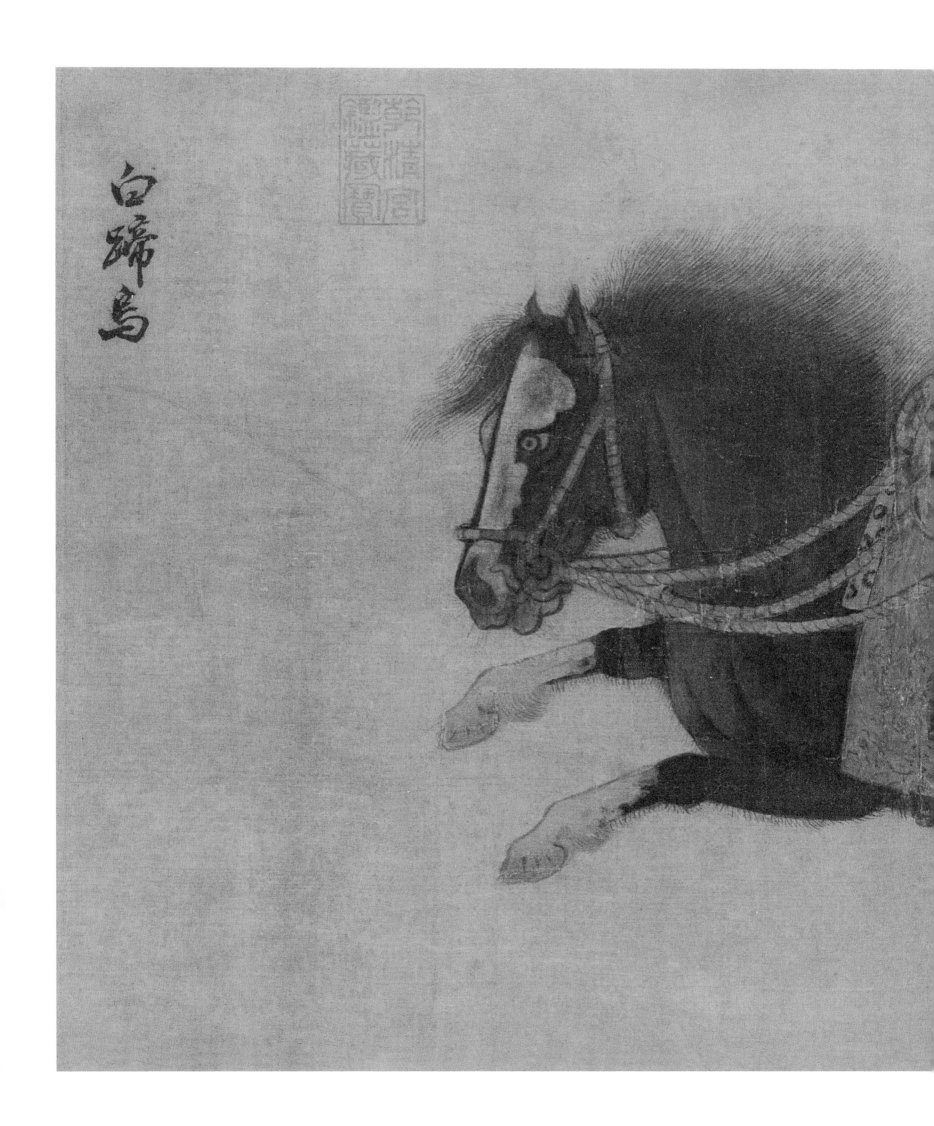

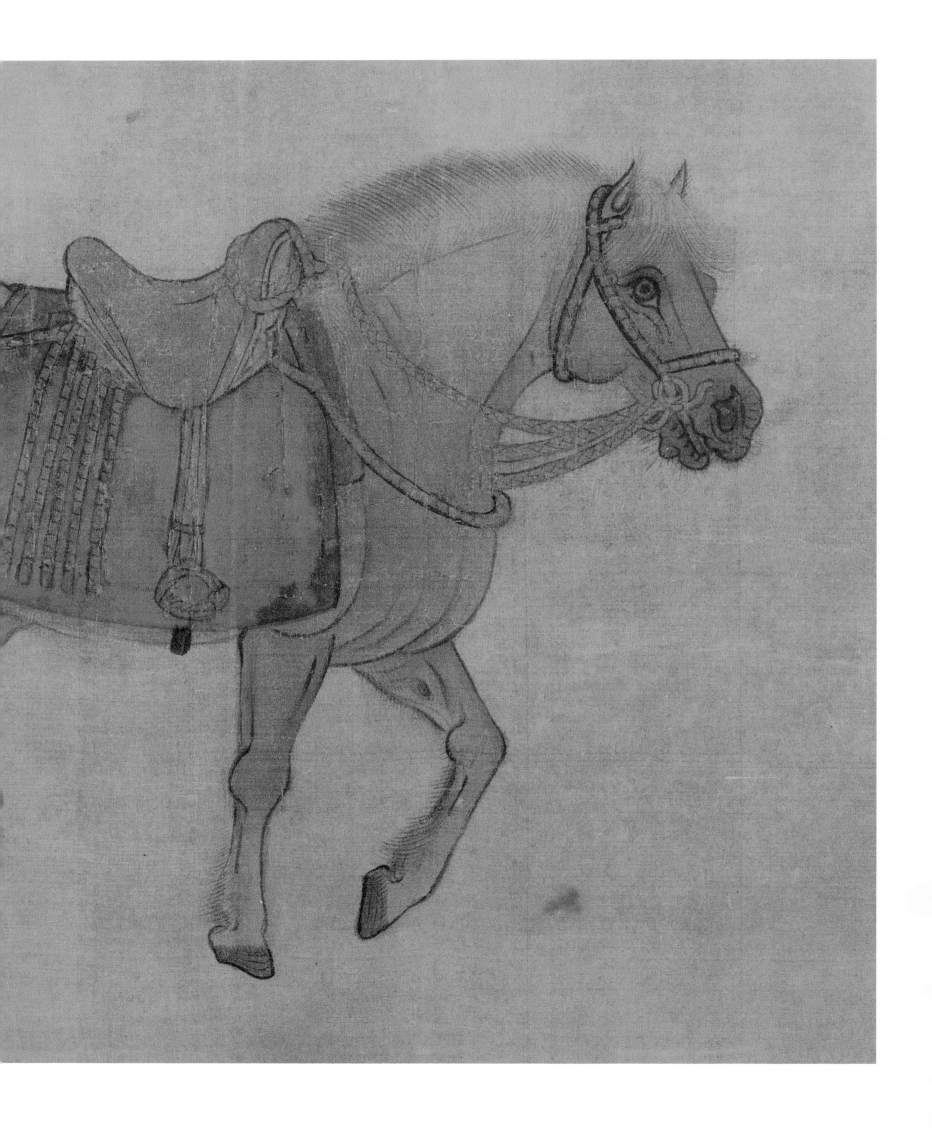

特勒驃

平家金剛時乘

東第一黃白

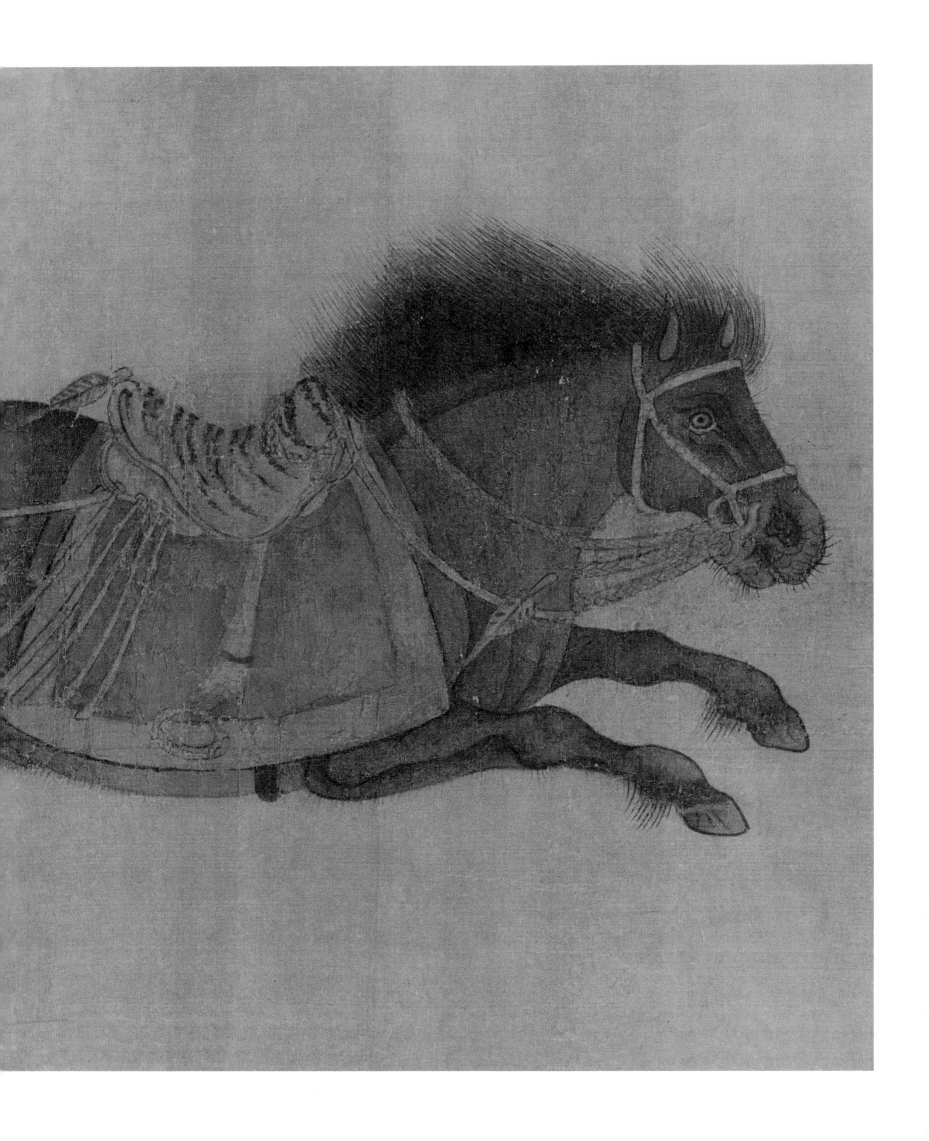

青骓

平叢進德時來

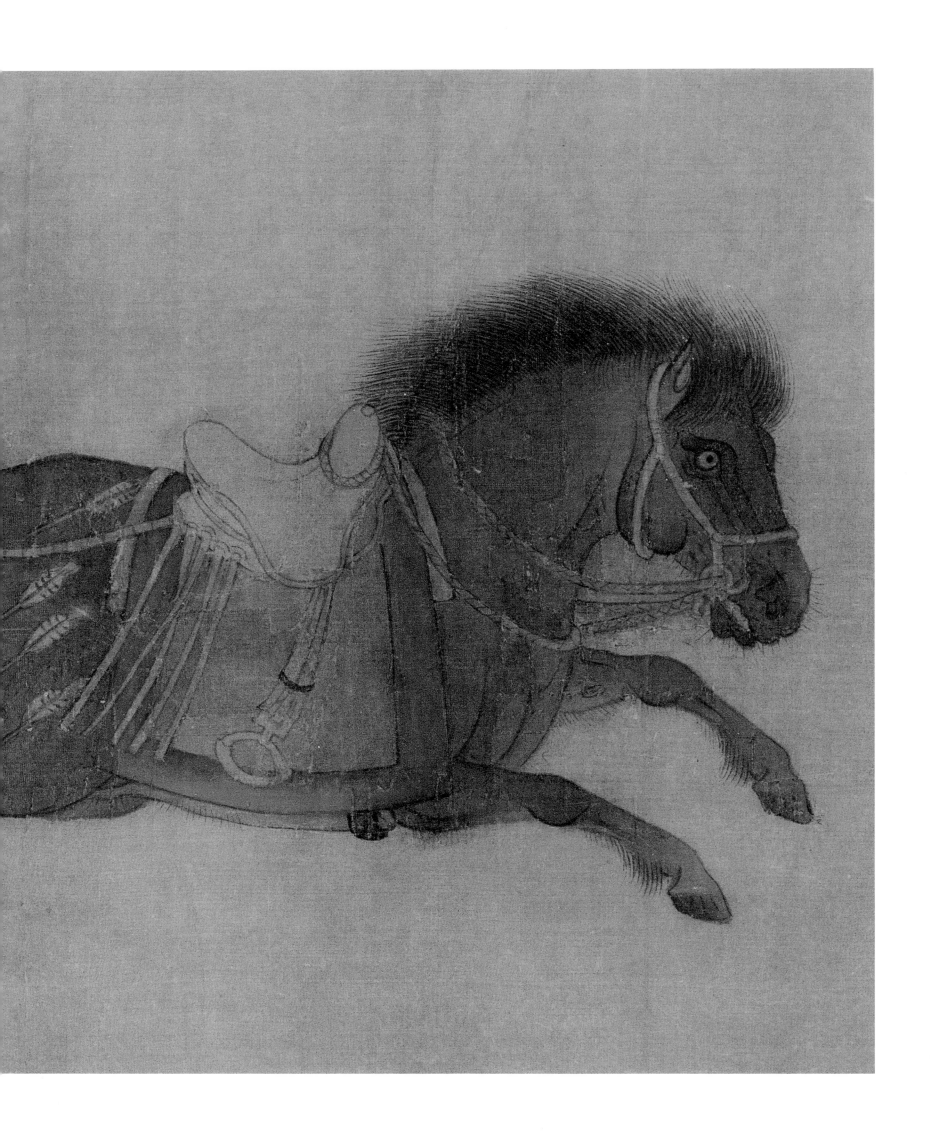

什伐赤

平世充建德時乘

來第三純赤色前

中四箭皆中一箭

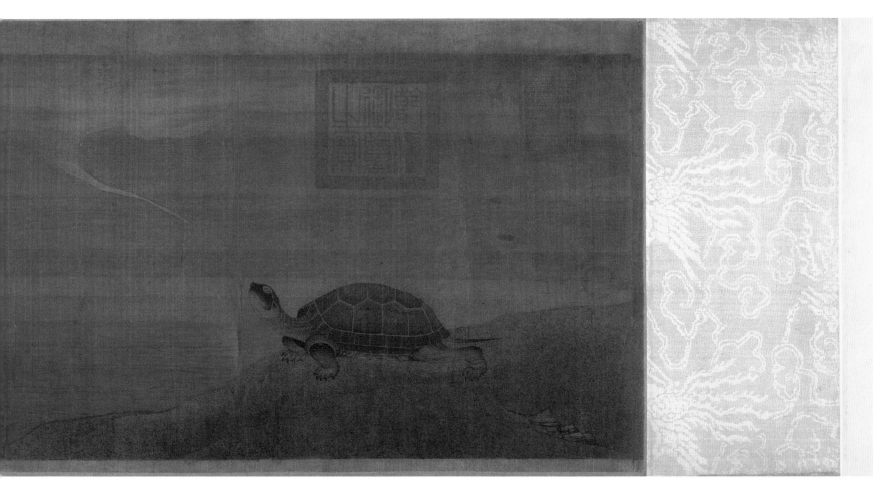

於無窮

聖王之瑞應而何令焉歷歲

既久偶而得此誠預兆我

聖明之

萬壽於無窮也

成化二十一年乙巳秋九月

望日熏沐頓首謹跋

凤闻名世生景運必

有先精氣賁辰象風

華翳山川既以熙

新146748

金　张珪

神龟图卷

147 | 绢本　纵34.5厘米　横55.3厘米

Xin146748

Zhang Gui, Jin dynasty

Auspicious Turtle

Handscroll, silk

34.5 × 55.3 cm

右神龜圖乃元明宗時善
畫者所作筆力精緻神氣
沖融宛然生意之在目稽
諸洪範五行謂龜之言久
也千歲而靈能知吉凶玄
文五色神靈之精其象上
圓法天下方法地背有鑑
以法丘山甲虫三百六十
而龜為之長王者之嘉瑞
也自洛水呈書而昭理數
於無窮非

斯真養生主得全乃
於天何論媧黃庭性
牆本自悅閑襟遠其
和巖情內清壁縱橫
古今際竊偃於奇權
善夫歐陽子以道不以
仙呈知道所備默為遊
年

錢士升

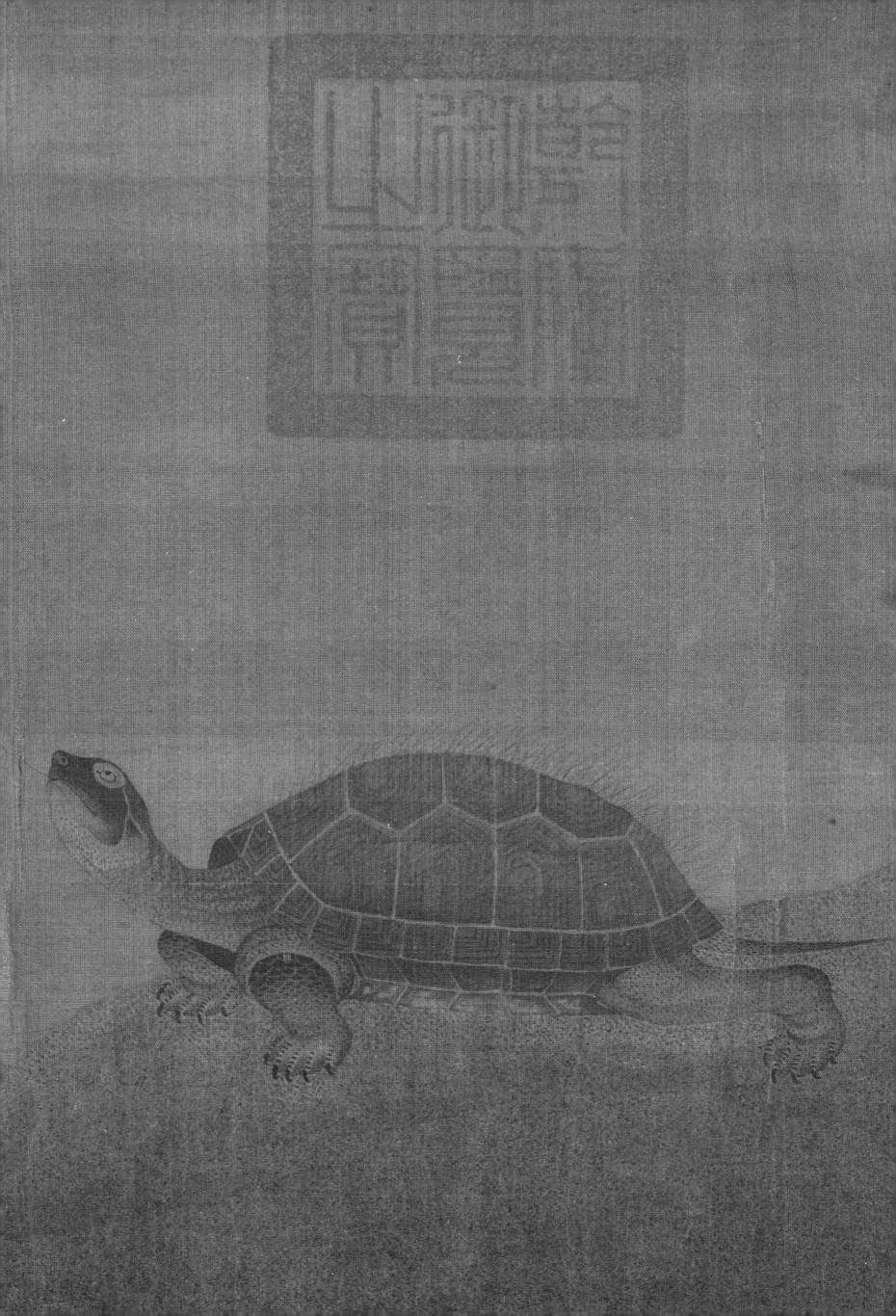

崆峒山哉、中有真人
居與天為之友與道為
之徒萬物等觸蠻乾坤
真緒餘昔在帝軒轅治
民心匪舒三往拜下風
滕行意趑趄躑躅渺江
海一飲盈其虛外物入
大妙未始知有初再視
區中民不膋調群狙並
言浸無為化國如羊昏
畫師千古人寫此千古
圖作詩不知耻笑殺南
荣趑
雲翔賈郁再拜題

新147060
金 杨世昌
崆峒问道图卷
绢本　纵28.2厘米　横49.5厘米
Xin147060
Yang Shichang, Jin dynasty
Asking Daoist Doctrine in Kongtong Mountains
Handscroll, silk
28.2 × 49.5 cm

148

北宋楊世昌畫問道圖

<div style="writing-mode: vertical-rl">

強致則人可得而仙可得而王道又得仙漸
矣古令以来得王道又得仙漸
惟帝軒轅一人而已王者何何
以主夫蒼生也仙者何何以白
日而上昇也當軒轅之為帝於
天下也聞仙人廣成子住崆峒
山往問以治身之術而廣成子
告以治身之要若曰無勞爾形
無搖爾精廼可長生帝悟而歸
垂胡髯下迎帝騎龍上天摩臣
采銅鑄鼎錬丹砂砂成有龍
龍髯騣拔陷弓抱其弓而號後
人名其地曰鼎湖其弓曰烏號
從者七十餘人小臣不得上持
此所謂得王衛又得仙道者也
太常馮仲翼好古博雅之士也
家藏是屬仲翼日吾嘗觀之是
蓋昔人楊世昌之筆子按世昌
字子京宋人也當與東坡游以
善畫名是則斯為六世之稀有
者也仲翼尚珍襲我
永樂九年冬十月十又五日
趙府伴讀吉安鍾启晦書

</div>

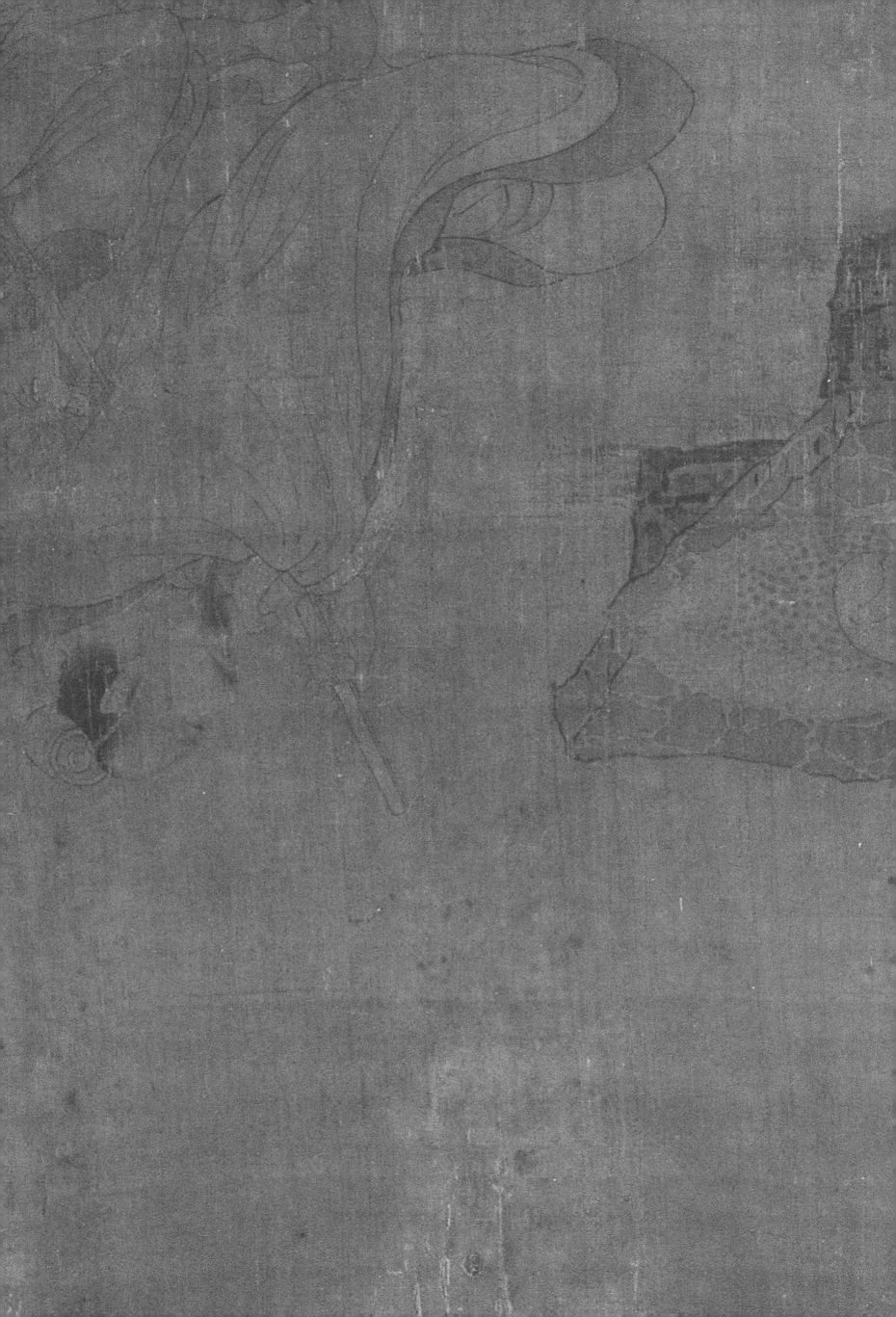

图版索引

7 42

新147426 1/14

宋 佚名
仙女乘鸾图页

绢本 纵26.2厘米 横25.3厘米

Xin147426 1/14

Anonymous,
Song dynasty

Fairy Riding on a Phoenix
Album leaf, silk
26.2 × 25.3 cm

8 44

新147423 11/12

宋 佚名
山居对弈图页

绢本 纵24.8厘米 横24厘米

Xin147423 11/12

Anonymous,
Song dynasty

Playing Chess in the Mountains
Album leaf, silk
24.8 × 24 cm

9 46

新147426 13/14

宋 佚名
柳溪钓艇图页

绢本 纵24.5厘米 横23厘米

Xin147426 13/14

Anonymous,
Song dynasty

Fishing on a Willow Stream
Album leaf, silk
24.5 × 23 cm

10 48

故6152 5/10

宋 佚名
柳荫云碓图页

绢本 纵23厘米 横20.6厘米

Gu6152 5/10

Anonymous,
Song dynasty

*Hulling Rice in
Willow Shade*
Album leaf, silk
23 × 20.6 cm

11 49

新13844 6/14

宋 佚名
水阁风凉图页

绢本 纵22.7厘米 横21.3厘米

Xin13844 6/14

Anonymous,
Song dynasty

Cool Breeze at a Waterside Pavilion
Album leaf, silk
22.7 × 21.3 cm

12 50

新17780 10/11

宋 佚名
临流抚琴图页

绢本 纵25.5厘米 横26.5厘米

Xin17780 10/11

Anonymous,
Song dynasty

Playing a Zither by a Stream
Album leaf, silk
25.5 × 26.5 cm

1 16

新147494

宋 佚名
雪渔图卷

绢本 纵25.3厘米 横332.6厘米

Xin147494

Anonymous,
Song dynasty

Fishing in Snow
Handscroll, silk
25.3 × 332.6 cm

2 22

新147497

宋 佚名
卢鸿草堂十志图卷

绢本 纵25.6厘米 横711.6厘米

Xin147497

Anonymous,
Song dynasty

*Illustration of Ten Views from
A Thatched Hut of Lu Hong*
Handscroll, silk
25.6 × 711.6 cm

3 30

新121183

宋 佚名
九歌图卷

纸本 纵40厘米 横885厘米

Xin121183

Anonymous,
Song dynasty

Nine Songs
Handscroll, paper
40 × 885 cm

4 38

新147482

宋 佚名
丝纶图轴

绢本 纵83.2厘米 横37.6厘米

Xin147482

Anonymous,
Song dynasty

Spinning
Hanging scroll, silk
83.2 × 37.6 cm

5 40

新147423 3/12

宋 佚名
山坡论道图页

绢本 纵25.4厘米 横25厘米

Xin147423 3/12

Anonymous,
Song dynasty

Discussing Doctrine on a Hill Side
Album leaf, silk
25.4 × 25 cm

6 41

新147427 3/10

宋 佚名
松荫谈道图页

绢本 纵25.3厘米 横25.6厘米

Xin147427 3/10

Anonymous,
Song dynasty

*Talking about Doctrine in the
Shade of a Pine*
Album leaf, silk
25.3 × 25.6 cm

18

米佚名
梧桐庭月图页
新147427 7/10
绢本 纵24厘米 横17.5厘米

Anonymous,
Song dynasty
Enjoying the Moon in the Shade of Paulownia Trees
Album leaf, silk
24 × 17.5 cm

62

17

米佚名
莲塘泛舟图页
新147427 6/12
绢本 纵24.3厘米 横25.8厘米

Anonymous,
Song dynasty
Boating on a Lotus Pond
Album leaf, silk
24.3 × 25.8 cm

60

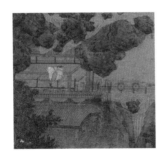

16

米佚名
永泉激凉图页
新147428 1/12
绢本 纵24.7厘米 横24.8厘米

Anonymous,
Song dynasty
Viewing Waterfall and Enjoying Coolness
Album leaf, silk
24.7 × 24.8 cm

58

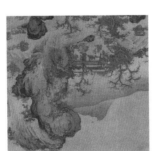

15

米佚名
山店风帘图页
新6150 4/10
绢本 纵24厘米 横25.3厘米

Anonymous,
Song dynasty
An Inn in the Mountains
Album leaf, silk
24 × 25.3 cm

56

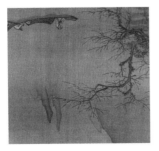

14

米佚名
梅溪放艇图页
新147429 4/12
绢本 纵24.4厘米 横24.8厘米

Anonymous,
Song dynasty
Boating on Stream with Plum Trees on the Bank
Album leaf, silk
24.4 × 24.8 cm

54

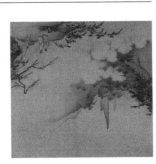

13

米佚名
云峰远眺图页
新147505
绢本 纵24.8厘米 横26.4厘米

Anonymous,
Song dynasty
Distant View of Peaks and Clouds
Album leaf, silk
24.8 × 26.4 cm

52

24

米佚名
秋亭客话图页
新147425 1/12
绢本 纵24.3厘米 横22.6厘米

Anonymous,
Song dynasty
Chatting in an Autumn Pavilion
Album leaf, silk
24.3 × 22.6 cm

70

23

米佚名
竹涧焚香图页
新6152 3/10
绢本 纵26厘米 横20厘米

Anonymous,
Song dynasty
Burning Incense at Bamboo Ravine
Album leaf, silk
26 × 20 cm

69

22

米佚名
柱人煮茶图页
新6158 13/16
绢本 纵25.2厘米 横25.2厘米

Anonymous,
Song dynasty
Thatched Inn
Album leaf, silk
25.2 × 25.2 cm

68

21

米佚名
深堂琴趣图页
新6158 14/16
绢本 纵24.2厘米 横24.9厘米

Anonymous,
Song dynasty
Playing a Zither in a Quiet Hall
Album leaf, silk
24.2 × 24.9 cm

67

20

米佚名
柳院纳凉图页
新6158 3/16
绢本 纵29厘米 横29.2厘米

Anonymous,
Song dynasty
Enjoying the Breeze in Willow Courtyard
Album leaf, silk
29 × 29.2 cm

66

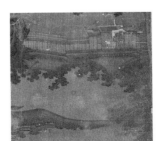

19

米佚名
梧桐庭院图页
新13844 10/14
绢本 纵24厘米 横19.3厘米

Anonymous,
Song dynasty
Courtyard under Paulownia Trees
Album leaf, silk
24 × 19.3 cm

64

31 82

故6150 8/10
宋 佚名
南唐文会图页
绢本 纵30.4厘米 横29.6厘米

Gu6150 8/10
Anonymous,
Song dynasty
Literary Gathering in the
Southern Tang Dynasty
Album leaf, silk
30.4 × 29.6 cm

32 84

故6158 7/16
宋 佚名
松荫策杖图页
绢本 纵28厘米 横28.7厘米

Gu6158 7/16
Anonymous,
Song dynasty
Walking with a Stick in the Shade of Pines
Album leaf, silk
28 × 28.7 cm

33 86

故6151 9/10
宋 佚名
竹林拨阮图页
绢本 纵22.7厘米 横24.5厘米

Gu6151 9/10
Anonymous,
Song dynasty
Playing Ruan in Bamboo Grove
Album leaf, silk
22.7 × 24.5 cm

34 88

新147425 2/12
宋 佚名
柳塘泛月图页
绢本 纵23.2厘米 横28.1厘米

Xin147425 2/12
Anonymous,
Song dynasty
Boating on Willow Pond in Moonlight
Album leaf, silk
23.2 × 28.1 cm

35 90

新147427 12/12
宋 佚名
耕获图页
绢本 纵25.7厘米 横24.8厘米

Xin147427 12/12
Anonymous,
Song dynasty
Farming and Harvest
Album leaf, silk
25.7 × 24.8 cm

36 92

新92267
宋 佚名
杂剧(卖眼药)图册页
绢本 纵23.8厘米 横24.5厘米

Xin92267
Anonymous,
Song dynasty
Selling Eye-ointment
Album leaf, silk
23.8 × 24.5 cm

25 72

新156354
宋 佚名
松谷问道图页
绢本 纵21.8厘米 横21.2厘米

Xin156354
Anonymous,
Song dynasty
Asking the Doctrine in Pine Ravine
Album leaf, silk
21.8 × 21.2 cm

26 73

新147424 12/12
宋 佚名
采花图页
绢本 纵24.1厘米 横25.2厘米

Xin147424 12/12
Anonymous,
Song dynasty
Picking Flowers
Album leaf, silk
24.1 × 25.2 cm

27 74

新148941
宋 佚名
莲舟仙渡图页
绢本 纵21.4厘米 横23.5厘米

Xin148941
Anonymous,
Song dynasty
Daoist Immortal Crossing the River in a
Lotus Raft
Album leaf, silk
21.4 × 23.5 cm

28 76

新17779 3/20
宋 佚名
初平牧羊图页
绢本 纵23.5厘米 横24.6厘米

Xin17779 3/20
Anonymous,
Song dynasty
Chuping Herding Sheep
Album leaf, silk
23.5 × 24.6 cm

29 78

新87182
宋 佚名
渔乐图页
绢本 纵23.7厘米 横25.3厘米

Xin87182
Anonymous,
Song dynasty
The Pleasure of Fishing
Album leaf, silk
23.7 × 25.3 cm

30 80

新87183
宋 佚名
山居说听图页
绢本 纵25厘米 横25.7厘米

Xin87183
Anonymous,
Song dynasty
Living in Mountain
Album leaf, silk
25 × 25.7 cm

故6158 8/16

宋 佚名
天寒翠袖图页

绢本 纵25.7厘米 横21.6厘米

Gu6158 8/16

Anonymous,
Song dynasty
Lady Standing by Wintry Bamboo
Album leaf, silk
25.7 × 21.6 cm

新92266

宋 佚名
杂剧（打花鼓）图册页

绢本 纵24厘米 横24.3厘米

Xin92266

Anonymous,
Song dynasty
Playing Flower-drum
Album leaf, silk
24 × 24.3 cm

故6151 4/10

宋 佚名
百子嬉春图页

绢本 纵26.6厘米 横27.7厘米

Gu6151 4/10

Anonymous,
Song dynasty
Hundred Boys Playing in Spring
Album leaf, silk
26.6 × 27.7 cm

故6158 15/16

宋 佚名
春游晚归图页

绢本 纵24.2厘米 横25.3厘米

Gu6158 15/16

Anonymous,
Song dynasty
Returning at Dusk from Spring Outing
Album leaf, silk
24.2 × 25.3 cm

新147428 10/12

宋 佚名
秋庭婴戏图页

绢本 纵23.7厘米 横24厘米

Xin147428 10/12

Anonymous,
Song dynasty
Children Playing in Autumnal Garden
Album leaf, silk
23.7 × 24 cm

新147426 2/14

宋 佚名
槐荫消夏图页

绢本 纵25厘米 横28.5厘米

Xin147426 2/14

Anonymous,
Song dynasty
*Enjoying the Cool in Summer under the
Shade of a Locust Tree*
Album leaf, silk
25 × 28.5 cm

新17779 10/20

宋 佚名
小庭婴戏图页

绢本 纵25.8厘米 横25.3厘米

Xin17779 10/20

Anonymous,
Song dynasty
Boys Playing in the Garden
Album leaf, silk
25.8 × 25.3 cm

新13845 3/15

宋 佚名
柳荫高士图页

绢本 纵29.4厘米 横29厘米

Xin13845 3/15

Anonymous,
Song dynasty
Hermit in the Shade of a Willow Tree
Album leaf, silk
29.4 × 29 cm

新119840

宋 佚名
蕉石婴戏图页

绢本 纵23.7厘米 横25厘米

Xin119840

Anonymous,
Southern Song dynasty
Children Playing by Rocks and Plantains
Album leaf, silk
23.7 × 25 cm

新147426 12/14

宋 佚名
松荫间憩图页

绢本 纵23.6厘米 横22.5厘米

Xin147426 12/14

Anonymous,
Song dynasty
Taking a Rest in the Shade of a Pine
Album leaf, silk
23.6 × 22.5 cm

新147428 5/12

宋 佚名
蕉荫击球图页

绢本 纵25厘米 横24.5厘米

Xin147428 5/12

Anonymous,
Song dynasty
*Playing Ball Games in the Shade of
Plantains*
Album leaf, silk
25 × 24.5 cm

新156348

宋 佚名
柳荫醉归图页

绢本 纵23厘米 横24.8厘米

Xin156348

Anonymous,
Song dynasty
*Two Tipplers Returning Home
In the Shade of a Willow Tree*
Album leaf, silk
23 × 24.8 cm

新188240 1/15

宋 佚名
双童牧牛图页

绢本 纵24.5厘米 横24.9厘米

Xin188240 1/15

Anonymous,
Song dynasty
Two Boys Herding Cattle
Album leaf, silk
24.5 × 24.9 cm

新147424 6/12

宋 佚名
水村烟霭图页

绢本 纵23.6厘米 横25.3厘米

Xin147424 6/12

Anonymous,
Song dynasty
Waterside Village in Mist
Album leaf, silk
23.6 × 25.3 cm

新147427 5/10

宋 佚名
松冈暮色图页

绢本 纵24.1厘米 横25.9厘米

Xin147427 5/10

Anonymous,
Song dynasty
Pines at Twilight
Album leaf, silk
24.1 × 25.9 cm

新147424 4/12

宋 佚名
风雨归舟图页

绢本 纵25.6厘米 横26.2厘米

Xin147424 4/12

Anonymous,
Song dynasty
Boat Returning in a Rainstorm
Album leaf, silk
25.6 × 26.2 cm

新147501

宋 佚名
江上青峰图页

绢本 纵24.5厘米 横26.2厘米

Xin147501

Anonymous,
Song dynasty
Verdant Peaks by a River
Album leaf, silk
24.5 × 26.2 cm

新6150 6/10

宋 佚名
春江帆饱图页

绢本 纵25.8厘米 横27厘米

Xin6150 6/10

Anonymous,
Song dynasty
Full Sails on Spring River
Album leaf, silk
25.8 × 27 cm

故6150 5/10

宋 佚名
层楼春眺图页

绢本 纵23.7厘米 横26.4厘米

Xin6150 5/10

Anonymous,
Song dynasty
Viewing Spring Scenery from a Pavilion
Album leaf, silk
23.7 × 26.4 cm

新147426 9/14

宋 佚名
柳堂读书图页

绢本 纵24.5厘米 横22.5厘米

Xin147426 9/14

Anonymous,
Song dynasty
Reading in Willow Pavilion
Album leaf, silk
24.5 × 22.5 cm

新13845 4/15

宋 佚名
雪溪放牧图页

绢本 纵25.7厘米 横26.5厘米

Xin13845 4/15

Anonymous,
Song dynasty
Herding Cattle in Winter
Album leaf, silk
25.7 × 26.5 cm

新13844 1/14

宋 佚名
雪山行骑图页

绢本 纵29厘米 横23.1厘米

Xin13844 1/14

Anonymous,
Song dynasty
*Traveler on Donkey's Back
Through Snowy Mountains*
Album leaf, silk
29 × 23.1 cm

新147426 8/14

宋 佚名
归牧图页

绢本 纵24厘米 横23.4厘米

Xin147426 8/14

Anonymous,
Song dynasty
Return from Herding
Album leaf, silk
24 × 23.4 cm

故6151 2/10

宋 佚名
骑士猎归图页

绢本 纵22.3厘米 横25.2厘米

Gu6151 2/10

Anonymous,
Song dynasty
Return from Hunting
Album leaf, silk
22.3 × 25.2 cm

新13845　6/15

宋 佚名
云关雪栈图页

绢本 纵25.2厘米 横26.5厘米

Xin13845　6/15

Anonymous,
Song dynasty
Cantilevered Roads in Snow-covered Mountain
Album leaf, silk
25.2 × 26.5 cm

新147427　1/12

宋 佚名
山腰楼观图页

绢本 纵23.7厘米 横22.6厘米

Xin147427　1/12

Anonymous,
Song dynasty
Pavilion in the Mountain
Album leaf, silk
23.7 × 22.6 cm

新17779　5/20

宋 佚名
柳溪春色图页

绢本 纵22厘米 横24.8厘米

Xin17779　5/20

Anonymous,
Song dynasty
Willow Stream in Spring
Album leaf, silk
22 × 24.8 cm

新147425　8/12

宋 佚名
木末孤亭图页

绢本 纵23.3厘米 横24.6厘米

Xin147425　8/12

Anonymous,
Song dynasty
Lofty Pavilion in the Woods
Album leaf, silk
23.3 × 24.6 cm

新17779　14/20

宋 佚名
山水人物图页

绢本 纵25.3厘米 横25.3厘米

Xin17779　14/20

Anonymous,
Song dynasty
Landscape and Figure
Album leaf, silk
25.3 × 25.3 cm

新147425　11/12

宋 佚名
春山渔艇图页

绢本 纵21厘米 横21.5厘米

Xin147425　11/12

Anonymous,
Song dynasty
Fishing Boat in Spring Mountains
Album leaf, silk
21 × 21.5 cm

新147305

宋 佚名
岩桧图页

绢本 纵50.5厘米 横39.2厘米

Xin147305

Anonymous,
Song dynasty
Juniper on Cliff
Album leaf, silk
50.5 × 39.2 cm

新147427　4/10

宋 佚名
五云楼阁图页

绢本 纵23.2厘米 横23.2厘米

Xin147427　4/10

Anonymous,
Song dynasty
Mountain Peaks in Clouds
Album leaf, silk
23.2 × 23.2 cm

新119841

宋 佚名
山水图页

绢本 纵23厘米 横24.8厘米

Xin119841

Anonymous,
Song dynasty
Landscape
Album leaf, silk
23 × 24.8 cm

新147430　3/21

宋 佚名
沧溟涌日图页

绢本 纵23.4厘米 横24.7厘米

Xin147430　3/21

Anonymous,
Song dynasty
Sunrise at Sea
Album leaf, silk
23.4 × 24.7 cm

新13844　3/14

宋 佚名
杨柳溪堂图页

绢本 纵22.5厘米 横24.5厘米

Xin13844　3/14

Anonymous,
Song dynasty
Living in the Shade of Willows
Album leaf, silk
22.5 × 24.5 cm

故6158　16/16

宋 佚名
柳阁风帆图页

绢本 纵25.2厘米 横26.7厘米

Gu6158　16/16

Anonymous,
Song dynasty
Willow Pavilion and Wind-filled Sails
Album leaf, silk
25.2 × 26.7 cm

新147426 7/14

宋 佚名
天末归帆图页

绢本　纵25.5厘米　横24.2厘米

Xin147426 7/14

Anonymous,
Song dynasty
Boat Returning from Afar
Album leaf, silk
25.5 × 24.2 cm

80　168

新147429 5/12

宋 佚名
溪山水阁图页

绢本　纵24.2厘米　横24.7厘米

Xin147429 5/12

Anonymous,
Song dynasty
Waterside Pavilion at the Foot of Mountains
Album leaf, silk
24.2 × 24.7 cm

81　170

故6151 1/10

宋 佚名
蓬瀛仙馆图页

绢本　纵26.4厘米　横27.9厘米

Gu 6151 1/10

Anonymous,
Song dynasty
Penglai Daoist Temple
Album leaf, silk
26.4 × 27.9 cm

82　172

新147424 11/12

宋 佚名
仙山楼阁图页

绢本　纵23厘米　横23.4厘米

Xin147424 11/12

Anonymous,
Song dynasty
Palace on the Mountain of Immortals
Album leaf, silk
23 × 23.4 cm

83　173

故6158 11/16

宋 佚名
长桥卧波图页

绢本　纵24厘米　横26.2厘米

Gu6158 11/16

Anonymous,
Song dynasty
Long Bridge across a River
Album leaf, silk
24 × 26.2 cm

84　174

新17779 2/20

宋 佚名
江山殿阁图页

绢本　纵23.2厘米　横24.3厘米

Xin17779 2/20

Anonymous,
Song dynasty
Waterside Palace
Album leaf, silk
23.2 × 24.3 cm

73　156

新156347

宋 佚名
清溪风帆图页

绢本　纵24.6厘米　横25.6厘米

Xin156347

Anonymous,
Song dynasty
Sailing on Clear Stream
Album leaf, silk
24.6 × 25.6 cm

74　158

新17779 7/20

宋 佚名
水村楼阁图页

绢本　纵23.5厘米　横23.5厘米

Xin17779 7/20

Anonymous,
Song dynasty
Waterside Village
Album leaf, silk
23.5 × 23.5 cm

75　159

新147502

宋 佚名
西湖春晓图页

绢本　纵23.6厘米　横25.8厘米

Xin147502

Anonymous,
Song dynasty
West Lake in the Early Morning
Album leaf, silk
23.6 × 25.8 cm

76　160

新147503

宋 佚名
松溪放艇图页

绢本　纵24.6厘米　横25.5厘米

Xin147503,
Anonymous,
Song dynasty
Boating on a Stream with Pines on the Bank
Album leaf, silk
24.6 × 25.5 cm

77　162

新147427 8/12

宋 佚名
青山白云图页

绢本　纵22.9厘米　横23.9厘米

Xin147427 8/12

Anonymous,
Song dynasty
Green Mountains, White Clouds
Album leaf, silk
22.9 × 23.9 cm

78　164

新147426 6/14

宋 佚名
秋江暝泊图页

绢本　纵24.3厘米　横23.7厘米

Xin147426 6/14

Anonymous,
Song dynasty
Anchoring on Autumn River
Album leaf, silk
24.3 × 23.7 cm

故6154 8/10

宋 佚名
乌桕文禽图页

绢本 纵27.5厘米 横26.9厘米

Gu6154 8/10

Anonymous,
Song dynasty

Two Graceful Birds Perching on a Tallow Branch
Album leaf, silk
27.5 × 26.9 cm

新147428 12/12

宋 佚名
春溪水族图页

绢本 纵25.5厘米 横24.3厘米

Xin147428 12/12

Anonymous,
Song dynasty

Fish Swimming among Aquatic Plants in Spring Stream
Album leaf, silk
25.5 × 24.3 cm

故6158 1/16

宋 佚名
秋树鹏鹉图页

绢本 纵26.5厘米 横25厘米

Gu6158 1/16

Anonymous,
Song dynasty

Mynah Perching on the Branch of an Autumn Tree
Album leaf, silk
26.5 × 25 cm

故6158 2/16

宋 佚名
夜合花图页

绢本 纵25.4厘米 横24.5厘米

Gu6158 2/16

Anonymous,
Song dynasty

Silk Tree Flowers
Album leaf, silk
25.4 × 24.5 cm

故6158 12/16

宋 佚名
青枫巨蝶图页

绢本 纵24.2厘米 横23厘米

Gu6158 12/16

Anonymous,
Song dynasty

Flying Butterfly and Green Maple
Album leaf, silk
24.2 × 23 cm

新147426 14/14

宋 佚名
红梅孔雀图页

绢本 纵24厘米 横31.6厘米

Xin147426 14/14

Anonymous,
Song dynasty

Red Plum Blossoms and Peacocks
Album leaf, silk
24 × 31.6 cm

新17779 6/20

宋 佚名
柳塘秋草图页

绢本 纵23.4厘米 横24.2厘米

Xin17779 6/20

Anonymous,
Song dynasty

Willow Pond and Autumn Grass
Album leaf, silk
23.4 × 24.2 cm

新1474265 3/12

宋 佚名
出水芙蓉图页

绢本 纵25厘米 横23.8厘米

Xin1474265 3/12

Anonymous,
Song dynasty

Lotus in Bloom
Album leaf, silk
25 × 23.8 cm

新147426 3/14

宋 佚名
溪芦野鸭图页

绢本 纵27厘米 横26.4厘米

Xin147426 3/14

Anonymous,
Song dynasty

Reeds by a Stream and Wild Ducks
Album leaf, silk
27 × 26.4 cm

新147426 4/14

宋 佚名
斗雀图页

绢本 纵25.4厘米 横24.2厘米

Xin147426 4/14

Anonymous,
Song dynasty

Sparrows Fighting
Album leaf, silk
25.4 × 24.2 cm

新147426 5/14

宋 佚名
红蓼水禽图页

绢本 纵26.8厘米 横25.2厘米

Xin147426 5/14

Anonymous,
Song dynasty

Red Knotweed and Water Bird
Album leaf, silk
26.8 × 25.2 cm

故6154 7/10

宋 佚名
瓦雀栖枝图页

绢本 纵29.1厘米 横28.6厘米

Gu6154 7/10

Anonymous,
Song dynasty

Sparrows Perching on a Begonia Branch
Album leaf, silk
29.1 × 28.6 cm

103

新17779 12 /20

宋 佚名
白头丛竹图页

绢本 纵25.4厘米 横29厘米

Xin17779 12/20

Anonymous,
Song dynasty

Grey Starlings and Green Bamboos
Album leaf, silk
25.4 × 29 cm

104

故6151 6/10

宋 佚名
疏荷沙鸟图页

绢本 纵25厘米 横25.6厘米

Gu6151 6/10

Anonymous,
Song dynasty

Withered Lotus and Little Bird
Album leaf, silk
25 × 25.6 cm

105

故6151 8/10

宋 佚名
榴枝黄鸟图页

绢本 纵24.6厘米 横25.4厘米

Gu6151 8/10

Anonymous,
Song dynasty

*Yellow Bird Perching on
Pomegranate Branch*
Album leaf, silk
24.6 × 25.4 cm

106

故6152 6/10

宋 佚名
秋兰绽蕊图页

绢本 纵25.3厘米 横25.8厘米

Gu6152 6/10

Anonymous,
Song dynasty

Sword-leaved Cymbidium in Blossom
Album leaf, silk
25.3 × 25.8 cm

107

故6152 10/10

宋 佚名
胆瓶秋卉图页

绢本 纵26.5厘米 横27.5厘米

Gu6152 10/10

Anonymous,
Song dynasty

Vase with Autumn Flowers
Album leaf, silk
26.5 × 27.5 cm

108

新70985

宋 佚名
碧桃图页

绢本 纵24.8厘米 横27厘米

Xin70985

Anonymous,
Song dynasty

Peach Blossoms
Album leaf, silk
24.8 × 27 cm

97

新147424 8/12

宋 佚名
群鱼戏藻图页

绢本 纵25.5厘米 横24.5厘米

Xin147424 8/12

Anonymous,
Song dynasty

School of Fish among Aquatic Plants
Album leaf, silk
25.5 × 24.5 cm

98

故6154 1/10

宋 佚名
梅竹双雀图页

绢本 纵26.5厘米 横26厘米

Gu6154 1/10

Anonymous,
Song dynasty

*Two Titmouses Perching on Plum
Branches in Bamboo Grove*
Album leaf, silk
26.5 × 26 cm

99

故6154 5/10

宋 佚名
鹡鸰荷叶图页

绢本 纵26.5厘米 横26厘米

Gu6154 5/10

Anonymous,
Song dynasty

Wagtail and Withered Lotus Leaf
Album leaf, silk
26.5 × 26 cm

100

故6154 3/10

宋 佚名
绣羽鸣春图页

绢本 纵25.7厘米 横24.1厘米

Gu6154 3/10

Anonymous,
Song dynasty

Beautiful Bird Singing in Spring
Album leaf, silk
25.7 × 24.1 cm

101

故6154 6/10

宋 佚名
霜筱寒雏图页

绢本 纵28.7厘米 横28.2厘米

Gu6154 6/10

Anonymous,
Song dynasty

*Young Sparrows and Bamboos in
Cold Weather*
Album leaf, silk
28.7 × 28.2 cm

102

新17779 8/20

宋 佚名
松涧山禽图页

绢本 纵25.3厘米 横25.3厘米

Xin17779 8/20

Anonymous,
Song dynasty

Titmouses, Mountain Stream and Pine
Album leaf, silk
25.3 × 25.3 cm

115 220

故6154 9/10
宋 佚名
驯禽俯啄图页
绢本 纵25.7厘米 横24.1厘米

Gu6154 9/10
Anonymous,
Song dynasty
Tamed Sparrow Pecking at Food
Album leaf, silk
25.7 × 24.1 cm

109 213

新70987
宋 佚名
写生草虫图页
绢本 纵25.5厘米 横26厘米

Xin70987
Anonymous,
Song dynasty
Plants and Insects
Album leaf, silk
25.5 × 26 cm

116 222

新147428 6/12
宋 佚名
无花果图页
绢本 纵24.8厘米 横25.3厘米

Xin147428 6/12
Anonymous,
Song dynasty
Fig
Album leaf, silk
24.8 × 25.3 cm

110 214

新156346
宋 佚名
牡丹图页
绢本 纵24.8厘米 横27.3厘米

Xin156346
Anonymous,
Song dynasty
Peony
Album leaf, silk
24.8 × 27.3 cm

117 224

新156350
宋 佚名
荷蟹图页
绢本 纵28.4厘米 横28厘米

Xin156350
Anonymous,
Song dynasty
Withered Lotus and Crab
Album leaf, silk
28.4 × 28 cm

111 215

新156351
宋 佚名
蓼龟图页
绢本 纵28.4厘米 横28厘米

Xin156351
Anonymous,
Song dynasty
Knotweed and Tortoise
Album leaf, silk
28.4 × 28 cm

118 226

故6151 3/10
宋 佚名
晴春蝶戏图页
绢本 纵23.7厘米 横25.3厘米

Gu 6151 3/10
Anonymous,
Song dynasty
Dancing Butterflies in Spring
Album leaf, silk
23.7 × 25.3 cm

112 216

新147425 7/12
宋 佚名
古木寒禽图页
绢本 纵25.3厘米 横26厘米

Xin147425 7/12
Anonymous,
Song dynasty
Withered Trees and Wintry Birds
Album leaf, silk
25.3 × 26 cm

119 228

故6152 7/10
宋 佚名
夏卉骈芳图页
绢本 纵23.7厘米 横25.2厘米

Gu 6152 7/10
Anonymous,
Song dynasty
Beautiful Flowers in Summer
Album leaf, silk
23.7 × 25.2 cm

113 218

新147425 12/12
宋 佚名
水仙图页
绢本 纵24.6厘米 横26厘米

Xin147425 12/12
Anonymous,
Song dynasty
Narcissus
Album leaf, silk
24.6 × 26 cm

120 229

新70988
宋 佚名
海棠蛱蝶图页
绢本 纵25厘米 横24.5厘米

Xin70988
Anonymous,
Song dynasty
Begonia and Butterflies
Album leaf, silk
25 × 24.5 cm

114 219

新147424 9/12
宋 佚名
鹌鹑图页
绢本 纵23.3厘米 横24厘米

Xin147424 9/12
Anonymous,
Song dynasty
Quail
Album leaf, silk
23.3 × 24 cm

127

新147430 2/21

宋 佚名
晚荷郭索图页

绢本 纵23.9厘米 横24.7厘米

Xin147430 2/21

Anonymous,
Song dynasty
Withered Lotus
Album leaf, silk
23.9 × 24.7 cm

121

故6156 1/11

宋 佚名
折枝果图页

绢本 纵52.8厘米 横46.5厘米

Gu6156 1/11

Anonymous,
Song dynasty
Sprays of Fruits
Album leaf, silk
52.8 × 46.5 cm

128

新156349

宋 佚名
霜柏山鸟图页

绢本 纵25.4厘米 横24.2厘米

Xin156349

Anonymous,
Song dynasty
*Tallow Tree and Mountain Birds in
Winter*
Album leaf, silk
25.4 × 24.2 cm

122

新156352

宋 佚名
竹涧鸳鸯图页

绢本 纵24.8厘米 横24.8厘米

Xin156352

Anonymous,
Song dynasty
*Mandarin Ducks under Waterside
Bamboo*
Album leaf, silk
24.8 × 24.8 cm

129

新148940

宋 佚名
丛菊图页

绢本 纵24厘米 横25.1厘米

Xin148940

Anonymous,
Song dynasty
Chrysanthemums
Album leaf, silk
24 × 25.1 cm

123

新20637

宋 佚名
柳林牧牛图页

绢本 纵23.2厘米 横24.1厘米

Xin20637

Anonymous,
Song dynasty
Cowboy and Buffalo in Willow Grove
Album leaf, silk
23.2 × 24.1 cm

130

新147430 5/21

宋 佚名
寒塘凫侣图页

绢本 纵16.6厘米 横20.8厘米

Xin147430 5/21

Anonymous,
Song dynasty
Duck Couple in Spring Pond
Album leaf, silk
16.6 × 20.8 cm

124

新13845 10/15

宋 佚名
猿猴摘果图页

绢本 纵25厘米 横25.6厘米

Xin13845 10/15

Anonymous,
Song dynasty
Apes Picking Up Fruits
Album leaf, silk
25 × 25.6 cm

131

新20636

宋 佚名
豆花蜻蜓图页

绢本 纵27厘米 横23厘米

Xin20636

Anonymous,
Song dynasty
Bean Flower and Dragonfly
Album leaf, silk
27 × 23 cm

125

新147430 7/21

宋 佚名
蛛网撄猿图页

绢本 纵23.8厘米 横25.2厘米

Xin147430 7/21

Anonymous,
Song dynasty
Ape Touching Spider Web
Album leaf, silk
23.8 × 25.2 cm

132

新156353

宋 佚名
牧牛图页

绢本 纵23厘米 横24厘米

Xin156353

Anonymous,
Song dynasty
Cowboy and Cattle
Album leaf, silk
23 × 24 cm

126

故6154 10/10

宋 佚名
霜柯竹涧图页

绢本 纵27.5厘米 横26.8厘米

Gu6154 10/10

Anonymous,
Song dynasty
Perching on Waterside Tree in Winter
Album leaf, silk
27.5 × 26.8 cm

139 263

新60898

宋 佚名
人物楼台壁画

泥质 纵138厘米 横50厘米

Anonymous,
Song dynasty

Figure and Architecture
Wall painting, plaster
138 ×50cm

140 264

新14246

宋 佚名
松云壁画

泥质 纵55.7厘米 横40.7厘米

Xin14246

Anonymous,
Song dynasty

Pines in Clouds
Wall painting, plaster
55.7 ×40.7cm

141 265

新60904

宋 佚名
观音坐像壁画

泥质 纵91.5厘米 横97厘米

Xin60904

Anonymous,
Song dynasty

Seated Avalokitesvara
Wall painting, plaster
91.5×97cm

142 266

新60902

宋 佚名
三仕女立像壁画

泥质 纵157厘米 横60厘米

Xin60902

Anonymous,
Song dynasty

Standing Ladies Holding Pot and Fruits
Wall painting, plaster
157×60cm

143 267

新60897

宋 佚名
二仕女立像壁画

泥质 纵133厘米 横43.8厘米

Xin60897

Anonymous,
Song dynasty

Two Ladies
Wall painting, plaster
133×43.8cm

144 268

新14248

宋 佚名
上元大帝、指山山崩壁画

泥质 纵70厘米 横80厘米

Xin14248

Anonymous,
Song dynasty

*Shangyuan God Pointing at Mountain,
Which Collapses Immediately*
Wall painting, plaster
70×80cm

133 248

故6150 3/10

宋 佚名
垂杨飞絮图页

绢本 纵25.8厘米 横24.6厘米

Gu6150 3/10

Anonymous,
Song dynasty

Weeping Willow and Flying Catkins
Album leaf, silk
25.8 × 24.6 cm

134 250

新147506

宋 佚名
鹌鹑图页

绢本 纵22.9厘米 横26.1厘米

Xin147506

Anonymous,
Song dynasty

Quail
Album leaf, silk
22.9 × 26.1 cm

135 252

新147430 4/21

宋 佚名
荷塘鸂鶒图页

绢本 纵16.8厘米 横21厘米

Xin147430 4/21

Anonymous,
Song dynasty

Mandarin Ducks on Lotus Pond
Album leaf, silk
16.8 × 21 cm

136 254

新153385

宋 木版印赵城县
阿差末菩萨经卷

纸本 纵29厘米 横960.2厘米

Xin153385

Anonymous,
Song dynasty

*Block-printed Aksayamati Sutra of
Zhaocheng*
Handscroll, paper
29 × 960.2 cm

137 258

新176125

宋 佚名
赵城版画经卷

纸本 纵25.2厘米 横30厘米

Xin176125

Anonymous,
Song dynasty

Printed Illustration of Zhaocheng Sutra
Handscroll, paper
25.2×30 cm

138 262

新60907

宋 佚名
持箫独立女佛壁画

泥质 纵117厘米 横91.5厘米

Xin60907

Anonymous,
Song dynasty

Standing Goddess Holding Vertical Flute
Wall painting, plaster
117 ×91.5 cm

145

新18972

辽 陈及之（传）
便桥会盟图卷

纸本　纵36厘米　横117厘米

Xin18972

Attributed to Chen Jizhi,
Liao dynasty

Meeting at the Bian Bridge

Handscroll, paper
36 × 117 cm

146

新147139

金 赵霖
昭陵六骏图卷

绢本　纵27.4厘米　横444.2厘米

Xin147139

Zhao Lin,
Jin dynasty

Six Steeds of the Zhao Mausoleum

Handscroll, silk
27.4 × 444.2 cm

147

新146748

金 张珪
神龟图卷

绢本　纵34.5厘米　横55.3厘米

Xin146748

Zhang Gui,
Jin dynasty

Auspicious Turtle

Handscroll, silk
34.5 × 55.3 cm

148

新147060

金 杨世昌
崆峒问道图卷

绢本　纵28.2厘米　横49.5厘米

Xin147060

Yang Shichang,
Jin dynasty

Asking Daoist Doctrine in Kongtong Mountains

Handscroll, silk
28.2 × 49.5 cm

List of Plates

Contents

COMPENDIUM OF COLLECTIONS IN THE PALACE MUSEUM

PAINTINGS

4

Song, Liao, and Jin Dynasties

The Forbidden City Publishing House